CHOLAMANDAL

An Artists' Village

Cholamandal
An Artists' Village

Edited by

Josef James

OXFORD

UNIVERSITY PRESS

CHENNAI DELHI MUMBAI KOLKATA

2004

OXFORD
UNIVERSITY PRESS

YMCA Library Building, Jai Singh Road, New Delhi 110 001

Oxford University Press is a department of the University of Oxford. It furthers the
University's objective of excellence in research, scholarship, and education
by publishing worldwide in

Oxford New York

Auckland Bangkok Buenos Aires Cape Town Chennai
Dar es Salaam Delhi Hongkong Istanbul Karachi Kolkata
Kuala Lumpur Madrid Melbourne Mexico City Mumbai Nairobi
São Paulo Shanghai Taipei Tokyo Toronto

Oxford is a registered trademark of Oxford University Press
in the UK and in certain other countries

Published in India
By Oxford University Press, New Delhi

ISBN 019 566988 6

Text layout K.P. Nagarajan, Chennai 600 014
Typeset by Gurucharan Graafics, Chennai 600 014
Printed in India by Galaxy Printers, Chennai 600 014
Published by Manzar Khan, Oxford University Press
YMCA Library Building, Jai Singh Road, New Delhi 110 001

Foreword

The creative urge faces interesting challenges and opportunities in any modern society. In an ancient country such as India where the weight of its past as well as its diversity is great, and where the process of modernization has taken place in an exceptionally uneven way—transcending different epochs, cultures, and stages of civilization—the challenges are difficult and complex. But where there are individuals of talent and sincerity, the responses to these challenges can be richly productive.

Creative individuals in field after field in India have faced the same type and quality of challenge over the past century: how to make a systematic, assured living out of pursuing creativity without undue compromise, without having to divert time and energy into unwanted earning pursuits. The challenge has been to find ways and means to professionalize the pursuit of creativity in tune with modern times, where old systems of patronage no longer work. This challenge was faced in the first half of the twentieth century by the 'big three' of creative Indian writing in English—R.K. Narayan, Mulk Raj Anand, and Raja Rao. Narayan was perhaps the first modern Indian writer to make a full-time career out of literature. These three writers may be said to have 'invented the Indian English novel' but they did it under circumstances that may be termed heroic.

Madras in the fifties witnessed much the same striving in the field of art, with K.C.S. Paniker, eminent painter and visionary, who was principal of the Government School of Art and Crafts, daring to dream and leading a movement of artists towards a way of life that may now be recognized as a professional breakthrough. In his memorable phrase, the vision was of an art 'Indian in spirit and world-wide contemporary' that would break away from what was 'at best an almost sterile version of a European way of art expression'. The response, which took concrete shape in the mid-sixties, can now be recognized as a declaration of independence of a rare kind in the field of modern Indian art.

Freedom needs certain material conditions for its realization. Without these minimum conditions being met, creativity finds its path blocked by mundane obstacles. Thus the mathematical genius, Srinivasa Ramanujan (1887–1920), was obliged to take up a job in the Madras Port Trust before he was 'discovered' by mathematical Cambridge. Thus Ramanujan's older contemporary, the poet Subramania Bharati (1881–1921), the greatest Tamil literary figure of modern times, had two stints in the newspaper *Swadesamitran* as a sub-editor and writer.

This book, the work of many hands, in keeping with the diversity and collegiality that characterized the Paniker-led response, tells the fascinating and moving story of how artistic freedom and independence were aspired for and won along a path strewn with obstacles. It is part elegy, part scholarship, part informed journalism. Not surprisingly for anyone who knows the artists' village, Josef James, teacher of Economics and Chennai's pre-eminent theoretician of modern art, provides the steadying narrative hand and voice, the running thread of this work of many hands. In a sense, James invented Cholamandal as much as his friends, the diverse artists, did—and lived the experience memorably, until his life was cut short by a cruel disease.

Starting with the founding father, Paniker, many of the painters and sculptors presented here are gone, but their works speak eloquently to their individual qualities as well as to the intellectual diversity of a unique colony. As the founding vision allowed, there is no guarantee that Cholamandal will continue to be a centre of artistic creativity a generation or two hence, or indeed that it will continue to be populated by painters, sculptors, and other people of art. But whenever a discerning observer undertakes a visit to explore or glimpse the Pallava-patronized artistic greatness of Mahabalipuram of the seventh and eighth centuries, he or she should stop over, *en route*, at the contemporary artists' village. A reading of *Cholamandal: An Artists' Village,* preferably ahead of the visit, will help the observer share in the quality and integrity of the experience.

N. RAM
Editor-in-Chief, *The Hindu*

Contents

Acknowledgements

We are grateful for the help readily given to us by many in producing this book. The idea of the book originated in 1996 when the late Josef James felt the need to document the conception, establishment and evolution of Cholamandal. A major part of this documentation was done by James himself. After his death in 1998, the editorial board of the village compiled and completed the venture.

The line drawings on Cholamandal have been contributed by S.G. Vasudev and V. Viswanadhan. We would also like to acknowledge G. Venkatram who has taken most of the photographs in this book.

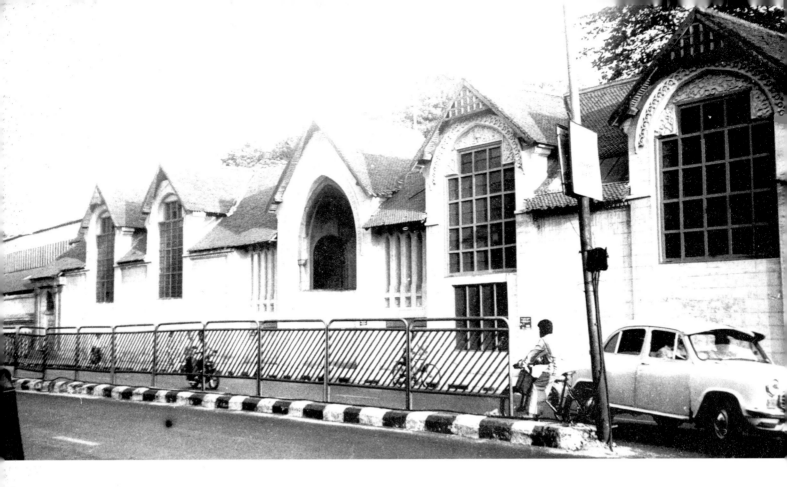

Cholamandal

AN ARTISTS' VILLAGE

Introduction

The Cholamandal Artists' Village is located on 10 acres of land, about nine km from Adyar along the New Mahabalipuram Road. It consists of artists' studios, a permanent gallery of paintings, graphics, drawings and sculptures, a workshop for metal work, guest houses, the Artists' Handicrafts Association office and the

College of Arts and Crafts, Madras

◁　Outer view

▷　Main building

▽　Garden

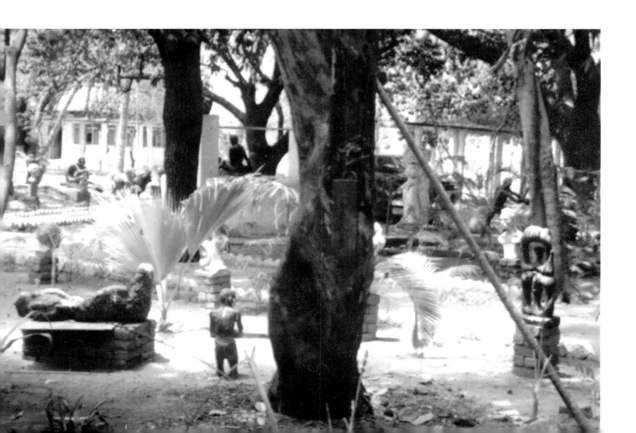

residences and studios of the artists living and working there. The thirty painters and sculptors who formed the village make up the Artists' Handicrafts Association, which overseas the colony.

Towards the east, past a casuarina grove and a fishing village, lies the Bay of Bengal. Nearby is the old and sparsely populated village of Injambakkam. Frequent bus services, taxis and autorickshaws connect the village to Chennai.

Back in the fifties, the spot was part of an uninhabited stretch of sand with casuarina plantations. At that time, most of the artists who live and work here now were students of the Government School of Arts and Crafts, Madras[1] (now known as Chennai). The principal of the institution was the late K.C.S. Paniker. He was in quest of an art, which he described as 'Indian in spirit and world wide contemporary'. In his work, wherein he had dared such a prospect, he was making a significant departure from the state of art in the country which was, as he put it 'at best an almost sterile Indian version of an European way of art expression'. Towards the end of the fifties many painters and sculptors in the School of Arts and Crafts joined hands with him in search of what amounted to a new way of life in contemporary art. This was an exciting venture, which soon proved to be exacting as well.

This is the story of an artists' village that has completed almost four decades of existence. What is remarkable is that it has done so practically on its own. It has not, during these years, received nor asked for any funding from the government, quasi-governmental bodies, charitable foundations, or persons. Apart from the small grant that it is entitled to, like any other art organization in the country, it has no particular support from art bodies like the Lalit Kala Akademi. The land where the artists set up their village was purchased with their own money. They built everything: their houses, studios, gallery, theatre, workshop and kitchen, on their own. In other words, the artists who make up this settlement, owe their village and the living they have managed out of it to nobody's charity, patronage, munificence or eccentricity.[2]

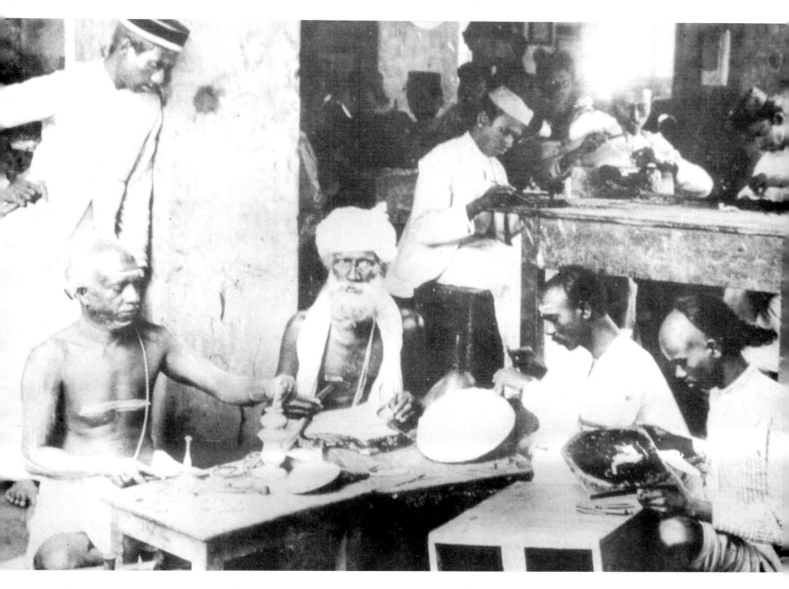

△ Craftsmen at work—the Government School of Arts and Crafts (late eighteenth century).

The notion was bold and practical. They spelt it out as follows: 'The painters and sculptors of Madras representing the various art organizations, met in February, 1964 and resolved that since paintings and sculptures do not sell sufficiently, it is necessary to find other legitimate means for the serious artists to survive'. The practice of commercial art or full-time employment under government or private agencies as art teachers in schools or as designers were found unsuitable as they permitted too little time for sustained creative work. Moreover, these occupations were found in most cases to be too stifling. Part-time work of two or three hours a day where the artists could freely extend their art on to a congenial craft of utilitarian nature appeared to be the answer. That was the concept of Cholamandal spelt out in 1964 by these artists in their journal *Artrends*. Two years later, the need was felt for a residential work-centre for artists at a suitable place preferably near the sea on the outskirts of the city with transport facilities. On 13 April, 1966, the Association acquired 10 acres of land near the seashore, six miles south of Adyar on the new East Coast Highway. A month later, in May 1966, the first batch of eight artists moved in to live and work there.[3] The building of an artists' village and work centre was soon underway. Since this magnificent little plot of land lies on the Coromandel Coast, the artists' village was named Cholamandal.

There have been other solutions to the question of an artist's vocation and existence in society. One of them is widely accepted and even idealized, that of a defiant and eccentric relation to others pursuing their purposes. Accordingly, the artists appropriate a rebellious attitude towards the disciplines of the commercial circuit, administrative procedures, office routines, teaching curricula and the host of other properties and conventions that cramp their initiative and stifle their spirit. They grant themselves the licence to go at these with a kind of expression that is worked up to shock people out of their common wisdom and conventional ways. That arrangement would give the artists a perpetual grouse to fan their fires with and in return, a heady bohemian existence that could be honourably affordable. What has come to be accepted as modern art is part of that solution to the attitude towards art and artists and of artists towards others in society. This developed in

The Madras State Lalit Kala Akademi Building
as it stands today—Cholamandal artists in the
foreground—the joint working and living here
was a forerunner of the way of life they were
to experience later on in Cholamandal.

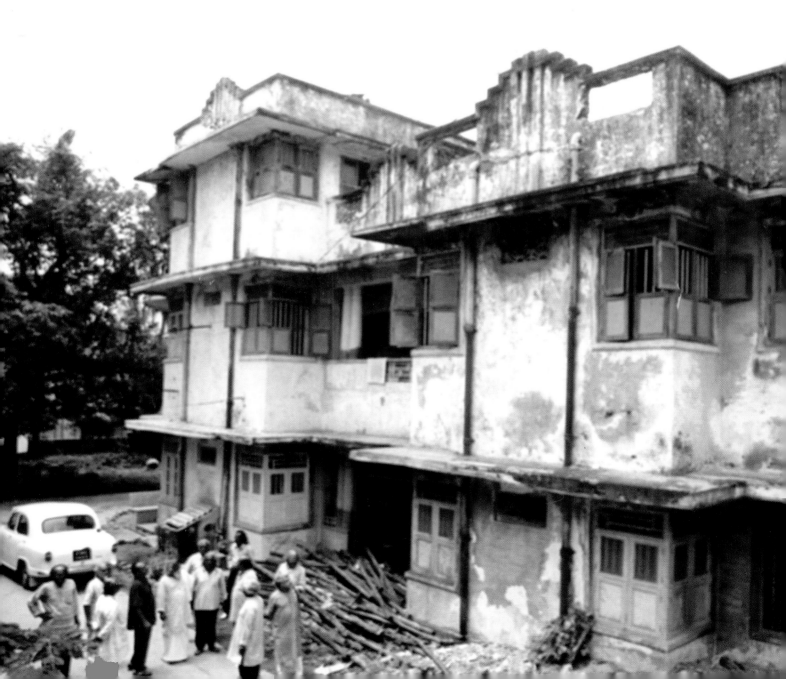

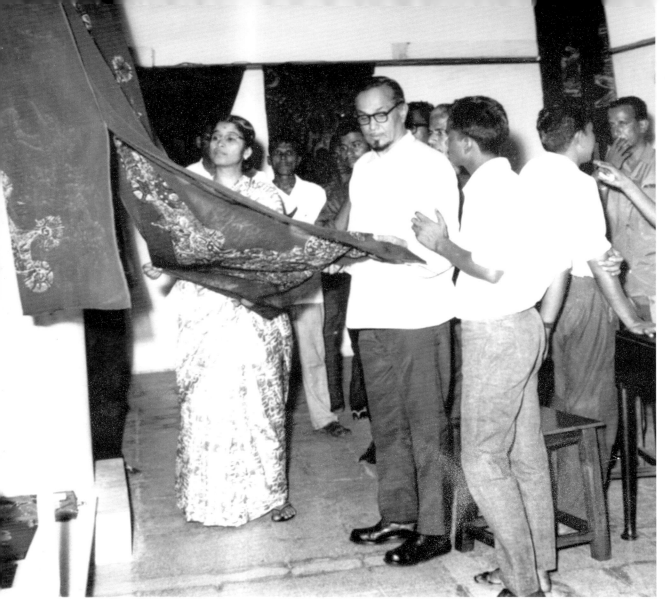

Paniker showing batik to a visitor at the School of Art in 1964.

Metal craftwork done at the village sometime in the sixties.

Craftwork by the Cholamandal artists:

Palmyra seed mask ▷

Silver filigree jewellery ▽
designed by the artists

Europe towards the end of the nineteenth century. This distinctly middle-class ideal has since been philosophized to legitimize modern art. The romance of this solution proved so captivating that people were willing to fake its existential and societal circumstances to liberate themselves into that kind of rebellious expressiveness.[4]

This solution, comprising the philosophy of isolation and alienation from the run of common life and that of a violently paranoic art is certainly historic and authentic to the cultural situation in Paris, where it originated, also to that of Germany and the United States where it flourished sensationally. This philosophy of art and existence did sway many minds in India as well and some of them lent themselves to the kind of solution that it held out. This group of artists in Madras spoke out against this phenomenon:

In India the so-called progressive school adopts not only the various techniques and approaches to art prevalent in New York, Paris or Mexico but also to the

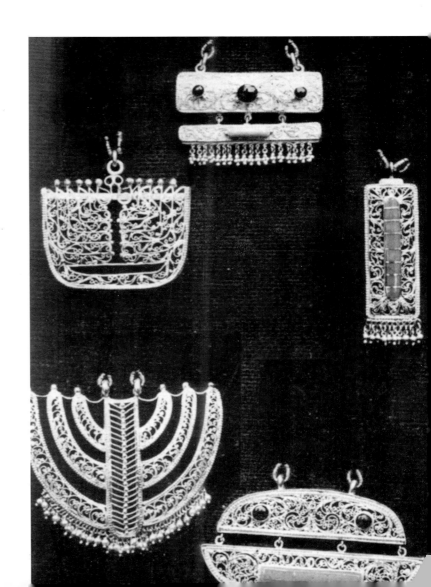

Editorial in the *Indian Express*—the inception of Cholamandal ▷

fundamental thought-feelings of the nationals or races of these regions. That these thought-feelings and racial or national tendencies have been inherited by these people through long tradition is perhaps overlooked in the face of the intense and moving experiences of close contact provided by modern life. In order to rise to its greatest stature of self-expression in the arts a race or a nation has to depend in the midst of all influences on its own fundamental ways of thinking, feeling and shaping.[5] (*Artrends*, Oct. 1964.)

Like earlier schools that advanced the truth of a more authentic vision and inspiration, this group of artists rejected the sensational philosophy of art and existence and the bohemian solution.

Latin Quarter for Madras

TO many people in Madras Kodambakkam is the centre of the universe. That is where the real epics of modern India, the films (Mr. Nehru mistakenly thought these would be factories) are being produced. Just to stare at the studios for hours on end seems to be the height of felicity for many people. When they want a change, they go and stare with similar intensity at the houses of certain film stars. But no one, least of all these persons, ever believes that he is satisfying any artistic cravings. In terms of aesthetics south Indian films are in a special category, neither fish nor flesh.

But a real centre of art is soon to be established in the city. It will never rival Kodambakkam in popularity, but its values would mean more. The Artists' Handicrafts Association is to set up a centre near the sea where about 35 artists, with their families, would live and exercise their genius in salubrious surroundings. Whether artistic products emerge from this colony or not, it is undeniable that the choice of the location is eminently artistic. What more could an artist require than an area far from the madding crowd, in the vicinity of the mysterious, everlasting sea! This is the most artistic thing that has happened to the Bay of Bengal since, about a thousand years ago, a Chola emperor despatched a navy across it to conquer parts of Burma, Malaysia and Indonesia.

The artists of Paris congregate on the left bank of the Seine, and those of the United States at Greenwich. These areas have earned a prescriptive right to eccentricity; even the bizarre does not shock overmuch. After all, something is due to unorthodox genius. But eccentricity in the initial stages is rather apt to annoy. The Philistine may be outraged. It is, therefore, wise that the Madras colony should nurture its extravagances, if it is minded to them, away from the vulgar gaze. In time, these eccentricities would, so to say, mature, and then Madras would be as proud of its Adyar (or whatever its name is to be) as Paris is of its Latin Quarter.

But a great city requires not only a Latin Quarter but also a Bloomsbury. Where is this to be found in Madras now? Such a question would have been laughed to scorn about ten years ago when the intellectual supremacy of Mylapore was undoubted. Unfortunately, however, the last decade has dealt rather harshly with Mylapore, which is becoming an extended slum. *Ex oriente lux*, it has been said. The artistic sun is to rise in the east. Will the intellectual sun rise in the west?

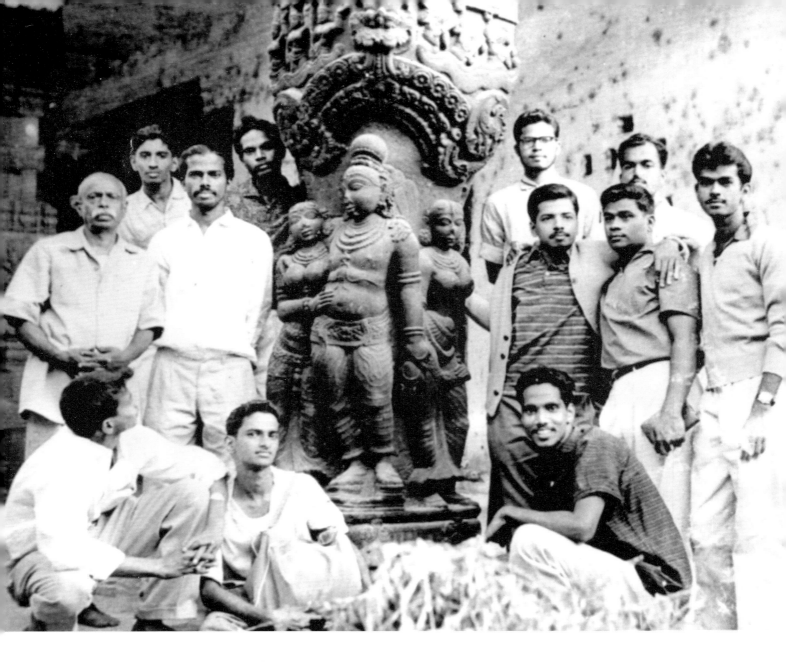

△ Member artists during the annual college
tour—(group on the right) sitting in
foreground, V. Viswanadhan—
standing (back row, left to right)
K.V. Haridasan, and Balan Nambiar
(front row, left to right) S.G. Vasudev,
Jayapal Panicker, and K.R. Harie.

▷ Painter Ramanujam at work in the village in 1969.

They preferred a philosophy of art and existence wherein the relationship between the two is not that of paranoic alienation but of ritualistic identification. The ritualistic approach of traditional disciplines eliminates the ego or the self-centred subjectivity that really is the incriminating agent and sees art and existence as a selfless discipline of living and working. It is but natural and honest for artists with a sense of tradition to find themselves anchored to this view. 'It is in this depersonalization,' they declared, on the authority of T.S. Elliot, '...that art may be said to approach the condition of science.' Indian tradition has always been aware of this truth. 'The almost total anonymity of great Indian masterpieces of painting, sculpture and architecture and sometimes even of literary works tend to indicate that the ancient Indian masters aimed at taking art beyond the bonds of

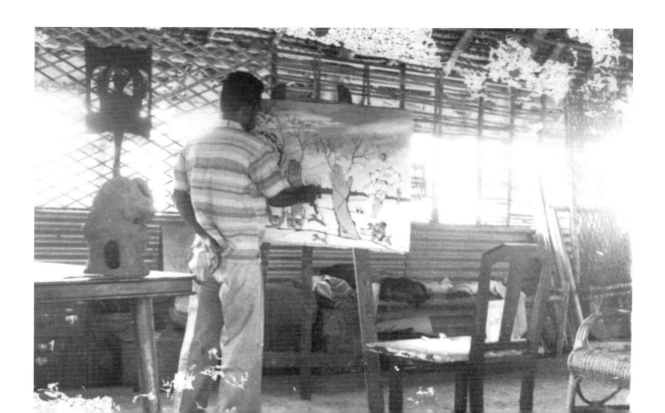

Some of the first cottages built at the village ▷
at the inception.

personality, towards the truly human in a broader sense.' (*Artrends*, Jan.–April, 1965.)[6] This position is certainly not wholly alien to the range of exigencies of the modernistic philosophy of expression. It was present right at the height of the paranoic outburst in Cézanne's desire and striving for classicism, in the medievalism of Walter Gropius, in Rothko's attempt to express his 'not-self', in the aesthetic withdrawal of Robert Morris and the whole reaction against 'luddite' art by the futuristic-technology school. But that was no more than the wind that blew abroad, which did not change the weather much in the Indian subcontinent.

At Madras, in the sixties, this group of artists was more alive to the practical steps to be taken than to philosophizing precisely about the stand that it was being intuitively led to take. The artists were quick to see that, 'it is a thin line that divides a great painter or sculptor from a great craftsman though present-day thinking sometimes appears to under-estimate the place of a craftsman in society.[7] It is often forgotten that a great artist is also a great craftsman for there can be no art without craftsmanship.' (*Artrends*, Jul.–Oct. 1966.) It was in craft, which had wrought such marvels as the Mohenjodaro and Harappan seals, the carvings on the temples of Konark, Khajuraho, Tanjore, and Madurai, the south Indian bronzes, the jewellery and handicraft objects of utility, that they identified the enormous ritual that relieved artists of their personality, self-centred individualism and other contentious manifestations of their being, and transformed them into 'the truly human, in a broader sense'. In craft, therefore, they saw the cure for the alienation of art and artists from their own humanity and of those around them:

It is often felt that modern painters and sculptors are insufficiently understood by a large majority of people. The Association's experience has been that while it is difficult to sell a modern painting or sculpture, it is easy to find a market for the most avant-garde work of utilitarian character in handicrafts. Woodwork, ceramics, batiks and leather works are easily bought by the people at good prices. Some of them find in the new crafts something which gives them an introduction to modern painting and sculpture as well. (*Artrends*, Jul.–Oct. 1966.)

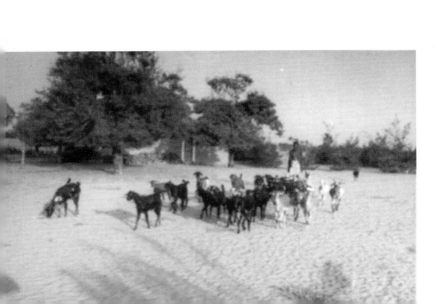

△ The founding of Cholamandal:
building the first cottage.

▷ The Bharathi open-air theatre

▽ Goats grazing at the village:
photograph taken at
Cholamandal in the late sixties.

'The Association is convinced,' they went on to say, that a more complete acceptance of modern artists by the people will be achieved partly and to a great extent at that, by the normal and natural education in aesthetics and taste of the people through utilitarian craftwork created by him. It is felt that the gulf that exists today between the artist and the people can be bridged this way effectively. (Ibid.)

Once the shift (from self-expressive to ego-negating, from the emotive content to exhaustive craft) had been effected intuitively, they were emboldened to re-do for themselves the existential circumstances, or the working and living conditions according to the new orientation. The Bohemian act that artists were obliged to don for a living could be shed because one is fooled no more by the ego that pushes one into the act. 'We are not bohemians out here, neither are we recluses,' said one of them

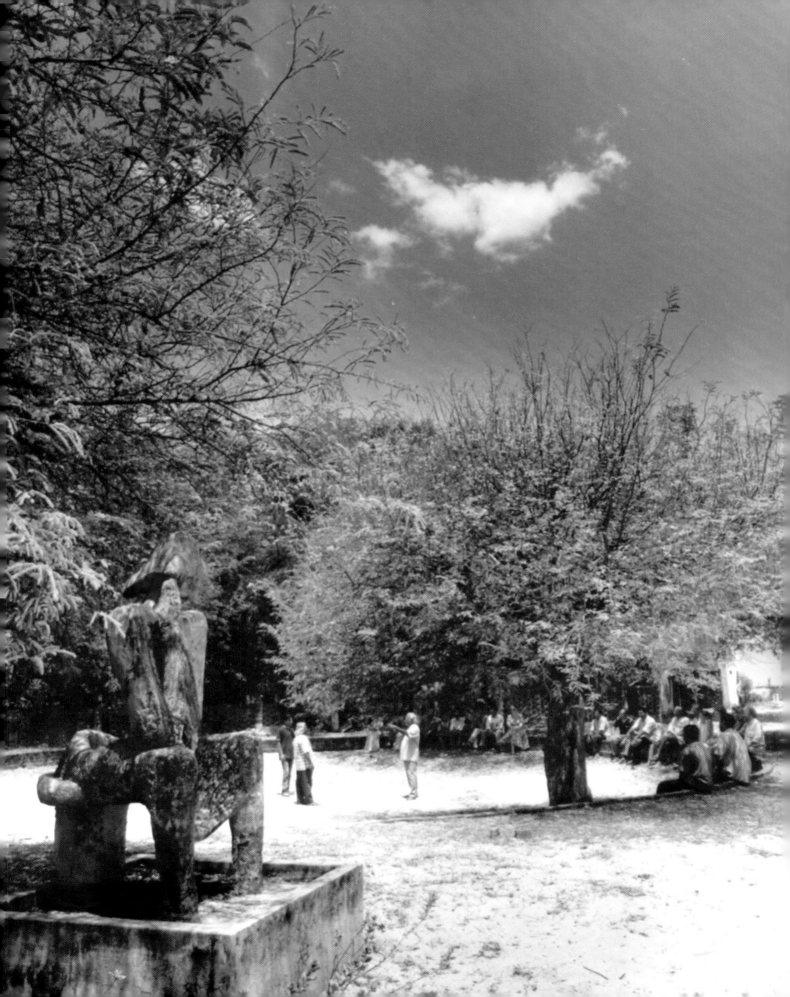

in an interview, 'we are just artists, I do not know, I just paint, I guess,' professed another, more like a devoted craftsman than as an imposing performer.' (*Aside,* Mar. 1987.) It took some years for the conviction to form clearly in their minds. During the sixties the existential issue was to find release from the ego-expressive art they were disagreeing with and from the harsh, demeaning demands the practice of it was making on them. 'One of the maladies that has dogged the step of the contemporary artist,' they declared,

is his apparent need to keep himself in the lime-light without a break for survival. He has to continually please all through his life in order to sell and live. Truly an artificial situation considering human limitations—it does not seem to allow for the perfectly normal slack

▽ Twin guest houses donated by
the German government:
a visiting French artist couple relax near
Hiroshi Mikami's zen inspired
installation in the foreground.

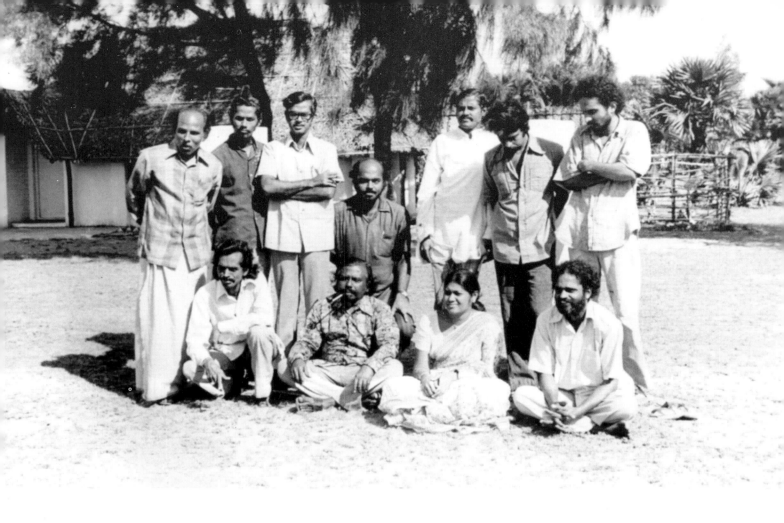

△ A group of artists relax after a general council meeting
at the village in the late seventies:
(standing, left to right) S.P. Jayakar, M. Senathipathi,
K.R. Harie, K.S. Gopal, Kanayi Kunhiraman, and
C. Douglas—(sitting, left to right) P.S. Nandan,
M.V. Devan, Balan Nambiar, Anila Jacob, and
S. Paramasivam.

▷ Inside the art gallery

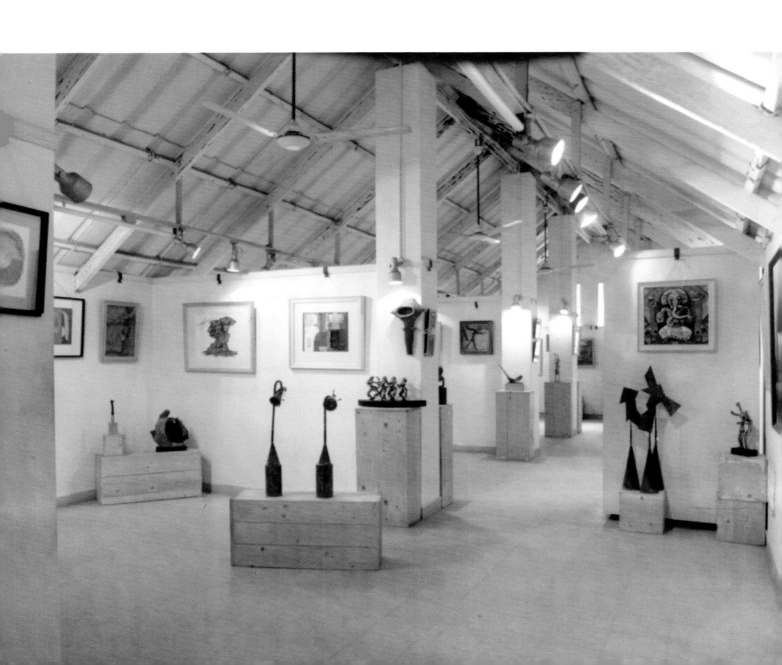

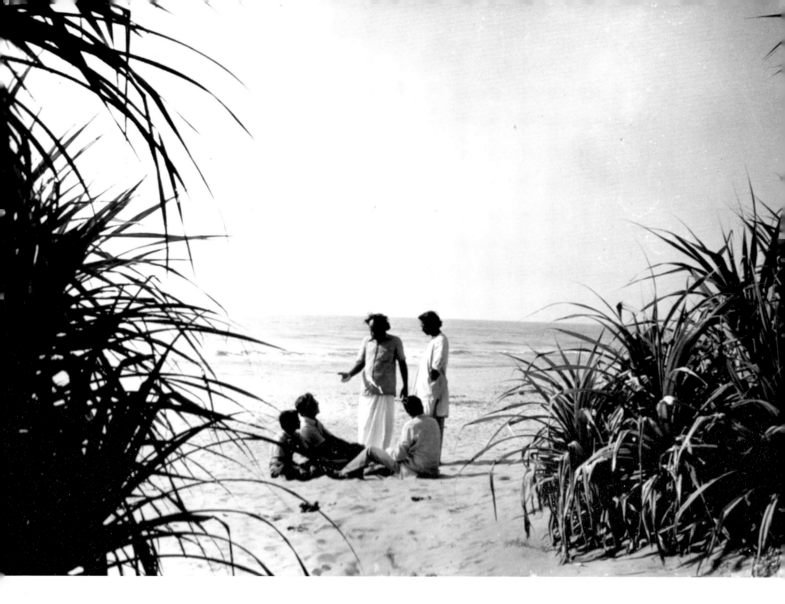

periods of creativity in man. As a result we have too many exhibitions of painting where the artist has really nothing new to say...the spiritual significance of such self-imposed and periodical withdrawal from public exhibitions of one's work by a potentially creative painter does not appear to be much understood. It can possibly give the artist clarity of mind and vision and help him to find himself—to *arrive*.[8] (*Artrends*, Jan.–Apr. 1966.)

They sought to withdraw and seek an existence where they could put their minds to the 'truly human' prospect which they had been able to sense assuredly in their works.

The number of artists who shared this prospect was more than forty; all of them

◁ Artists at the beach (standing, left to right)
D. Venkatapathy and M. Senathipathi
with vistors to the village.

▽ International sculpture garden:
granite sculpture by Ajit Chakravarti

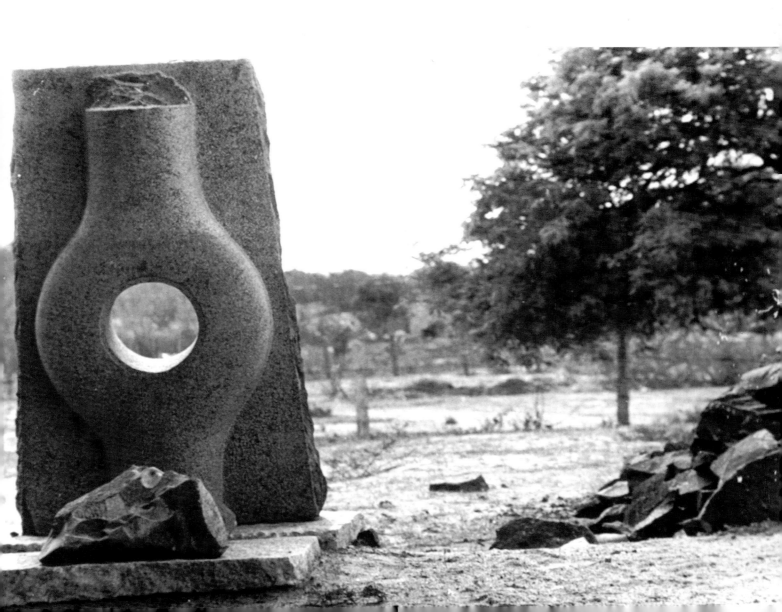

either students or faculty members at the Government School of Arts and Crafts, Madras. This institution, helpfully, had an excellent craft department consisting of engravers, mould-makers, goldsmiths, and woodworkers, alongside the faculties of painting and sculpture. It is difficult to assess how much this circumstance had to do with the centralization of the ritual of craft to the discipline of creative expression that these artists were led to attempt. But it was here that craft was institutionalized along with the freer disciplines of painting and sculpture. There was acceptance and appreciation on both sides and also instances of unwelcome interference as between the moulders and sculpture students. But the forty-odd painters and sculptors that the institution held worked freely and intensely, not

▽ Guest house of the
 Transport Corporation of India.

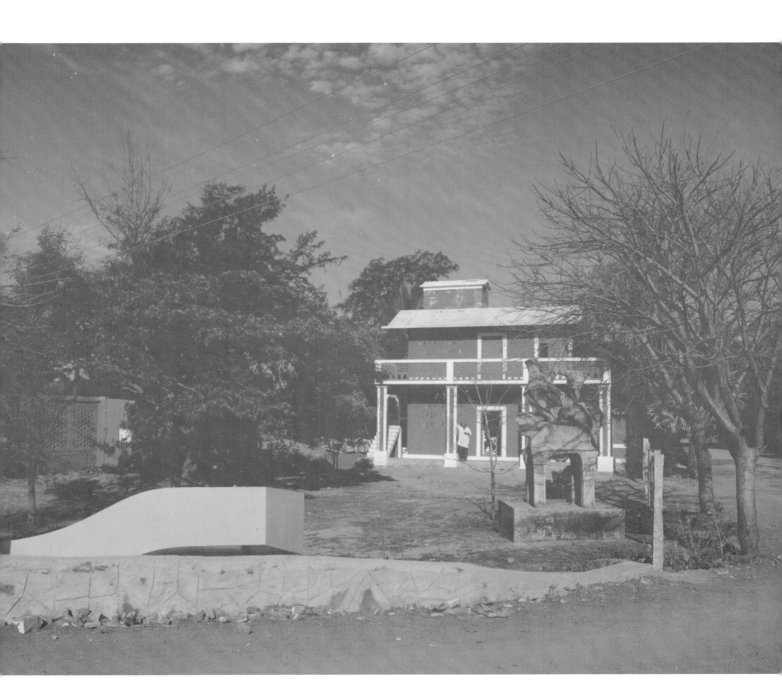

tended by any overt ideological management or frontage.

After class, they would move over to the premises of the State Lalit Kala Akademi[9] to continue their paintings and sculptures till late into the night; and then were at it again the next day at the college and at the Akademi. To take care of the collection, exhibition and sale of their output they formed the Progressive Painters' Association. This Association started its journal *Artrends* in 1961. They termed it 'a quarterly bulletin on contemporary art, mainly Indian'. The members used it to express the ideas they came upon in their attempt to bring about the value shift in art. Soon this grew into a movement, as the members became conscious of their distinctive vision. As the volume of output increased, the members formed the Artists' Handicrafts Association to handle their crafts projects. As the sixties progressed,

◁ A group of artist members.

△ Dancer Mallavika Sarukkai
 at the Bharathi open-air theatre in the early seventies.

▽ Concert by Carnatic Maestro
 M.D. Ramanathan in 1974.

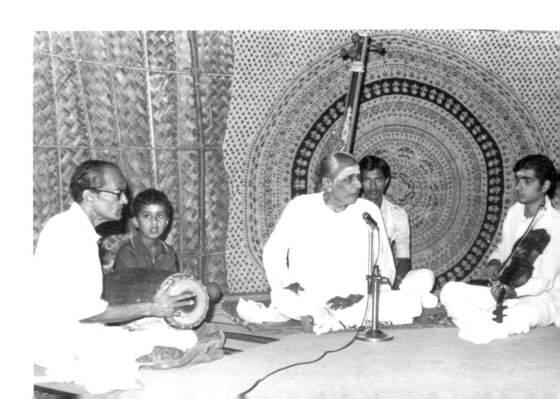

it was clear that this whole activity would outgrow the School of Arts and Crafts, if it had not already done so.

Clearly, Paniker was himself the prime visionary and the nerve-centre of the whole development. His own attempts to move away from an emotive valuation (served by fauve colours and cubist drawings) to a holistic and transcendental description had, by the early sixties, taken him to a point where the established order of craftsmanship in the medium had to be critically examined and possibly redone. While this focus shift appeared in a summary form in his own work, the results obtained by his colleagues in their own individual exercises fully stood witness to this. Paniker retired from the institution in 1967. It is difficult for art institutions

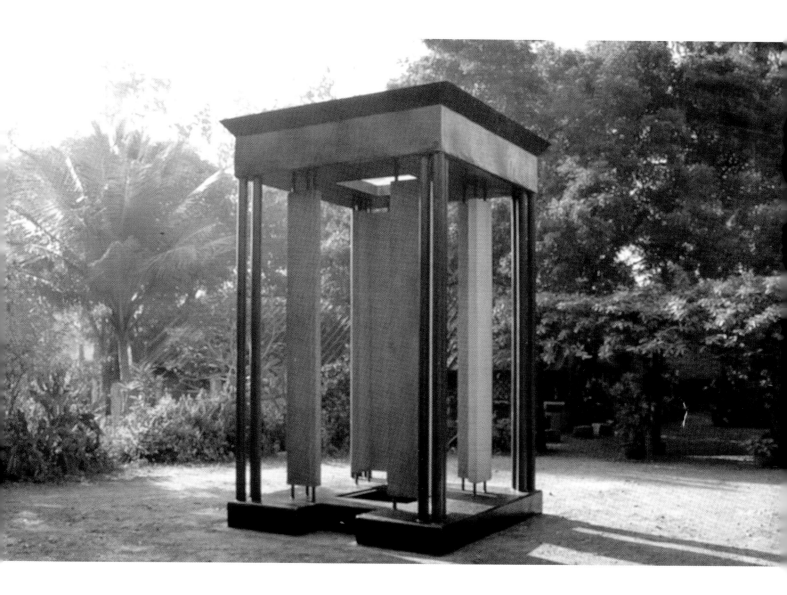

△ Dutch sculptress
Cune Van Groeningen's
Temple (steel and concrete)

with fixed courses and tenures like the one in Madras or elsewhere to keep up with an art movement beyond a point. Artists, for all they might owe their institution, cannot count on it to keep them together as long as they need to. It must at some point in the development of the movement disown them and in ordinary circumstances frustrate them as a group or as individuals. 'Art institutions in India', they reflected helplessly,

turn out hundreds of possible young painters, sculptors and creative craftsmen every year. But over ninety-five per cent of them seem to disappear from the field sooner or later. At least, they are never heard of again. Probably, many of them eke out a dreary living somewhere drudging on uncongenial commercial artwork of some kind or other. Many of these unfortunate young artists often have brilliant backgrounds of student work. Some were, perhaps even looked upon, while they were students, as the up-and-

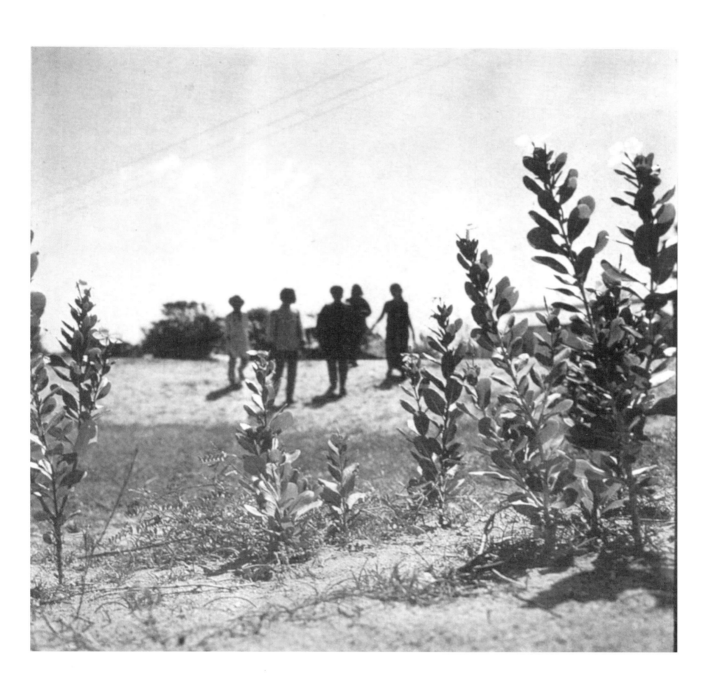

Dutch artist Maggie Owel's *Tree* (painted steel) ▷

coming artists of our times. (*Artrends*, Jul. 1964.)

A movement that attempted a deep revaluation needed to concern itself not just with its sources of inspiration and the emerging convictions but also with the question of the survival of those who were making it happen. This concern loomed large among the painters and sculptors in Madras by the mid-sixties. Their assurance on this seems to have arisen from the very fact that they were advancing with their work. In craft, which they were advancing as the possible content of creative expression (in place of a self-suffering emotion) they sensed something that could also serve as an honest and independent means of livelihood, if practiced with care, as is done by India's millions of craftsmen. On that note, '...some of the

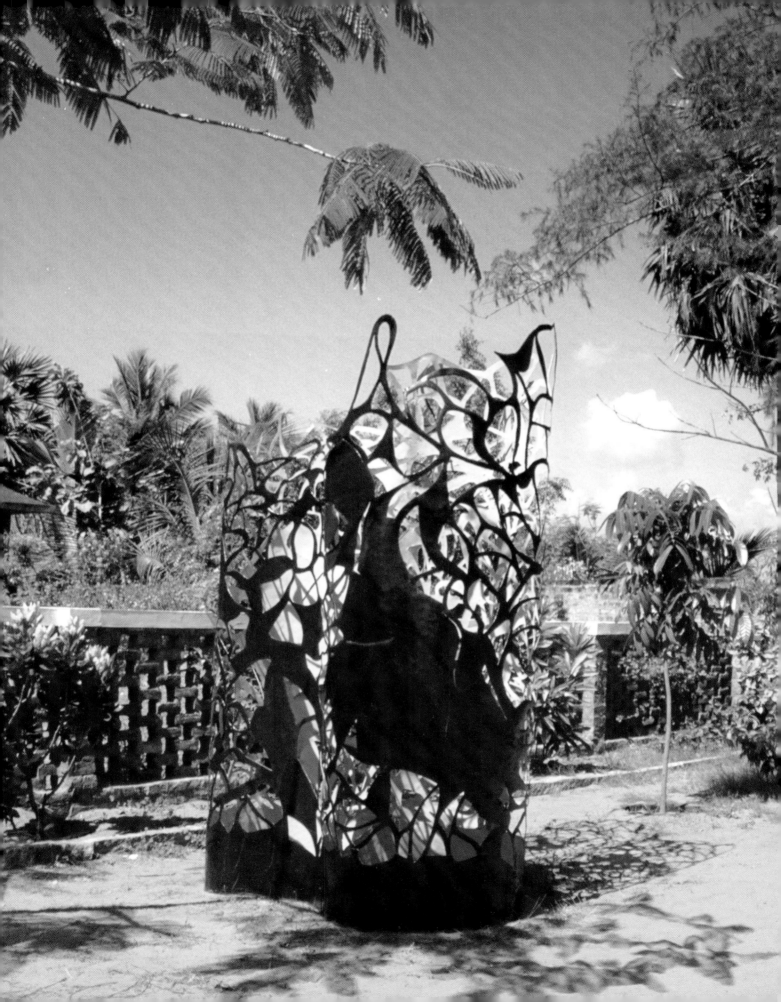

Visit to the village in 1969 △
by students from the Art College.

The beach at Cholamandal. ▷

Women celebrate Pongal (the harvest festival) ◁
in the month of January 1970.

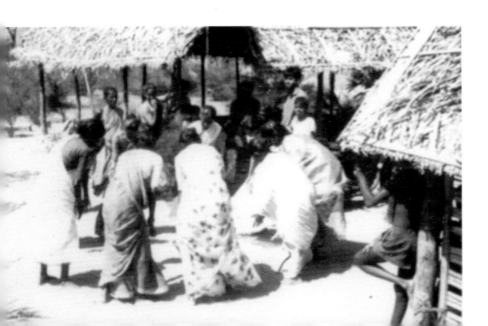

more restless painters and sculptors in Madras resolved, that they would henceforth live a fuller life in society as creative artists. As painting and sculpture did not sell sufficiently...they would employ themselves part-time, say, two to three hours a day, on creative handicrafts for an independent living. They would extend their art on to these.' (*Artrends*, Jul.–Oct. 1966.) It was to promote this ideal that the members formed the Artists' Handicrafts Association. A new solution to the larger issue of art and existence was now in sight for this group of artists.

The public in Madras seems to have regarded them well. When the artists donated their paintings to the war effort in the early sixties, people came out and bought

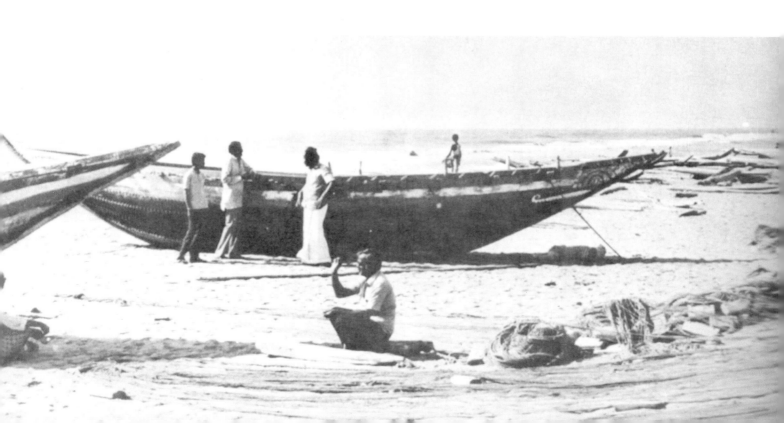

The pathway. ▷

most of them. This trend continued well into the later years of the decade. Much more went on. The artists spoke to the people through their journal, reasoned with them at seminars and exchanged ideas with them at the Artists' and Writers' workshops held periodically at the School of Arts and Crafts. The public responded tensely and passionately. There was therefore no despair or derision when the artists decided to move out of such familiarity. The force behind that decision to part with the public was the ideology of anonymity, suggested by the rule of craft, and of course the availability of land at prices they could afford. An export order from Italy for their hand-painted textiles worth Rs 10,000, brought up their savings to what would cost them to buy 10 acres of land at Rs 4,000 an acre on the outskirts of the city. The Artists' Handicrafts Association pooled its savings and bought the land on 13 April, 1966. Over forty painters and sculptors marked out their individual housing plots on this land, leaving out a central area for a common workshop, gallery, and kitchen. Some of them moved into it with their families and continued to work. In a couple of years, the artists' village was up in place, and work continued unabated.

The artists' sustenance hinged on three basics: food, a place to live, and fellow artists to keep up with. If fellow artists were forthcoming as they had been, a place and sustenance could be secured with the money they could make. It looked simple once it was accomplished but it would not have been real had it not been for the ideal of craft and its ideology of anonymity, which artists identified themselves within their paintings and sculptures. While the artists were free to sell their paintings and sculptures in any manner as they pleased, all their craftwork such as ceramics, batiks, leather, lacquer, wood, and metal were to be marketed by the Association and the sales proceeds would be distributed among the artists after deducting the cost of material and ten per cent for the artist's charges. This ten per cent went to the general funds from which overheads and improvement expenditures were to be met. The artists elected from among themselves the president, vice-president, secretary and treasurer of the Association. This is the set-up they have maintained since then.

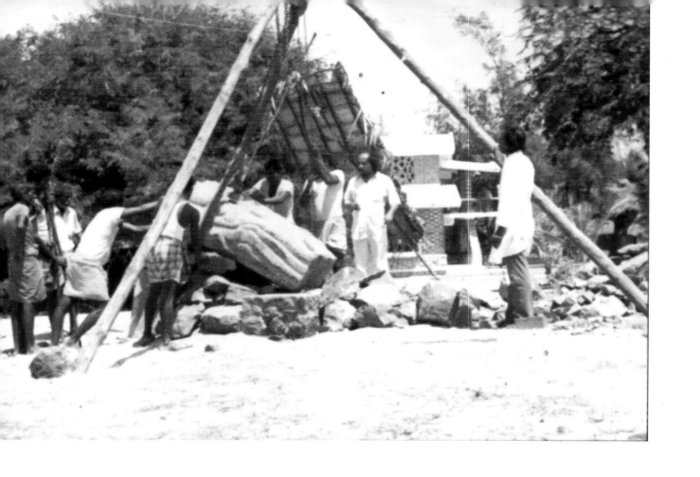

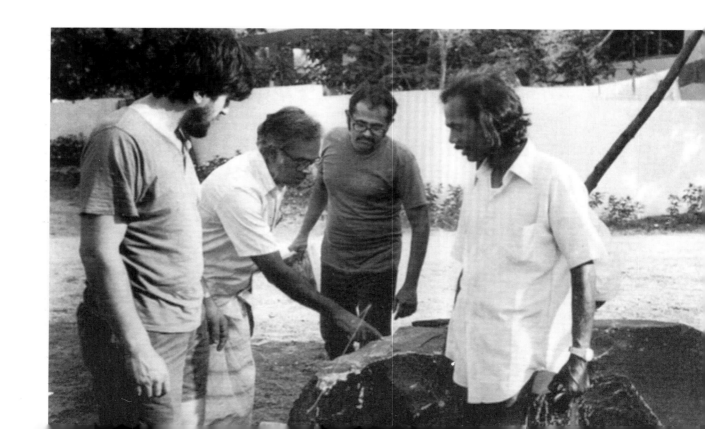

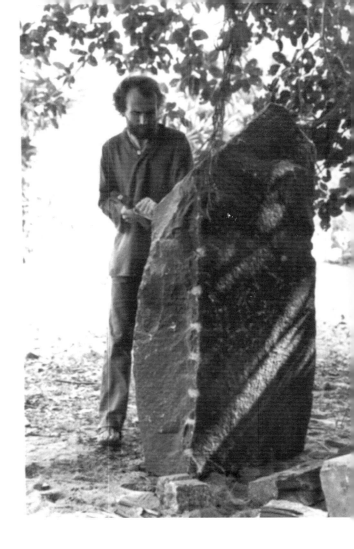

International stone sculptors' camp in 1988:

◁ Erection of sculpture—
 artist Gopinath in the centre.

▷ German sculptor Thomas Link
 works on a granite block.

▽ Artists discuss a problem—
 (left to right) Yugoslav sculptor
 Pejovic, K.R. Harie, S. Nandagopal,
 and C.Dakshinamoorthy.

The sustenance and freedom that the artists had designed for themselves did not look the same to everybody. Paniker, who had, in a sense, led them to this, was inclined to view it as a state of renunciation, a moral negation of a world of strife and achievement, an existence 'beyond the bounds of personality', the turning away once more 'to life and nature, the perennial inspiration to man's creative faculties for a fresh and vital new experience'. To another, this was like losing oneself in some religious or spiritual order. Some found the closeness and constancy of the nascent ruralism too parochial for their spirit. Two of them went away to Paris (Viswanadhan and Narayanan) to prompt themselves with the excitement of that historical art metropolis. Two others who married visitors from abroad

Sculptor Paul Schneider at work. ◁

Dutch sculptor Paul Beckmann's ▷
Tiara (rivetted aluminium)
at the Cholamandal
International Sculpture Park.

and accompanied their spouses, one to West Germany (Douglas) and another (Paramasivam) to the United States. Another (Jayapal) desired more domesticity for his family than he could find in the village and left for his hometown. A few preferred to remain where they were in town but stayed affiliated to the village. One remarkable painter (Ramanujam) found the village too open for the protection he sought from his own genius.[10] He painted away helplessly, brilliantly and finally, out of desperation, ended his life in his hut in the village. Besides these, ego problems of many kinds did arise often enough in the village, shaking its picture of tranquility.

The work of the individual artists and of them as a group in the new environment

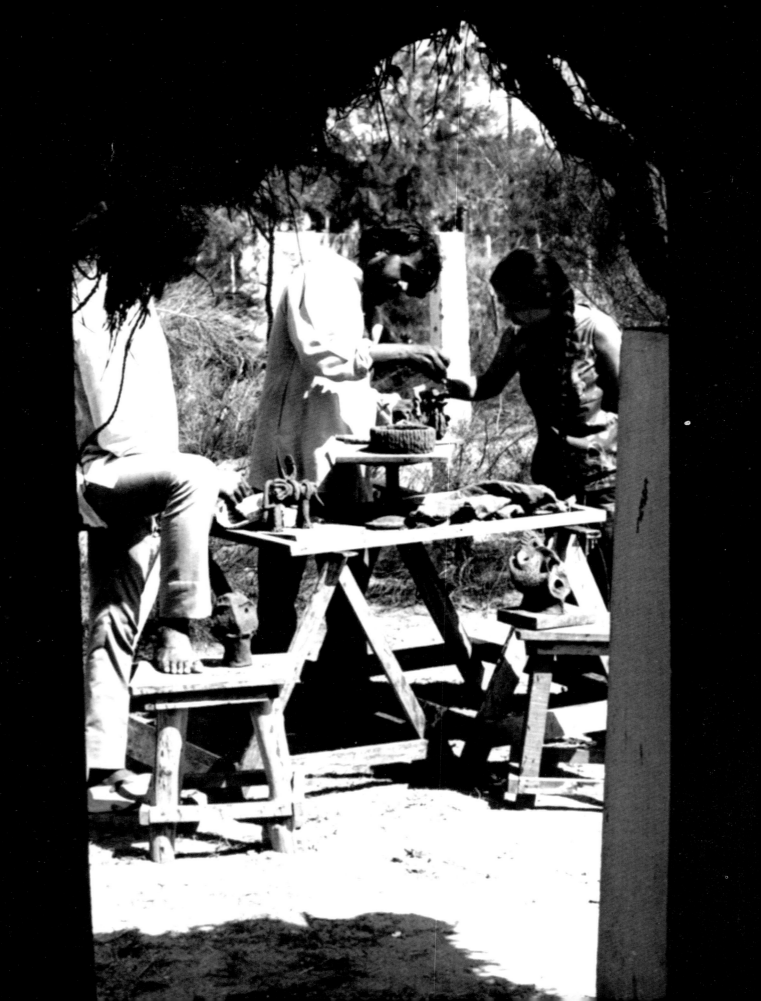

THE NEW YORK TIMES, THURSDAY, JANUARY 29, 1998

ARTS ABROAD
Stephen Kinzer

In India, Pioneers of Modernism Savor Their Success

CHOLAMANDAL, India — The tapping and torching sounds of a sculptor at work spilled from a shed above the Bay of Bengal on a hot afternoon, signs that one of India's most ambitious experiments in modern art is still thriving after more than three decades.

The artist hunched over his bench, Paramasivam Samanna, was one of 40 students at the Government Arts and Crafts school in Madras who resolved in the early 1960's to devote their lives to art. They pooled their meager funds to buy a cheap eight and a half acres of land south of the city, and set out to build a cooperative that would support them and their aspirations. The first group of seven artists arrived in May 1966.

"There was no road out here then, just a cow track," Mr. Samanna remembered. "We went shopping once a week with a wood cart, so we had to live on dry grains that wouldn't spoil. Cyclones would blow our houses and our work away."

Mr. Samanna now spends most of his time in Seattle, where he produces the same kind of whimsical copper, ceramic and bronze sculptures he was making here. In his visits every few years to his old base at Cholamandal, he has seen the Indian attitude toward contemporary art change.

"When we were in school, the only contemporary art we saw was in books about Picasso and Chagall at the British Council and the U. S. I. A.," he said, referring to the United States Information Agency. "As late as 1985 there were hardly one or two art books published in this country. Now there are big fat ones.

"If a newspaper covered an art opening in 1985, it was a tiny box, but now you see The Indian Express or The Hindu devoting a whole page with two or three reproductions. There is a market, and lots of rich people are buying. It's all quite new."

One reason the Cholamandal group survived to see this happy day is that its members understood from the start that they could not support themselves with fine art. Following the Bauhaus credo that art needs to embrace crafts, they began producing batik fabric printed in imaginative patterns. For years it was normal for artists here to spend two or three hours each day on batik preparation or other crafts-related work, free the rest of the time to pursue their muses.

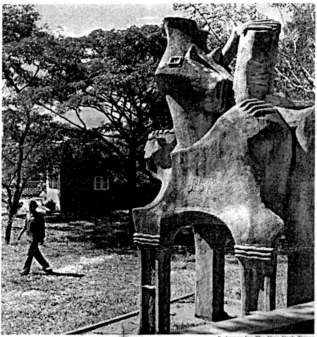

S. Anwar for The New York Times

A sculpture on the grounds of the Cholamandal Artists' Village, India's largest self-supporting art colony, in Tamil Nadu in the south.

Today Cholamandal, named after an ancient dynasty that encouraged the arts, is India's largest self-supporting art colony and one of the most successful in Asia. Twenty-one of the original 40 artists remain. The group does not accept new members, but there are usually about half a dozen younger artists working or studying here.

An airy complex contains studios where the artists work, cottages where they live, a well-lighted gallery where they show and sell, an open-air theater and a guest house donated by the West German Government. Set in a grove of beefwood trees a few miles from the coast, it is an idyll of warm breezes and sandy paths.

Although the artists here still produce some batik, now they are mostly able to live comfortably from their painting and sculpture. It is widely recognized as some of the best art produced in postwar India, and is shown regularly in galleries

across the country. Several Cholamandal artists have also shown in Europe, the United States and South America.

The artists' earnings are not pooled, but a portion goes into a fund that helps pay their joint expenses. This system, together with the popularity of many member artists with the growing art-buying public in India, has made Cholamandal a financial as well as an artistic success.

Many Indian art historians say Western-style painting here began with Rajah Ravi Varma, a prince from the cultured southern state of Kerala. In the 1890's, Varma, who had studied under a Dutch art teacher, began producing realistic-looking pictures of Hindu gods and goddesses. They were reproduced on calendars that hung in many homes and inspired countless young people.

In India as elsewhere, there have been painters who have latched on to nearly every trend in the art world. But the story of 20th-century Indian

art is also the story of a series of regional schools.

The first post-Varma school, which sprang up in Bengal, was influenced by French Impressionism. Its exponents used flowing lines and diffused, misty colors to portray historical and metaphysical subjects.

At the end of the 1940's, as the Indian independence movement reached its turbulent peak, the Bengal movement fell before a new generation that rejected mystic sentimentalism as outdated and remote from the modern Indian experience. This movement, based in Bombay, admired Picasso's figurative style and embraced foreign art as a way to pull India into the modern world.

Extending or reacting to the Bombay movement, a group of art students banded together in the early 1960's in Madras, now officially called Chennai, which lies on India's eastern coast about 380 miles from the southern tip.

"You can describe their artistic ideas as metaphysical and poetic," said Josef James, an Indian art critic who has followed the Cholamandal experiment from its beginning. "They were consumed with the challenge of finding an Indian response to the sort of art that was coming out of the West. They were influenced first by Mark Rothko, then De Kooning and later Cy Twombly, Jasper Johns and Frank Stella."

"Madras is where Abstract Expressionism was studied very closely," Mr. James said. But like Abstract Expressionism itself, the Cholalmandal artists have been elbowed aside by young insurgents who complain that they have lost their love of color and have never developed an appreciation of the esoteric aspects of Indian culture. Still, Cholamandal remains one of India's artistic centers. Its members radiate a sense of satisfaction and accomplishment, as much for the growth of the art market here as for their own success.

"They are the enlightenment of contemporary art in India," said Santhana Raj, a prominent painter who recently spent several days here. "They have combined Western and Eastern influences and generated a cycle of interest in contemporary art. What has happened and is happening here is of great importance for the growth of art appreciation in this part of the world."

◁ At work on the wheel—
(left to right) Jayapal Panicker and V. Arnawaz.

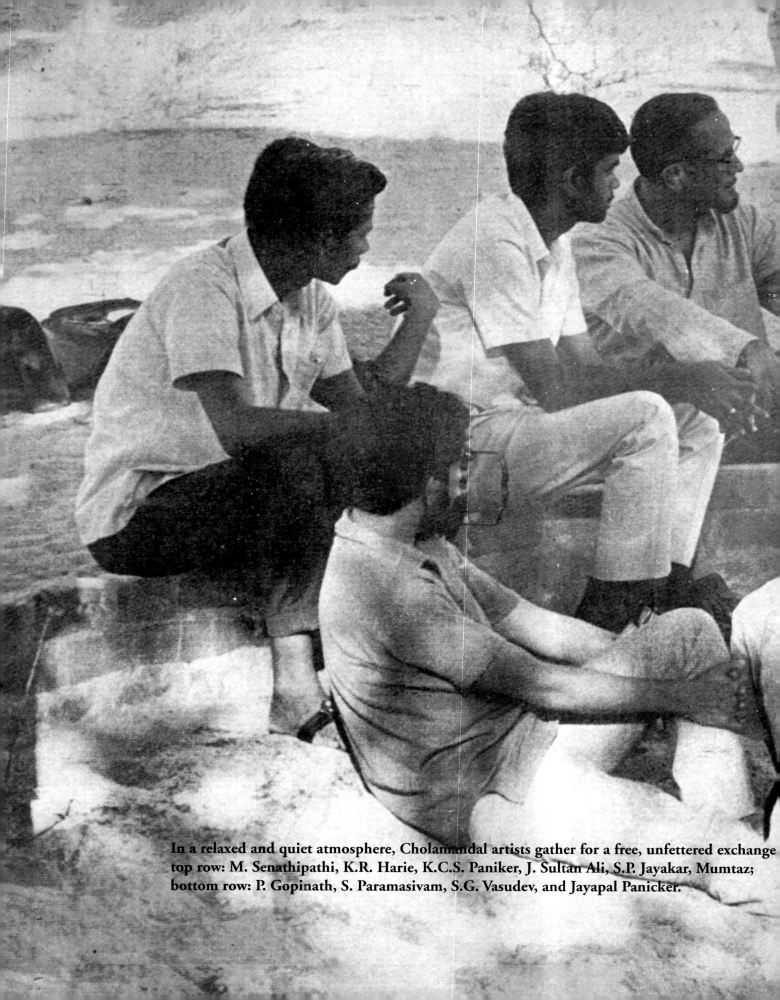

In a relaxed and quiet atmosphere, Cholamandal artists gather for a free, unfettered exchange top row: M. Senathipathi, K.R. Harie, K.C.S. Paniker, J. Sultan Ali, S.P. Jayakar, Mumtaz; bottom row: P. Gopinath, S. Paramasivam, S.G. Vasudev, and Jayapal Panicker.

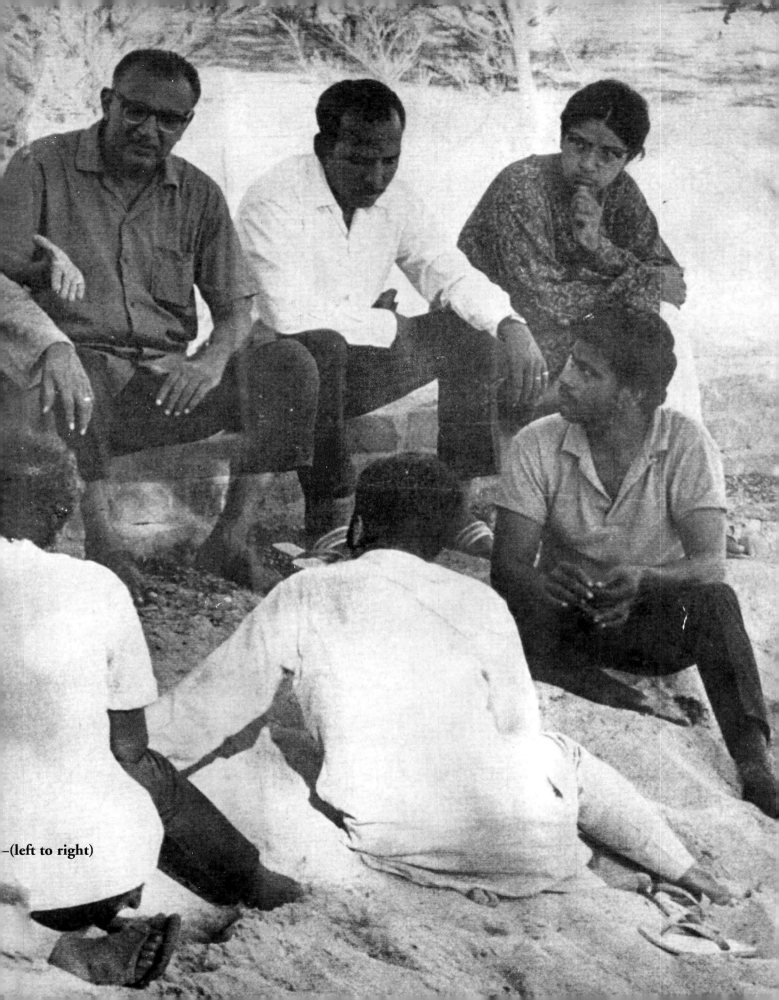
–(left to right)

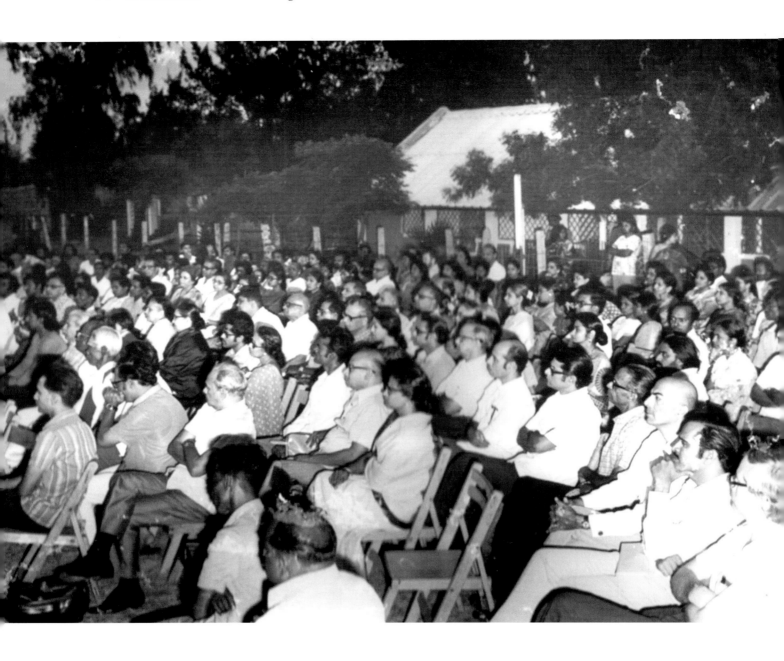

Fellowship of the National Akademi △
conferred on Paniker in 1976, a few days
before his demise.

▷ A pensive Ramanujam.

▽ Fishermen on the Cholamandal coast.

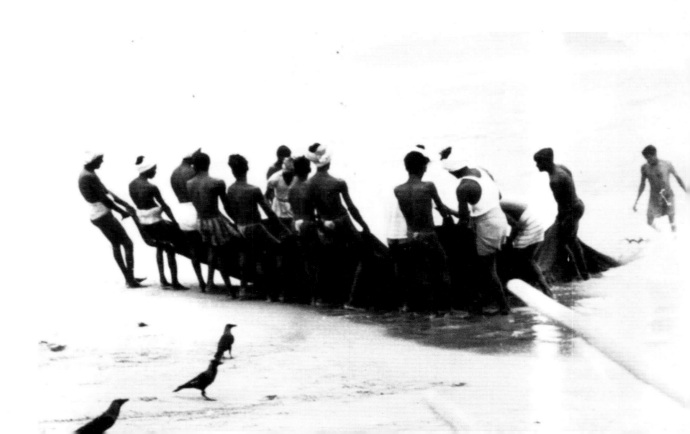

Modern Family on a Scooter ▷
(cement concrete)
by Vasudevan Namboodiri

was to start with a continuation of what was initiated during their days at the School of Arts and Crafts. Paniker went on with his research into the discipline of figuration which he had started while at that institution. He went on to conclude it in his final *Words and Symbols* series of paintings, which he carried out here. In this series, he shook off the ego-consciousness and its burden of emotion with an extremely crafty organization of purely syntactical graphic conventions. He passed away in 1977, ten years after moving into the village. He was cremated at the ghat near the village which had been set apart traditionally for the last rites of the craftsmen in that area. In those ten years, while he was advancing with the ritual of ego-exhaustion, the self-suffering image and its expressionist registers dropped

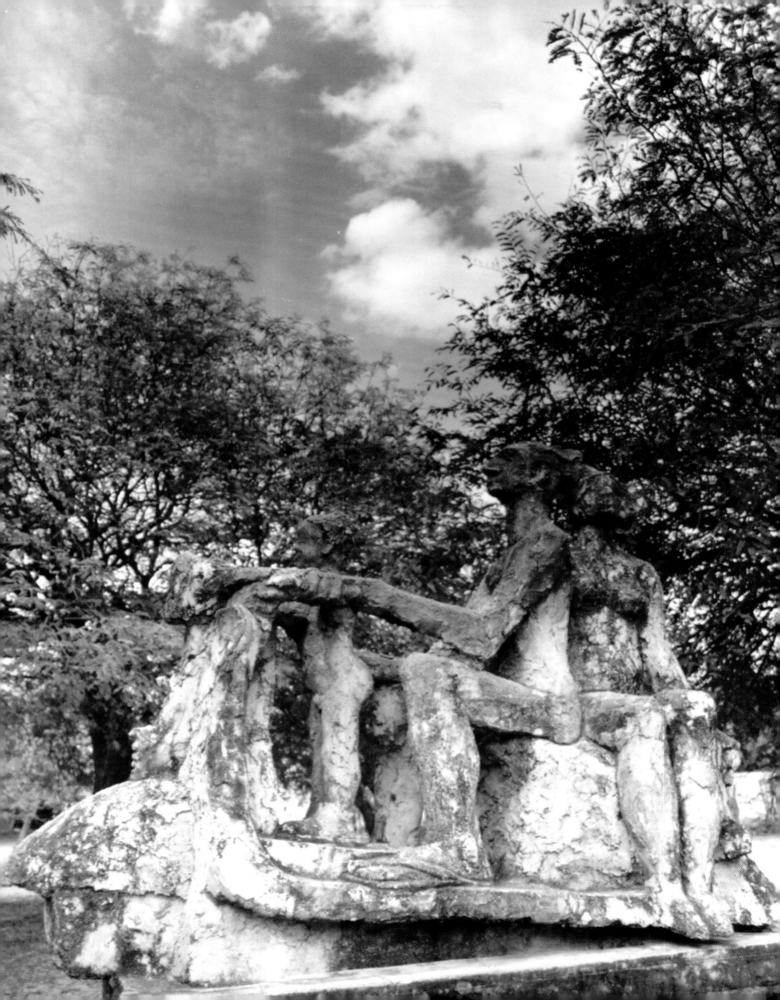

Japanese sculptor ◁
Hiroshi Mikami at work.

Japanese sculptor ▷
Keizo Ushio's
Seven Thoughts (granite)

out of the paintings and sculptures of his colleagues in the village. The colour turned transparent like an illumination, the form became subtle and patterned and the vision relieved of anxious thought turned freely metaphysical. It had taken around ten years in the new environment for the artists to gather the strains and to effect the crucial shift. The possibility and the effort came to be shared by artists at other centres very quickly and the outlook became widespread. (See Philip Rawson, *Lalit Kala Contemporary,* Sept. 1980.) The shift-over in sculpture, which took place along with that in painting, led to striking results. The crafting away of the ego-expressive image in this case went so far as to finally identify such craft with the 'art' of the piece. The sculpture looked acceptable as craftwork of

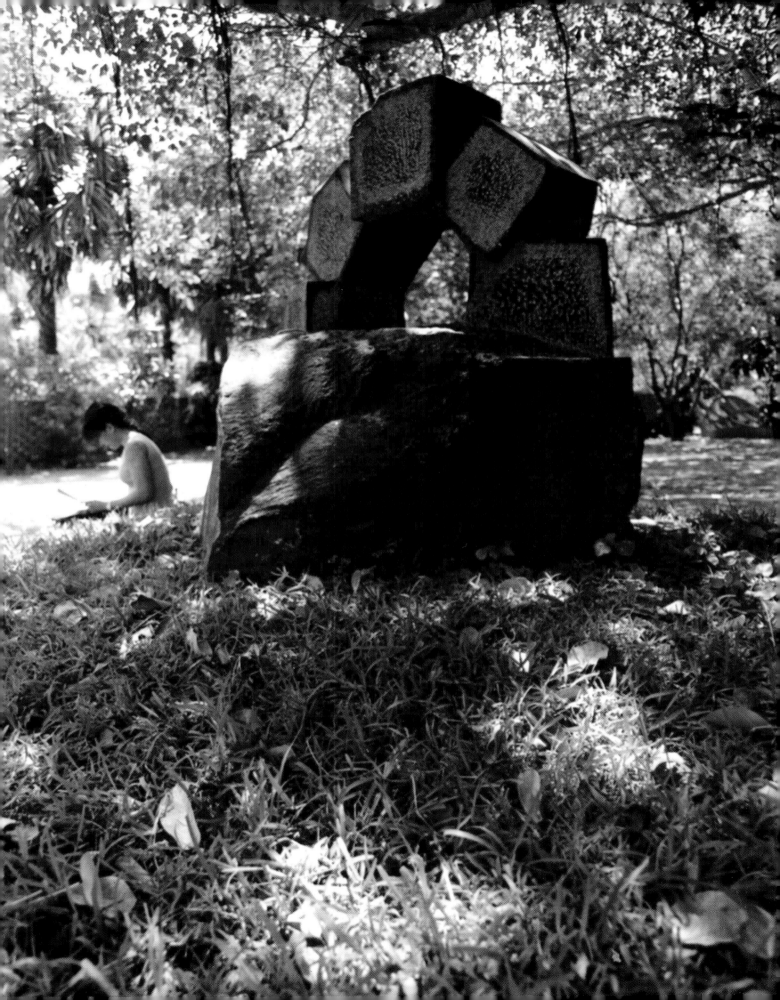

Sculptor Thomas Link's family ◁
takes a break in the heat of the afternoon.

A visitor looks at ▷
Chirstmas Tree (welded steel)
by a young Dutch sculptor.

remarkable freshness and equally as a strangely expressive work of 'art'. This identification of 'art' with 'craft' foreshadowed the final series of Paniker's paintings. It was so forthright and impulsive in his sculpture that it unexpectedly showed up the flaw in the solution these artists had worked out towards the issue of art and existence. 'Art' and 'craft' in their scheme were two separate categories and their strategy consisted of extending their 'art' to congenial crafts. Such 'artistic' craftwork was to be the commodity with which they were to buy their livelihood, time, and the freedom needed to do serious 'art'. Implied in this, quite definitely, is a subservient, means-to-an-end role to craft in relation to art. That clearly was inconsistent with the way art and craft become one in Paniker's paintings and in the distinctive sculpture the argument had given birth to in the village. This

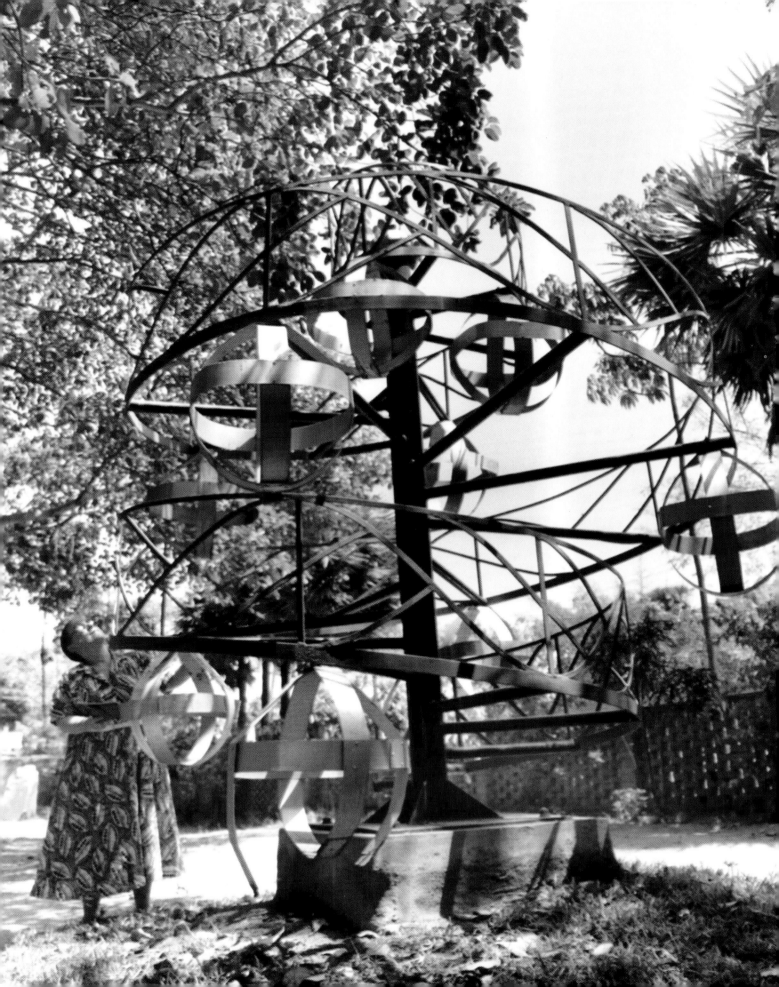

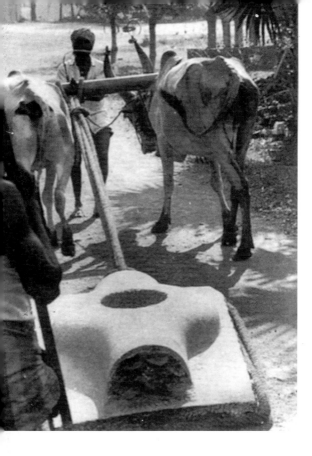

Bullocks haul a massive granite piece ◁
during the international sculpture symposium.

Dakshinamoorthy's granite piece ▷
The Group in the foreground

convincingly invalidated the distinction which had been foundational to their survival.

In any case, after the first ten years, things had not been going well with the solution. There were some artists who found the craftwork they were doing to be a distraction, a temptation and more a concession to the oddities of public taste than the ritual of self-extinguishing application or of alms-gathering that it was meant to be. The off-hand job many of them were led to do with it got them stuck on the romance of antiquity, religiosity, or of picturesqueness to get the specialized market for artistic craft to clear them in sufficient quantities. Such concession and convenience, besides making their crafts products dull, started to

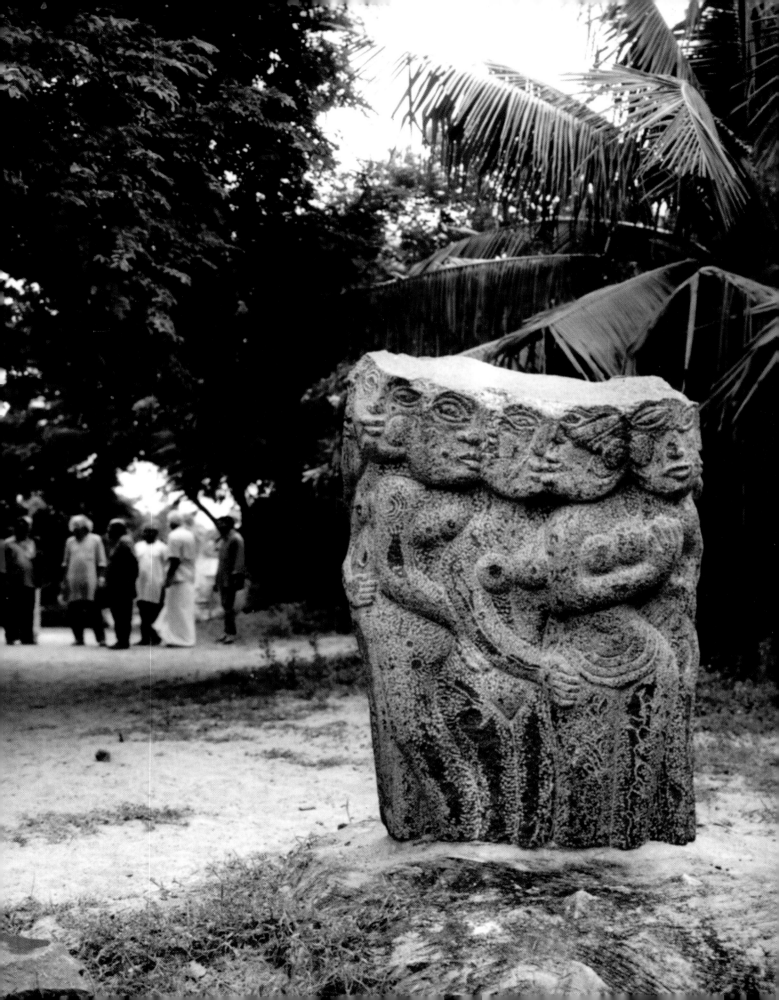

Austrian sculptor ◁
Peter Paszkiewicz at work.

Father and Son granite sculpture ▷
by Rajasekharan Nair

A blacksmith prepares steel chisels ▽
during the international stone symposium.

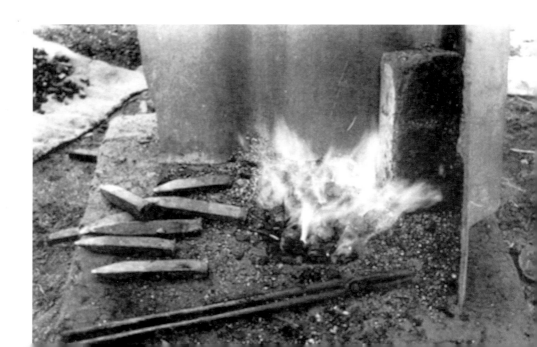

eventually hold their 'serious' art down, although not without exceptions. The impasse was finally reached when the market for craftware shrank to a fraction of the original size. The market for hand-painted textiles, their chief craftware, was flooded by imitations and by cheaper and standardized ware put out by the textile industry, befuddling the choosy clients who had stood by them in the early years. It became necessary for the artists to take note of Paniker's work and to review their routine and the pre-suppositions which had stabilized it for them.

The distinctive sculpture in which their identity was accomplished and those brilliant paintings that were distinctive for the same reason helped them out of the impasse, which had started to hold up the enterprise the village had embodied.

◁ P.K. Gangadharan
Untitled
Oil on Canvas

K.M. Gopal ▽
Deity
Silver-plated copper

▽ R. Sarangan
Symbol
Mixed media

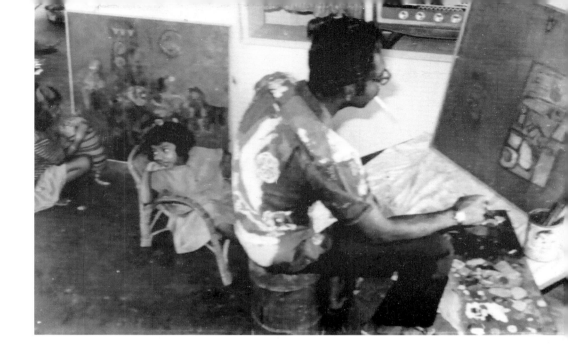

△ A.C. Mammen at work.

Another breakthrough was in architecture. Years later, one of the artists, Devan, took to designing and constructing buildings. Without any formal training in the discipline, he went about absorbing professional ideas and ventured designing fresh and low-cost conceptions, putting them up with a group of specially-trained workers. His constructions were convincing as sculptures when considered with an open mind, and were functional as well when considered from the common man's point of view. They also cost on an average forty per cent less than standard market rates of construction. In a few years after he had started, he had found more clients than he could take on, including three in the village itself. One cannot conclude whether these realizations in brick and cement were 'art' or 'craft' or

Japanese sculptor ▷
Keizo Ushio at work.

'industry'. They were all of these simultaneously and in remarkable union.

The painter-architect, the sculptor, and the painters could have desired greater variety and scale of their output since the distinctive products had come to be very remuneratively priced in the market. But the scope for increasing both the scale and variety of work in the village stood subject to a constraint implicit in the set-up they had made for themselves. It appears to have been a principle that they would not have for the village any more of management and administration than what the artists could do by themselves. They have had no paid staff other than a receptionist and a guard. The limit to the volume and variety of activity that the village could manage and support would therefore depend on the time and energy the freedom-loving artists could spare for such tasks. Besides, apart from an informal, intuitive assent to a certain outlook on art and existence, there was no ideological bind to keep them tied down to a strict discipline of work and management. This has left the village unique, free of officialdom or establishment of any kind. It has left them free, in a sense, of activity exceeding what they can manage with their spare time and residual energy. That has set the inertia, an institutionalized reservation against expensive experimentation, against any such expansive approach to art and

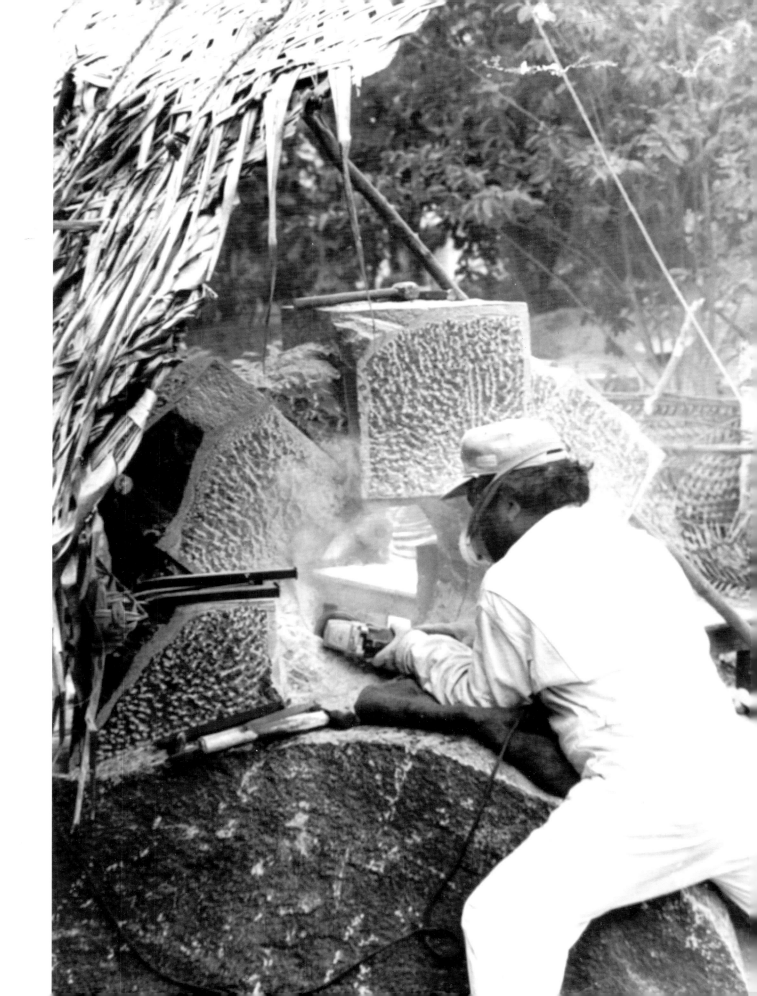

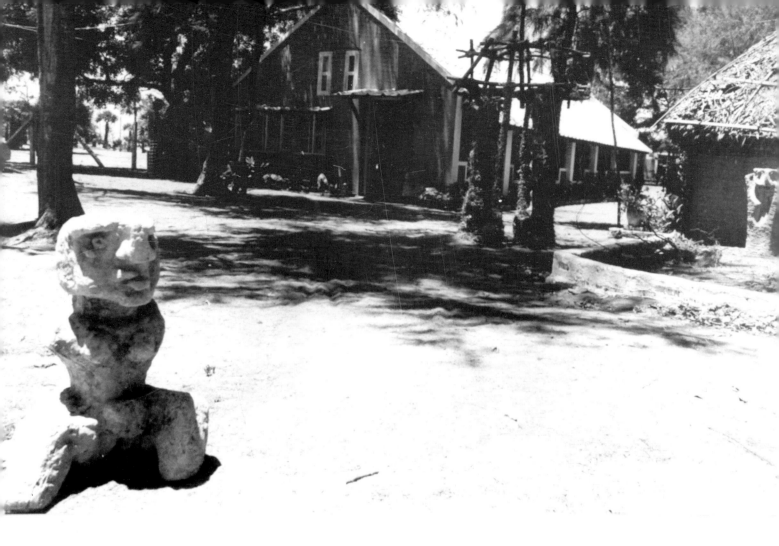

existence in their midst. This has preserved the place from the administrator and the ideologue and prevented the artists from turning into ogres.

The absence of an 'establishment' and officialdom leaves this set-up without the common preservatives to make it last. 'I have not thought about it and nothing moves me to think about it,' said Paniker, when he was once asked about it. 'This place is here,' he said, 'because the artists who are here needed such a place. It may be that they will not need it anymore some day. If and when that happens it would be best for this place to die and be as if it had never been. It could be burdensome and pathetically so if this place is not permitted to be no more if and when it turns dead to those who are here.' 'When Cholamandal was conceived,'

◁ Kannayi Kunhiraman's
 Figure (concrete)

▷ Dutch sculptor Olaf Mooij
 poses with his sculpture.

▽ Yugoslav sculptor
 Pavle Pejovic at work.

Dutch sculptor Olaf Mooij's sculpture ▷
Untitled (stone and steel)
installed in 1991

said one of the artists in an interview, 'it was meant to be a one-generation thing'. That was the generation which had to peddle paintings for money to live, have meals sometimes only of tea and peanuts, huddle on the floor of the Akademi buildings and sometimes on the steps of the School of Arts and Crafts to pass the night, hang around patrons, dealers, and newspaper columnists for favourable consideration and a word of encouragement, dreaming all the while of an art with which to kill the anxiety and to sense 'the truly human, in a broader sense'. To them Cholamandal has been a moment of glory, real, impermanent, like a dream come away.

Josef James

Notes

1. The Government School of Arts and Crafts, Madras, the oldest art institution in India, was founded in 1846 in Chinglepet by Dr Alexander Hunter who was an eminent surgeon in the British military service. When the school started functioning in Madras, it was located in a building on Popham's Broadway. It shifted soon afterwards to its present premises on a four-acre plot fronting Poonamalle High Road and adjoining the Gandhi Irwin bridge on its western side. Contemporary British opinion had little or no sympathy with India's own fine art traditions, so the schools aimed to inculcate the Victorian taste for art in its students. At the same time, their practical purpose was to provide a new generation with useful and employable skills in the industrial ornamental arts. The modern outlook to art with an appreciation of Indian heritage was preached by one of the early principals of the School of Art, Mr E.B. Havell, when he came to India in 1884. He later went to Calcutta to take charge of the Calcutta School in 1898.

2. Paniker's concern for a better way of life for artists finds expression in a letter to the painter R. Krishna Rao who was also an instructor at the Government School of Arts and Crafts:

K.C.S. Paniker Government School of Arts and Crafts, Madras–3.
Principal 26 Feb., 1966

My dear Krishna Rao,
I must thank you for your two letters and the wood carving. I seem to find so little time even for writing letters. We are now busy wriggling through the formalities for zinc sheets, permission to build, etc. at Injambakkam. Cement posts for the boundary are now ready. 50 posts for Rs 450/-. The boys shift to the place in April '66. No more delay...I am not going to be here much longer. It has been a wonderful period of work and usefulness...these twenty years and more. I now feel I need a fresh adventure; an opportunity to work on a much larger canvas of life. I mean our Centre. It is so tempting, so alluring. So relaxing, without dull and philistine government servants in the way. I want to simplify my life to the barest minimum...just sufficient to keep one in excellent health and good cheer. Amidst a family of artists who can always get along together splendidly so long as they don't allow philistines to get into their midst. I promise anyone who comes to us a good living and

financial and other social security. At least, I feel, there is no harm in dreaming. The best things in life, the things men go into raptures about, are only the small parts of dreams some have dared to dream. All that I can therefore tell you is that no artist need hereafter worry if happiness, work and plenty be his aim in life. About official positions in life and jobs I haven't thought much. They are not going to be very important in the years to come. I hope you understand me.

With kind regards,

Yours sincerely,
K.C.S. Paniker

3. Among the first group of artists who moved into Cholamandal in May 1966 were K. Jayapala Paniker, V. Viswanadhan, K.M. Adimoolam, C. Dakshinamoorthy, K.R. Harie, A.C. Mammen with family, and others. This pioneering batch of artists and their families had to undergo untold hardships during those early years. There was no electricity, no roads to talk about and no bus service or conveyance of any sort. To reach the city of Madras one had to wade across the nearby Buckingham Canal and reach the nearest town from where one took a *jutka* (horse carriage) to come to Madras. A little later, upon the artists' requests, the government started a bus service No. 19C ('C' standing for Cholamandal) from Adayar to the village and back once every two hours. This was considered a rare luxury at that time. Today the East Coast Road on which Cholamandal is situated is one of the busiest highways connecting the city to various places of tourist interest like Mahabalipuram (the seventh-century sea port of the Pallavas), Thirukazhikundram, Auroville, etc.

4. In this context, one recollects the late expatriate painter and writer Sushil Mukherjee's memoirs of his days at the Government School of Arts and Crafts, Madras, under the title 'Devi Prosad and his disciples at Madras School of Arts'. Following are some excerpts in which the idea of the artist living in isolation is idolized and which was certainly authentic to the situation which prevailed in Europe and the US in the early thirties and forties. In the sixties a group of artists in Madras rebelled against this very situation which took their fancy so much, earlier on.

It was an early summer morning in 1938. I got off the gray, noisy tram in front of the Madras Government School of Arts and Crafts on Poonamalle High Road. Along the sidewalk opposite the Art school the delicate branches of a row of beautiful gold-mohur trees swayed into the gentle breeze, casting kinetic shadows which resembled some ancient chirography on the wall of an old ochre building. Alas, those beautiful trees are no longer there and neither are the slow, noisy trams. They have become victims of urban renewal, to save space with the forlorn hope of containing and absorbing the frenzy of a crowded, ever-growing city.

Devi Prosad Roy Chowdhury was the then principal of the Madras Art School. He was also the most colourful and romantic Indian artist of that time. Although a student of Abanindra Nath Tagore, the leader of the Bengal revivalist school, he was considered a rebel by his peers because his work indicated the rejection of the lyrical, sentimental style of the Bengal school and a preference for Western technique. So it was that as a very young man, naïve in the ways of the world, I had ventured to travel all of twelve hundred miles from Ranchi in Bihar state to join the Madras School of Art and be a disciple of Devi Prosad Roy Chowdhury. For the next five years I was a student at the Madras Art School and later I lived in Madras for many years and fell in love with the wonderful city. During those years I and a few other friends of mine, among them Paritosh Sen, K.C.S. Paniker, E. Kothandaram, S. Dhanapal, the sculptor-dancer Rajagopal, Damodar Prasad Ambastha, Ramgopal, Sultan Ali, Sreenivasulu and a few others became very closely associated with and attached to Devi Prosad Roy Chowdhury.

I met Paniker on the second day after joining Art School. It was lunch time at the end of the morning session of the life class. He was standing on the front steps with a group of other students. Slightly built, of medium height, he looked smart in Khaki pants and white shirt and a sun hat with a chin strap. He came up to me and shook my hands. 'Hello, you must be the new student from Bihar. Glad to meet you.' 'Thank you. My name is Sushil Mukherjee. I have seen reproductions of some of your watercolour landscapes in a Calcutta magazine. I like them....'

Ramaiya's hotel was only a couple of blocks from the Art School. Many of the Art School students patronized Ramaiya's because it was close by, fairly clean, cheap and served excellent *masala dosai* and *idly sambaar*. As we sat down in the crowded hotel, a young man in white kurta and pajama came to our table and said, 'Arrey Baba Paniker, Kothandaram, it's so nice to see you. How are you? You must have painted many masterpieces during the summer vacation. And who is this young man with you? Is he the new student from Ranchi?' 'Yes, he is.' Paniker said, 'Sushil Mukherjee. Meet Damodar Prasad, Sushil. He is from your part of the land.' Sitting and chatting with them at Ramaiya's that day I realized that there was something so very open and unconventional about artists, something so different from my staid, middle-class upbringing and background. I felt an exhilaration to be with them which I had never felt before in my life.

From the very first time we met, Paniker and I became inseparable friends. We lived together, struggled together, shared each other's joys and sorrows and with a few other friends at Madras Art School, passionately discussed and dreamt of new approaches to aesthetics which we fondly hoped would astound the Indian art world. Most of us had little money and lived essentially a day-to-day precarious existence. But in hindsight, I have little doubt that our unconventional, at times turbulent lifestyle would have made us the darlings of bohemian Paris even at the turn of the century. Poverty and hardship never did dampen our enthusiasm for art or passion for life and we always felt privileged to be artists. Not that many people cared. We were just a bunch of unknown struggling artists largely ignored by the society and the media in Madras.

5. (*Artrends,* editorial, Vol. IV, No.1, Oct. '64)

 In search of the roots for a breakthrough

 In one of his letters, a Paris art critic mentions the intense search some of the younger painters there are making to discover their own traditional or racial artistic roots with a view to break through the present veil of confusion and ineffectiveness. The young Frenchman is seeking frantically to find some material in his Celtic past to inspire him afresh with something that will be truly authentic and legitimate. The Parisian is already aware that to be French and original in the true sense he has to be French in the fundamentals, that is, in the main as well as in the initial springs of thought and emotion. Celtic origins, he feels, hold out a promise of rediscovery and a new lease of fresh and intimate creative endeavour.

 In India, the so-called progressive school adopts not only the various techniques and approaches to art prevalent in New York, Paris or Mexico, but also the fundamental thought-feelings of the nationals or races of those regions. That these thought-feelings and racial or national tendencies have been inherited by those people through long traditions, is perhaps overlooked in the face of the intense and moving experience of close contact provided by modern life. In order to rise to its greatest stature of self-expression in the arts, a race or a nation has to depend, in the midst of all influences, on its own fundamental ways of thinking and feeling and shaping. It is here that a search for the roots of tradition can help to correct the main approach. It appears paradoxical, however, that the Indian painter has to pass through the school of contemporary world art to be able to reinterpret today his own racial or national roots of tradition.

6. (*Artrends,* editorial, Vol. IV, Nos 2 & 3, Jan.–April '65)

 Art and Anonymity

 Poetry, says T.S. Elliot, is not the expression of personality, but an escape from personality. It is in this depersonalization, he asserts, that art may be said to approach the condition of science. In the Indian tradition we have perhaps always sensed this truth. The almost total anonymity of authorship of great Indian masterpieces of painting, sculpture and architecture and sometimes even of literary works tend to indicate that the ancient Indian masters aimed at taking art beyond the bounds of personality, towards the truly human in a broader sense. It was perhaps with a view to free himself from the shackles of his personality that the ancient Indian poet often attributed his inspiration to a bird. It certainly gave him deeper insight and greater freedom in the practice of his art. The first lines of the *Adhyathma Ramayanam* of Ramanujan Ezhuthachan begins with an invocation to the parrot to tell the poet the story of Rama. This ancient device gave the author a deeper insight into life and freedom from his own personality. We have parallels of this in the Classical poets and Milton.

7. The cremation ground forms part of Cholamandal's eastern boundary by the side of the Bay

of Bengal. In a letter to a young Jewish couple he met in Paris in the early fifties, Paniker alludes to this.

K.C.S. Paniker Cholamandal Artists' Village, Madras–41, India.
31 May, 1971.

Dear Sonja and Cy,

According to Indian custom one has to be very civil and kind to a person on his/her birthday even in the face of serious provocation. Today is my birthday. I chose to write today since I have the above-mentioned advantage over you. You can't morally be angry with me today for any lapse on my part such as a long silence, etc.

How the years pass. Imagine I am 60 today. Was 43 in Paris and 52 when we met in Chicago. You are both always 23 and 27 to me.

My address in Cholamandal is permanent. This is the last lap of race of life. No more shifting. Cholamandal is our artists' village on the sea. It is amidst rural surroundings and casuarina trees. Perfect silence and peace. The ancient burial ground nearby abuts on the sea. The waves almost lick the feet of the ones laid there to rest in perfect solitude. How wonderful. A small part of this vast burial ground is set apart for the burial of traditional craftsmen, the carver, the goldsmith, etc. In India of old the line that divided the craftsman from the creative artist was thin. Her greatest artists were also her greatest craftsmen. Some day I will be laid there. Sure, I shall not be in bad company. The masters of Mahabalipuram and Salluvankuppam were laid there 1400 years ago.

Love,

Paniker.

8. (*Artrends*, editorial, Vol. V, Nos 2 & 3, Jan.–April 1966)
Restraint

One of the maladies that has dogged the steps of the contemporary artist is his apparent need to keep himself in the limelight without a break for survival. He has to please continually, all through his life, in order to sell and live. Truly, an artificial situation considering human limitations—it does not seem to allow for the perfectly normal slack periods of creativity in man. As a result we have too many exhibitions of paintings where the artists have really nothing new to say. They are mostly painted and rigged up in a hurry for the sole purpose of selling. One seldom sees in these exhibitions evidence of any sustained search after idiom or technique. People appear to paint or sculpt with no valid purpose. One may watch a painter for years and all you see him do is change his style or technique from time to time. No logic nor linkage in these shifts. He makes no progress, but has, all the same, a few 'periods' to his credit.

Cézanne, it is recorded, withdrew from public exhibition of his work for a period of seventeen years while he was at the height of his powers. He had perhaps a reason—they laughed and jeered at him; thought his whole work was a joke. Nevertheless, this self-imposed isolation and withdrawal gave him an opportunity to delve deeper into his own self and to paint for sheer necessity. The spiritual significance of such self-imposed and periodic withdrawal from public exhibitions of one's work by a potentially creative painter does not appear to be very much understood. It can possibly give the artist clarity of mind and vision and help him to find himself—to *arrive*.

9. In the sixties the Madras State Lalit Kala Akademi (see photo on page 15) had its premises on Subbiah Naidu Street in Vepery, one of the quainter areas of Madras with a sizeable Ango-Indian population. The building was a three-storied one with large verandahs which the artists used as studio spaces. The top floor was where the batik and leather work was done. The Chairman of the Akademi was the highly respected citizen of the city, the late Shri P.V. Rajamannar, a retired chief justice of the Madras High Court and a lover of the arts. The Vice-Chairman was Shri K.C.S. Paniker. The proximity of the Akademi to the Government School of Arts and Crafts prompted many of the students to congregate there to paint and engage in some craft or other to augument their income. A time came when some of them approached Paniker and asked him whether they could sleep in the premises of the Akademi as they had no hostel accommodation, or as in some cases they had to go back to their homes in the interior suburbs of the city. Though the regulations didn't permit overnight stay at the Akademi, Paniker gave in to their demands. From then onwards, there was a period of hectic activity with the students shuttling between the School and the Akademi, with the latter becoming a second home to them. Some of the finest work of the 'Madras School' as the movement came to be known, was done during this time of feverish activity. On a recent trip down memory lane, some of the artists discovered to their great joy that a church had acquired the place but no significant changes were effected and the building seemed as if it had been vacated just the other day. The period of joint living and the lifestyle and the togetherness these artists experienced here had anticipated the creation of Cholamandal in more ways than one.

10 This is a reference to that brilliant painter, K. Ramanujam who was schizophrenic. He was handicapped physically in many ways, and came from an extremely impoverished orthodox Brahmin family. His mother was the only one in the household who cared for him. His end came tragically in Cholamandal when, unable to come to grips with the practical and mundane world, he killed himself.

ANILA JACOB

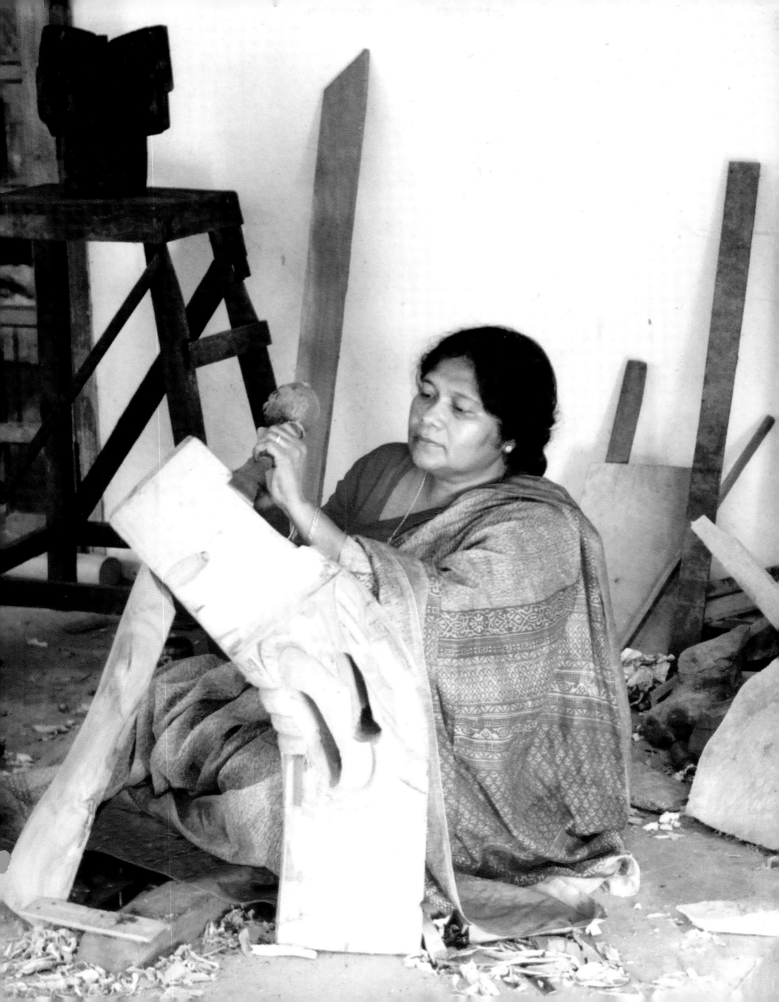

Anila Jacob

Soumya James: How did your interest in art begin, and who were your major influences?

Anila Jacob: I think my interest in art started from the time I used to watch my grandfather paint. He was not a painter by profession but he pursued it as his hobby. I also had an uncle who did a fine arts course in the US. Seeing their interest in art and watching them paint provoked my interest and I decided to join the Government School of Arts and Crafts in Madras. There, of course, I was taught by such well-known artists as K.C.S. Paniker and Dhanapal. They encouraged me in many ways…and also asked me to experiment with different media. I first started working with clay and then Paniker asked me to try working with wood. That was how I changed to wood, a medium on which I continue to work even today, besides welded metal sculpture.

S.J.: You were in Madras during the inception of Cholamandal. You left India for quite a while after that. What is your impression of Cholamandal, then and now?

A.J.: I was among the many artists who were involved with Cholamandal in its early days. I never really stayed in the village as such; I would go there, work throughout the day and get back in the evening. I used to work mainly with metal, especially copper murals. The atmosphere in Cholamandal, I think, was

King Pharaoh ▷
(Jack wood)
2001

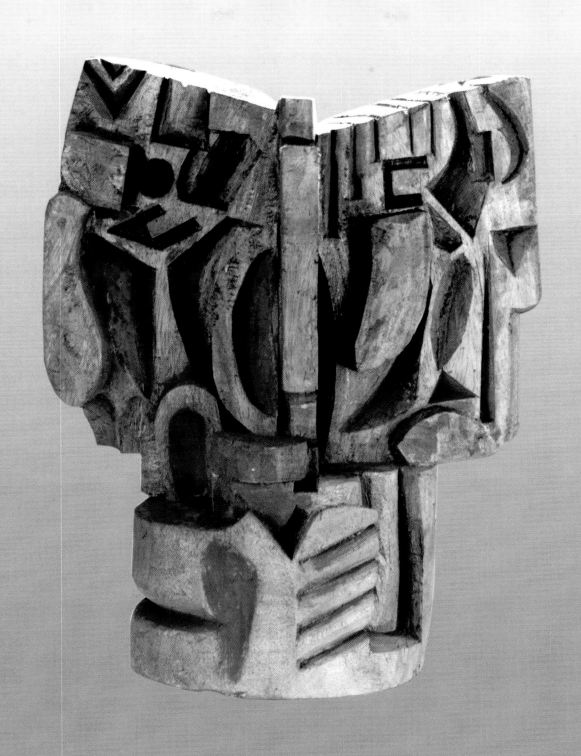

Mother and Child ▷
(Jack wood)
2001

most conducive to work. There was a lot of unity among the various artists and we used to discuss our work and ideas. It was the ideal environment for artists. After I got married, I went abroad with my husband. I could not continue my work but I was not completely out of touch either. There is one big change I have noticed in the Cholamandal artists today. Their work has become mature and the quality is much better. There are also a number of young artists who are part of Cholamandal now, which is a very heartening sign. It is such a good idea that they are given an opportunity to exhibit their work in the gallery. I am sure it will help them immensely.

S.J.: Could you elaborate on your subjects and influences?

A.J.: I have done a lot of figure studies, such as *Mother and Child*. But I also like to do abstract pieces. When I see a piece of wood, I observe it for a while, after which it starts to take a form. I first put it down on paper and then start working on the wood itself. Inevitably, there are changes during the course of work. As I incorporate new ideas, the sculpture begins to take on a different shape. I get ideas when I observe the works of other artists as well. Making a profit from my work is something I have never given a thought to, even from the beginning. I create for my own satisfaction and peace of mind.

S.J.: You were residing in the Gulf for a long while. What were the changes and challenges you faced there as an artist?

A.J.: It was quite different there. I was living in a flat and it was difficult to work without disturbing the neighbours. So I took a break from being a full-time artist. I think that was a good decision. I was in the Gulf for eight years and I worked in a Chinese gallery selling art pieces. I must say that my experience of Cholamandal helped me a lot during this period. I found it so easy to explain the aesthetics and artistic significance of the various works of art that I was acquainted with through my job.

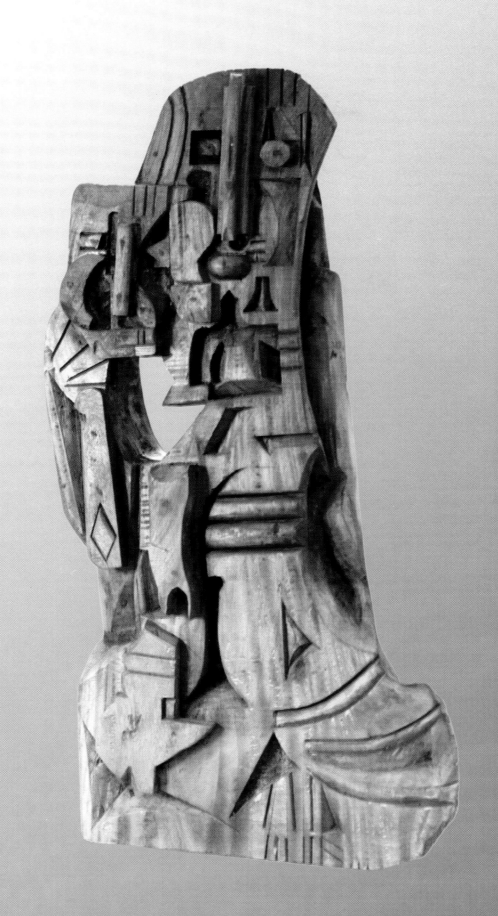

Birds ▷
(Jack wood)
2002

In the beginning when I went there, the people did not seem very interested in art. But slowly, things began to change. Nowadays, art is a big part of life there, with many galleries being started and exhibitions beings held. Spending money on a piece of sculpture or a painting is no longer considered a luxury. When I returned to Kerala, I decided to get back to my art and work at it with renewed vigour. I did not have any problem getting back into the rhythm. It was such a good feeling. After that I have not taken any breaks. The place where I work in Kerala is peaceful and serene, very conducive to an artist. It is near the river Periyar. As an artist whose medium is wood, Kerala is a boon. There are so many different kinds of wood that are so easily available. It is the perfect place for me and I am very happy.

S.J.: You are one of the few women artists to be associated with Cholamandal when it was first started. You were also the first Indian woman sculptor to win a National Award. Even today, the number of women artists in Cholamandal has not increased much. What do you think are the reasons for this?

A.J.: During the inception of Cholamandal, there were only two women who were members of the Association—Arnawaz and myself. Arnawaz was doing painting, metal relief, sculpture, and ceramics. She was more active as an artist than I was, maybe because she was staying in Cholamandal itself and was also married to another artist. In those days, a woman artist had to overcome a number of limitations, especially after marriage. I was very lucky that my family encouraged me to fulfill the choice that I had made. When my husband got a job in Dubai I had to leave India but even then, I used to work in Cholamandal every time I came for a holiday.

Today, the facilities for women to pursue art as a way of life have increased but even then many of them are not really interested in studying art as there are other avenues open to them. Even if they do study art, many of them abandon their

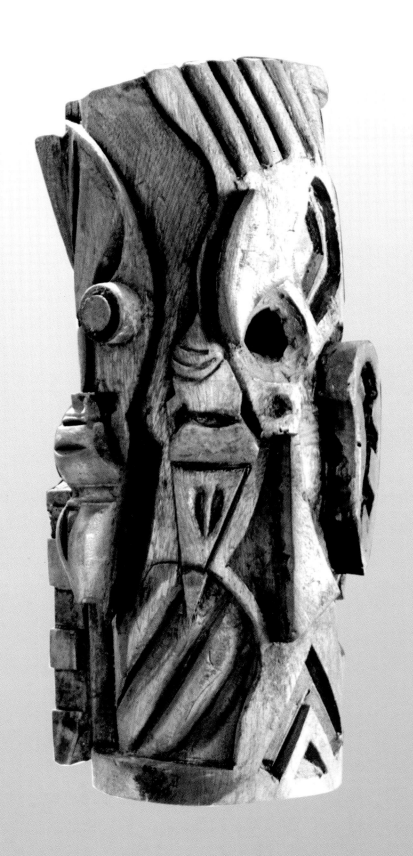

King ▷
(Rose wood)
2002

interest after marriage. One cannot really blame them because the reasons are very subjective and could well be legitimate. Many of them are not lucky to have the financial security or an understanding family which ultimately provides the peace of mind and security that is so essential for an artist to make a success out of her career.

S.J.: Among external factors what do you think could change this situation?

A.J.: One important factor could be the media—people who can write and effectively encourage young women to pursue their dream of being an artist.

S.J.: Would you consider experimenting in painting? Do you think it is possible for a sculptor like you to take up painting?

A.J.: I don't have much confidence in me as a painter. No, I don't think I will ever take up painting seriously. Recently I have seen many painters at Cholamandal who have created really good sculptures in metal and stone. But personally, I find it rather difficult to do paintings as I want to express my ideas through sculpture. I have experimented in media like wood, cement, copper, brass, granite, and bronze. And some granite and metal sculptures have been a commercial success, such as the bronze portrait of Colonel Godavarma Raja of Kerala Palace. But I believe wood is the medium I am most comfortable with.

S.J.: Who actually does the manual work of carving and shaping your sculptures? Do you think there is a difference when someone else does it for you?

A.J.: I get a helper who comes once a month to cut large pieces of wood, metal, or granite. But his contribution to the work is only mechanical. He does not suggest ideas. My works are entirely my own creations.

S.J.: What are the most important qualities that an artist should have?

A.J.: This is a profession that does not bring in instant success to everybody. It

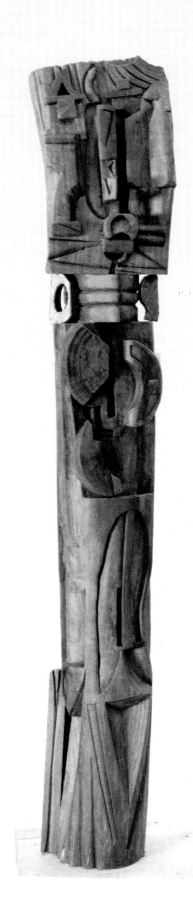

may take a while, perhaps longer, and so one needs to have a lot of patience and the dedication to carry on. One should consider other artists as fellow beings and follow their examples for inspiration. It is important to remember that critics too are part of an artist's life. There will be times when they, or for that matter anybody else, may criticize a work. One has to learn to take these things in their stride and in the right spirit. Keeping the mind open to people, ideas, things all around us... that's important too.

ANILA JACOB

1941	*Born in Kottayam, Kerala.*
1962	*National exhibition of Art, New Delhi (also in 1963, '64, '66, '68, '76 and '78).*
1963	*Award at the exhibition of Ceramic art at Washington D.C.*
1965	*National Award of the Lalit Kala Akademi, New Delhi; participated in Sculptors' Camp organized by the Lalit Kala Akademi, New Delhi at Mahabalipuram, Madras; Three Women Artists exhibition organized by MRF Ltd., Madras.*
1970	*Took part in Expo '70 Japan.*
1972	*'Contemporary Miniatures', exhibition conducted by Cholamandal Artists' Village in Bombay and Madras.*
1975	*Exhibited at the all India exhibition at Hotel Taj Coromandel in connection with the Pugwash Conference for nuclear disarmament.*
1979	*One person show at Hotel Chola Sheraton, Madras. (One person show again in 1980 at the same venue.)*
1999	*Small format exhibition at Cholamandal Artists' Village.*
2000	*Small format bronze sculpture exhibition at Cholamandal Artists' Village.*

Soumya James graduated in History from Stella Maris College, Chennai, and later did her post-graduation from Madras Christian College, Chennai. She has contributed articles to the *Indian Express* and the magazine of the Ability Foundation, Chennai. She is currently pursuing her doctoral degree specializing in South and South-East Asian art history at Cornell University, USA. This interview with Anila Jacob was conducted in 2002.

ARNAWAZ

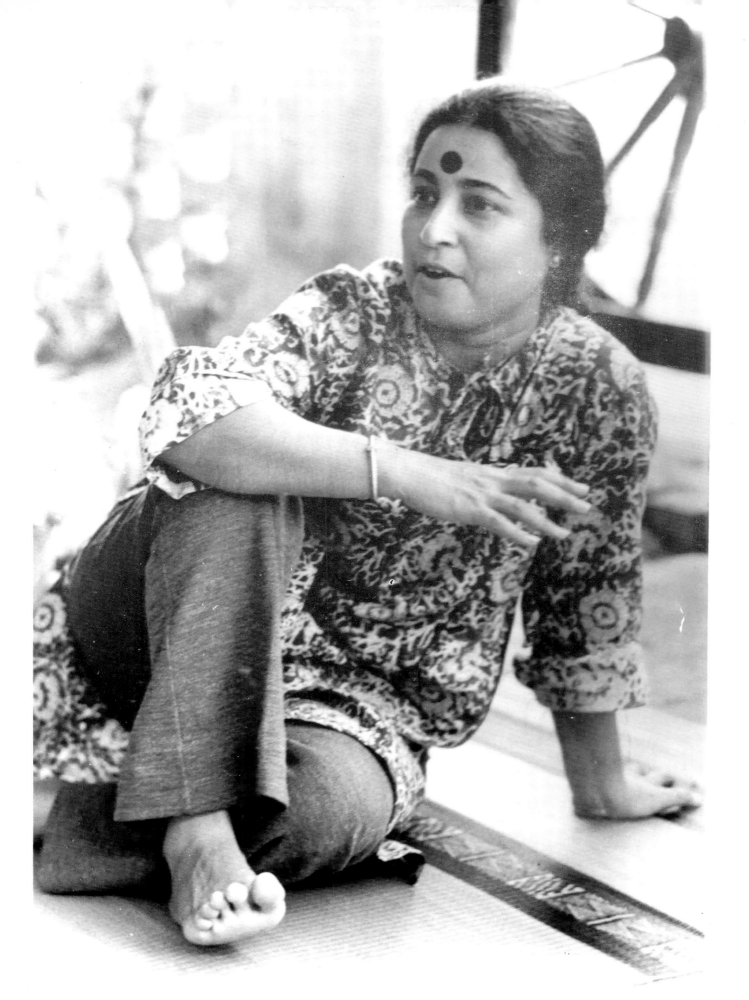

V. Arnawaz

Readiness is all. And if, within the short space of time that we call life, the artist can create something beautiful, something lofty, then death shall have no dominion. Such an artist was Arnawaz, who like the brightest summer flower fought her last battle against the dreaded disease in 1988.

What intensifies such a loss is the fact that Arnawaz was just beginning to find a true aesthetic idiom of her own. Always the experimenter, in colour, style, and media, she was continuously making new discoveries within her art.

Experiment and serendipity was what brought Arnawaz into art in the first place. Born into a Parsi family in Madras, Arnawaz Driver used to draw and sketch casually and randomly at home until a friend of the family's urged her parents to let her study art.

From a background where there was little or no art, Arnawaz moved into a life steeped into it; first at the Madras School of Arts and Crafts, and then at the Cholamandal Artists' Village. At college, too, chance was to play a crucial role in shaping up her artistic development: while family pressures obliged her to take Applied Arts as her formal course, it was the perceptive and inspiring K.C.S. Paniker who recognized and encouraged her creative instincts.

It was at Cholamandal, the artists' village that had for so long been Paniker's dream, that Arnawaz came into her own as an artist. With a furious intensity, she

Lines from the Ramayana ▷
(Ink on paper)
1975

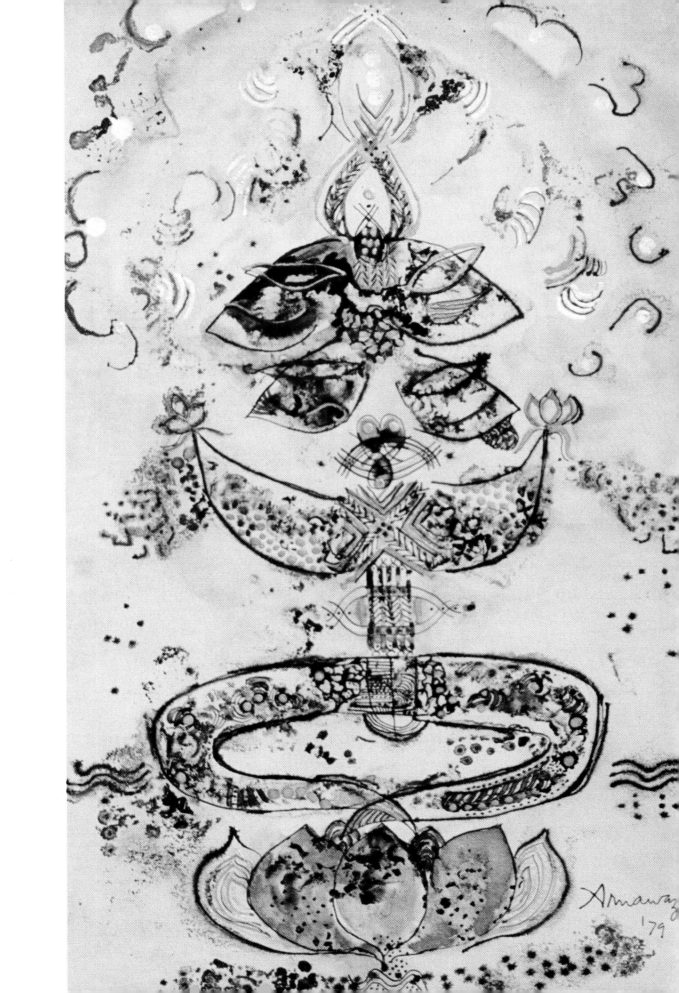

began to work on Van Gogh-like seascapes before she had even heard of the Dutch painter. Then she started doing delicate pen-and-ink sketches and ink-and-water washes. Again, chance played its part, through a drop of ink, a blot, and water—and as the ink spread, she had discovered a strange new medium that was to become peculiarly her own.

Drawing was important to Arnawaz. It was the single-most fundamental element in her work. It meant exploration, mystery, and lingering questions. Taut and intense, her lines moved darkly and broodingly over the white, blank surface. Monkeys cavorted and gamboled in her familiarly unfamiliar landscapes. Possibilities were infinite, and the artist's vision grew, trying to include and encompass.

Soon, colour began to enter her work, gently and softly-toned like the washed pen-lines. And then she found another new element: the immediacy of folk art, in its earthy, rooted ruggedness. All the while her design training continued to help her synthesize decoration and expression into a more beautiful artistic language, whimsical, witty, and filled with wonder.

Change again: stumbling upon Jagdish Mittal's *Andhra Paintings of the Ramayana*, Arnawaz was instinctively able to recognize a mode of expression that would give direction to her own work. Her new series, *Lines from the Ramayana*, contained a radical, even deconstructionist interpretation that blended elements and dimensions into a new mystical vision. Shapes like the lotus, the kaleidoscopic clustered triangles, and the crowded arches were to recur frequently in her work. Delicate use of the traditional Tamil 'kolam' design began to adorn the periphery while Ravana became a central force, a focus, many-eyed and antithetical to the lotus emblem that radiates its own power. The flame and the lotus are inextricably linked, like the fire and the rose in Dante.

The abstraction of the *Ramayana* series continued into the *Deity* series, each with

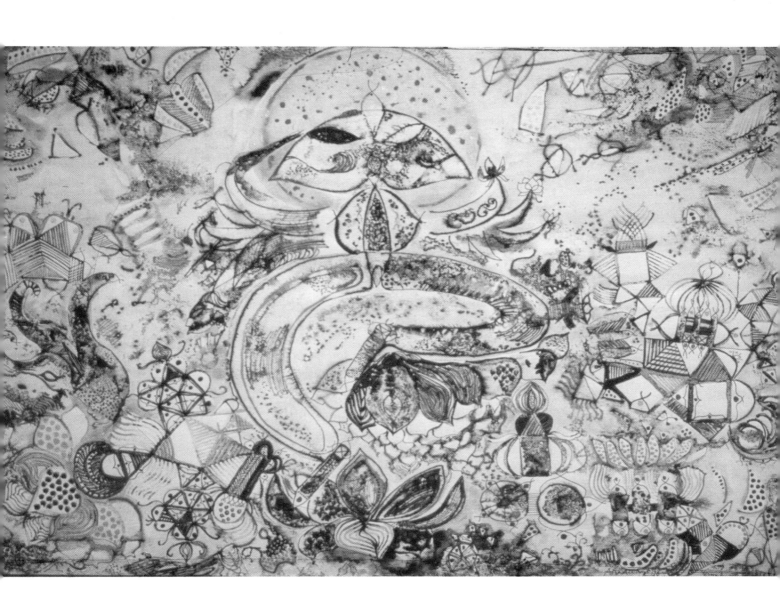

△ *Deity*
(Ink on paper)
1979

Garuda ▷
(Ink on paper)
1980

a central meditative figure surrounded by a delicate and ornamental arch. The sprawling, vast Ramayana visions led to these contemplative studies in tranquility and harmony. The lotus image recurs in the seated *Hanuman* and *Garuda*, both of whom epitomize sublimity in morals.

In her metal work, in her craft, lay what was possibly her true genius. A native design sense, combined with newly-found modes of expression, is fully realized in the tremendous possibilities offered by metal. Her beaten copper bowls, for example, are sturdy and lovely little pieces decorated with kolam patterns, leaves, and plant forms—anything that caught the whimsical eye of the artist.

As the arch began to fascinate Arnawaz, she was asked to execute a mural around a large wooden garuda. Her design and decorative sense, her painstaking attention to detail, and her tremendous vision went into the work that transformed the art of miniature ink and wash drawing into a monolithic structure, 11 ft by 17 ft.

Another mural done for the Standard Chartered Bank contains her three predominant obsessions. A central figure is abstracted from earlier conceptions of *Deity*, now, influenced by Tantric ideas, a cluster of stars and lotuses. A delicate, pure, and lined arch lies overhead. Floral, leaf, and shell patterns are interspersed with kolam designs. An elegant, refined, subtle, lofty work.

Arnawaz died on 24 February, 1988.

Uma Mahadevan

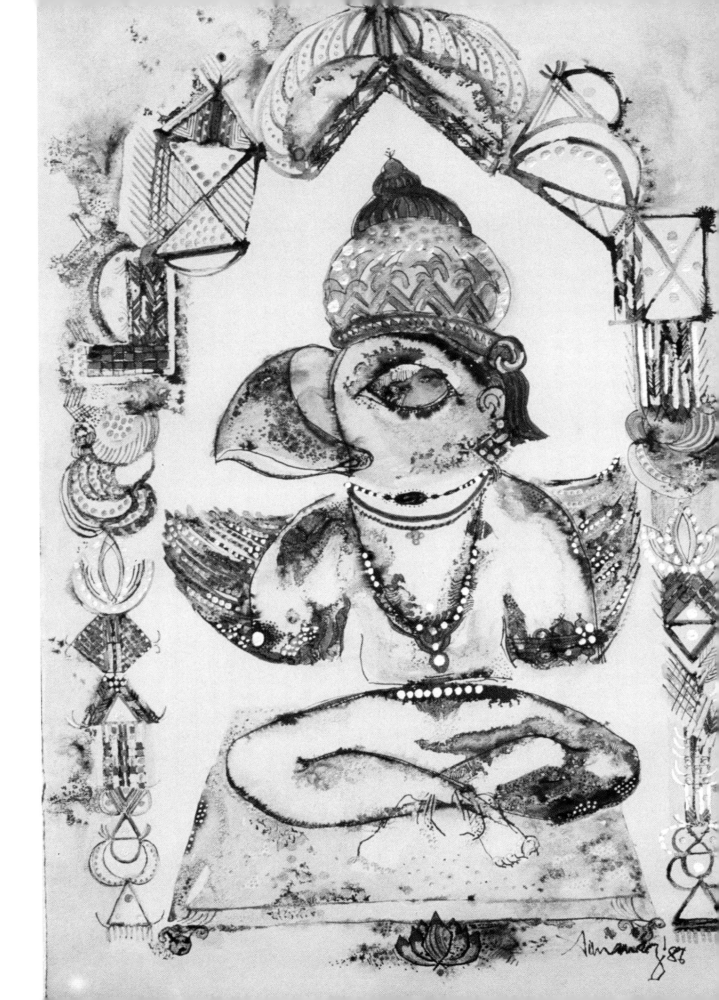

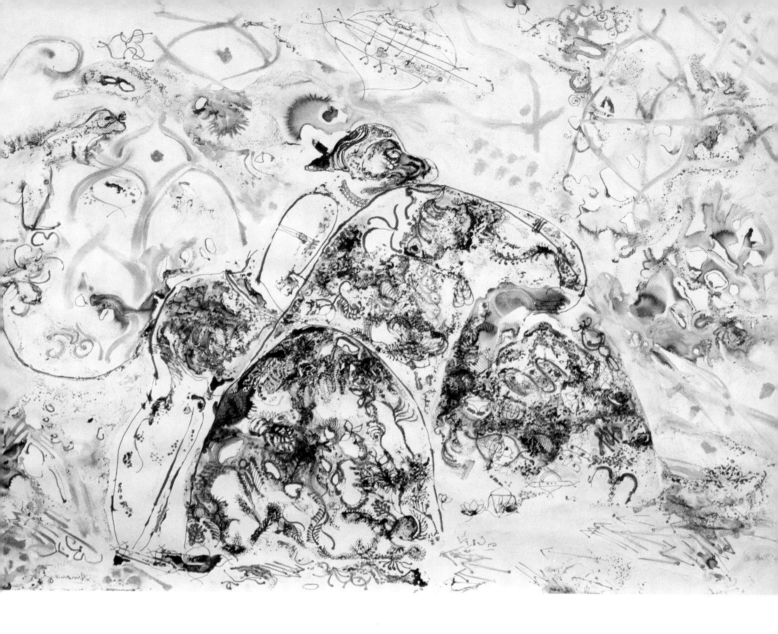

Lines from the Ramayana △
(Ink on paper)
1975

V. ARNAWAZ

1945	*Born in Madras, Tamil Nadu.*
1966	*'Twelve Indian Painters' organized by Progressive Painters' Association at Bombay; award of the Tamil Nadu State Lalit Kala Akademi.*
1967	*'Four women Painters' organized by Sarala Art Centre, Madras.*
1968	*Diploma in Fine Arts, Government College of Arts and Crafts, Madras; National exhibitions of Art, Lalit Kala Akademi, New Delhi. (Also exhibited in 1969, '71, '77 and '78.)*
1970	*Graphic workshop organized by the U.S.I.S., New Delhi under the Smithsonian International Art Programme.*
1971	*Contemporary Indian prints organized by the U.S.I.S., New Delhi at Bombay, New Delhi, Calcutta, and Madras.*
1972	*One person show at New Delhi, 'Contemporary Miniatures', organized by Progressive Painters' Association at Bombay and Madras; Cholamandal Artists' Village exhibition sponsored by UNICEF at New Delhi.*
1973	*'25 years of Indian Art' organized by Lalit Kala Akademi, New Delhi.*
1974	*'Asia Today' Contemporary Art International Exhibiton, Italy.*
1975	*One person show, New Delhi.*
1976	*Art exhibition on the occasion of the 25th International Pugwash Conference for nuclear disarmament at Taj Coromandel Hotel, Madras; award of the Madras State Lalit Kala Akademi.*
1977	*One person shows at Bangalore, Ottawa, Toronto, New York, Los Angeles, and Chicago. Travelled in USA and Britain at the invitation of the British Council and the Government of France.*
1978	*Travelled in Japan at the invitation of the World Crafts Council to attend the 8th International Conference.*
1988	*Passes away at Madras.*

Uma Mahadevan is a freelance writer who contributes articles on art and cinema. She is a bureaucrat who lives and works in Mumbai. This article was written in 1998, ten years after Arnawaz's demise.

DEVAN

M.V. Devan

The one word that comes to mind when describing Devan is versatility. A well-established artist, Devan is also an architect, writer, and illustrator. Indeed, many were skeptical when he embarked upon a career in architecture, designing buildings without any qualifications in architecture or civil engineering. Of course, he was to prove them wrong.

A skeptical reception to his endeavours is something Devan has been quite used to. His writings on literature, remarkable for their sharpness of expression, rare insight, and well-founded information, have provoked a similar response.

Clearly, many who have known Devan as an artist have not been able to come to terms with the versatile personality that he has grown into over the years. Unlike most artists, he never confined his quest to the fine arts alone. He is extremely well-read and has always taken a keen interest in Malayalam prose styles, poetry, theatre, and radio plays. It was due to his keenness for literature that he became a renowned magazine illustrator in the fifties.

When Devan took to architecture, he essentially put into practice what he has been preaching all throughout: that the artist is a creator; the artist can create something better and more beautifully than anybody else. He believed that applied

△ *Koothuparambu*
Kannur, Kerala
1984

art, as in the case of furniture, textiles, everyday utensils, packaging and even machines, vehicles, and buildings can bring about a qualitative change to the environment.

Devan was naturally pained to see buildings that he thought were concrete monstrosities, coming up all over the place. Although they were designed by qualified architects, he found them unsuitable for India's environment, living conditions, and heritage. The situation needed a remedy.

These were the issues that Devan and his fellow artists dwelled upon during the inception of Cholamandal. During this time, they met M.K.K. Nayar, who was then managing director of the engineering and design organization FACT, and he encouraged them to experiment with their ideas, incorporating traditional Kerala architecture into functionally efficient space planning.

This was first tried out at the Ambalamedu House and township, which was being built by FACT. The same pattern was also adopted for the new flat-type buildings constructed at Udhyogamandal. Soon, a new breath of life was being ushered in the landscape.

Devan was associated with these experiments as the art consultant to FACT. This provided him with the opportunity to interact with engineers and architects, and he was able to learn quickly from them. He also started looking into old texts on traditional Kerala temples, palaces, and mansions. These proved to be an eye-opener for him.

It was during these days that Devan met the British architect Laurie Baker, who had settled in Trivandrum and was experimenting with the construction of affordable homes taking local conditions such as climate, landscape, and tradition into account.

△ *Ananda Matha Asram*
Wynad, Kerala
1988

Soon, Devan decided to start designing houses himself. Before long, his unique houses started making an impressionable difference to the surrounding landscape. Despite some initial misgivings, those who had entrusted Devan with their houses had full faith in the purpose of the artist, who had thrown his heart and soul into his new mission in life. And he did not let them down. Not only are these houses attractive to look at, they are highly cost-efficient and suited to local conditions.

A.N. Nambiar

▽ *Residence*
Mr Unni Nair
1982

M. Govindan Auditorium ▽
Malayala Kala Gramam,
New Mahe, 1992

M.V. DEVAN

1928	*Born in Kerala.*
1953	*Diploma in Fine Arts, Government School of Arts and Crafts, Madras.*
1963–68	*Secretary, Madras State Lalit Kala Akademi.*
1968	*On the judges' panel for the National exhibition.*
1968–72	*Art consultant for the FEDO (FACT).*
1969	*Honorary director, Kerala institute of Arts; designed Ambalamedu township; served as Chairman, Kerala Lalit Kala Akademi; participated in All India exhibitions at Madras, New Delhi and Bombay; collections in Dr Sommerville collections UK, Asian Foundation, USA, FACT, Kerala and the Madras Christian College; has executed murals for various hotels in Kerala; also designed many houses in Kerala and Chennai.*
1994	*Director of Kala Gramam, the artists' village in Mahe, Kerala.*
2002	*Awarded the Ravivarma Puraskar by the Government of Kerala.*
2003	*Conferred the Mathrubhumi award; travelled in Europe extensively.*

The late A.N. Nambiar held a Masters' Degree in Economics and a Diploma in Journalism. He resigned a lucrative job with the Kerala government to devote himself to cultural activities and initiated the 'Little Magazine' movement in Kerala. He served as editor of *Sameeksha,* a prestigious literary and art magazine in Malayalam. He passed away in 1985. The article on M.V. Devan was written by him in 1982.

DOUGLAS

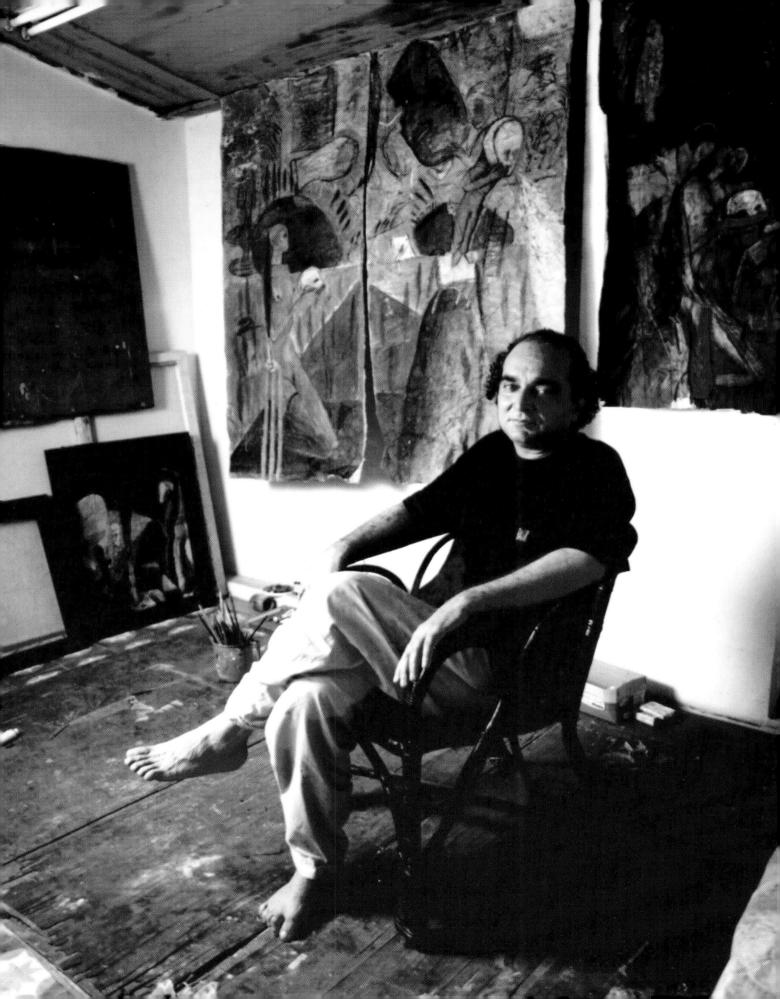

C. Douglas

C. Douglas, who hails from a coastal town in the far south of India, started as a painter at the age of twenty. That was in 1970, when he travelled to Madras to enroll himself at the Government College of Arts and Crafts. He was just out of college, a voracious reader who had briefly apprenticed under a highly respected art master in his hometown. He seemed to be a sensitive person. A career in art was thought of for him by the elders in his family because there was nothing else he would put his mind to. That it should be at Madras was decided in the hope that good instruction and the company of artists would help him open up and make something out of his temperament and abilities.

Happily for him, when he joined, the College of Arts was an exciting place, full of interesting personalities. The painters and sculptors there were involved in an art movement of their own, and some of them were at the peak of their careers at that time. K.C.S. Paniker, who had led the movement, had just retired and moved to Cholamandal. Douglas also moved in after he finished his course. The making of Douglas as a painter has much to do with what he had received and continues to receive from the group he had been initiated into at the college and later Cholamandal. Douglas bided his time, reflected quietly on his own and waited for an exemplar. It was eventually to be Ramanujam, the demented draughtsman

Untitled ▷
(Mixed media on paper)
1996

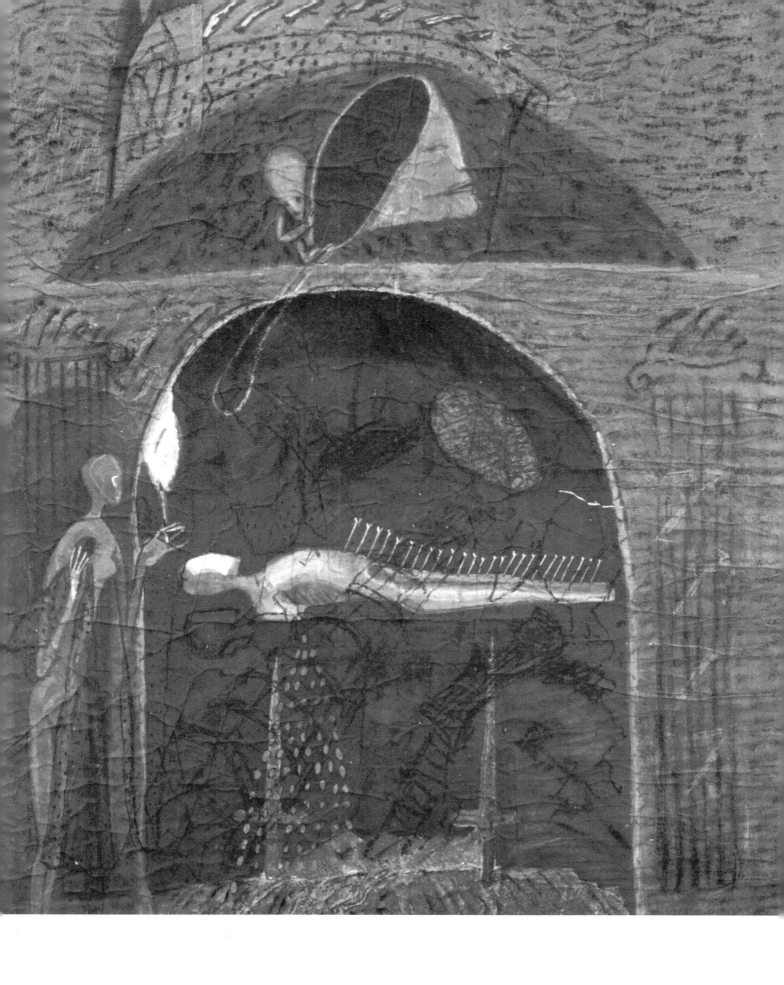

Untitled ▷
(Mixed media on paper)
1996

and painter, a former student at the college of art, whom Douglas would meet quite often.

Ramanujam was an eccentric and uncommunicative painter. But to Douglas he was a rare spirit who could picture the semi-sane, queerly formed state of being. Douglas' earliest exhibited work, done while he was still a student, showed how closely he had studied Ramanujam's workmanship. The way Ramanujam could play with his lines and make patterns out of them made a strong impression on the young Douglas. The style was a highly personal one, not unrelated to the expressionistic linearity that the artists at the college had evolved as a group. The commonest apprehension in these works were the disturbing unspecificity of the subject. Even Douglas was apprehended by this.

His metaphor for this in his work of that period was the foetus, the pre-natal condition in which there is neither separation nor participation of any kind. His ability to flight the line and to freely make figures with it was at play in the fragile personal myth he tried to hazard in the drawings of that period.

His shifting to Cholamandal confirmed his career as a full-time painter. It gave him a place to stay, the companionship of others like him, the needed time for painting and together with them all, the possibility of earning enough for minimum upkeep. Douglas joined the fellow students there and some seniors who had moved in earlier, and carried on painting without being disturbed by any feeling of discontinuity or dislocation. He was twenty-seven years old when he became a professional. The time and situation were entirely right for equipping himself for the hardy professional work ahead in his career as a painter.

He now started to 'paint' his pictures, instead of drawing and colouring them as he was doing so far. He proceeded to capture with brushwork and colour values, what he already knew how to gather delicately with his flighted lines and tints.

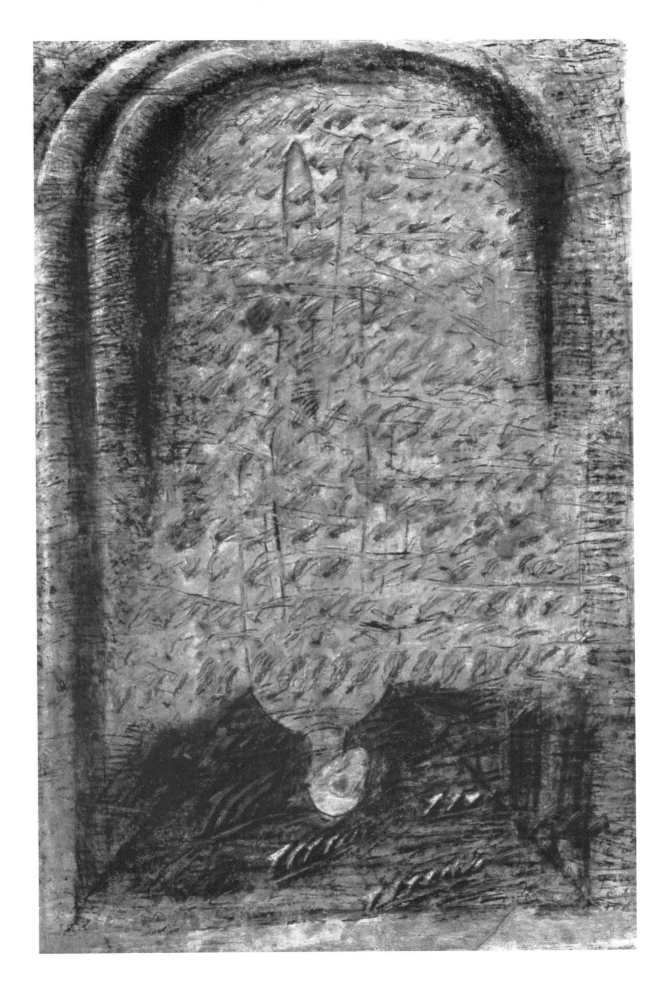

Upside-down Elephant ▷
(Mixed media on paper)
1995

This move warranted some reappraisal of his closely-held perceptions of the subject and of its pictorial form. In the attempt, Douglas was inclined at first to make abstractions of it with colour formulae, patterns, structures, and rhythms. It would have been a heroic move at this stage to try to unify in one large conception the ill-formed, intimidating aspect of his subject on the one hand and the ordered feel of his intellect that he had been equally afflicted with on the other.

Instead, Douglas refused to allow colour to illuminate his painting. As he worked, the picture got dirtier and denser, revealing the unlit, unruly apparition that hung over his vision. The formal devices in the painting, the grids, triangles, vertical, and horizontal lines appeared so idealistic and unsubtle that they cleared nothing as they spanned his painting.

The disorientation, hurt and pain started to register in Douglas' paintings towards the end of his nine-year stay in Europe in the eighties. They were no longer painted but stained, scribbled upon, muddled, excessively wrought, and dense. On an impulse, he decided to return to India. Left alone in the artists' village, he could introspect freely and deliberate upon the unsettlement he had experienced. For a while after his return he appeared to be turning out in his pictures the little that was left of his idealism, and taking a fond last look at the linearity of his early days. In a short while, a vague figure started to weigh in his pictures and it began to grow and take shape. His latest series of paintings is what he has arrived from those eerie beginnings after nearly a decade of self-examination and reflection.

Douglas knew that idealization deludes and demoralizes. The order in the oppositions of order–chaos, light–darkness, and figure–ground are not factual. They are themselves idealizations, not descriptions or evaluations.

Such was the contention of the new expressionist painting in the West. Douglas

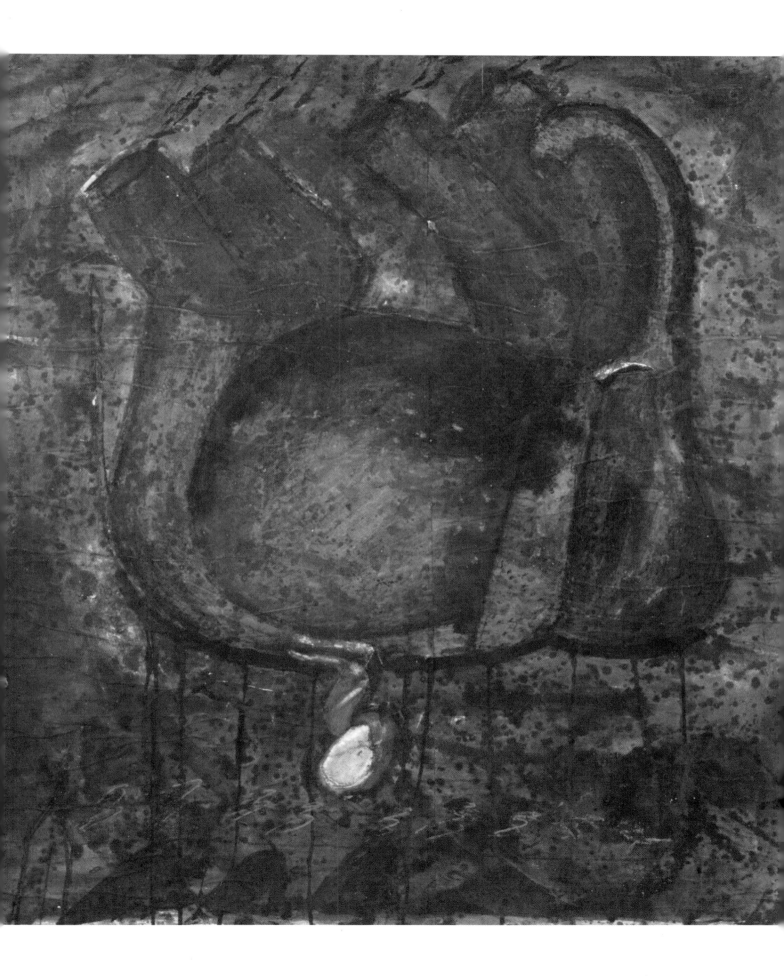

Incircle ▷
(Mixed media on paper)
1995

had the opportunity to take a close look at it while he was abroad. The contention that disorder is just as pictorial as order and compositon, is what an earlier wave of expressionism had come up with. Such a demonstration against idealism and good sense must have struck Douglas, frayed and uncivil as he insisted that his existence should be.

Attitudinizing makes a poor picture, Douglas must have noted, as poor as idealism. He was careful not to be distracted as he moved to get the figure back into the picture. This seems to have been a delicate manoeuvre, which he seems to have managed with characteristic reticence and fineness of feeling. When in due course the figure made its appearance, his pictures appeared to cover it up, masked and strangely reminiscent of the limp foetal form he had started with in his early student days. Such a figure is too introverted and solicitous to be attitudinal in any way.

Douglas' figure is that of an unbearable existence, one that would be grateful not to have been brought forth at all. The way he vouches for it is expressive of his extraordinary tenderness of spirit. His artistry lay in turning the picture surface into the fictional ground or recess which his vexed figure might stray into and haunt. When his figure first appeared in his student days, there was little he could do to give it a setting for lack of appropriate ground and design.

Techniques for creating antinomies that the figure creates: figure and ground, inside and outside, space and mass, live and inert, have been developed and reworked from time to time, including most recently in the expressionist revival. The issue apparently is one that stays open all the same, leaving it to the spirit of one's workmanship to effect some kind of a completion. Douglas, for his part, stayed free of the plastered finish of oils on canvas, working instead with chalk and crayons on crumpled and muddied paper glued on cloth. He stuck to

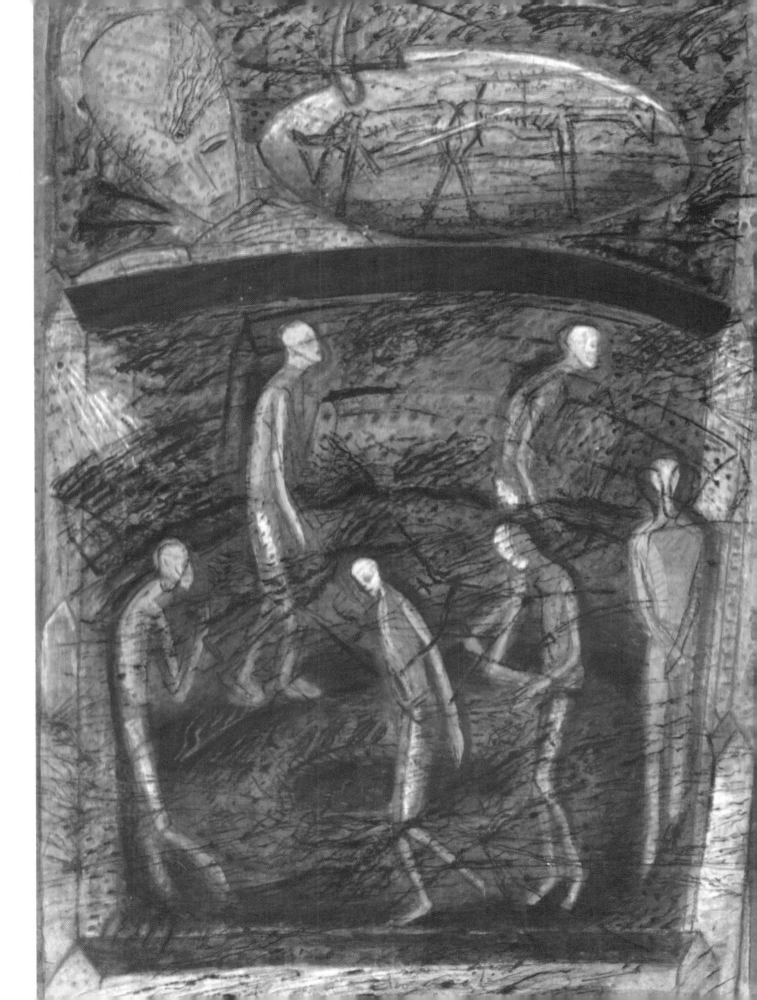

unobtrusive colour; greys, browns, and blacks that kept thickening and receding as he worked his pictures to a finish. These detours helped him arrive at an uneasy middle ground, an odd state of undifferentiated being where it is night when it is day, where each part of the picture is outside as much as inside, where the figure is as unresisting as the ground and possessively gone over and over again until the picture was exhausted and done. In that kind of a finish which Douglas is able to achieve in his later works, his figure turns decidedly picturesque. It turns out in the end to be amazingly constant, only a great deal more pictorial than at the beginning.

Josef James

C. DOUGLAS

1951	*Born in Kerala.*
1976	*Diploma in painting, Government College of Arts and Crafts, Madras.*
1980	*Award of the Madras State Lalit Kala Akademi.*
1990	*Bharat Bhavan Biennal, award in Bhopal and Tamil Nadu State Lalit Kala Akademi award, Madras.*
1992	*National Award of the Lalit Kala Akademi, New Delhi; one man show, Sakshi gallery, Madras and Bombay.*
1994	*Awarded the Charles Wallace grant; awarded the UNESCO grant and Government of India Cultural Fellowship.*
1995	*'Recent Trends in Contemporary Art', Vadehra Art Gallery, New Delhi; 'View from the Edge', Sakshi Gallery, Bombay; 'Water colour—A wide spectrum', Chemould Gallery, Bombay.*
1996	*One man show, Sakshi Gallery, Bangalore—Bombay—Alliance Française, Madras; 'New South', Delphina Gallery, England.*
1997	*'Looking Glass self', Gallery Lakeeran, Bombay.*
1998	*'Cryptograms', Gallery Lakeeran, Mumbai.*
1999	*'The Creative Process', the Guild Gallery, Mumbai; 'Embarkations', Sakshi Gallery, Mumbai.*
2000	*'Coming Voices for the New Century', Vis-à-vis and Art-Inc., New Delhi.*
2001	*'Time—Trace—Transitions', Sumukha Gallery, Bangalore.*
2002	*'Finding the Centre at the Margins', Apparao Galleries, Chennai.*
2003	*'Sites of Recurrence', Chennai—Sweden, Dakshina Chitra—Bores Museum; 'Said and Unsaid', Jehangir Art Gallery and Apparao Galleries, Mumbai; 'Collectors Choice' Gallery, Müller and Plate—Munich.*

The article on C. Douglas was written in 1985 by Josef James, the editor of this book.

GOPAL

K.S. Gopal

'I take symbols as a source of inspiration in building up a composition,' said K.S. Gopal in an interview in 1981, eight years before he breathed his last in Cholamandal. For an artist born in 1938 in the Tamil village of Tiruninravur on the outskirts of the present city of Chennai, life presented an immense storehouse for such inspiration. Tiruninravur (literally, a place where God stood) is known for its famous Vishnu temple, which was the centre of life in the village, playing a vital part in the social, cultural, and economic life of the people in the area. The temple symbolized the world in all aspects.

Gopal had his early education at the local school in the village. The art teacher in the school was convinced about Gopal's artistic inclination and so when the time came for Gopal to choose a line of education and instruction, both his teacher and he had no doubt that the School of Art in Madras was his destination. 'His parents and siblings were supportive, although no one else in his family had taken up art as a career choice,' says Saraswati, his wife, 'as soon as he came out of the School of Art with a diploma in hand at the end of five years, our respective families had arranged for our marriage. I had just started working in a government office and so initially we were not burdened by financial constraints. That gave Gopal the time and freedom to explore and arrive at a medium through which he could express himself.' Coming to Cholamandal was an important milestone in

Vinayaga ▷
(Zinc plate etching on paper)
1986

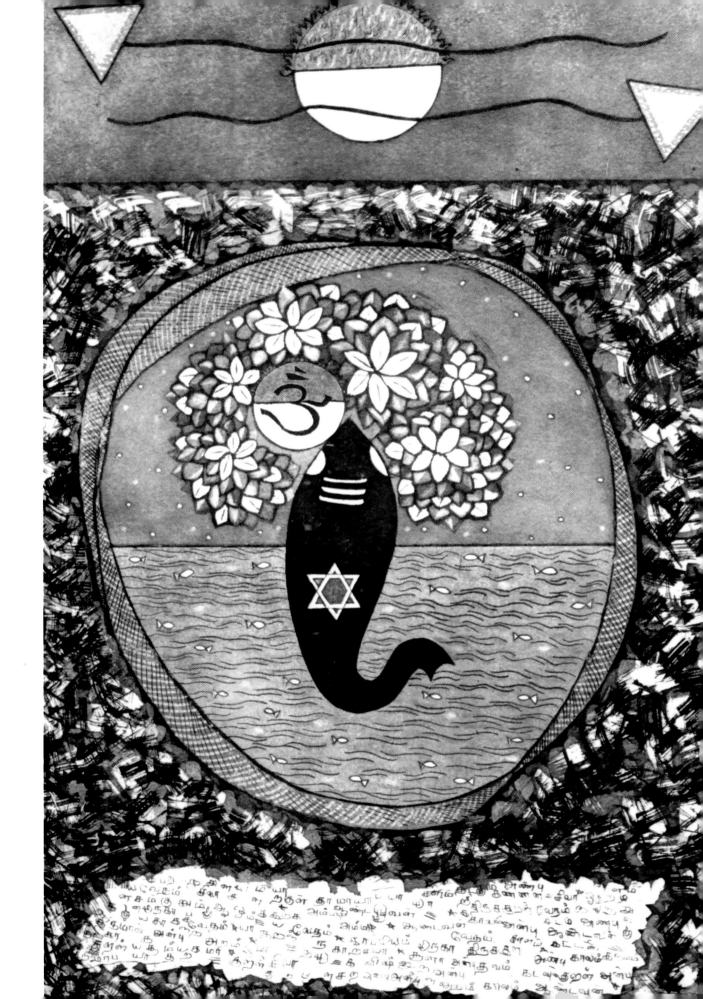

Om ▷
(Zinc plate etching on paper)
1986

his journey. When Cholamandal was founded, Gopal built his studio there while his family which by then consisted of his wife and two daughters, lived in the city. 'Soon we built a small house and moved in with our two daughters. There were of course the practical problems of travel to the city for my work and for the children's education. But looking back, we are content, for, those mundane and practical problems were insignificant when we think that the self-imposed isolation and withdrawal gave him the opportunity to delve deeper into his own self and to paint and etch for sheer necessity. It helped him find himself.'

Gopal, like his contemporaries K.M. Adimoolam and K.R. Harie, drew upon Hindu mythological symbols and one sees in his graphics the Swastika, Surya, Chandra, Linga, and Om. The workshop he attended in 1971 at the Ghari Studios in Delhi and the constant dialogue and experimentation at Cholamandal saw a marked degree of skill in his graphic prints. The various operations for printing on wood, stone, metal or other surfaces are original techniques which have their own characteristics and their own laws. He soon found that these techniques must be appraised on the same level as sculpture, painting, or drawing.

In Gopal's graphics and etchings, the textures around the main symbol gain a quality that elevates it and gives it a personal meaning. It seems to have given the artist the experience where he felt as if he had come out of himself; a sense of liberation. Gopal had told one of his contemporaries that a beautiful *sloka* from the Bhagavad Gita inspired many of his compositions, 'I am the taste in the water, I am the light in the sun and the moon, I am Om in all the Vedas.'

Shalini M. Devan

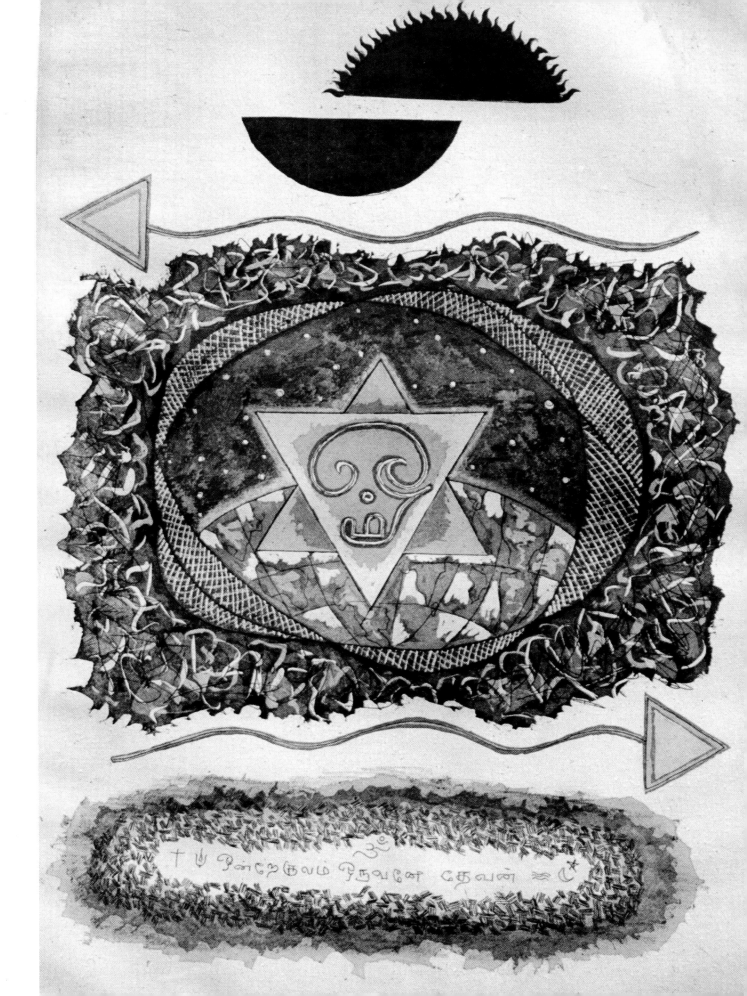

Om ▽
(Zinc plate etching on paper)
1987

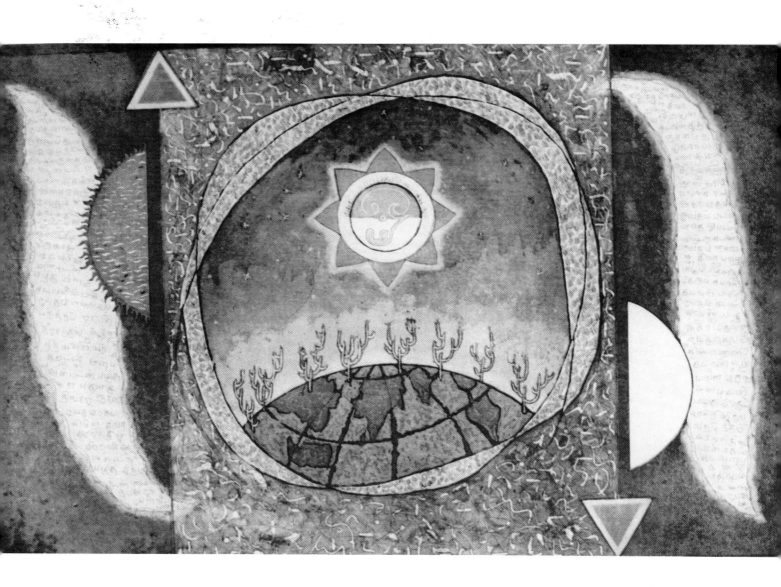

K.S. GOPAL

1938	*Born in Tamil Nadu.*
1963	*Exhibited at Madras State Lalit Kala Akademi. (Also in 1965.)*
1966	*Diploma in Fine Arts, Government School of Arts and Crafts, Madras.*
1970	*Exhibited at the Academy of Fine Arts, Calcutta. (Also in 1971 to 1976, 1978 to 1980.)*
1972	*Showed with 'Group 8', New Delhi. (Also from 1973 to 1976); exhibition of 'Contemporary Miniatures' by the Progressive Painters' Association at Madras and Bombay.*
1975	*Three man show at Jehangir Art Gallery, Bombay.*
1976	*Exhibited at the State Akademi for Visual and Plastic arts, Madras. (Also in 1978, '80, '81 and '82); National exhibition of Art, New Delhi. (Also in 1978, '80, '81 and '89.)*
1977	*Graphic workshop held at Ghari Studios, Lalit Kala Akademi, New Delhi.*
1978	*'71 Prints', Lalit Kala Akademi, New Delhi, and Regional Centre, Lalit Kala Akademi, Madras.*
1979	*All India exhibition, Karnataka Lalit Kala Akademi, Bangalore.*
1980	*'Art Trends' in Southern Region, New Delhi. 'Graphic '79', Chandigarh.*
1985	*Festival of India at USA exhibition of Contemporary Prints; graphic workshop held at the Regional Centre, Lalit Kala Akademi, Madras and conducted by Paul Lingran, American print-maker.*
1986	*Exhibition at Max Müller Bhavan, New Delhi.*
1987	*Award of the Tamil Nadu State Akademi.*
1988	*Artists' Camp, Tamil Nadu State Akademi at Kumbakonam.*
1989	*Passes away at Cholamandal.*

Shalini M. Devan is an architect by profession and writes on art for various journals. She worked with the well-known British architect Laurie Baker at COSTFOD, an institution started by him at Trichur, Kerala. The article on K.S. Gopal was written in 2001.

GOPINATH

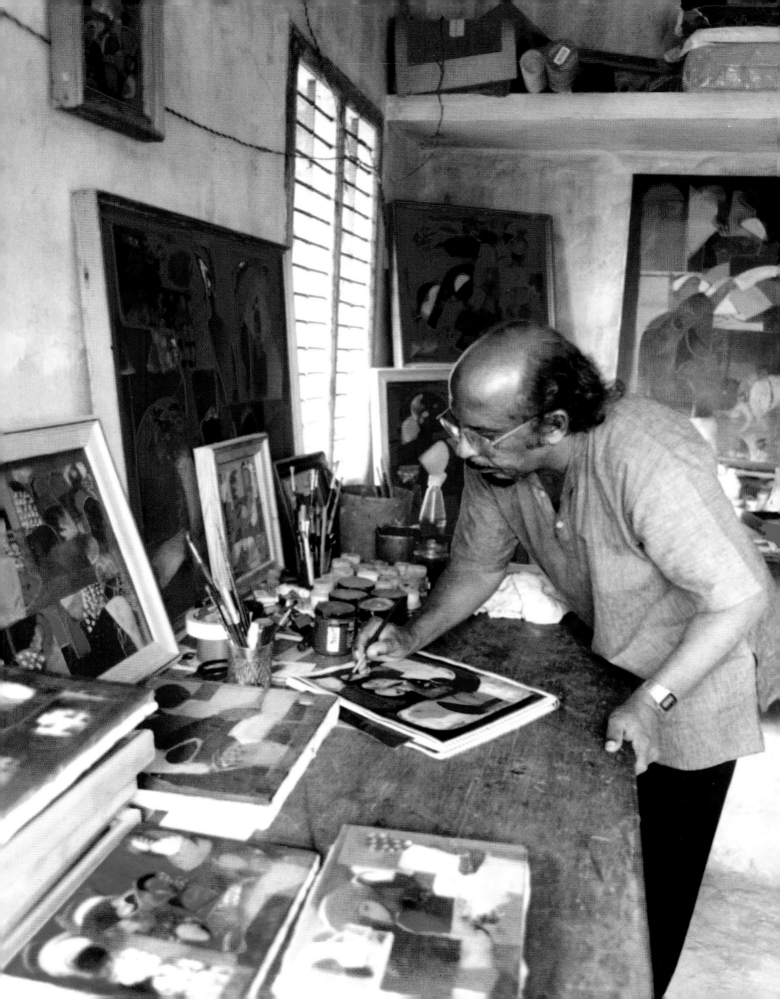

P. Gopinath

Seeing P. Gopinath's paintings within the norms of the far too often presumed bi-polar divide of abstraction and figuration would be rather limiting, if not totally futile. This is so since the development of abstraction (in art) in colonial/postcolonial nations, and within regional/local (read marginal) variations (as in the provincial cultural pockets of India), introduces major, if not basic, ruptures in the presumed monolithic Euro-American/international criteria in theorizing. Rather than being a credo with avant-gardist and absolutist claims, here the adopted languages of art instantaneously turn into a synthetic/eclectic/polyvalent field, where questions of modernity, indigenous identities, and the will to encode specific subjectivites realize themselves. For here, from Gaganendranath Tagore to V.S. Gaitonde or Nazreen Muhammadi, and K.C.S. Paniker to L. Munnuswamy, the different language options make art a highly charged field, generating particularized meanings and differences; imbued and inflected with the personal subjectivity and ideology of the artist. Here, the languages of art, in the sense of affecting a mode of speech, thus have to be one of the primary concerns.

Rather than considering abstraction as an elimination of reality, and as an attempt in moving towards the non-material, spiritual or transcendental, it should be seen as a strategy of affecting the presence of the corporeal world as a simulacrum, that which then assigns to the artist the capability of maintaining the reality of the real in captivity.

Biomorphic Images ▷
(Acrylic on paper)
1990

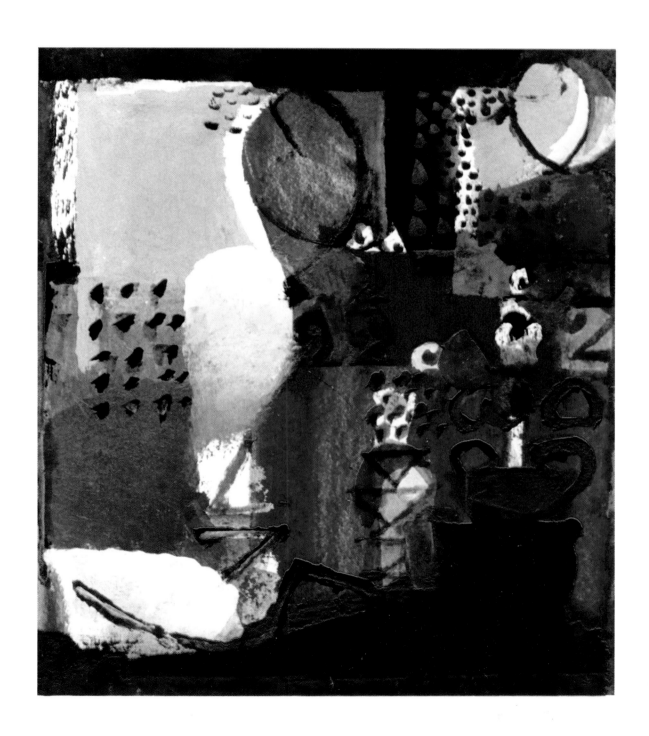

Biomorphic Images ▷
(Acrylic on paper)
1992

In art, figuring the 'world out there', whether in figuration or abstraction, is a matter of representational restructuring, and hence is highly mediated by what one may call the sensibility of the maker. In fact the tendency towards abstraction and figuration has been latent in art down the ages. Thus it signals the dissolution and collapse of distinctive credos of semblance and dissemblance, and allows viewing these as mere (artistic) expressions of sensations, knowledge, and feelings, based on the material world and its interpretations.

The three distinguishable phases that can be discerned in the works of Gopinath indicate no dramatic shifts, where the differing approaches in pictorial configurations would be seen as engaged within a certain basic premise. Right at the outset the pictorial aesthetic that he chose enabled a rejection of mimetic possibilities of realism in its varied forms, academic or stylized; the varied modernist-abstract ramifications. 'Art here has never been confused with nature...,' as he once said.

According to Gopinath, 'Art...has been understood as a purely creative work of man where nature is the source of all inspiration.' Right from the early stage he rejected the literal and narrative as well, as he thought they would limit his creative possibilities. Considered purely in pictorial terms, what he discards is basically the spatial logic of constructing relational recessive spaces in terms of foreground, middle ground and background, or in other words the designated pictorial illusionism.

In the 1960s and 70s, notionally, the illusion of space combined with realism, connoted a Western materialistic approach, whereas the flat, non-illusionist two-dimensional spatial organization was understood as the Indian approach. Thus to be contemporary, modern, and Indian meant the rejection of the former for the latter. However, what Gopinath learnt from Monet and Cézanne, and from the cubists to Paul Klee were significant in the sense that these modernist anti-illusionist approaches reinforced the validity of pictorial values of the traditional Indian approach.

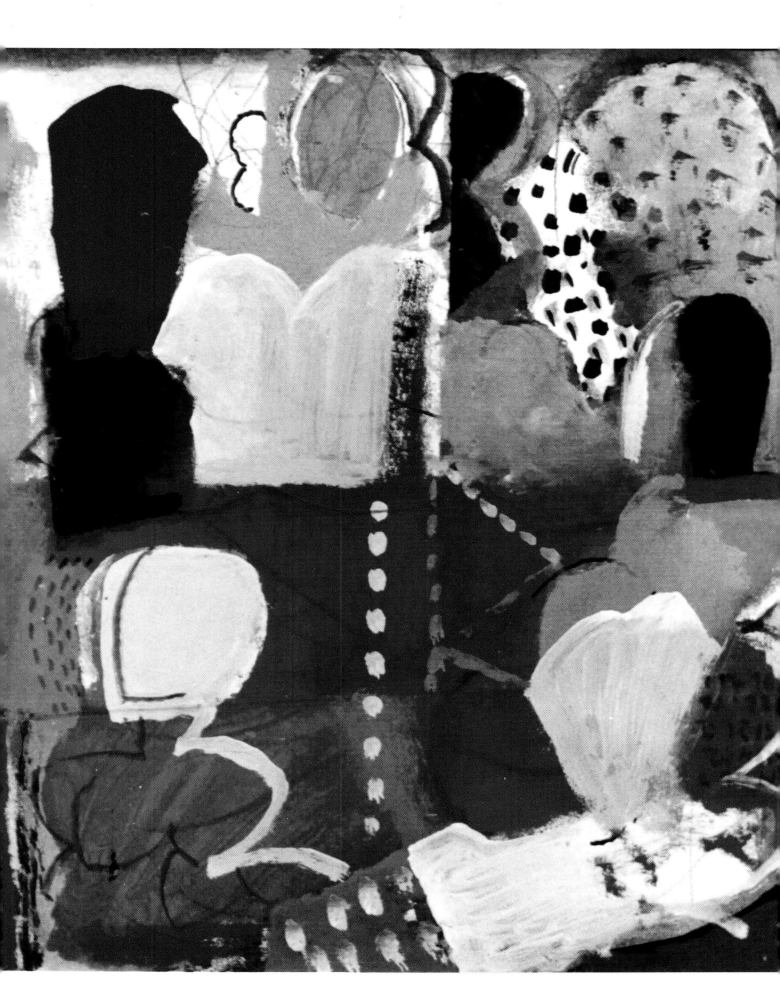

Gopinath's conviction for the wall-like pictorial space is so total that he casts off even the last vestiges of an illusionary real world recreated on canvas. For instance, he rejects the horizon, that structural principle that unites and separates the land and sky, and in that place he adopts a self-sufficient diagrammatic construction that can significantly reabsorb and restructure the real world into a meta-reality or alternative reality.

It is significant that when Gopinath's painting career began (in the late sixties and early seventies) much of the nativist argument (led by K.C.S. Paniker) was either absorbed, or contested and rejected by a previous generation of artists. Multiple choices were indeed present. In the early seventies Cholamandal was already an established institution and a centre of art activities. Whether they agreed with him or not, the resourceful guiding spirit of Paniker was a point of reference to all those who were beginning to live here as artists.

Although Gopinath's early works share a certain common ground with those of Paniker (*Words and Symbols* series), much of it also originates from a highly eclectic personal vision. The predilection for the flat pictorial space apart, the choice to work with certain primary geometric and organic shapes and traditional design forms are features both artists use. In fact, this inclination is shared by a number of other students of Paniker, such as Kanai Kunhiraman, Jayapal Panicker, and Viswanadhan.

For many artists starting in Madras in the late sixties and seventies, 'Primitivism' was an important way of marking identity, not necessarily that of the so-called Indianness, but more as a pre-occupation with regional (*adi-dravida*) invocations. In Gopinath's paintings such as *Fish and Figure* and *Ritual Memories,* the images of the mother archetype, symbolic signs of the *yoni* (the single or multiples of intersecting triangles) and the *linga* forms, the *nagas*, and deity-like figures derive from a variety of traditional/religious literary and visual sources. Certain other possible interpretations (sexual sublimation, phallicentricity) apart, on an

▽ *Untitled*
(Acrylic on paper)
2002

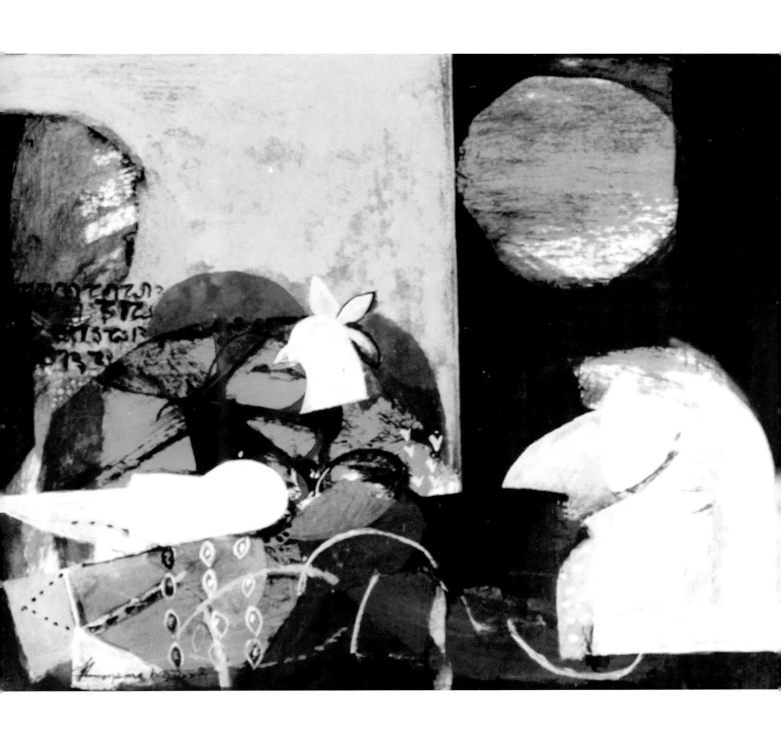

Untitled ▷
(Acrylic on paper)
2002

ideological level these indices evoked and asserted the spirit of the particular genius of native cultural traditions (*arivalithanmai* in Tamil, and *thanathu-thanima* in Malayalam).

As such the modernist vocabulary in Madras stressed two primary pictorial elements, drawing and colour. 'I was fascinated by Paniker's colour and drawing of Santanraj', Gopinath once said. Nowadays, the sources that he draws from are as varied as Madhubani paintings and Mughal and Pahadi miniatures.

In the works of his early phase, the rather loosely floating organic and geometric shapes and forms create brisk, staccato rhythmic movements that are coordinated by the ground colour and relatively fainter linear over spatial scaffoldings. In the later half of the seventies the horizon reappears, which coincides with a renewed interest in nature and its myriad organic forms in his series *Biomorphic Images*. Contrary to the Western academic practice of conceiving form as a mass disciplined into a body, Indian tradition renders it in drawing as a continuous and linear movement, resulting in a rhythmic whole. The use of simplified outlines, and the elimination of the representational line and shading, lent possibilities of surface decoration, and the pictorial structuring (by dividing the canvas into two or more larger areas) enabled placing other smaller structural shapes and forms within these to achieve a total overall unity.

Finely honed, sharply faceted, and using echo-like overlapping shapes in some places, the pictorial space appears as a translucent veil draped over the as yet undisclosed mystery of nature. The geometrically simplified and hushed-in iconic human shapes often mysteriously loom large. Discretely ordered against flat colour fields, these rhythmic shapes surrounding the often off-centre and firmly planted vertical figures are drafted within the grid of sharp-edged, geometric, darker tonal spaces. The paintings indeed emanate a mystical light, where the simplified, ripe organic shapes sprout and expand into their convex–linear fullness, much like the highly saturated contours of classical Indian sculpture. The idealization, and the

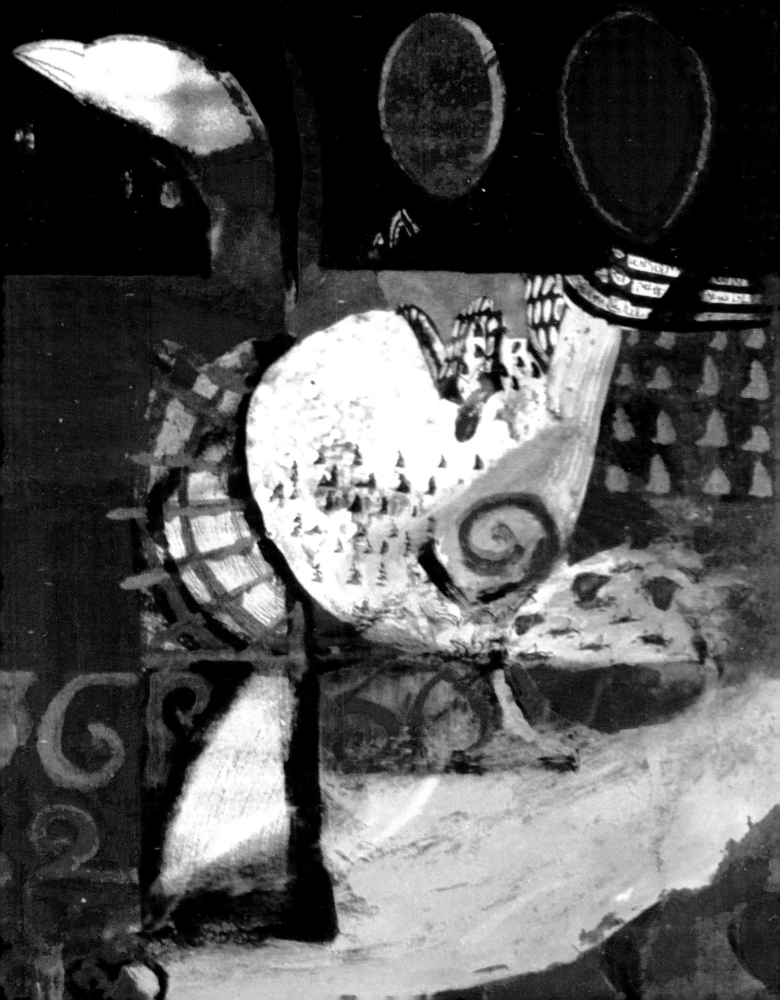

Untitled ▷
(Acrylic on paper)
2002

purely artistic and creative spirit meant a yearning similar to the presence of controlled physical perfection in classical Indian art. The figures are treated as purely abstract shapes, where they integrate into an overall design that is spread all over the surface. The entire surface begins to reverberate with organic and simple abstract elemental forms, echoing the outside world. Halos, *prabhavali*-like shapes (much like the structuring devices of windows and balconies in the traditional miniature paintings), frame and hold the design together.

His technique too went through a transformation. In the earlier phase, he first drew and then filled in colours. Later he started doing both simultaneously, giving them equal importance. Linearity and flatness are major elements in Gopinath's paintings of this phase, which in its simplicity, boldness, and clarity embody the vitality of living shapes. The bright colours, with their warmth, contribute greatly in animating the pictures. These paintings employ the light and shade that is inherent in colour tones and through their translucence suggest depth and a three-dimensional effect. Different forms have varied tonal and structural values that are coordinated into a pictorial order. Divisions create an illusion of space where lines and colours merge, while retaining their individual qualities.

The intensity of colour, its brightness, transparency, and its transitory aspect are experiences by themselves, and Gopinath in this context refers to the intoxicating colours of ritualistic art (Indian floor paintings and diagrams). These preoccupations in Gopinath's works establish a longing for giving shape to an unrevealed truth of the physical presences. However, if a mood comes in painting it is by chance, and it is not achieved by will. Much like in the *Sahaja* tradition of living, the spiritual reflects, as an aspect of existence. For the artist, expressing through the making of forms is a way of working with the paintings' own innate logic as in nature, revealing infinite variations and mutations in the process.

These prepare the ground for an entry into Gopinath's third phase. The diagrammatic grid reappears, but as an unlimited and unframed spatial expanse. Colours largely become opaque and dark, and greater freedom and spontaneity in

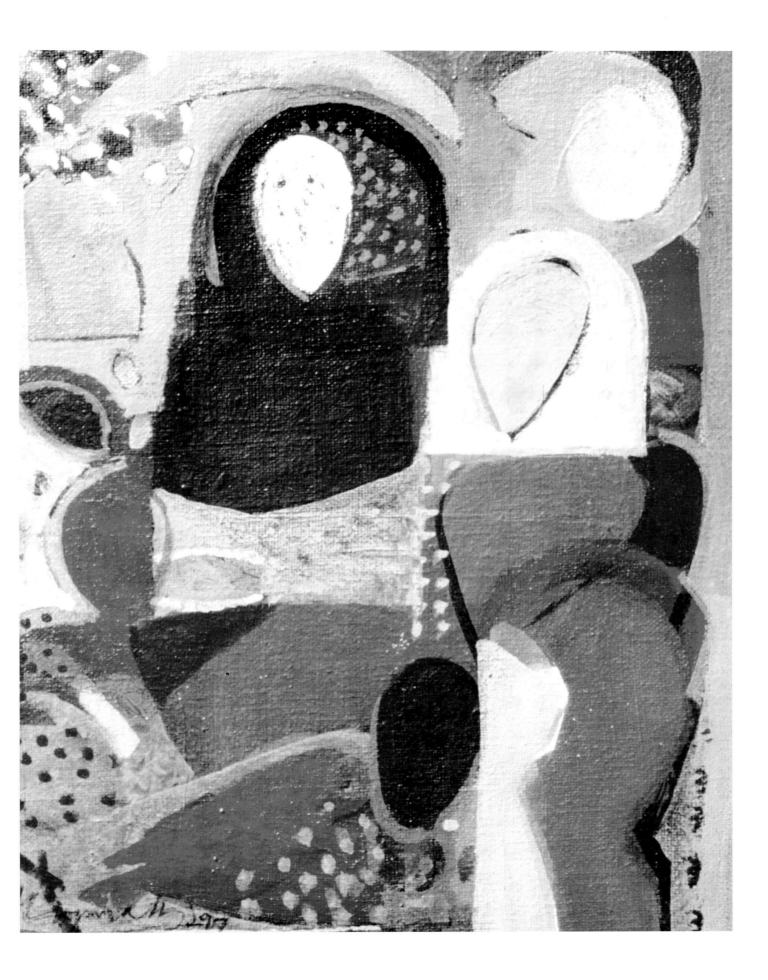

the treatment sets in. The process of painting now is more a dialogue of colours and shapes, rather than a pre-meditated act.

Figural vestiges linger on like a shadow, but are largely obliterated in the process. The analogy that can be drawn to this process is an attempt of the erasure of the self, the elimination of personality, much like the metaphor of denuding the self so as to reach a primal state of existence. 'I am not being deliberate, there is no particular pressure. I give that to myself,' he says.

As the figure is made to ebb away, the surface receives greater enrichment through overlapping shapes that move in all directions. The gestured marks, the repetition of motifs, the play of tonal variations and the resulting hide-and-seek of light and shadow lend the paintings a swiftness of rhythm, a fleeting shimmering sensation of light upon dark. The sensation of light is a major element in these pictures, which is achieved by the manipulation inherent in tonal values of colour. The extensive use of white enlivens much of these paintings, since it gives a sense of highlight within the dark forests of colours and shapes.

In these works, what the artist begins with and ultimately creates are totally different, since the process is based on free-play and unconditional engagement. 'My painting starts from chaos, and later I order it, till I reach a state of play, like being in an unknown reality,' maintains the artist. In his view, his paintings are never finished. 'I leave no finished products,' he says.

Inclined toward the metaphysical aspect of transformation, conceptually these paintings assert the endless possibility of picture making, and as an analogy the artist draws attention to the eternal making and unmaking of the sensory world. 'It is a yearning for perfection, a process of cutting down things of sensuality one by one, yet, it is still there, and it will always be there,' the artist repeats, 'like a monk saying prayers in the sanctuary, like a mantra; painting is endless, and the possibilities within are limitless.'

<div align="right">Shivaji K. Panikkar</div>

P. GOPINATH

1948	*Born in Ponani, Kerala.*
1966	*Became a member of the Cholamandal Artists' Village, Madras.*
1970	*Diploma in painting, College of Arts and Crafts, Madras.*
1976	*PUGWASH All India exhibition, Madras.*
1977	*'Pictorial Space' All India exhibition, Lalit Kala Akademi, New Delhi.*
1978	*IV International Triennale India, New Delhi.*
1980	*State Award, Lalit Kala Akademi, Madras.*
1981	*'Art Trends in Southern Region' exhibition at Madras.*
1985	*Exhibition at Asia Pacific Museum, Poland and also in the ICCR exhibition at Morocco.*
1987	*VIII Biennel International de Art, Valparaiso, Chile.*
1988	*Nominated as an Eminent Artist member, Lalit Kala Akademi, New Delhi.*
1989	*'Indiase Moderne Kunst', Kasteel, Arcen, Holland. Sponsored by Gate Foundation, Amsterdam.*
1990	*Represented India as Commissioner for the International Festival of Painting, Cagnes-Sur-Mer, France; visited France, Netherlands, Belgium.*
1994	*100 years—National Gallery of Modern Art, All India exhibition at NGMA, New Delhi; 'Art for Hearts' Sake' Sotheby's Auction, Bombay.*
1997	*'Major Trends in Indian Art since 1947', Lalit Kala Akademi, New Delhi, Regional Centres, Chennai, Mumbai, Calcutta.*
1998	*'Symbolism and Geometry in Indian Art', National Gallery of Modern Art, New Delhi; 'Movements in Indian Art—A Tribute', All India exhibition of Art, Chithra Kala, Parishad, Bangalore.*
1999	*Lalit Kala Akademi Group Show at Gallery Art Centrum, Boda, Glasburk, Sweden.*

Shivaji K. Panikkar is Head of the Department of Art History and Aesthetics, M.S. University of Baroda. He is the author of *Twentieth Century Indian Sculptures: Last Two Decades* by MARG Publications, Mumbai. He is presently engaged in writing on art developments in Chennai since the 1940s. The article on P. Gopinath was written by him in 2002.

HARIDASAN

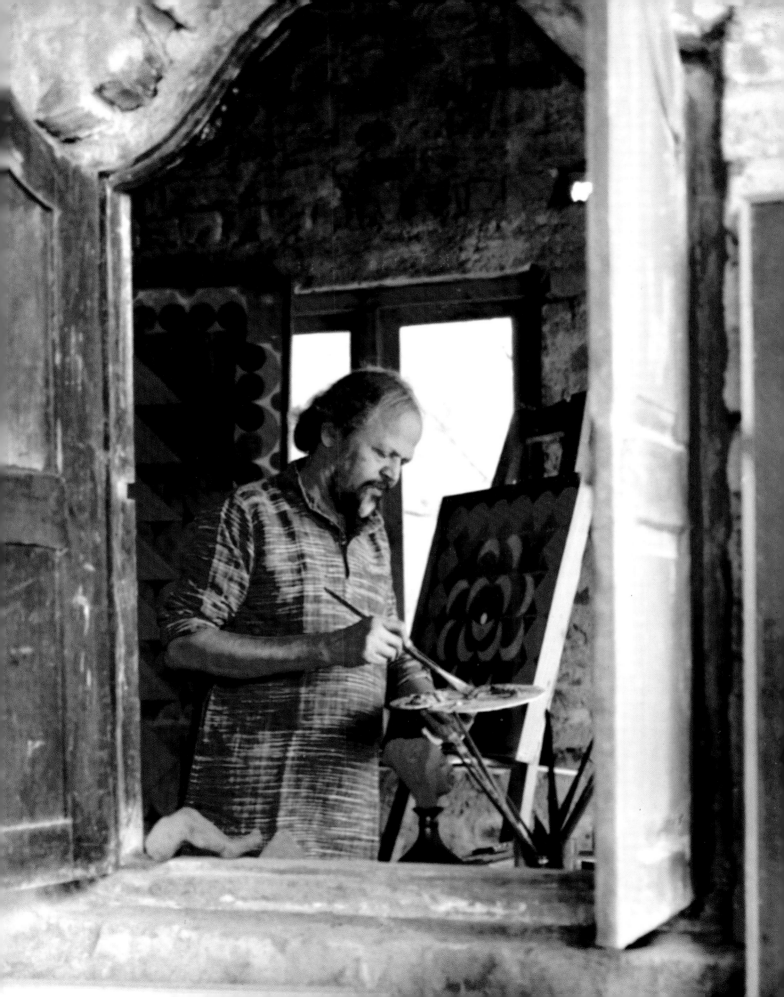

K.V. Haridasan

Among the creative fields that constitute human culture, the licence to flout the rules of the game was gained the earliest in the visual arts. This is what happened in modern art, which expanded the scope and extent of artistic expression.

The modernists sidelined the naturalistic conventions of Western art altogether and recognized and accepted extra-European manners of art expression. The result has been an array of works in acknowledgment of all cultures the world over, resulting in a kind of cultural unification.

Art in earlier ages was confined to a limited geographical area. It was verily the region's soul, its characteristic expression, through which it could be identified. All art is now being assimilated in the process of a global cross-circulation. But we must not forget that those who control the communication media have the power to determine what kind of art is propagated. In such a situation, it becomes necessary for us to hold on fast to whatever distinct features we have inherited in our own culture.

What follows here is an attempt at taking stock of what we have lost and what we have gained in the field of art in recent years. Modernity began with questioning, and questioning brings with it the possibilities of rejection. The initial steps towards modernity were taken by science, which instilled a new-found confidence among

Brahmasutra ▷
(Oil on canvas)
1989

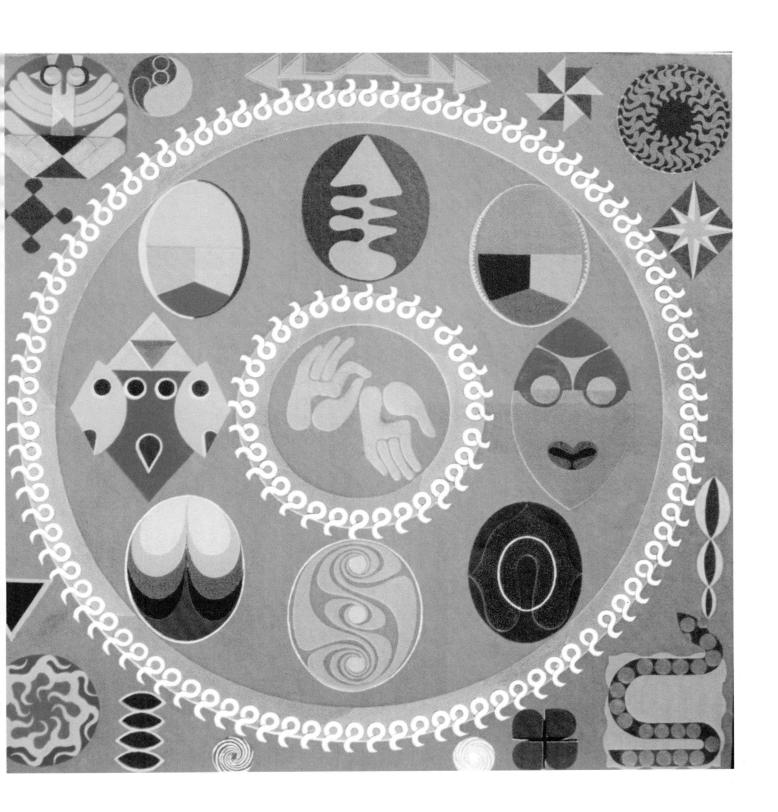

humans who came to believe that they could create a new era on their own. In other words, man could become the creator and defy God.

Ideas produce chain reactions and this particular idea spread to art expression as well. The shock method became common in art. In the course of time, this destroyed expression. This development may be discerned in recent international art history. Innovation has become an alibi for hybridization, and we are in the midst of a crisis in which endless improvisation has made it difficult to distinguish one manner of expression from another.

Traditionally, in India, artists preferred visionary exuberance, extending fantasies and distilling psychological states into their graphic art. India's great temple sculptures and cave paintings are perfect examples of this attitude. In the modern period, Western art and Indian art are comparing notes, and it must be said that unification efforts have not been entirely futile, although the process itself has been traumatic.

But one question begs an answer. Why do Indian moderns bend backwards to show the world that they are more familiar with other cultures than with their own? Why do we ignore, and sometimes even desecrate, our own culture?

Time distorts the relevance of certain mores. We need sometimes to be agnostics and suspend our judgement in order to free ourselves from certain beliefs. Yet, not to have any terms of reference is a loss that will eventually be regretted. Traditional values must be revalued and not dismissed.

The course of the world is directed by ideas. This is an age in which ideas are worn like apparel, a new one substituting the older, soiled one. Thinkers cannot claim absolute ownership over their ideas, just as those who absorb the ideas cannot separate the received ideas from their own. Ideas dissolve in the mind, and the mind refuses to acknowledge their source. Everyone illegitimately tries to own ideas without realizing the extent of *sadhana* that has gone into their creation.

▽ *Brahmasutra*
(Oil on canvas)
1975

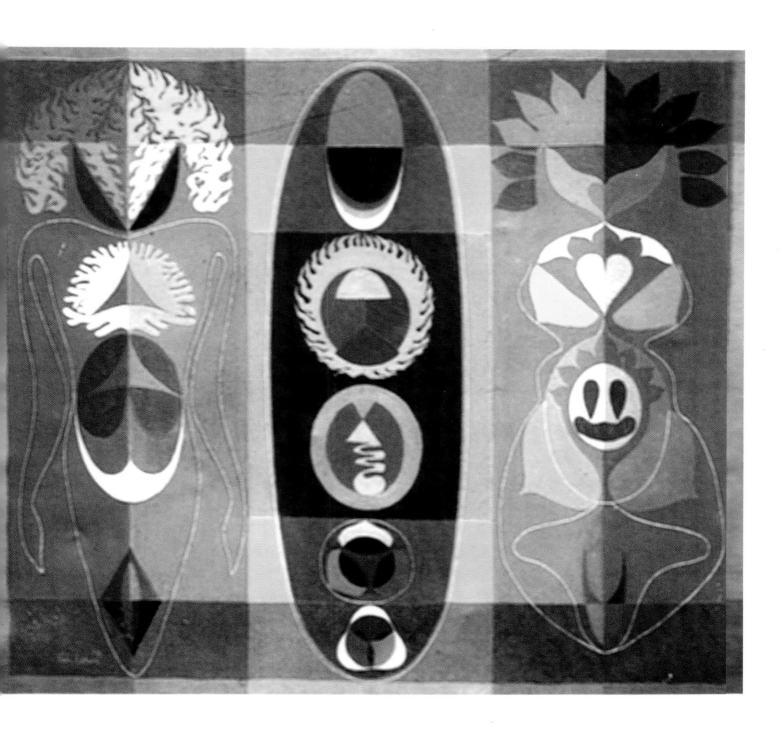

Brahmasutra ▷
(Pastels)
2002

The egalitarian idea has been stretched to such an extent that each individual has become an unassailable island and fortress, claiming supremacy of achievement. The worst-affected field is that of visual art, where to question is to find the other side strengthen its defence! Common grounds of communication are rarely achieved. Each artist gets tragically moored in his or her own blind alley.

In our country, rigorous discipline was once maintained in the training of the arts. When challenged by foreign domination, the system got demoralized. The tide has turned into a free-for-all in flouting norms. To confound the situation, the public is trained only to the extent of comprehending contemporary art as something non-communicative, so that when it comes to patronage, the choice is automatic and can be expected in favour of whatever is incomprehensible! Accordingly, one particular mode spreads like forest fire.

India is a conglomerate of cultural units. Yet there seems to be an ingrained lack of pride in the national genius, from which modernity could have learned a few lessons. Discriminative norms of judgement are thus lost sight of. A multiplicity of angles is in circulation, but no cultural perspective is inculcated. Coomaraswamy is in the wilderness of our bookshelves.

There was an age when man was overawed by nature in its elemental powers, by the unyielding stubbornness of the earth, the strength and ferocity of animals, the mysterious epidemics, the cosmos.... Then there was devotion. Now we have to constantly remind ourselves that our seeming security and confidence will be destroyed the moment we cross the earth's tolerance limits. But man has got used to his technological cocoon. So far, so good in this fool's paradise!

Faith is not the basis of one's convictions any longer. Yet one cannot fail to observe that traditional Indian thought is based on a unique methodology predominantly in favour of understanding the links of humans in phenomenal terms. Those who study further will find that this tradition seems to correlate disparate elements of

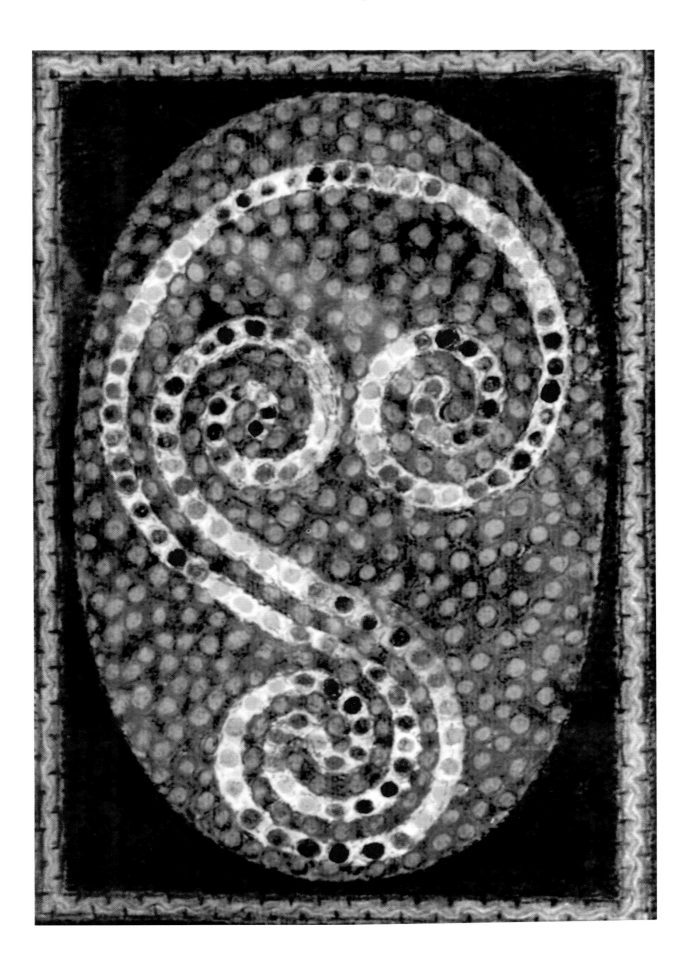

Brahmasutra ▷
(Oil on canvas)
1985

the existential enigma, treating the physical and material needs of man as inconsequential. Ours is a tradition which encourages humans to face challenges through self-abnegation, suggesting that there is a source of strength within. Such an attitude transmutes the physical into the non-material and inspires extraordinary courage. No other culture has asserted such a philosophy in such definite terms. This was the ideal of traditional India, from the Upanishads, through innumerable *rishis, ascetics* and *sanyasis,* to the present time.

The mystical is often treated as an aberration, yet man is invariably driven to reflection on his own condition. He escapes, through dance or music, into realms of fancy. These realms offer him a vicarious experience. Here he chances upon a state of joy which he dismisses out of fright. We have a great inheritance which helps us maintain that joyful state of mind. It can make life an experience of great intensity, fulfillment, and elevation. Yet conformists of the modern world harp against it. Many charges are made against India and it is written off as backward. There are people who never tire of exclaiming that there was no psychology, philosophy, art, science, logic, or medicine in this part of the world.

In reality, the depth and range of traditional Indian knowledge is so vast that wading through it can be exasperating. It is made up of numerous streams of knowledge vying with one another. There is the moral *dharma* stream, the dutiful *karma* stream, the learning-oriented *shastra* stream and the astrological *jyotishya* stream—what unifies this interdisciplinary maze is the living presence of mystics who appeared from time to time. They manifested the principles contained in these philosophies in flesh and blood. We may recall here the names of Vyasa, Vasishta, Krishna, Rama, Shankara, Buddha, Ramakrishna, Ramana, Tulsidas, Aurobindo, Krishnamurthy, and Rajneesh.

We in India traditionally had an abstract art form which is still preserved, in parts of our country, in ritualistic practices. The system of values underlying these

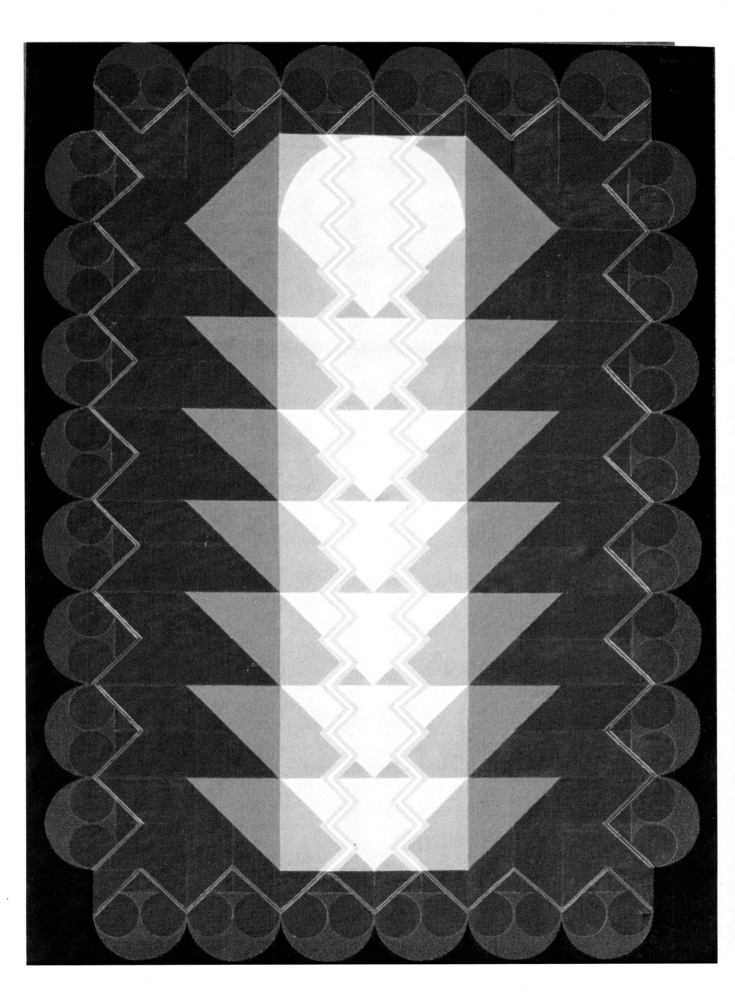

practices has been identified as Tantric. In Tantra, Brahman is the basic concept, the axle on which the wheel of phenomenal reality rotates. The intriguing duality in nature is explained in terms of the masculine and femine spirits—*purusha* and *prakriti*. These principles, along with the five elements and the three *Gunas* or functional qualities, constitue a unified whole. There are unified meta-physical treatises on the principles of Tantra.

Our ancients had identified vital forces that operate within the human organism so that a link is established with the totality of the cosmic phenomena. As a result, the reality observed did not remain the 'other' but became an extension of the self. The rituals concerned with the system were a means to realization, a therapeutic means of liberating one's creative potential from inhibitions. They were meant to help us evolve the highest forms of self-expression.

Tantra naturally developed into a rigorous yoga discipline, however trying the technique of conditioning involved in it might be. The practice of rituals helps in deconditoning and shows an escape from the grooves we are in. We may well use rituals if we see a need for them.

Tantra invested Indian art with a distinctive flavour and character that we can identify. Expressions such as *rasa* in dance and *raga* in music are the results of similar enquiry and indicate the aesthetic heights to which one can ascend in a state of bliss (*ananda*).

All of Tantra and yoga do not advocate renunciation. They direct one to find the source of power in terms of intelligence, perception, pleasure, or capacity. So one benefits by all-round development. Just as we don't do away with the wheel in industry for something new simply for the sake of modernity, so also in art we must understand the relevance of *bhaavas* (emotions) to express experience.

Austerity and purity indicate, in any form of art, a mind free from diversions, an attitude close to meditation. A line, when given potency, can become the axis on

▽ *Untitled*
(Drawing on paper)
1987

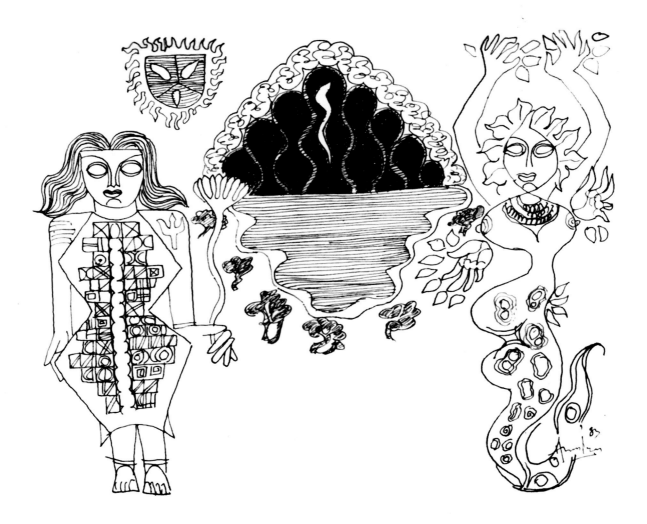

which the universe can rotate. Colour has to act as a medium of possession. It should not be limited to mere representation. It should be permitted to reach its farthest possibilities of being in contact with the cosmic forces. Human states—psychological, sentimental, emotional, or cognitive—are infectious. One's reactions reflect on one's fellow beings. Thus there is a social need to provide hope, to search into areas in the mind which can engender beauty, confidence, and love. This was once meant to be the purpose of art—to avoid suicide, whatever the vagaries of real life. That is how we have traditionally preserved our psychological strength.

K.V. Haridasan

K.V. HARIDASAN

1937	*Born in Cannanore, Kerala.*
1958	*Graduate, Madras University.*
1960–66	*Diploma in painting, School of Arts and Crafts, Madras.*
1964	*Award Tamil Nadu Akademi; participant, National exhibition of Art (1964–77).*
1968–71	*Exhibition of YANTRA series of paintings in British Council, Madras and Kumar Gallery, New Delhi.*
1974	*(Also '83 and '88) visited Russia, Germany and France on cultural exchange.*
1975	*Award and Gold Medal, Kerala Akademi; participant, International Triennale, New Delhi (and in '78).*
1976	*Exhibition of 'Brahmasutra' series of paintings, New Delhi (also '78, '81, '92, '94 and '97).*
1979–85	*Editor* Artrends *magazine.*
1980–92	*College of Fine Arts, Trivandrum, Kerala, Professor and later Principal.*
1981	*Jury, National exhibition of Art, New Delhi (and in '92).*
1983	*Participant, Neo-Tantra exhibiton, West Germany, by National Gallery, New Delhi.*
1985	*Neo-Tantra exhibition as part of India Festival UCLA, USA.*
1989–94	*Member, Lalit Kala Akademi, New Delhi, its publication committee and of Regional Centre, Chennai and Executive Member, Kerala Akademi.*
1991	*Special invitee, International Triennale, New Delhi.*
1992–95	*Senior Fellowship, Department of Culture, Government of India.*
1994	*Nominated Eminent Artist Member, Lalit Kala Akademi, New Delhi. Published a book* Intimations on art, Indian and Western.
2003	*'Lalit Kala Puraskaram', Award for art, Kerala Akademi.*

This article is by the artist himself who is a prominent Neo-Tantric painter of India. He served as editor of *Artrends,* an art journal run by the Progressive Painters' Association of Madras, for a brief period. This piece was written in 1993.

HARIE

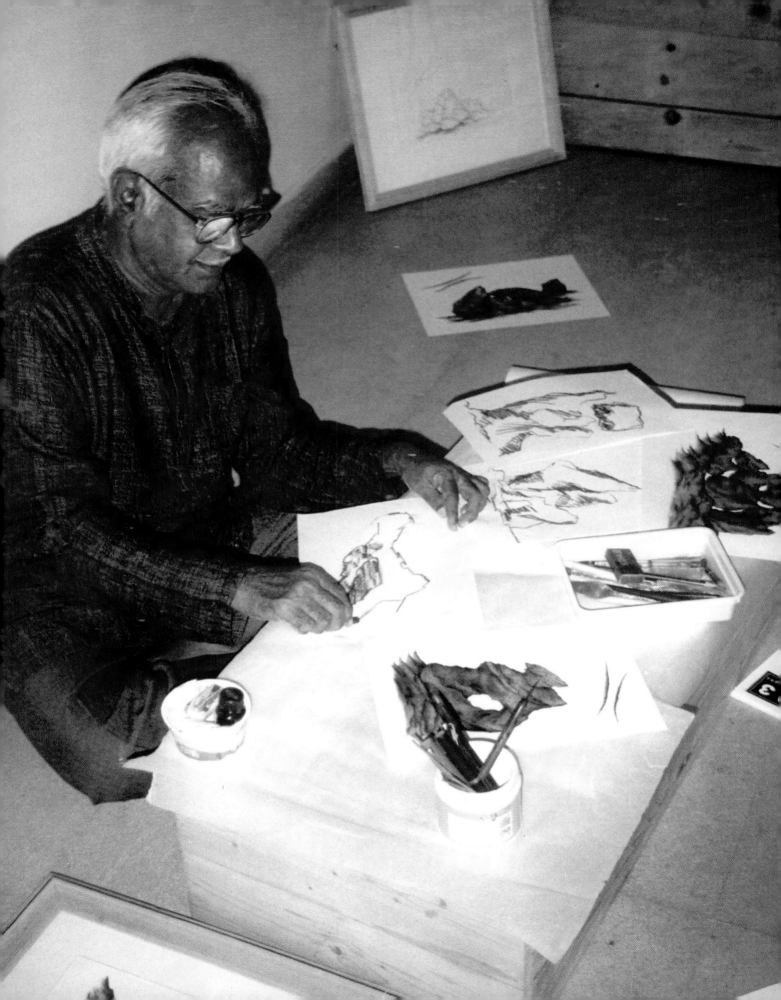

K.R. Harie

Lakshmi Venkatraman: How did you choose to become an artist? Was anyone in your family in the field of art?

K.R. Harie: My father was in the textile business. When I was in school, I was not good at my studies. But I used to do very well in drawing and used to secure almost hundred per cent marks in drawing examinations. After I failed twice in the ninth standard, I joined the Madras school of Art in 1960.

L.V.: Who were your contemporaries?

K.R.H.: For the first two years, all students had to be together for general drawing. Jayapal Panicker, K.S. Gopal, Dakshinamoorthy, Adimoolam, Susairaj were my classmates. After that, we had to specialize. In the third year, some of them took up painting under Santhanaraj and I chose commercial art (now known as visual art) under Munuswamy.

L.V.: What did they teach you in commercial art?

K.R.H.: They taught us to create posters, sign-boards, press layouts with photographs, lettering, and designing containers/cardboard boxes. In the fourth and fifth year, our teacher was Krishna Rao. For half a day we would paint portraits.

Rockscape ▷
(Pen-and-ink drawing on handmade paper)
2003

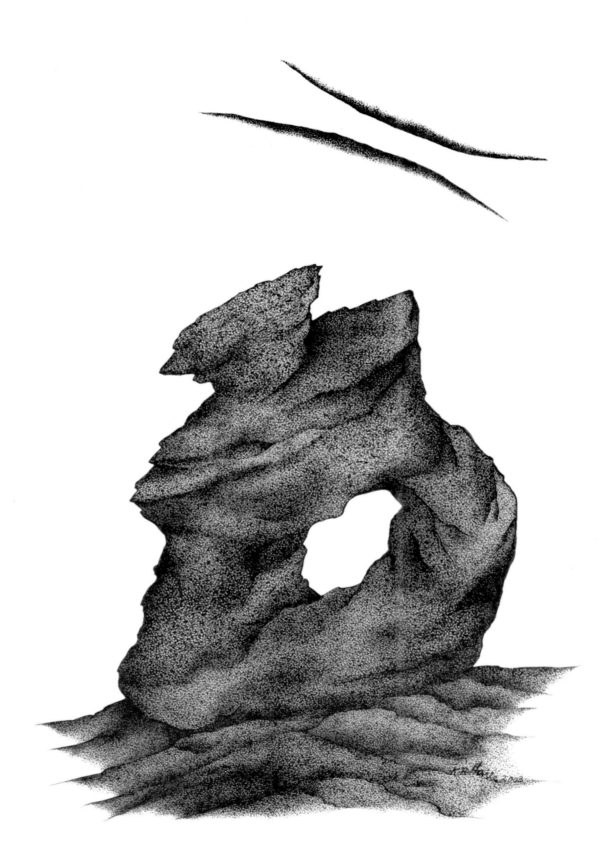

I was very interested in painting. I would complete whatever I had to in commercial art and then would start painting oils—still-life, landscapes and scenes from memory.

L.V.: Who was your inspiration at that stage?

K.R.H.: I liked Van Gogh very much and I tried to simulate his brush-strokes. I also painted with a knife, filling space with small patches of colour. I liked Gauguin too; but Van Gogh was special.

L.V.: Have you been in Cholamandal from the beginning?

K.R.H.: Cholamandal came into being in 1966, soon after our final year examination. I was one of the first set of artists to come here. We worked happily together. For earning a livelihood we did batik painting. We always felt that we as people belonged to this common mission of working in freedom as artists. We as people were at the centre of this mission; it was not meant to be a profit-making enterprise. Although I paint for myself, it is nice to know that my own interests correspond to those of many others.

L.V.: Did you live and work in Cholamandal from the time it was founded? Did all the artists build their houses then?

K.R.H.: I lived and worked in Cholamandal till 1970 initially. First a few artists set up their cottages. K.C.S. Paniker and D. Venkatapathy started building their houses too in 1968. After retirement as principal of the college in 1968, K.C.S. came and settled down with his family at Cholamandal. That gave us the moral support to move in despite many constraints and discomforts. Some of us stayed in the batik shed itself. We would buy rope cots and sleep on them at night and stack them against the wall during the day. For food, we bachelors ran a common

▽ *Rockscape*
(Pen-and-ink drawing on handmade paper)
2003

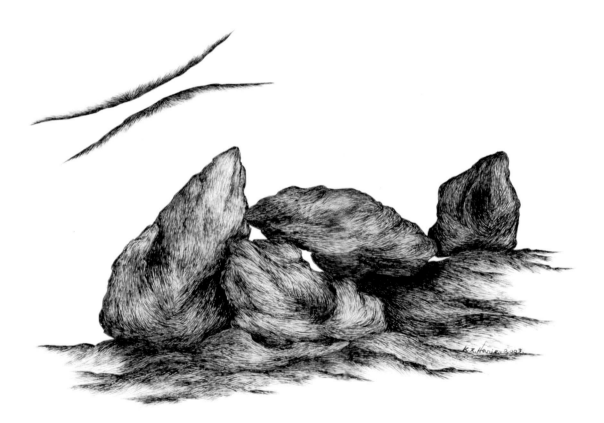

kitchen with the help of a cook. We ate well and each person would spend not more than Rs 80 a month. But as the young artists got married, running a common kitchen didn't seem viable. So we closed it down.

L.V.: How was life at Cholamandal then?

K.R.H.: We had great fun and adventure. Those days we had to go to Madras to collect our cheques from the Artists' Handicrafts Association for anything we might have sold. The State Lalit Kala Akademi had allowed us to have a small office in their premises. Initially, for about six months there was no bus facility to the village. We used to hitch a ride on lorries carrying sand or go by horse cart to where the city started and then take a bus. We would collect our cheques, go to a cinema, eat in a restaurant and then come back. Once a fortnight or month, we would go to visit our parents. If we had to make a telephone call, we had to walk more than a kilometre to Dr Dhairyam's home for the mentally challenged. I got married in 1970 and for some years my family lived in Thiruvanmiyur, about 7 km away, so that my two children could be closer to their school. When they were old enough to take the bus, we returned to the village. I built a small house and settled down with my family. Even when I was in Thiruvanmiyur, I would regularly come to Cholamandal and work.

L.V.: What type of work did you do then?

K.R.H.: I continued with oil painting. I would mix zinc white in an adhesive and draw the outlines of the forms with a knife. When it dried, it gave an embossed effect. I would then apply colours on the canvas. Initially, I did a lot of Saivite symbols like the *lingam* and snake. Afterwards, I created some abstract forms in the same technique. From there I moved to collographs. There again I used a similar technique—instead of painting the colour on the canvas, the tints were

△ *Rockscape*
 (Pen-and-ink drawing on handmade paper)
 2003

applied on the plate, in this case a cardboard over which the paper was pressed to make the collographic print. I made prints of Saivite concepts as well as landscapes. I was able to get textual effects quite well in them. One can't make many copies, as the cardboard would get flattened.

L.V.: You have made graphic prints as well. Where did you learn the technique?

K.R.H.: After coming to Cholamandal, Jayapal Panicker, K.S. Gopal and I began doing collographs. Then I became interested in print-making and in order to learn the technique, I joined the graphic section at the Lalit Kala Akademi Regional Centre in 1987 and worked for about two years. I also won an award for one of my works from the State Akademi. Then I did aquatint and etching. We had a small press in Cholamandal.

L.V.: You seem to prefer black and white to colour....

K.R.H.: From 1994, I concentrated on drawing. Until then I was doing small prints. It is not that I dislike colour; I just felt comfortable with black and white and continue to feel so. Now I am thinking of using some colours in my drawings. Initially I was doing landscapes, with dark and light areas. Slowly I began to draw mainly rocks, with maybe a hut or an animal alongside. A purely cold abstraction doesn't interest me too much. There has to be some kind of human touch. It must recall something that moves a person—maybe a recollection of loneliness or joy. What really moves me is trying to put down my own image. It is a search tied up with a lot of infantile memories.

One takes one's images during childhood. What we carry around us is a memory of our childhood when each day held the magic of discovering the world. My native village is Varadhayapalayam near Kalahasti in Andhra Pradesh. It is a very hilly area. I used to go there during the holidays when I was at school and college.

△ *Rockscape*
(Pen-and-ink drawing on handmade paper)
2003

I went for long walks early in the morning and at sunset. At those times, the rocks would appear in diverse figures and shapes. It was fascinating and it would cease to be just a stone. It seemed to come alive, shifting shapes. I wanted to capture that impression. When I started drawing rocks, I liked it so much that I continued with it. I would create depths and highlights in the drawing itself. The drawings were well appreciated and I was encouraged to do more.

L.V.: In painting you said Van Gogh was your inspiration. Similarly, there must be somebody who inspires you in drawing?

K.R.H.: In drawing, I have no model. I have developed my own style. I don't see anyone else following my style either. My elder son is into 3D animations. My younger son does colourful pastels and small sculptures.

L.V.: You seem to prefer small scale in your paintings and drawings.

K.R.H.: There is no particular reason except that of space. It is easy to store them; the paper drawings can also be rolled and kept. If I do a large painting where would I keep it? Nevertheless, sometimes I do larger drawings as well.

L.V.: In college what was the nature of interaction among the students?

K.R.H.: That was a great period for us students. We were like brothers. There was so much camaraderie, and hardly any major misunderstanding. We used to work hard and the teachers were committed and inspiring. It is necessary for art students to learn to work in a realistic style in the early stages. In the first and second year, we had Murugesan and Antony Doss. Moving to the third year in commercial art, our teacher was Munuswamy and in the fourth and fifth year, Krishna Rao. But I used to also visit the painting class to meet my friends and see Santhanaraj teaching and painting. He too was an extremely good teacher. There was of course K.C.S. Paniker who was an unending source of inspiration and guidance.

△ *Rockscape*
 (Pen-and-ink drawing on handmade paper)
 2003

L.V.: Did you ever try sculpture?

K.R.H.: I did have some desire to try my hand at sculpture, but somehow it just did not happen. Recently, however, I did two bronzes for an exhibition.

L.V.: How do you like being in Cholamandal now? Have you held any position in the governing committee?

K.R.H.: Like in all organizations, we do have occasional disagreements and arguments, but we don't dwell on them for long. Without the basic understanding and adjustments, we couldn't have lived here together for so many years. I am a founder member of Cholamandal and have held almost all the posts. But, I have no such aspirations—it doesn't seem very important for my life now.

K.R. HARIE

1941	*Born in Madras, Tamil Nadu.*
1966	*Diploma in Applied Arts, Government School of Arts and Crafts, Madras; Madras State Art exhibition; Tamil Nadu Ovium Nunkalai Kuzhu exhibition (also in '67, '68, '76, '78, '87, '88 and '95).*
1967	*All India exhibition, Hyderabad Art Society, Hyderabad (also in 1968); the Progressive Painters' Association exhibition held at the Government School of Arts and Crafts, Madras.*
1968	*All India exhibition, Akademi of Fine Arts, Calcutta (also in '69, '72 and '74).*
1972	*All India exhibition of Prints, Group-8, New Delhi, (also in '73, '74 and '76); Cholamandal Artists, exhibition sponsored by UNICEF, New Delhi.*
1978	*40 Artists from Madras organized by British Council, Madras.*
1979	*Cholamandal Artists' Group show in Bangalore; graphic workshop conducted by the Kerala Lalit Kala Akademi and the American Centre, Madras, held at Government College of Fine Arts, Trivandrum.*
1986	*'Two decades of Cholamandal Artists' Village', Jehangir Art Gallery, Bombay and Madras.*
1987	*Tamil Nadu Ovium Nunkalai Kuzhu Award.*
1988	*Graphic workshop conducted by the Tamil Nadu Ovium Nunkalai Kuzhu, held at Government College of Fine Art and Crafts, Kumbakonam.*
1989	*National exhibition of Art, New Delhi.*
1996	*Values Art Foundation, Madras, 'Three Decades of Cholamandal Artists' Village', Madras.*
1999	*Small Format exhibition at Cholamandal.*
2001	*Small Format Bronze exhibition at Cholamandal Gallery, Chennai.*

Lakshmi Venkatraman graduated from the Fine Arts department of the Stella Maris College, Chennai, in 1965. She has been an art critic for *The Hindu* since 1988. She is the recipient of the Art Critic Award of the Lalit Kala Akademi, New Delhi, 1995. This interview with K.R. Harie was conducted in 2002.

JAYAKAR

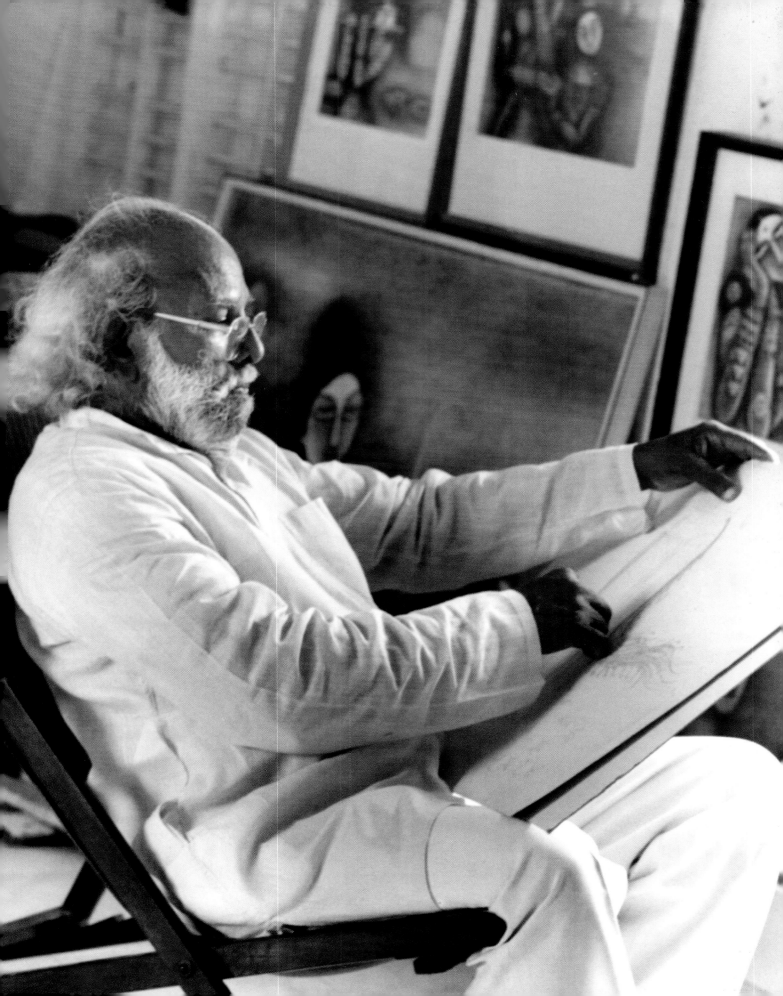

S.P. Jayakar

One way to understand the art of S.P. Jayakar is to identify the cultural and historical forces in colonial India that brought him where he is now.

In 1966, when Cholamandal, the exclusive artists' commune, was founded, there was a distinct shift in the locus of creativity from the autonomous, self-contained individual to a new kind of dialogical structure. In the atmosphere of new-found collective consciousness, S.P. Jayakar was inspired to see and trust the reservoir of cultural memory with its inner layers of regional aesthetic identities.

As one of the founder members of Cholamandal, S.P. Jayakar was much influenced by K.C.S. Paniker in his strong commitment to modernity with in-built Indianness. During the sixties and seventies, the modernity and cultural nationalism constructed by the earlier generation of artists were redefined and rebuilt with the emergence of a new generation of artists in various parts of India—K.C.S. Paniker and others in Madras, J. Swaminathan and his fellow painters in Bhopal, the 'Baroda Group' under the leadership of Gulam Mohammed Sheik and K.G. Subramanyan. Many Madras-based artists—A.P. Santhanaraj, Reddeppa Naidu, L. Munuswamy and others—started looking backwards and sideways to decide which styles and values to choose for the future. When a group-show of Cholamandal artists was proposed to be held at Jehangir Art Gallery, Bombay, in the sixties, Jayakar decided to step out of his conventional framework in search of a new idiom.

Fisherwoman ▷
(Coloured ink on paper)
1999

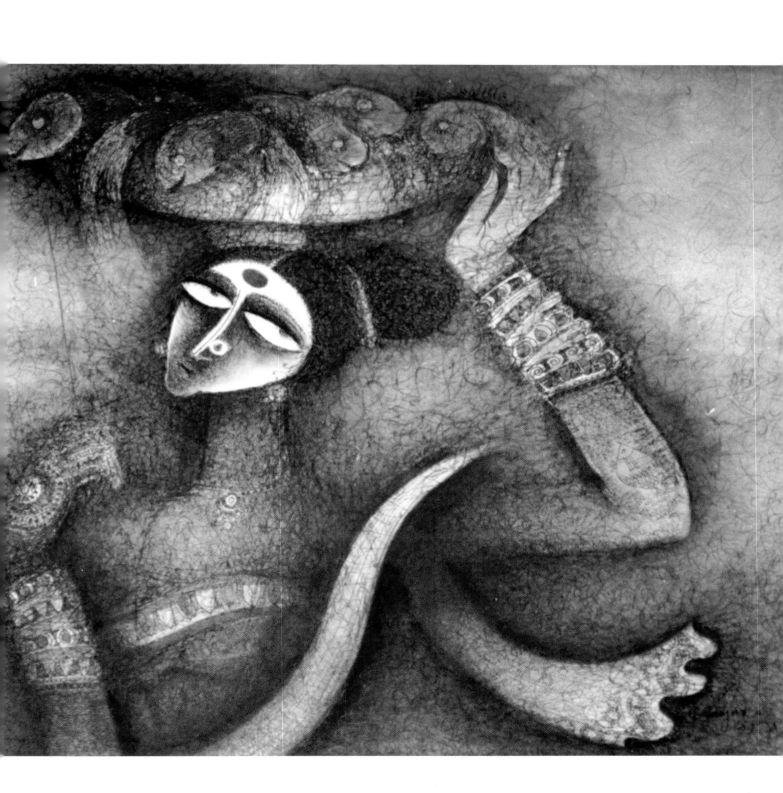

Crucifixion ▷
(Coloured ink on paper)
1992

Synthesizing the Japanese and British watercolour technique in search of a compositional purity, he chose the pen-and-wash technique as his favourite style for spontaneous effects. Sufficiently influenced by the expert handling of watercolour by Western masters ranging from Dürer to Turner, and Cézanne to Paul Klee during his days at the Madras School of Art, watercolour became his medium of choice. His creative dialogues with his illustrious teachers—D.P. Roy Chowdhury, K.C.S. Paniker, S. Dhanapal, Ram Gopal, and Narayana Rao—left their indelible fingerprint marks on his drawings and treatment of colour. His early attraction towards Indian subjects—village girls, fisherwomen, palm tree climbers, temple car festivals—during his student days, still remained intact but his idiom of expression underwent a drastic change.

Painting in a contemporary context, Jayakar mixed multiple styles in the structure of his work, exploring similarities and differences between the various styles of Indian art of the past and the present. In almost all his works, one can find the influences of the gracefully bending human forms of the Ajanta murals, the body language of the Tanjore wall paintings, the sharp and angular faces of Jain miniatures, and the fish-eyed females of Pahari paintings.

Whether it be a reclining woman or a 'Kali riding a raging lion', or a Krishna with a flute or Jesus on a cross, in all his works one can find the power of music and rhythm spreading with tranquility and poise towards all the corners of his paintings.

His art revolves around a flexible conceptual structure, which could at once constitute and contain the value of regional commitment both in the aesthetic and cultural sphere. Keeping the traditional notions of perspective intact, the perceiving subject still assumes a coherent and meaning-generating entity. His forms aim at a unifying coherence in both the formal and the thematic concept.

His choice of colours—mostly emerald green, sap green, vandyke brown, vermilion red, and crimson red are all used to enhance the serene simplicity of his forms with a dominating decorative element. The free-flowing lines, mostly thin, define

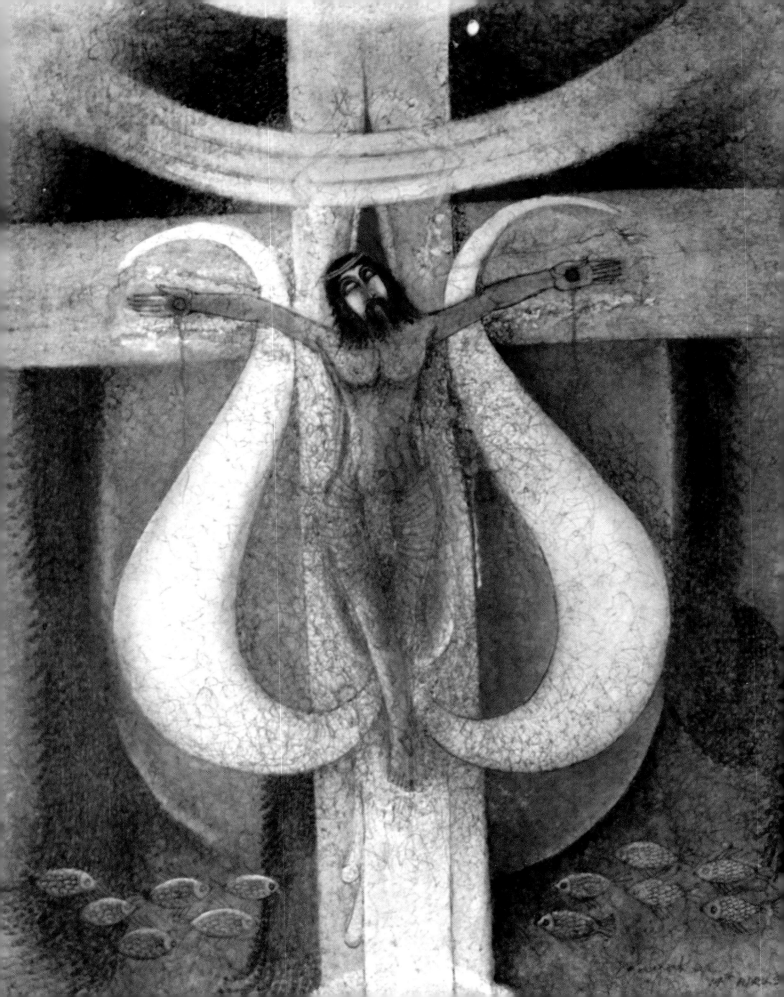

Musician ▷
(Coloured ink on paper)
1999

and demarcate the forms while serving as a part of the pigment in creating the required tonal vibrations. His aim is always towards actualizing the 'poetics of painting'. Even if the painting is of *Kali seated on a lion*, the lion's face is worked with decorative details in order to sublimate its ferocious expression. For the purpose of creating the head of the lion, he made many studies of the *yali* motif in the traditional sculptures of Tamil Nadu. One cannot find any difference between a *Girl conversing with a bird* and the *Kali seated on a lion* for both the forms simply celebrate feminine beauty with flowing hair, tilted head, overladen with heavy ornaments.

Strictly speaking, Jayakar's works are nothing other than a hybrid variety wherein the Western wash techniques are used as an instrument for enhancing the visual vibrations of traditionally defined forms which were already in existence for more than two thousand years. So whenever a viewer is tempted to classify his art as traditional, there emerges the question: Whose tradition?

In fact in a lengthy debate on the impact of Indian tradition on contemporary visual art of India, we learn many things about ourselves.

In Jayakar's pen-and-wash works, the 'presence of the past' happens in the most natural way because as far as India is concerned, many ancient traditional objects that find a place inside the museum have an active cultural role outside the museum as well. They find a place in the day-to-day life of the people. For us, the past is still a living tradition of the present.

If we find the same body language that operates in the *Bhodhisatva Padmapani* of Ajanta caves in the human forms of S.P. Jayakar, we cannot call the same a nostalgic return to the past. It is a critical revisitation, an ironic dialogue with the past of both art and society. His creativity makes the chemistry of converting tradition into contemporary expression.

The forms he uses are the means by which he expresses his own way of looking at the world. And then the world around him becomes his own world.

Indran

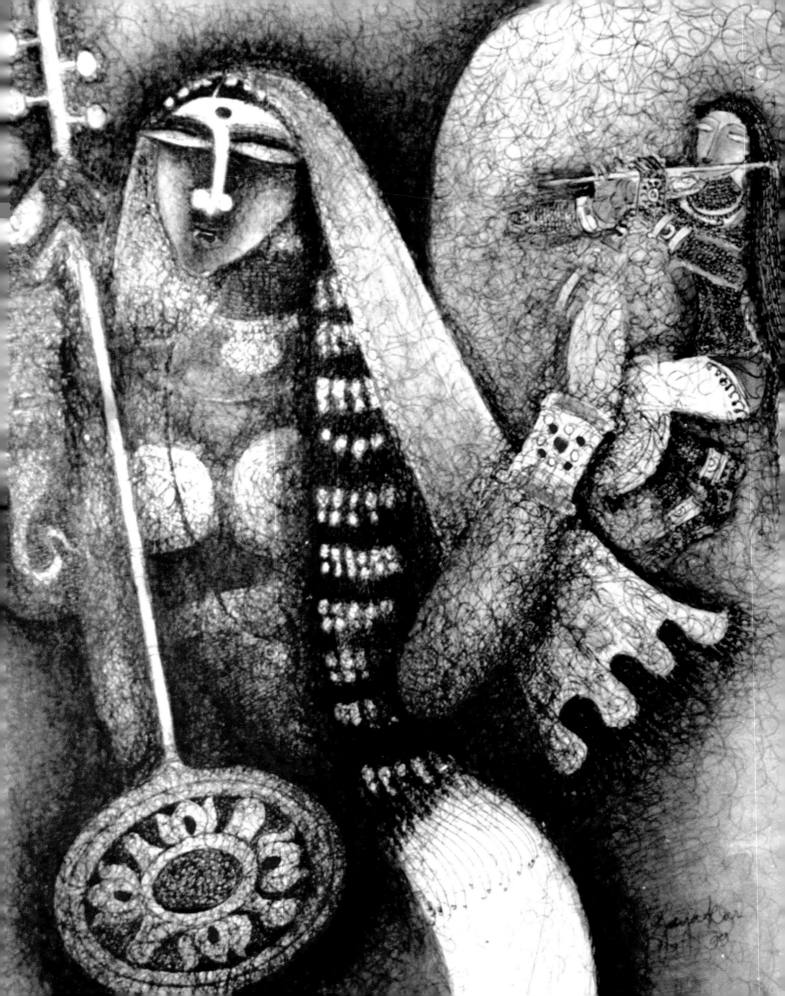

Christ ▽
(Coloured ink on paper)
1992

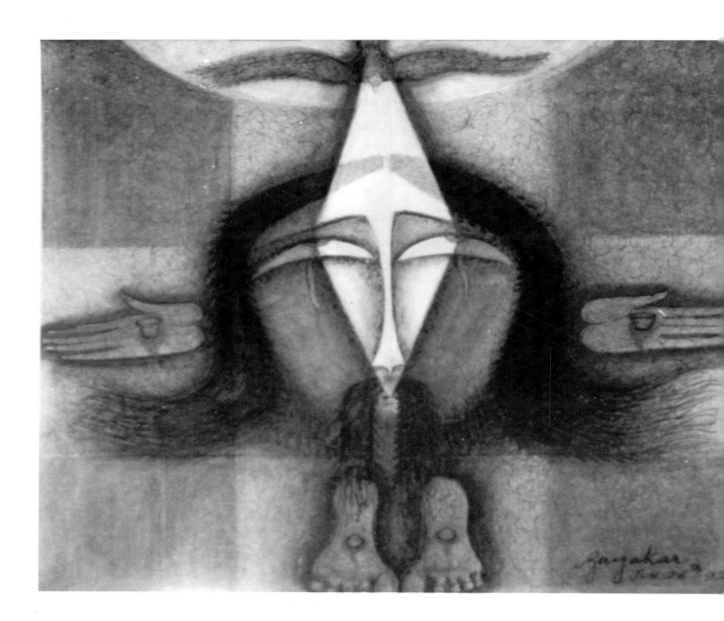

S.P. JAYAKAR

1931	*Born in Tamil Nadu.*
1951	*First Class Diploma in Fine Arts, Government School of Arts and Crafts, Madras.*
1966	*Came under the strong influence of K.C.S. Paniker, joined his charmed circle of committed artists striving to establish a commune outside the city for creative people to live and work in peace.*
1971	*All India exhibition of Art, Academy of Fine Art, Calcutta.*
1972	*Cholamandal Artists' Village exhibition sponsored by the UNICEF, New Delhi; (Contemporary Miniatures) Progressive Painters' Association in Madras and Bombay.*
1973	*Cholamandal Artists' Village exhibition organized by Max Müller Bhavan, Pune.*
1976	*State Art exhibition, Tamil Nadu State Lalit Kala Academi, Madras; Tamil Nadu State Lalit Kala Academi, Madras Award; AIFACS Award, New Delhi.*
1978	*Flood Relief exhibition, Tamil Nadu State Lalit Kala Academi, Madras; '40 artists of Madras' organized by The British Council, Madras.*
1987	*Participated in Victoria Technical Institute's Gandhi exhibition.*
1992	*Participated in Victoria Technical Institute's exhibition and received an award.*
1993	*Participated in Tamil Nadu Ovium Nunkalai Kuzhu exhibition.*
1994	*Participated in Kanpur and Tamil Nadu Ovium Nunkalai Kuzhu exhibition.*
1995	*Participated in Kala Mela exhibition, Bangalore and Madras.*
1996	*Participated in Kerala exhibition, Nunkalai Kuzhu exhibition, Essal exhibition, Alumni exhibition, Cholamandal exhibition, VKI Gandhi Centenary exhibition.*
1999	*6ᵗʰ All India Veteran Artists' exhibition held at Delhi.*
2000	*Participated in Tamil Nadu Ovium Nunkalai Kuzhu exhibition; received Kalai Chemmal Award, Chennai.*

Indran writes regularly on literature and art for national dailies like the *Times of India, Indian Express,* etc. He is a poet and is also the current editor of *Nunkalai* the art magazine of the Madras State Lalit Kala Akademi. He has travelled in Europe on a British Council travel grant to study Indian art collections in European museums. This article was written in 1999.

JAYAPAL

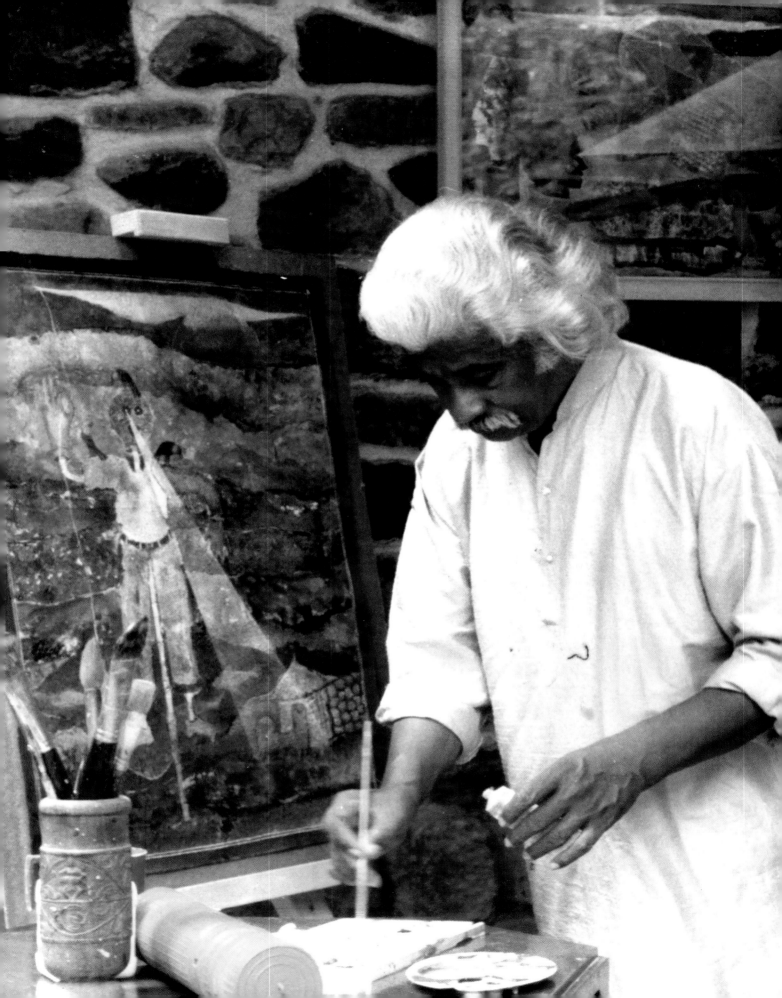

K. Jayapal Panicker

Colour is integral to painting in creating shapes, surfaces, and spaces. The common practice is to summon up colours onto pictorial space. But to Jayapal Panicker, colours become eternal when they reach the realm of philosophical reality. The startling juxtaposition of these eternal colours carry a transcendental meaning when it starts to luminate on the canvas of the artist who is profoundly influenced by Indian philosophy. After sensing his own vocabulary as a painter, Jayapal baptized his artistic caliber in the inferno of the Vedanta School of thought. Jayapal once went to the extent of stating that as a painter, he is just an instrument of Sankara, the saint-philosopher of *Advaita Vedanta*. To him all creation is nothing but self-manifestation, like the Lila of Viratpurusha, the creator of the entire cosmic world. All Vedanta philosophy is an attempt at the solution of the problem of the One and the Many. The ultimate Reality is Sat-Cit-Ananda, Existence-Consciousness-Bliss. The essence in man is identical with this Reality, but under the influence of maya, illusion, he has forgotten his true nature. What he takes for real is merely an apparent world of subject and object, and this error is the cause of his bondage and suffering. The goal of all spiritual practice is the rediscovery of his true identity with the Reality. For Jayapal, his artistic journey is a search for that identity.

Jayapal's early years were spent in literary quest and dialogues in the midst of like-minded persons in his hometown in Kerala. In his early still-lifes, he explored different possibilities of translating the images of his literary quest onto the space

Parimanam ▷
(Mixed media on paper)
1987

Parimanam ▷
(Mixed media on paper)
1987

of his canvas. In his series titled *Archaic memories,* referring to the primordial memories of mankind, a modern man's voyage to his primeval recollections presents itself, showing tremendous technical depth and compostional balance.

In the early seventies, Jayapal did a series of graphics titled *Beejagni* (fire within the seed) and *Jeevagni.* This signalled his onward journey into metaphysics with his own artistic sensibilities. In these paintings he used a number of personal images and symbols in trying to capture subtle experiences of different levels of consciousness. He says that *Kundalini,* the mechanism of evolution of human consciousness, appears in his paintings as a supramental vision through which reality is seen as an undivided entity. Devoid of all conventional Tantric symbols with his bold brush-strokes and the juxtapositon of various colours, Jayapal develops his own metaphysical artistic vocabulary, toning down its formal statements.

Jayapal followed the neo-Impressionistic style in his early graphics. He attempted to free colour and line from purely representational functions and returned to the emotional and symbolic values that the Impressionists sacrificed. He used dots of pure colour in such a manner that when viewed from an appropriate distance, the emerging form seemed to vibrate with an intense luminosity.

In his later series *Parimanam*, Jayapal used the same techniques to uplift and sublimate these pristine symbols and effects. He also created an optical mixture to disrupt the colour continuities and presented many abstract symbols with an Impressionistic perception. *Parimanam* was his experiment in measuring out the enigmatic cosmic time (which is the time taken by the Viratapurush to create the entire phenomenal universe) into pictorial space without compromising on the visual aesthetics of the painting. Through the *Parimanam* series, Jayapal tried to negate the everyday material level of Reality as a figment of imagination, as maya. Instead, he searched for the highest level of truth. In the true Vedantic perspective, he believes that when one receives illumination and comes to know the Self, one ceases to submit to the domination of maya.

Parimanam ▷
(Mixed media on paper)
1988

For Jayapal, the mind was not sufficient to explain the existence of the universe. Science has done some marvellous things, but these are things it cannot connect with—things that are as real as material objects and affect us as much if not more. Scientific instruments don't register these. Perhaps science no longer opposes these possibilities. An infinite mind, which was free from limitations, could be the creator of the Universe. Jayapal negated all existing conventional Tantric symbols and created a set of individual and abstract metaphysical symbols ranging from geometrical forms to pellucid and cellophane layers. He used a transparent veil-like symbol and covered all manoeuvres of material creation.

Jayapal's search for meaning in the phenomenal world with its constantly transcient nature led him to the *Scarecrow* series. The result is the presence of an eternal gatekeeper, a scarecrow on the canvas. The scarecrow with its woeful eyes, is seen witnessing this entire tangible universe, standing guard over the disintegrating cosmos from chaos. As a creator of light on the pictorial surface, he is seen to be possessing the entire inspired wisdom of the corporeal world.

In his journey from his early still-lifes and *Archaic memories* through the series of *Parimanam* and the latest *Scarecrow*, Jayapal shares with us a visual dialogue in the 'invisibles' which science cannot touch. It seems to suggest, then, that the stage is being set for the new century to accept art and religion as equal partners to science in discerning the full range of reality.

Benoy Arvind

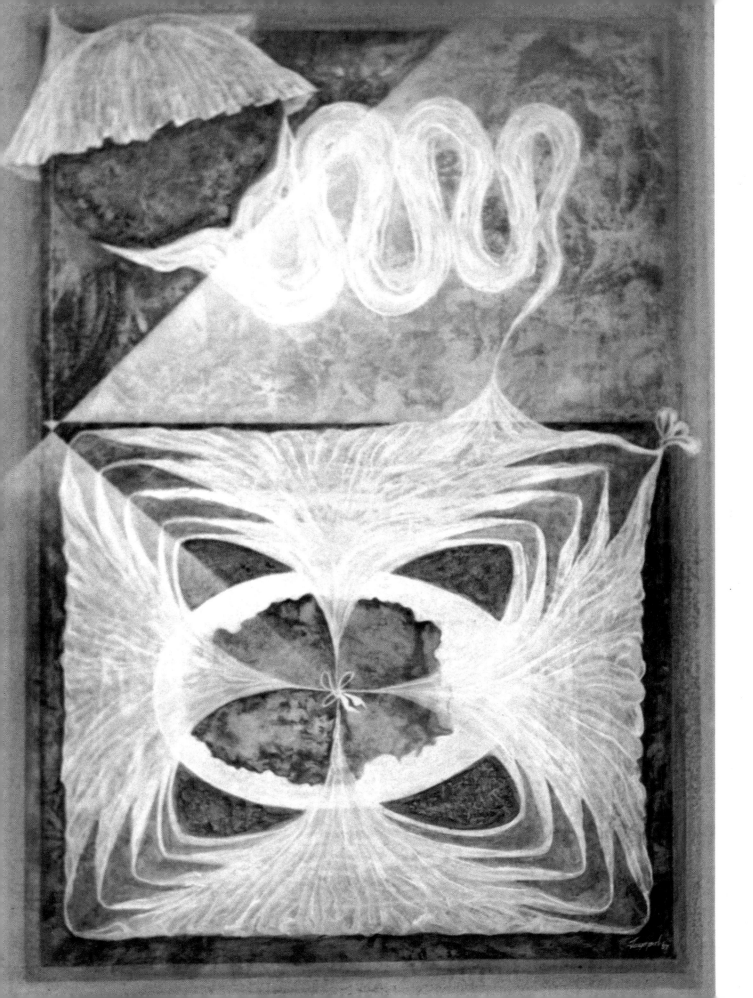

◁ *Parimanam*
(Mixed media on paper)
1988

K. JAYAPAL PANICKER

1937	*Born in Quilon, Kerala.*
1965	*Award of Hyderabad Art Society and the Madras State Lalit Kala Akademi.*
1966	*Diploma in painting, Government School of Arts and Crafts, Madras; among the first batch of artists who moved into Cholamandal.*
1967	*Award of the Academy of Fine Arts, Calcutta; travelling exhibition of art organized by the Cultural Affairs Foundation of India in Brussels, Amsterdam, Copenhagen, Vienna and Oslo.*
1974	*'Asia Today' exhibition in Milan, Italy; Asian Art Biennale, Bangladesh, Dhaka; Kerala Lalit Kala Akademi Award (awarded again in 1983 and 1989).*
1983	*Group show organized by Mahindra & Mahindra Ltd. at Jehangir Art Gallery, Bombay.*
1985	*Represented India at the artists' camp at Asilah in Morocco.*
1987	*VIIIth Biennale International De Art, Valpraiso, Chile; South Zone Cultural Centre camp at Madras.*
1988	*'Nature and Environment' exhibition in Prague, Czechoslovakia; awarded the senior fellowship of the Ministry of Human Resource Development, Government of India; South Zone Cultural Centre camp at Kerala.*
1989	*National Award of the Lalit Kala Akademi, New Delhi; All India artists camp by V.S.T. Industries Ltd. and Centre for Cellular and Molecular Biology, Hyderabad.*
1991	*VIIth Triennale, India, International exhibition of art conducted by Lalit Kala Akademi, New Delhi.*
1999	*Small format painting exhibition at Cholamandal.*
2000	*Small format Bronze Sculpture exhibition at Cholamandal.*
2003	*Passes away in Kerala.*

Benoy Arvind has done his post-graduation in Mass Communication and Journalism from Kerala University. He writes regularly on art in *Samakaleena Malayalam*, a weekly of the *Indian Express*, and in other magazines. The article was written in 2000.

MUMTAZ

Mumtaz

Meticulous lines, free spatial construction of images and interesting distribution of texture and tone are some of the striking features of Mumtaz's graphic works. Primitive and folk art of India have inspired her very much, yet her style and imagery are very personal and uninhibited. Nowhere in her work is technique allowed to outshine artistry. Its palpable intensity brims over with tangible emotion. Probably one reason for this is the fact that her watchword is restraint. There are no excesses anywhere and she always manages to convey her thoughts with a single line.

Mumtaz is the daughter of the late Sultan Ali, one of India's renowned artists. She was born at Kondapalle, Andhra Pradesh. She began to draw and scribble as a child and did not wait to be provided with art materials. She used the walls and floors of the Sultan Ali home like any other uninhibited child, but with the difference that Mumtaz's talent was discovered early enough by her father and he gladly provided her with paper and colours to express herself. After that there was no looking back for her.

She participated in the Shankar's International Children's Art competition regularly until she was sixteen and won prizes every year. In 1969, she graduated from the New Delhi College of Art with a first class diploma in Fine Arts. While at college,

▽ *Sangram Mata*
 (Colour intaglio)
 1980

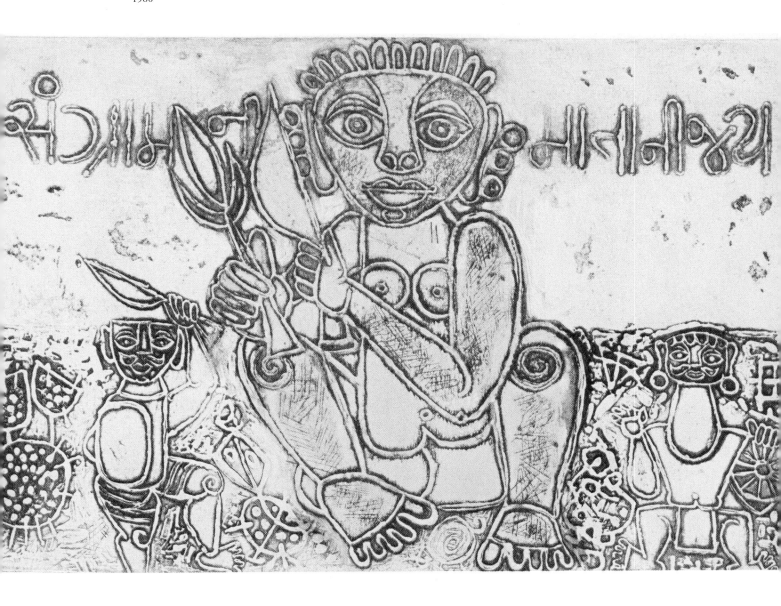

she took a deep interest in graphic arts and found that she was capable of expressing herself much better in this medium than oils and watercolour, and specialized in this medium of print-making for one year, trying to develop her own technique and style. It is with her vivid imagination that she created vibrant and highly stylized works. Her works lack a feminine touch of delicacy and her figures suggest solidity and weight though never making the composition appear crude. The use of decorative motifs here and there brings life and balance to the whole composition. Her themes of men, women, gods, and animals endowed with a powerful outer form do end up with an inner beauty. Mumtaz never let technical virtuosity take precedence over artistic excellence.

Some of her major works are *Mahakala on the Bull,* in which she has composed the animal carrying the great king and expressing its happiness through a grisly smile, *Airawati,* the dwarf woman, *Surya Rakshasa,* which shines in the bright orange sun tempting the devil to dance. It was for *Surya Rakshasa* that Mumtaz was awarded the Gold Medal at the annual art exhibition of the Bharath Kala Parishad, Hyderabad. She was the youngest participant in the second Triennale of World Contemporary Art at New Delhi in 1971. Her design, *Girl with Elephant* was picked up by UNICEF for its greeting card in 1972 that was sold internationally to draw funds for poor and needy children.

A significant development of Mumtaz's work in recent times has been her pen-and-ink drawings. They mostly depict rural life. She mainly works with black and brown inks, to give depth to her images.

Mumtaz uses lines in infinitely divine ways that are often a repetition and variation of tiny stitch-like strokes, calligraphic symbols, dense hatchings, and textural masks. In formal and thematic concepts, her drawings dominate with a raw vitality and exuberance. Figurative pictorial elements are organized on a delightful scale, mostly

▽ *Surya*
(Colour intaglio)
1992

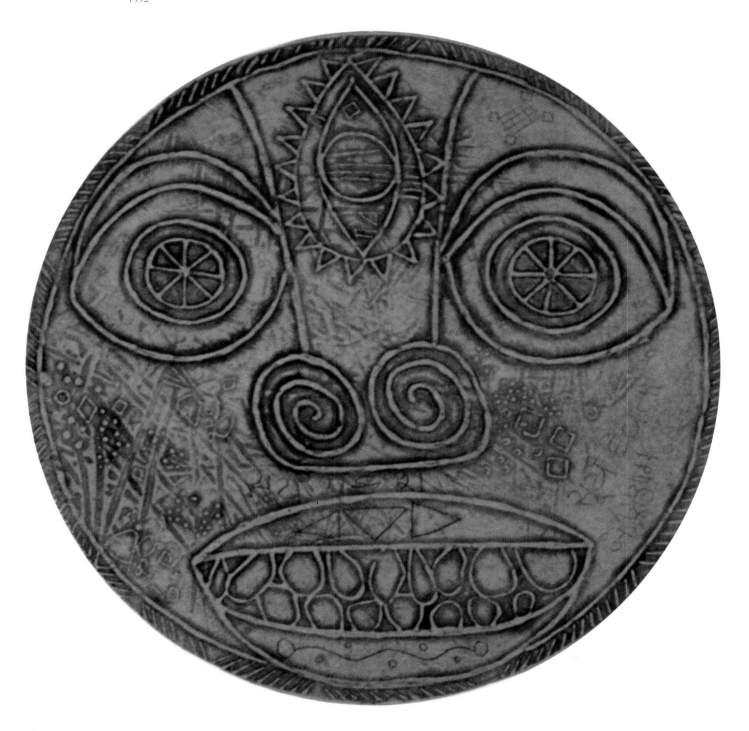

Scarecrow ▷
(Colour intaglio)
1979

on a two-dimensional space variously defined in toned and textured passages. Her visionary perception is evident in the manner in which the shades are handled. Subtle tonal and textural sophistication is evident. Her richly evocative chromatic scheme probes one's imagination. Fantasy is found meticulously manipulated with texture and delicately modulated tones. What is most delightful in these compositions of vibrant, grotesque figures is that despite their conceptual density and richly detailed execution, they are soaked in the spirit of childhood simplicity and fantasy of rural imagination.

Jacobson Schreiber

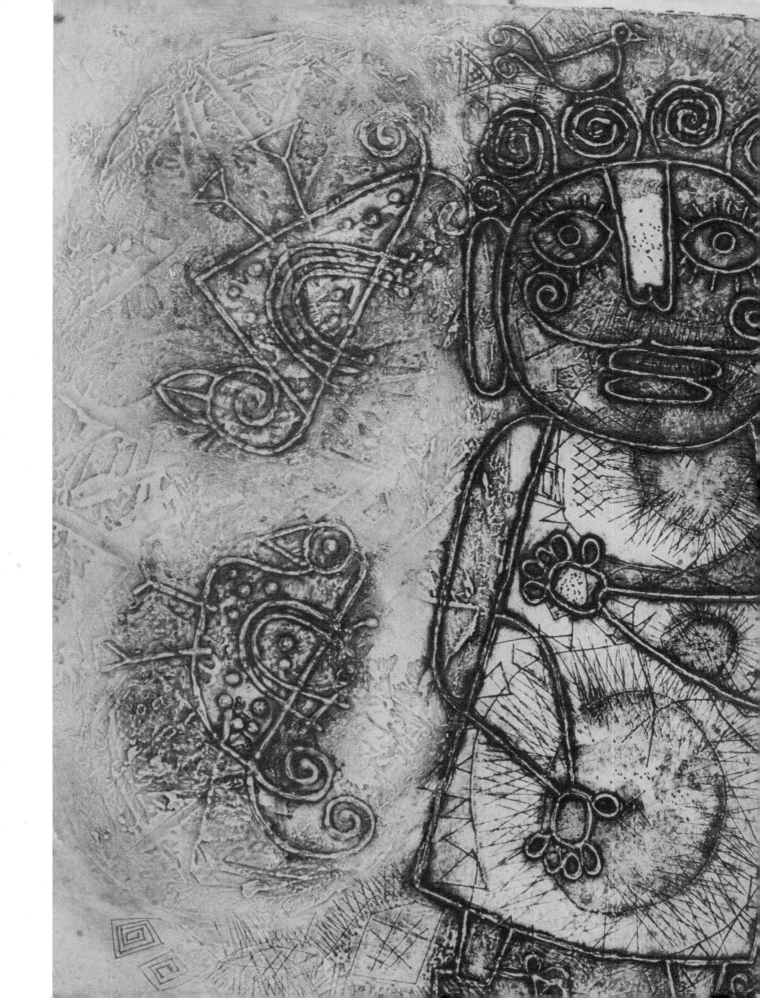

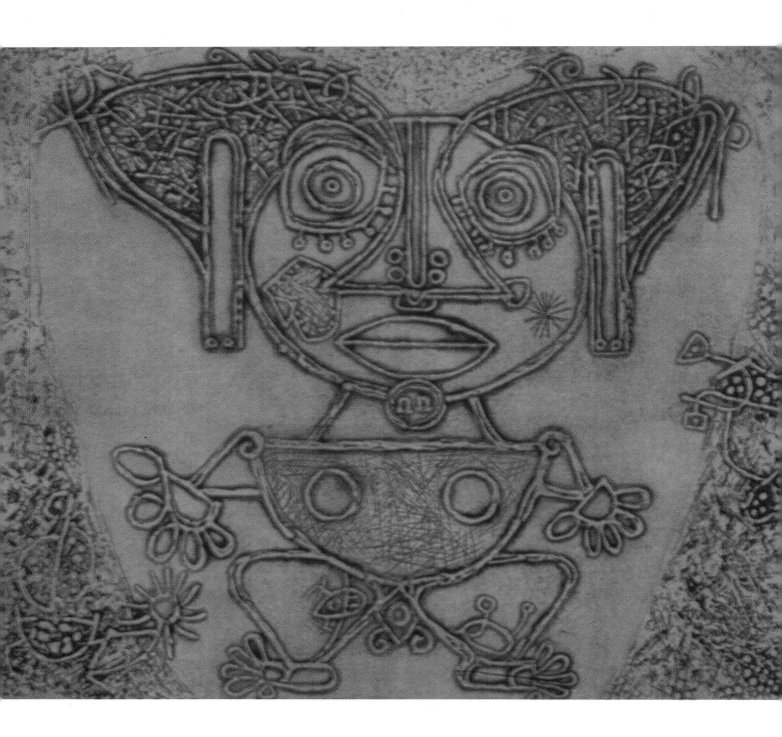

Airawati △
(Mixed media)
1980

MUMTAZ

1947	*Born in Kondapalle, Andhra Pradesh.*
1964–69	*Study at the College of Art, New Delhi; Travel Fellowship, Government of Nepal.*
1970	*Award of AIFACS New Delhi.*
1971	*IInd International Triennale India, Lalit Kala Akademi, New Delhi; Bombay Art Society Award; Gold Medal, Bharatha Kala Parishad, Hyderabad; IVth Biennale International De La Gravure, Cracovie, Poland.*
1972–82	*Solo exhibition at Nigeria, USA, Fiji, West Germany, UK, Papua New Guinea, Madras, New Delhi, Pune, Bangalore, Calcutta and Bombay .*
1973	*'One World through Art' a selection of 1001 works of Art, Ben and Abby Grey Foundation, USA.*
1975	*'International Art exhibition' for the benefit of CARE's World Hunger Fund, Charles Centre Gallery, Baltimore, Maryland, USA; 'Inaugural exhibition' Grey Art Gallery, USA; 'Contemporary Art from the Third World', The Institute of Papua New Guinea.*
1976	*4th Annual spring print International exhibition—The International Print society, USA; 'Exhibition of Indian Graphics'—to Algeria, Tunis, Lisbon, Madrid and Cairo—Ministry of External Affairs, Government of India.*
1980	*Visitorship Grant, British Council, London.*
1980	*Travel Grant, Indian Council for Cultural Relations, New Delhi, to England and France; State Award, Tamil Nadu Ovium Nunkalai Kuzhu, Madras.*
1987	*Awarded Junior Fellowship by the Department of Culture, Ministry of Human Resource Development, Government of India.*
1999	*Small Format exhibition, Cholamandal.*
2000	*Small Format Bronze exhibition, Cholamandal.*

The late Jacobson Schreiber was an American art critic who has written extensively on Western painting in the US and Europe. His keen interest in modern Indian art brought him into close contact with the Lalit Kala Akademi in New Delhi. It is here that he met Mumtaz whose father, the late painter J. Sultan Ali, was the exhibition officer of the Akademi. The article was written in 1980.

NAMBOODIRI

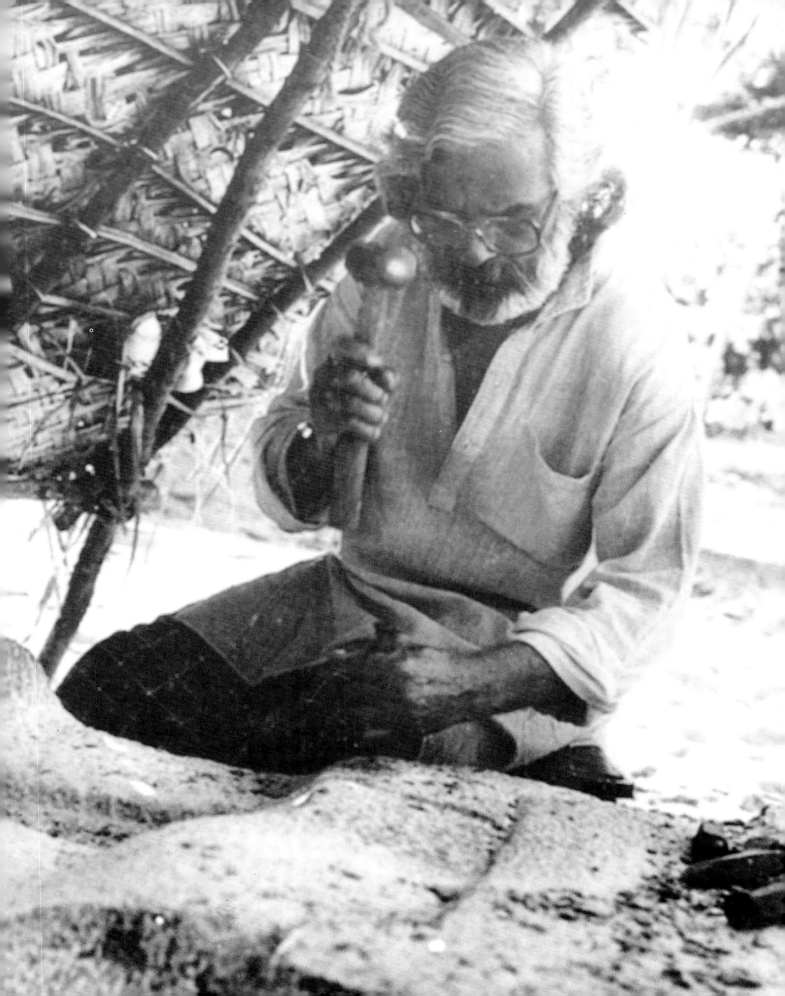

Vasudevan Namboodiri

In 1945, during my high school days at the small town of Ponnani in Kerala, I met an artist from my village. He had no formal schooling, but as a Namboodiri Brahmin from Kerala, he grew up in a community in which Vedic learning was intrinsic to its culture. Their large houses, set in the lush green countryside, were also home to a number of deities with their associated rituals. I vividly recollect their brick and laterite house with its cowdung-plastered floor. It was a typical middle-class Namboodiri *illam* (joint family house) by local standards.

I had shown some inclination towards painting and drawing and when I heard about this talented artist, I went to see him. He had created pencil and charcoal drawings and sculpted terracotta figures. He had no models in art or life or any knowledge of the techniques, but the sheer beauty of his work fascinated me. This interest nourished a bond of lasting friendship between us in spite of the different courses of our lives. I still remember how his eyes lit up and his face glowed with child-like delight when he spoke about art and life, legends, and folklore. The bookish dogmas paled into insignificance. At that time, he was just Karuvatt Vasudevan Namboodiri. To the common man, he was an unemployed youth who spent time in drawing and dreaming. Though his village community appreciated his talent, the world at large had no inkling about the potential that lay dormant in him. Some of the affluent members of the well-known families within his community, however, recognized his passion for art and helped him enroll at the Government School of Arts in Madras, where K.C.S. Paniker was the guiding force for a group of young artists in the early fifties. Paniker himself was emerging

Keerthi Mudra ▷
(Copper mural)
Cinema theatre in Vadakara, Kerala, 1990

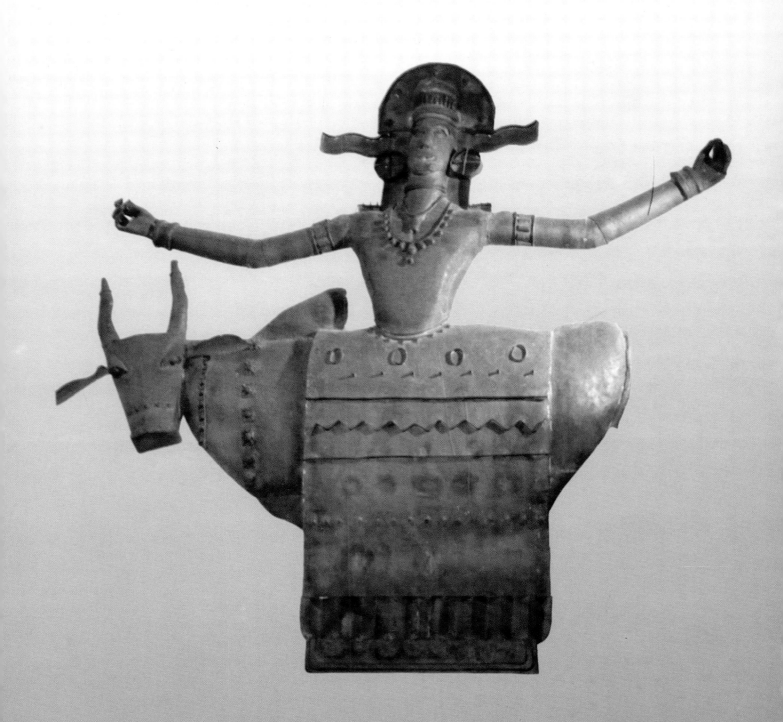

Line Drawing ▷
(Ink on paper)
1985

out of the cocoon of Western training in painting. Namboodiri completed his courses in Fine Art and Applied Art within a span of four years. The absence of formal schooling in his childhood was in no way a handicap for Namboodiri in his quest for knowledge and learning. He had private instruction in Sanskrit and ayurveda and got nurtured in a rich cultural environment during his childhood and adolescence. He didn't succumb to any pressure that could have influenced him to reject such a heritage and pretend that the Impressionist, post-Impressionist and modern art of Europe represented his real artistic heritage. On the contrary, he was impressed by the colourful theatrical performance of Kathakali, the impressive sculptures and woodwork in the temples, especially the ones close to his house. He breathed the clean air of his native Ponnani culture, savouring the works of Malayalam literary masters. With them, he shared the same open attitude to life in the small-town suburbs of Ponnani where orthodox Hindus and Muslims lived in perfect harmony, where Kathakali and *Kave* (temples or shrine) festivals were great events and the Gandhian ideas of Kelappan (a local political leader) moulded the minds of people. His mind remained unsullied by the Euro-centric notions of art and life and the theories about styles and techniques.

After his training in art, Namboodiri joined the publication *Mathrubhumi* in Calicut, Kerala, where M.V. Devan, his old friend and senior at art school was already working as an artist. Next to Paniker, Devan had a considerable share in shaping Namboodiri's views on art. Devan later moved on to explore other pastures in literature and architecture. The work of Devan and Namboodiri at *Mathrubhumi*, their leadership at Lalit Kala Akademi for years and Namboodiri's later work in the publications *Kalakaumudi* and *Malayalam Weekly* have all contributed a great deal towards a receptive climate of art appreciation in Kerala. The old traditions of mural painting had disappeared or degenerated and a rather muddled modernist school had come to dominate the art scene. In such an environment, Namboodiri developed his own personal style of line drawing that stood far apart from the mural art of medieval Kerala, drawing inspiration from

Keerthi Mudra ▷
(Copper mural)
Cinema theatre in Vadakara, Kerala
1990

Kerala's renaissance culture in which the classical spirit was re-awakened by the challenge of the modern age.

In the early years of his career in the publishing industry, Namboodiri followed the convention of illustrating poems and stories. This brought him in contact with literary masters like Basheer, Uroob, M.T. Vasudevan Nair, and Mukundan, to mention a few names. It was as if there was an organic process by which the artist who spent many hours in the company of authors, developed a sixth sense to track their heartbeats. He was perfectly at home with their characters and episodes. Many of these contemporary writers, especially the younger ones, constituted the literary core in the small office room of N.V. Krishna Varier, a truly renaissance figure and editor of *Mathrubhumi Weekly*, who contributed significantly to the cultural awakening in Kerala. Access to this magic circle gave me a chance as a writer to follow the interaction between the artist and the authors, and one was amazed at the rapport the artist had with them. That special quality helped him express their ideas with utmost lucidity through his illustrations and drawings. One could watch him listening to their endless gossip with wide open eyes and a disarming smile. His mature drawings and illustrations not only brought out the best in their writing, but also claimed attention in their own right as independent creations of art with their simple yet powerful lines.

Namboodiri tried his hand at sculpture too. His sculptures acquire a life of their own as they express varied feelings of sensuousness, aerial beauty, arrogance, pride, and joy, and Namboodiri does not hesitate to clothe them in exotic Asian and Western costumes when they are in attire. The celebration of worldly passions of love and hatred in Kathakali and the idealization of the feminine form in Pallava-Chola art seem to be the main sources of inspiration for his sculptures. Occasionally, he worked on some contemporary themes such as the *Modern Family on a Scooter*, which finds a prominent place in the sculpture garden at Cholamandal. Perhaps that is his tribute to the art community of Cholamandal.

M.G.S. Narayanan

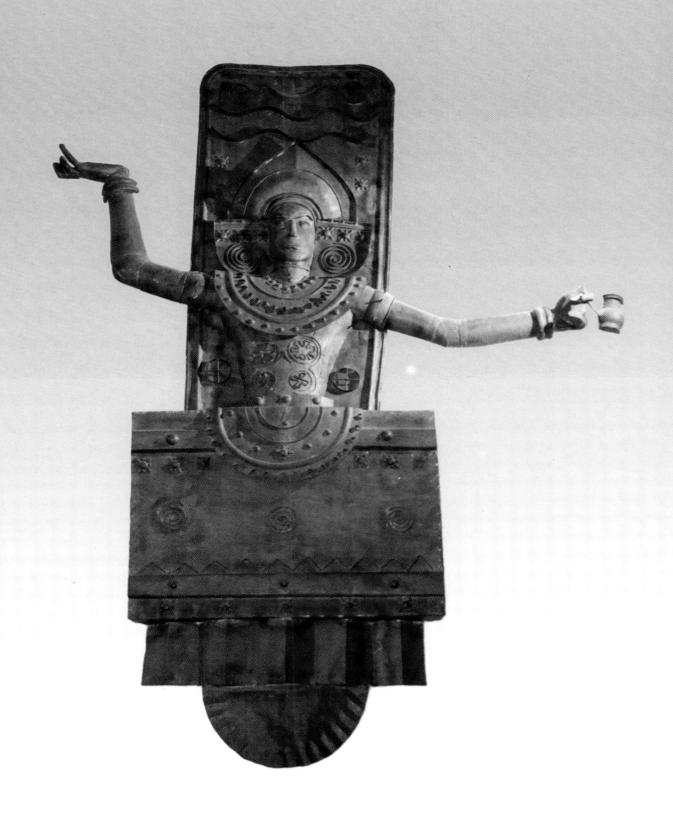

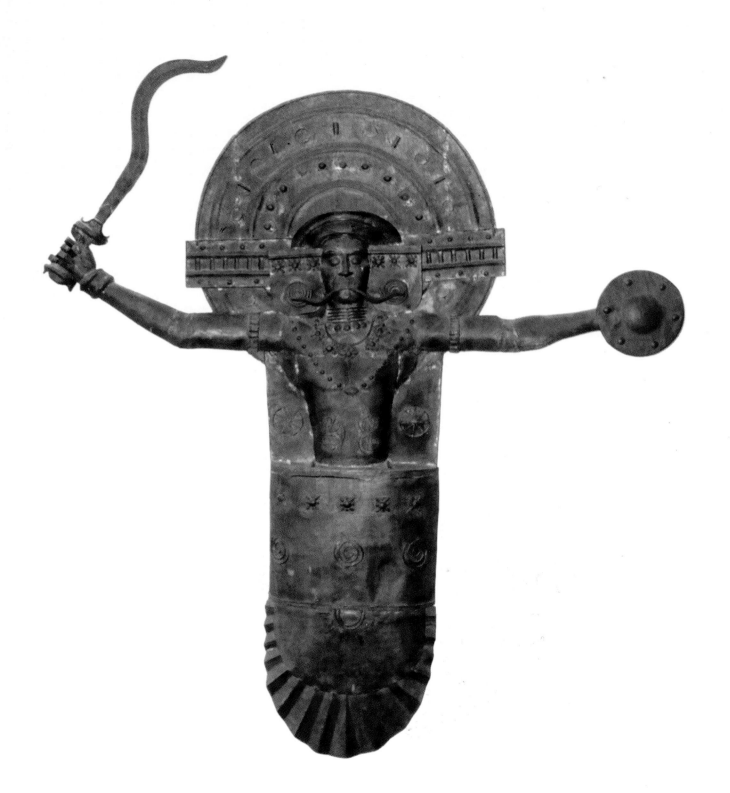

◁ *Keerthi Mudra*
(Copper mural)
Cinema theatre in Vadakara, Kerala
1990

VASUDEVAN NAMBOODIRI

1925 *Born in Ponnani, Kerala.*

1954 *Diploma in Fine Arts and Commercial Arts, Government School of Arts and Crafts, Madras.*

1960 *Joined* Mathrubhumi, *the Malayalam illustrated weekly as staff artist.*

1982 *Joined* Kalakaumudi, *the Malayalam illustrated weekly as staff artist; executed a large cement sculpture* Modern Family on a Scooter *at the All India Sculptors' camp at Cholamandal.*

1988–90 *Carved a granite sculpture* Maithuna *at the International Sculptors' camp at Cholamandal for the open-air Sculpture park.*

1997 *Executed a 500 ft long and 8 ft tall outdoor drawing illustration, depicting the entire saga of the Indian Freedom Movement.*

Dr M.G.S. Narayanan was Head of the Department of History at Calicut University. He also served as Secretary General of the All India History Association, New Delhi, and later became its President. This interview with Namboodiri took place in 1999.

NANDAGOPAL

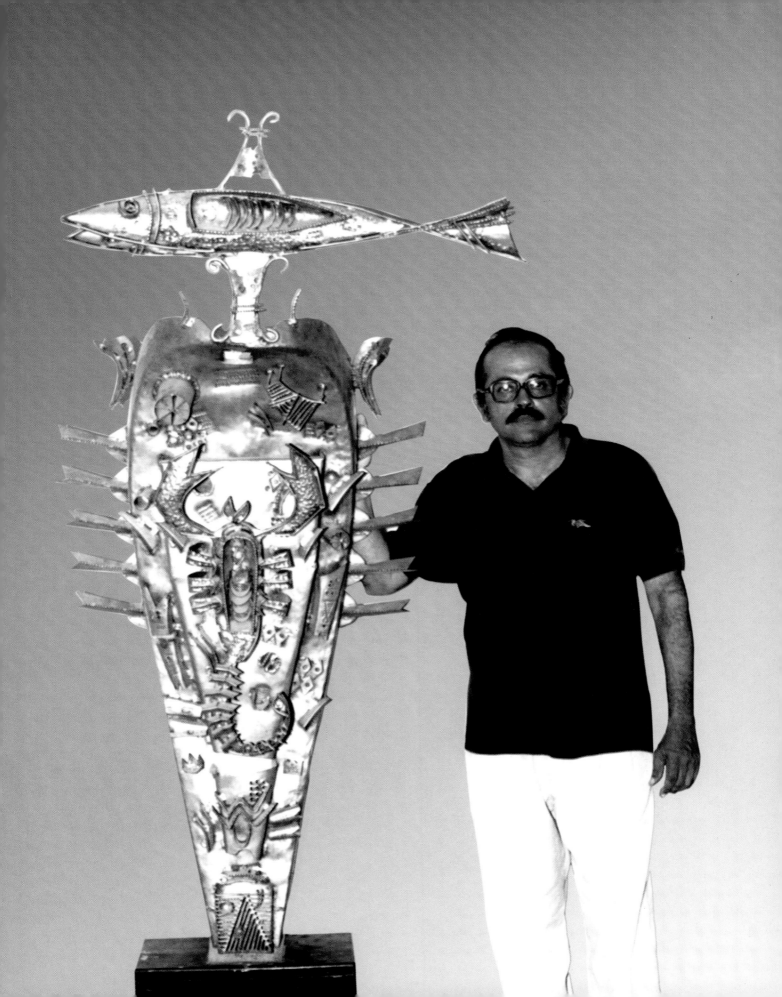

S. Nandagopal

Josef James: You started as a painter, and a very interesting one at that. What made you turn to sculpture?

Nandagopal: I was not only a painter to start with, I was a ceramist, a metalworker and I also did some jewellery. I don't think I have ceased to be any of these now or at any time. I have always sensed in me the liveliness of a drawing, the feel of colour, the genius of design, and the preciousness of the material I work with. My work habits turned sculptural early enough, but remained quite close to those I had learned while doing the crafts; including that of making a picture.

J.J.: How could you acquire such a base so early? By the time you were twenty-four, you had specialized in sculpture and won your first national award.

N.: Yes, I started my schooling in arts and crafts quite early in life. In fact, at the Government College of Arts and Crafts where I studied in Madras, I was regarded by my classmates as the little fellow around. It was a marvellous place, I owe very much to its curriculum, its setting, and its remarkable ethos. It had an excellent crafts section where I used to spend a lot of my time. It had some of the most renowned craftsmen in the state: ironsmiths, furniture designers, goldsmiths, textile weavers, and dyers working and teaching alongside artist-instructors in painting and sculpture. There was an arrangement by which a person doing painting, for instance, could go across and work in the sculpture section or in the ceramic

The Moon and Four Ladles ▷
(Welded copper and brass)
2000

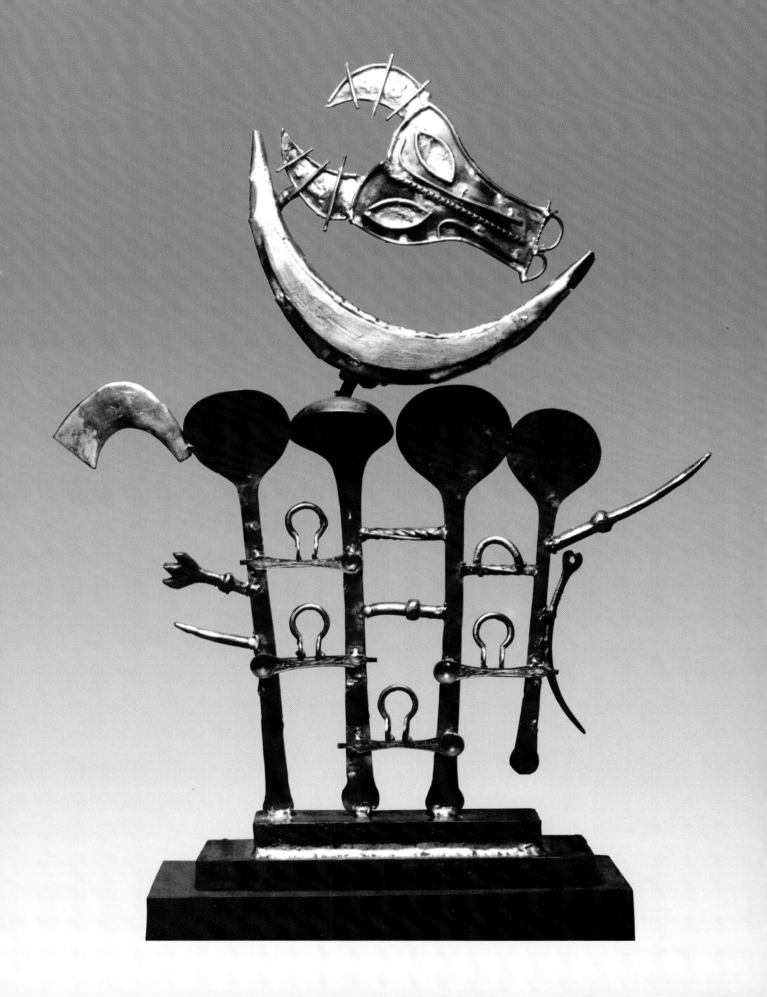

Faces ▷
(Welded copper and brass)
2003

workshop, textile design section or in the workshop of any of the other master craftsmen. I could therefore move around, observe the craftsmen at work, assist them sometimes, or go over the work in progress left in the workshops and studios by craftsmen or painters or sculptors I used to look up to. I knew very little art in those days, but I could react keenly to workmanship, no matter in what medium, and could get quite carried away by it.

J.J.: Besides the facilities, setting, and ethos, there must have been some personalities in that institution who influenced you or in some sense shaped you. How important were they to your development?

N.: In the late sixties and early seventies, when I was there, a number of painters and sculptors were doing outstanding work. There was so much interaction, initiative, and upsurge that I felt some of it happening inside me too. There was an important movement going on.

I am particularly indebted to a school of drawing my senior colleagues and teachers had developed. It consisted of a line so soft and spontaneous like a Japanese brush-stroke and just as free. With that they had developed a figure drawing, which was so unstructured that it could do such complexities as an elephant-headed presence, or a monkey-mannered wind-borne spirit, or one which could multiply its limbs, head, and body at will or issue out into configurations of calligraphic signs. That drawing remains with me and nourishes me still. It is that which activates my sculpture.

J.J.: Your work has been almost entirely in welded sheet metal. Why have you limited yourself to this medium?

N.: Firstly, I can't bring myself to do anything for which I cannot feel a necessity in me, even for an experiment or a joke. I have never had any feeling for working things in the round. I am not, however, insensitive to it. I can admire the work of Henry Moore and Constantin Brancusi and myself sometimes cast small bits for

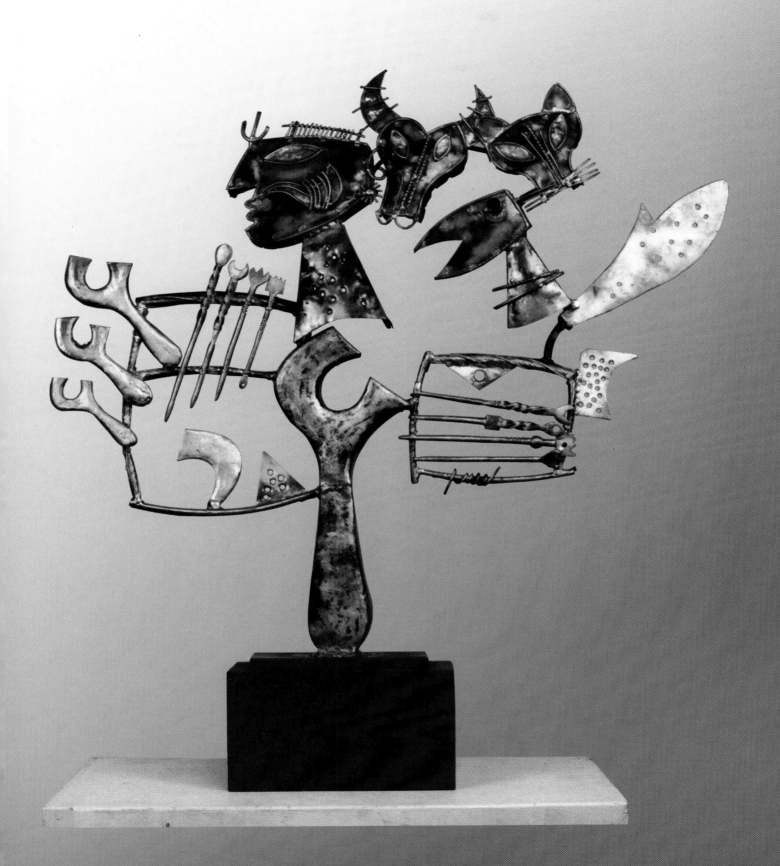

some of my own sculptures. But a whole conception in the round, the process of working it with my fingers, puts me off. I might put it down to a craftsmen's sense of economy with materials which probably impressed me very strongly. A craftsman, a goldsmith, for instance, must work his metal to such a pitch that the tiniest bit speaks.

J.J.: Sculptors abroad who shy away from 'roundness' have tended to turn abstract. Would you describe your work as abstract?

N.: No, my work is not abstract, if you mean by 'abstract' reduced schematized work like that of Caro's early work. I have known non-figurative, non-round sculptures in which the 'decorative' or the loosely 'expressive' aspect are built into it, giving it an ambience, poetry, and even some appeal, like in the work of Gonzales. I don't call that abstract. Abstraction facilitates thought and construction, I know. But that certainly cannot be the entire sculpture.

J.J.: Has your 'non-figurative, non-abstraction', if I may so describe your work, got anything to do with religion? A good many of your sculptures are on religious subjects and almost all of them have a strong iconic side to them.

N.: When I look at a sculpture I do not see it as religious or secular, nor am I aware of the distinction as I plan my own sculpture. What is true to life, as I see it, is something which is neither religious nor secular, or something which is both one and the other at the same time. I have sensed this from the start in the lives of the people around me, in the nature of belief, behaviour, art, and outlook. My sculpture cannot be true to life, I feel, if this unknown 'something' is not its subject or its ground. I do draw heavily from legend, mythology, and ritual because I find in them rich figures for the 'unknown something' which I feel reflected all around. I have not so far known it as an image, or an abstraction.

J.J.: Richard Hunt, the American sculptor and a member of the jury that awarded you a prize at the Fourth Indian Triennale, found your work 'open-ended and

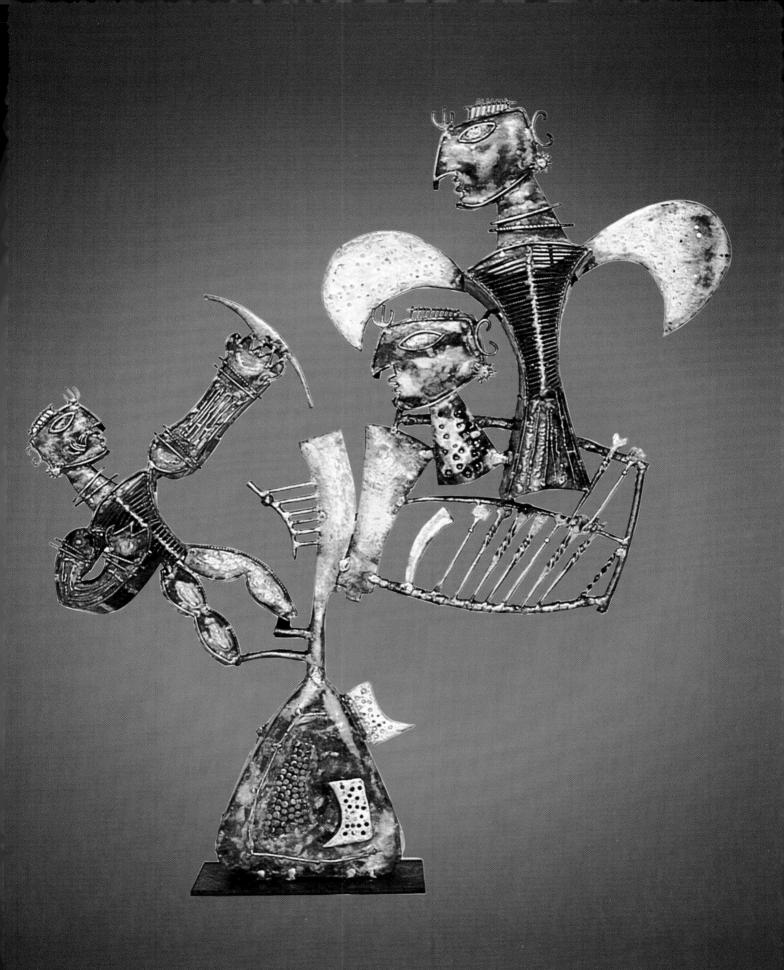

Tree ▷
(Welded silver-plated copper)
1975

capable of further development'. What do you make of that description?

N.: Richard Hunt said that nearly twenty years ago and much has happened to my sculpture since. My sculpture looked open and perhaps continues to, probably because it is not closed on all sides like something in the round; also because it is not spatial, that is, something fixed compositionally in space. I work it with a great detail which can be 'read' in diverse ways like an open text.

J.J.: It could be said by way of criticism of your work that it is worked too closely to a finish. Will you respond to that?

N.: I know I do not leave any free passages in my work. I minimize constructional devices: armature, supports and so on and I do not treat them as parts of the sculpture either. For handling the problems this raises, I find it helps me to use craft procedures rather than formal structural ones. In craft, the workmanship is greatly free; one can work on without constraints of subject, theme, or meaning. One can deviate at any state to take care of some contingency and move on afresh anywhere in the neighbourhood and so on indefinitely. That kind of working leaves very little to spare in the sculpture. Let me amplify this point. I have been thinking of doing away with the pedestal on which I have been placing my sculptures. I have noted how Caro had done it and recently how Tony Cragg has done it. Such solutions are efficient and I admire their formal elegance. But they are not 'pictorial' enough for me. Instead of the pedestal, which is also a formal device, I am working on the figure or metaphor of 'the Seven Hills', the mythological abode of Vishnu, the God of being. The figure of a mountainous formation for the base of a sculpture will show it as arising from the earth holding up a great wilderness of animals, birds, trees, reptiles, and jungle in a great and mysterious totality. Such are the tasks that I set for myself.

J.J.: You used the word 'pictorial' in relation to your sculpture. Can you elaborate?

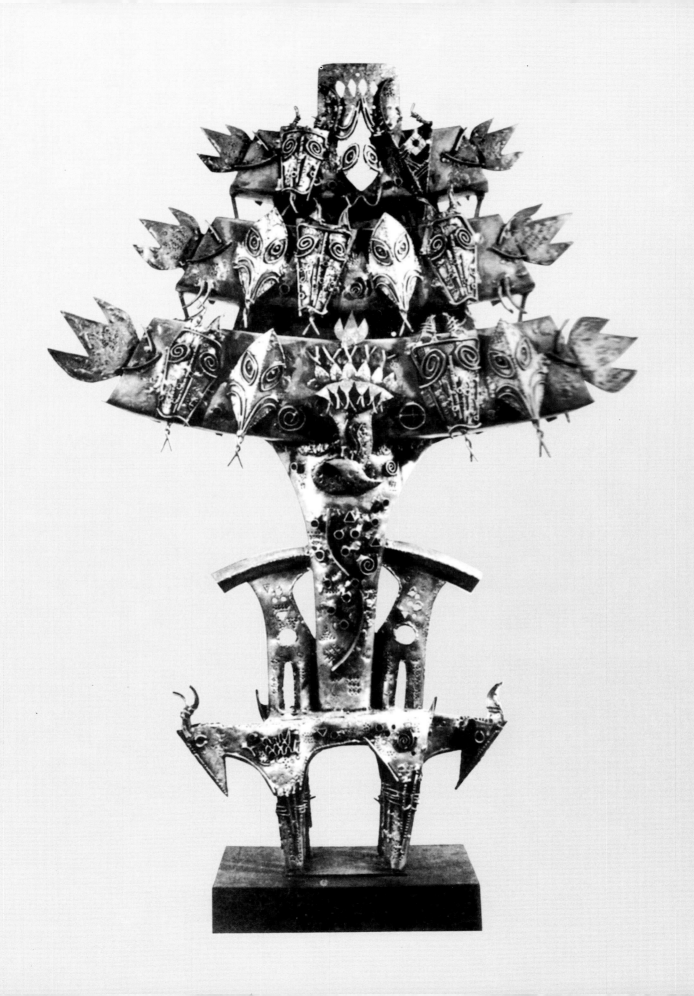

Four Spoons and a Bird ▷
(Welded copper and brass)
2003

N.: A pictorial formation is one which is totally free of coordinate systems, such as those of horizontals and verticals. It is not anything planned and completed to stay up as an object, but one which completes itself in the mind of the beholder like a picture, or some heightened visionary experience. That is not well put, I know. But consider India's traditional sculpture. Particularly the world-famous bronzes of south India. They are clearly pictorial and so are the great reliefs, a good many of the free-standing sculptures, and even the architecture. These and the abundant craftwork of the region and its culture have never seemed distant to me.

J.J.: Could it be said by way of criticism that your resorting to craft is a bit of medievalism?

N.: The criticism in this context is not a well-informed one. Medievalism, by which you mean the rule of craft and myth, is gone for good in the West (to abide by it today will look anachronistic and even absurd in that culture). It cannot be contemporary there in any sense. But in my situation here in India, the rule of myth and craft is alive and well, quite contemporary, and I am happy it is so. The medievalism in my case, therefore, is something rich and contemporary and I think it can be seen to be so in my sculpture.

There is one more thing. To say that a work is 'crafty' is not to say that it is all calculation and repetition. It is only to say that its genius is in its workmanship. When you see such a work you are moved to say, 'How well worked!' rather than 'How well conceived!' My examples of sculpture where the workmanship is to the fore are those of Caro, some of his late works especially, or those of Tinguely, some of Rauschenberg or those of the fine young sculptor Michael Puryear. There is nothing 'medievalistic' about them. Is there? To craft a work closely as I do is not 'medievalistic' as opposed to something live and contemporary.

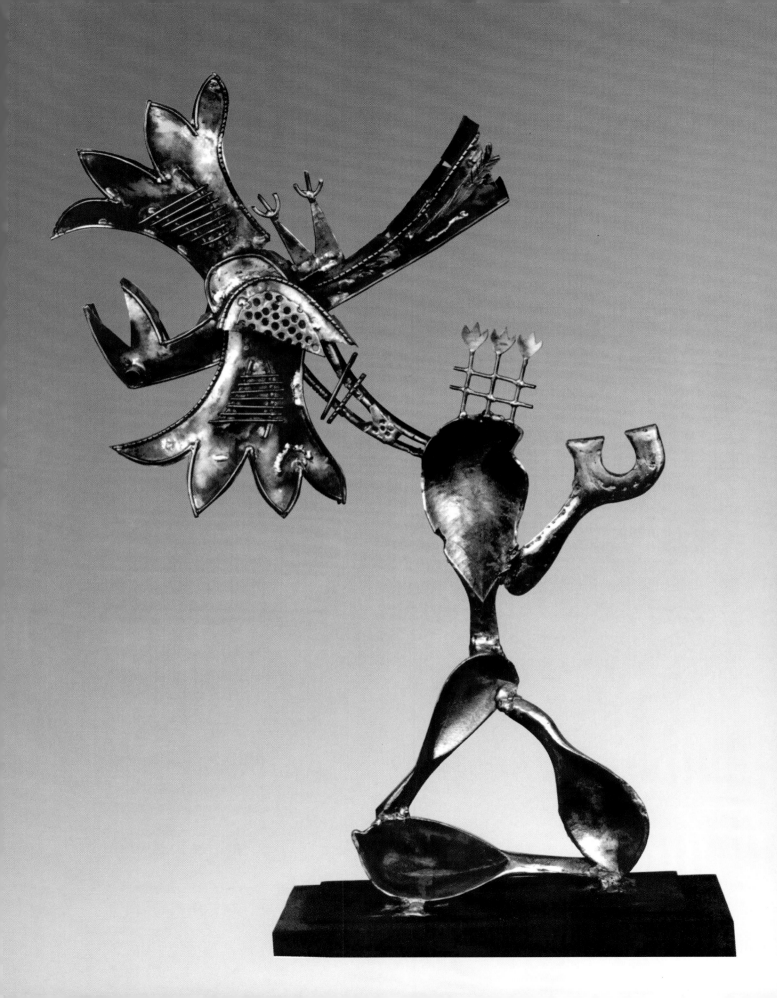

J.J.: Your sculpture has acquired a specificity at this stage. How do you propose to move on from here?

N.: Frankly I do not know. I move from sculpture to sculpture. But as I had moved that way over the years, I have accumulated a number of problems for which I have not found solutions; the stock of such perplexities are bound to increase as I go along. I have problems with colour. I am aware of its importance in illuminating sculpture. But I still do not have conviction about it even though I have used it a few times. The relationship between ready-made colour and the colour value of the metal is something I have not yet resolved. I have tried the technologies of plating or anodizing. I have worked in copper, brass, bronze, stainless steel; I have not yet attempted one in which all these and more are reconciled, maybe with colour coming in. I have attempted monumentality and sheer strength but am yet to combine it with a richness and fluidity that I can handle. I expect to be faced with situations that will force me to take on these issues and maybe some others, and work my way through them. The solutions I am able to come up with will advance my sculpture but when, how, and to what end, I am not able to say.

S. NANDAGOPAL

1946	*Born in Bangalore.*
1965	*Member of Cholamandal Artists' Village, Madras.*
1966	*Graduates with a degree in Physics from Loyola College, Madras.*
1970	*National Award, Lalit Kala Akademi, New Delhi. (Also in 1978.)*
1971	*Diploma in Fine Arts, Government College of Arts and Crafts, Madras.*
1976	*13ᵗʰ Middleheim open-air sculpture exhibition, Antwerp, Belgium.*
1978	*Gold Medal at the IVᵗʰ International Triennale, New Delhi.*
1980	*Homi Bhabha Fellowship, British Council Travel Grant; travels to Europe and the United States; Indian section at the Fukuoaka Museum, Japan; India's first International Sculpture camp at Punjabi Museum, Patiala.*
1985	*ICCR Travel Grant to Yugoslavia.*
1989	*Serves on the Henry Moore Foundation Fellowship Committee.*
1990	*Senior Fellowship conferred for two years by the Government of India.*
1992	*Nominated by the Government of India to serve on the purchase committee of the National Gallery of Modern Art, New Delhi (also in 2002).*
1993	*Featured in the book* The Madras Metaphor *by Oxford University Press.*
1998	*Nominated by the Government of India to serve as an advisor to the National Gallery of Modern Art, New Delhi (also in 2000). Featured in the book* The Algebra of Figuration *by Oxford University Press.*
2002	*The Jindal Stainless Steel award for sculpture, New Delhi.*

The interview with S. Nandagopal was conducted in 1989 by Josef James, the editor of this book.

NANDHAN

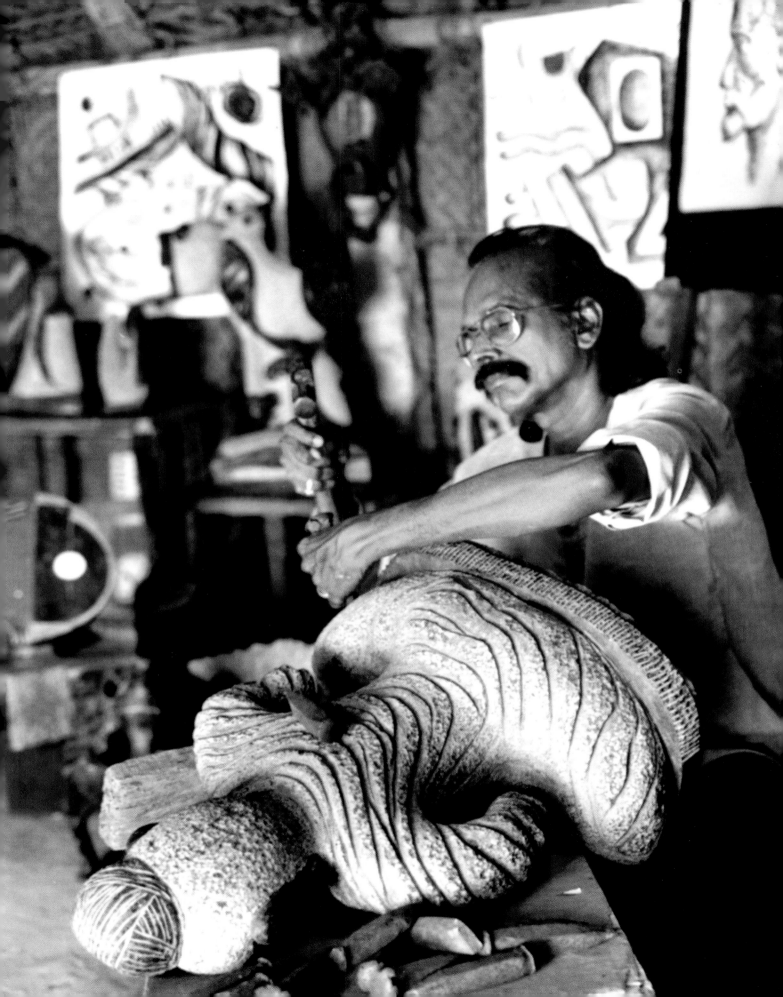

P.S. Nandhan

Soumya James: How did you come to Cholamandal?

Nandhan: I started my course at the School of Arts and Crafts in 1960. In 1964 my father passed away and I was thinking of going back home and taking over his job. At that time, a friend wrote to me about K.C.S. Paniker's plan of starting Cholamandal where an artist could work as a freelancer and earn a living at the same time. I was very happy to hear about it because I was convinced that I could never work under anyone. I felt that it would restrict my creativity. I borrowed Rs 500 from my brother-in-law and put it in as my share towards the project. We did batik work, saved money and with it bought land, which is now Cholamandal. In 1968, I moved here and in 1982 I bought my own land here. The feeling to work on my own is what drove me to take these decisions and come here. And I have been here ever since.

S.J.: How has being in Cholamandal helped you as an artist?

N.: First of all, I had the complete satisfaction of working for myself. Being in an atmosphere where artists live is enormously helpful for an artist to grow, like a tree planted in rich soil. Cholamandal has the ideal environment for an artist. Why? When I wake up in the morning, the first thing I see is an artist or even his house and it immediately connects me to his work. When I go out to the city, my mind becomes blind. I see traffic, vehicles and hear the noise, I know no one and no one knows me. It's an empty feeling. But when I enter Cholamandal, it's a

Mother and Child ▷
(Granite)
2003

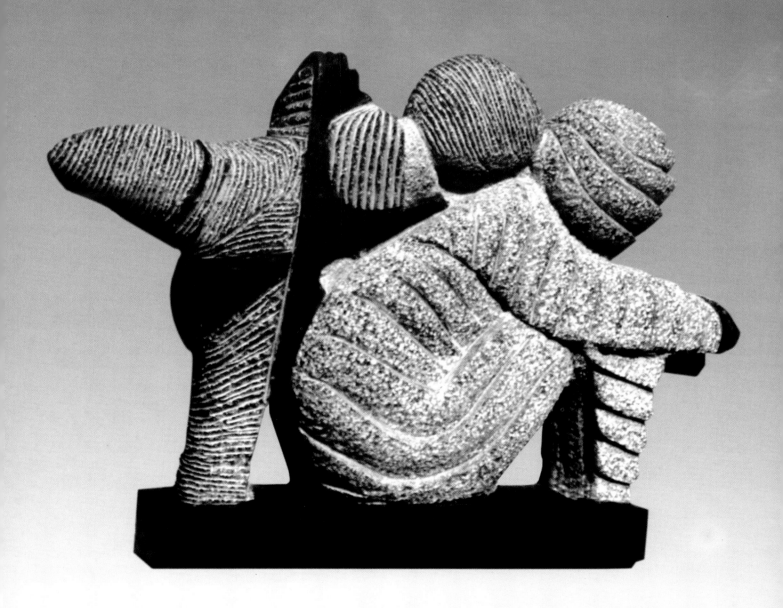

Shellfish ▷
(Granite)
2000

totally different sensation. I feel that when the people here see me, they connect me with my work, and that gives me a very secure feeling. And that is important to me. That's the major difference between living in the city and being here.

S.J.: Who were the main influences in your work before coming to Cholamandal, and after?

N.: Each artist is influenced or inspired by somebody or the other, either consciously or in the subconscious mind. In college, I was very much influenced by my teacher Mr Dhanapal. I consider him the best sculptor in clay. I admired the way he fashioned three-dimensional figures. I also observed the line movement in the paintings of K.C.S. Paniker.

Another teacher of mine from the School of Arts and Crafts, Mr Santhanaraj, was a major influence. The way he used to treat his canvas was fascinating. He could paint as though there is no end to creation. His influence was very strong and it still remains in my mind.

In Cholamandal, even though we have our own separate individuality in our work, I feel there is a common identity for all of us. It may not be conspicuous now but it is there. How? When I see a sculpture of any particular artist, there will be some aspects of it that strike me. Maybe the treatment of lines or maybe a particular colour. This may happen without me even knowing it but it will be stored up in my subconscious and I may use a similar concept in my work later on. I also need not use it but it will remain in my mind and it will help me develop my creative sense. The same thing can happen to another artist when he looks at my art. This is not the same as copying. It is like using many ingredients to make a mixture. Someone else can use a few of those ingredients to make something new.

But in the end I have to say that Santhanaraj's influence was the strongest. Because after seeing him work, I have learned to have the confidence that I can always finish my work without having the fear that I will lose the ability to create.

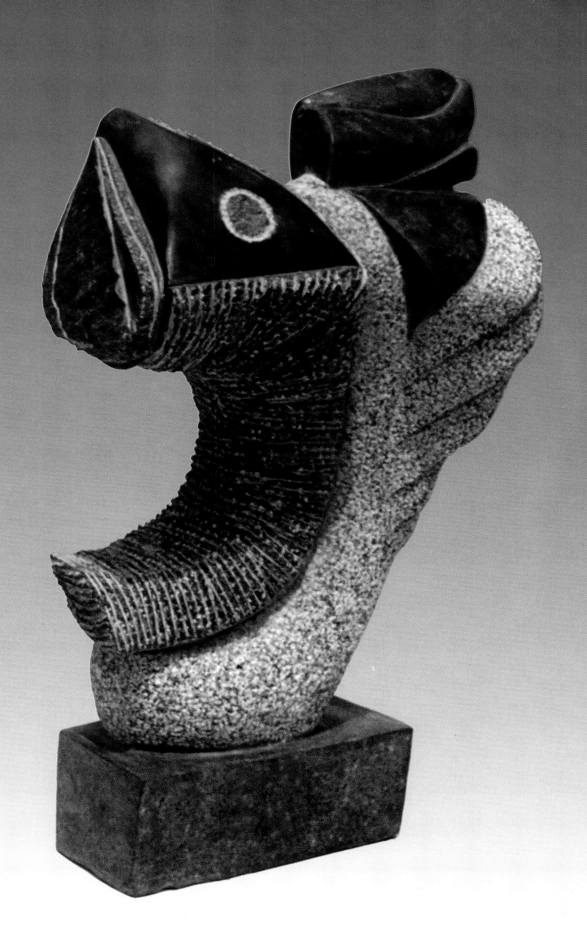

Untitled ▷
(Granite)
2000

S.J.: You have worked in metal, stone and clay. But you seem most comfortable in clay. Why?

N.: First of all, clay was the medium I was familiar with from my childhood. I used to watch potters at work near my house. Later, my grandmother used to ask me to make clay images for *poojas* and festivals (which I still do). It is not that I'm comfortable in clay, it is just that I consider clay basic to all work. Clay is so flexible. It can be as abstract as the figures in your mind. Nothing bends like clay, not even paper. I would have stone or metal to work on but at times I don't feel like doing anything with it. That's when I feel like working on clay. So I work with it for three or four days. At the end of it, my mind is free and flexible to work on anything else. Working on clay gives me a feeling of fulfillment and at the same time releases all the tension and rigidity from my mind.

I'll give you an example. This happened in 1979, when I was staying in Neelangarai. One day I had gone for a wedding with my wife, and when I returned in the evening, my house had been broken into. Everything was taken. I was very upset by this. I found it so difficult to accept and I kept on questioning myself why it happened and who could have done it. I started working on clay at this time and began making masks. I must have made around 2,000 or 3,000 masks in the space of three years. That was my way of dealing with the worry and uneasiness in my mind. But after those three years, I felt as though I had solved the mystery and found out who the thief was! Such was the relief.

S.J.: How do you react when the viewer does not perceive the idea behind your work?

N.: I don't start with a full-fledged idea for a sculpture or a painting. I start with whatever image I have in my subconscious. Only when I complete three-quarters of it do I get an idea of what it is evolving into. When I want to make a realistic figure, like a mask, the basic idea is there but I don't have a notion of how the ultimate figure will look like. Suppose I want to work in stone, I watch it for two

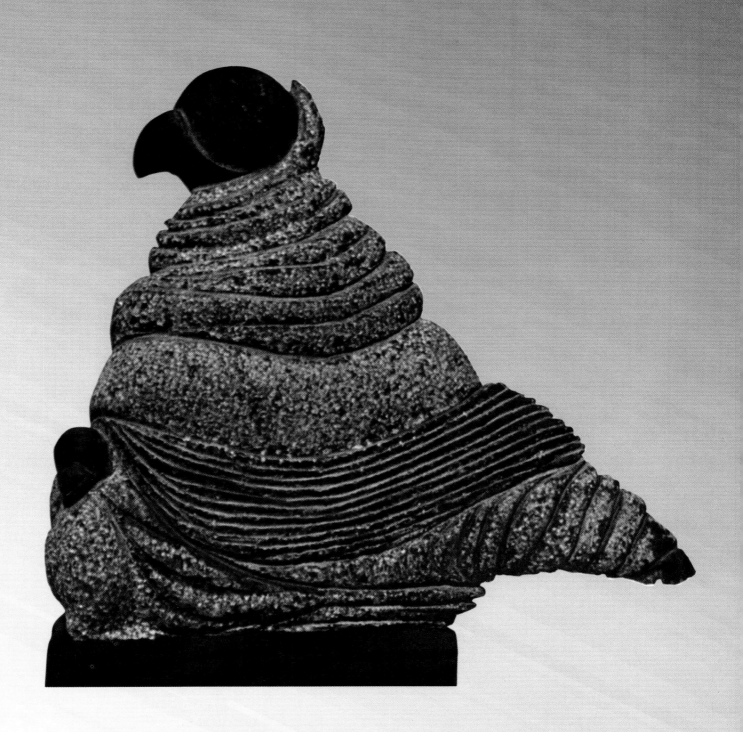

Tree With Two Trunks ▷
(Granite)
1999

or three days and then I get an idea of what kind of shape it could have.

Those who look at my art, mostly look at it with an artistic sense. So far, no one has viewed it with an idea to belittle it. Of course, there are those who do not understand my work and ask me about it. When I give them an explanation, they try and understand and see what I see. To those who deliberately seek not to understand, I have nothing to say.

S.J.: Who is your art for? What is your purpose in making art?

N.: I make my art for myself. There were times when I had severe financial difficulties and I was tempted to make more money using my art but I simply could not accept it. I can work on relief, clay, and stone sculptures but I don't. I do get requests to do large panels but I agree only to those commissions where I am given the freedom to choose the theme. My art is for my own happiness and peace of mind. If it gives pleasure to others, why not? They are welcome to enjoy it. There is a Tamil saying: A tree does not grow for the benefit of others. It doesn't offer fruits, flowers or shade to satisfy people. It grows for itself, not in a selfish way…it's not even aware of itself growing and bringing forth fruits. If its benefits are useful for people, why not?

S.J.: How has your work changed over the years?

N.: Have you seen the south Indian temples?…the profiles of the figures and lines of the temple itself? I find them very interesting and fascinating. But I don't think I have yet achieved that kind of perfection and beauty in my work. I am still working on it. I like to make creative figures that portray their attributes. The mythical figure of Ravana has ten heads. But that's an impossibility! No one can have ten heads! But it actually represents the different characteristics of that figure, like anger, passion, or happiness. I am trying to do something similar in my work now. I made a Nataraja, illustrating the character of Nataraja but not having the typical form of the celestial dancer. I have also made the figure of the Buddha. It doesn't have the traditional form either but I have tried to portray what you see

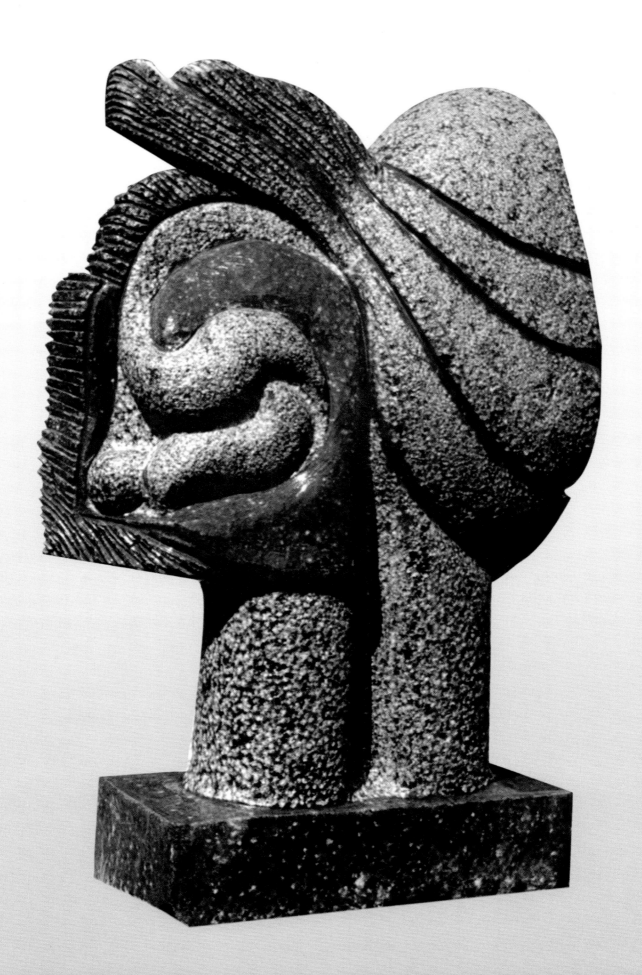

and feel in the shadow of the Buddha.

Dance is very useful in making sculptures. There are thousands of movements one can use. But these movements are limited because of the limitations of the human body. Whereas there are no such restraints in the mind of the artist. He can take any of these movements and expand the possibilities and take it to any length he wants.

I have been teaching art to children for some time now and I have learnt so much from them. Their movements are so free and unlimited. They create the exact image that their mind sees. They make a figure and call it an elephant. We will not be able to make it out at all! It may only remotely look like an elephant but the image is so clear in their minds that they can see what they have created. It's so wonderful to have that kind of free and unrestricted sense of perception. Teaching children has been a very educational experience for me.

S.J.: What would you consider essential for an artist to be creative?

N.: Whatever affects you naturally. Your house, people around you, things that we do around the house, and 'eye-experience'. One must be open to see and hear things around us, to feel and think about them. There will be certain things that strike us about different kinds of people who interact with us. Some are gentle and some are aggressive. These impressions will translate into concepts in our work, like hard or soft lines.

For an artist to be creative, our world should be free of disturbances. I don't mean that we should shut off the world. We should know what is going on, like when we see water, we should be aware that it could be deep. But it should not hinder one's creativity. We are constantly thinking, feeling, and absorbing, though we may not be actively working. I may not work for six months but when I make a piece at the end of those six months, it will contain all that I have assimilated during that time.

P.S. NANDHAN

1940	*Born in Madurantakam, Tamil Nadu.*
1965	*Becomes a life member of the Cholamandal Artists' Village.*
1968	*Diploma in painting and in the advance course with distinctions from the Government School of Arts and Crafts, Madras.*
1972	*Experiments with and starts sculpting in clay, sheet metal, bronze, brick, wood and granite.*
1976	*Taj Coromandel Hotel, Madras on the occasion of the 25th International Pugwash Conference; National exhibition, Lalit Kala Akademi, New Delhi.*
1978	*'40 artists of Madras', organized by the British Council, Madras.*
1988	*Asian Art Biennale, Bangladesh.*
1989	*Rashtriya Lalit Kala Kendra, Calcutta, on the theme of 'Sculpture on Nehru'.*
1990	*International exhibition of 'Asian-European Art', Biennale, Ankara, Turkey.*
1991	*'The Madras Metaphor' exhibition organized by Ebrahim Alkazi at Art Heritage Gallery, New Delhi.*
1992	*Awarded the National Award by the Lalit Kala Akademi, New Delhi.*
1993	*Featured in the book* The Madras Metaphor *by Oxford University Press.*
1998	*Featured in the book* The Algebra of Figuration *by Oxford University Press.*
2001	*Senior Fellowship, awarded by Ministry of Education, Government of India.*

Soumya James graduated in History from Stella Maris College, Chennai, and later did her post-graduation from Madras Christian College, Chennai. She has contributed articles to the *Indian Express* and the magazine of the Ability Foundation, Chennai. She is currently pursuing her doctoral degree specializing in South and Southeast Asian art history at Cornell University, USA. This interview with P.S. Nandhan was conducted in 2002.

NARAYANAN

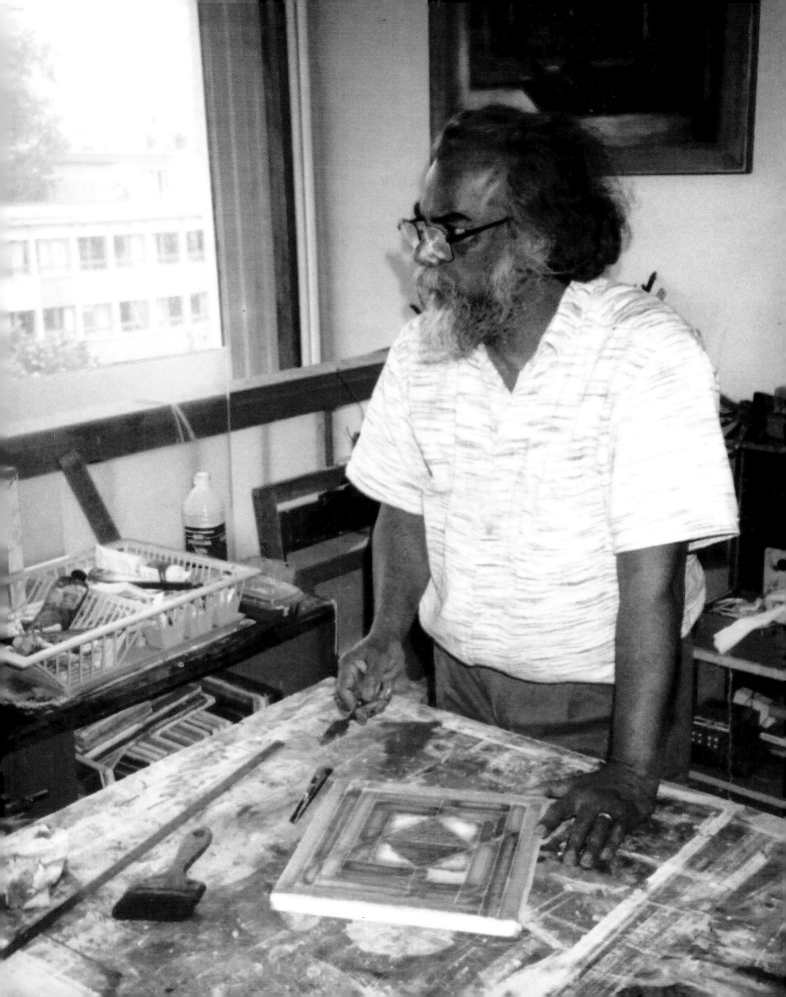

Akkitham Narayanan

M.V. Devan: A striking feature of your paintings is that they lack a title. Why is it so?

Akkitham Narayanan: It has been a long time since my paintings ceased to have a title. While I was a student and later an artist struggling in the cities of Madras and Delhi, they did have titles and I was in fact enthralled by strange and mysterious names. I would select Greek, Latin, and French terms to suit my whims and fancies. I shed this habit when I permanently settled in Paris.

D.: What is the content of your *Soundarya Lahari* series of paintings?

A.N.: *Soundarya Lahari* is a collection of my graphic prints done in 1973–74. The number of prints are limited, each being an original. It was exhibited in 1974–75 at the annual exhibition conducted by the Kerala State Lalit Kala Akademi.

D.: I presume it was during your attempt to trace the nameless essence of the great hymn *Soundarya Lahari* of Sri Sankara through your work that you stumbled upon the truth and gave up hunting for exotic titles. Where did you get this insight from?

A.N.: Thanks be to Paris, resonant with the famous words of Gertrude Stein, 'A rose is a rose is a rose'.

△ *Untitled*
(Oil on canvas)
1998

Untitled ▽
(Oil on canvas)
1996

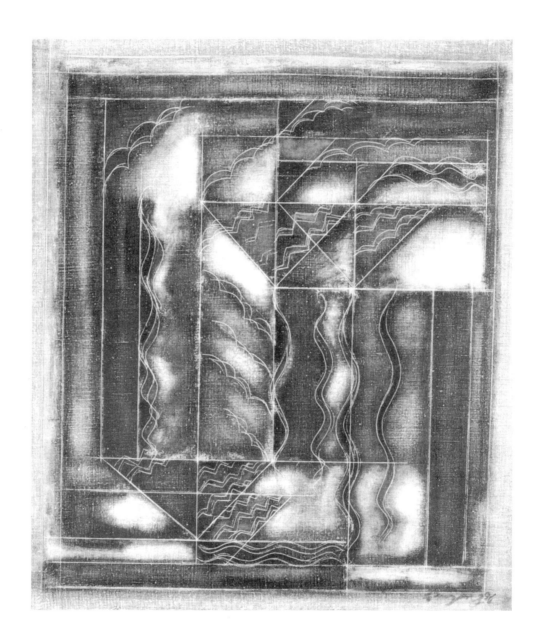

▽ *Untitled*
 (Oil on canvas)
 1998

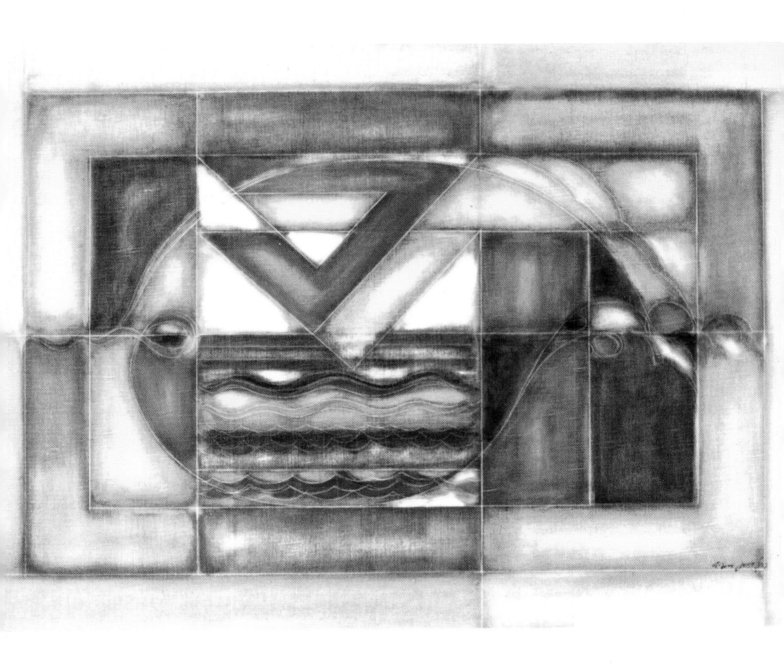

D.: Being a Namboodiri Brahmin from Kerala, tell us something about your background before you took up art.

A.N.: The Namboodiris formed a landed aristocracy and a religious elite in Kerala. Their house and lineage were both referred to as '*illam*' or '*mana*'. I was born into a *mana* named *Akkithath Mana* and my elder brother Akkithath Achuthan Namboodiri is a well-known poet in Malayalam. I recollect some of his lines, '— Light is but woe dear, Darkness is bliss'. His soft voice stunned the valiant, the progressive, and the die-hard communists of those days. Our *mana* was known as an *Agnihotri mana* that had conducted more than ten *yagna*s or sacrifices. The village of Sukapura was an abode of some of the prominent *mana*s and reflected the glory of Brahminism of those days. It is from such a conventional society that I left for Madras to join the School of Arts and Crafts in 1956. The renowned artist K.C.S. Paniker was the principal of the institution then. Cholamandal, the artists' village, was Paniker's dream. But for his strong personality this would never have materialized. Unity and the dedication of its members served to enhance its strength. I am proud to say that I was one of its strong supporters and a member.

D.: Could you talk about your early days in college?

A.N.: It was beautiful! I distinctly remember the cathedral at the extreme end of the premises. The Gothic structure with its pointed steeple that pierced the empyrean as though to give us a glimpse of the Heaven above. While down below, the human consciousness welcomes God Almighty, the church bells chime to proclaim His infinite compassion, that transforms the barren earth into the bountiful.

D.: Has that environment in any way influenced your work?

A.N.: Definitely! That cathedral and its creator have a prominent place in many of my works. The Gothic structure, sometimes its plain and sometimes its three-dimensional aspect was mirrored in my paintings. This incessant symphony of

▽ *Untitled*
(Oil on canvas)
1997

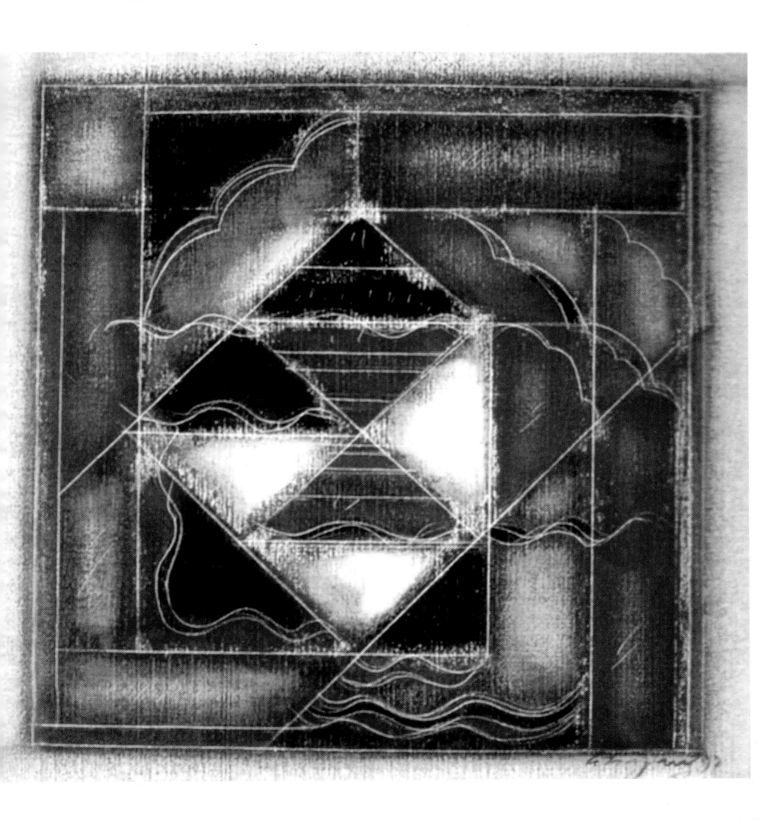

colours finally collaged to emerge anew in the myriad forms of cubism. Gradually the resemblance to the cathedral waned and what grotesque skeletal form remained, appeared like a gigantic prehistoric being all set to terrify the beholder. Presently, beside this horrifying creature there emerged a being so gentle and meek as a lamb (like a lamb that was shooed into 'Bimbisara's *yagasala*')—and a few birds (were they the Krouncha birds that inspired Valmiki—or the wounded ones that stirred the soul of Prince Siddhartha—I wonder!) I also remember that the art movement in south India was in full bloom during this period. In the wake of the quest for truth, answers and questions raced past one another.

D.: Do you think there is something called the Indian identity? If so, does it have any current relevance in the present times when the universal concept of art has spread all over the globe? Is it not rather a Balkanizational attitude to stand apart proclaiming the glory of Bharat (India)?

A.N.: I have been witness, a witness goaded by doubts, to the arguments and counter-arguments that raged all over the country. Debates everywhere, on the college campus, Akademi studios, Cholamandal Artists' Village, Delhi, Hyderabad, Bombay, Calcutta, Kochi, and Trivandrum. Quite often the diamond sharp razors of truth pierced through the darkness of ignorance. At times, there were explosions spitting volumes of smoke, but the sound and fury only served to lead people astray. To be frank, while I stood secure within the empire of cubism, I was invaded by doubts. What if this empire falls apart, the sand beneath my feet drifts away? Totally puzzled, I would approach you, Mr Devan, do you remember, and repeat the question that haunted me. In modern times does Bharat (India) really have any relevance? I still remember your reply, 'Who am I to say whether it has relevance or not? And if someone did give an answer, is it the final verdict? Who can say for sure if it is relevant or not? In fact, friend, this question is a cross that each one is destined to carry.' Traversing life burdened with this crucifix, one presents sights that are enthralling, sometimes mind-boggling and at times soul-stirring. In fact,

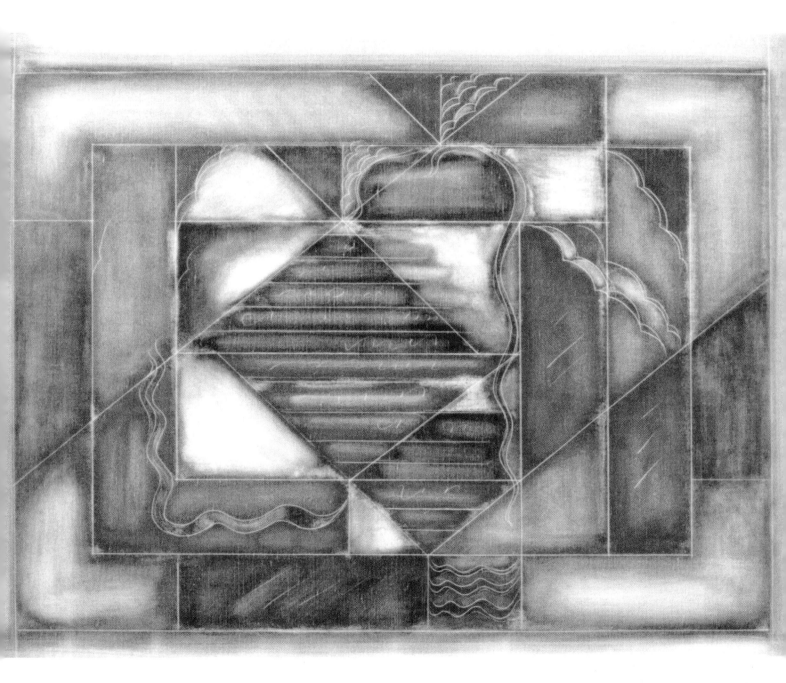

△ *Untitled*
(Oil on canvas)
1998

what else can an artist do? And then you would comment about my painting thus: ears resonant with *Gayatri Mantra,* eyes constantly caressing Yantras inscribed with mysterious invocations, amulets, palm leaves with age old mantras, your soul ever whispering *Swaha.* In your pictures, whether they be oil or acrylic or graphic print, I can see the echo of all these. In fact all these are abstract pictures where space contains time and time contains space in perfect unison—an important aspect of contemporary painting.

D.: Let me ask you one more question. How do you attain this enchanting perfection in your works? Are they just geometrical patterns woven in and out in a natural or unnatural flow or rhythm? Are forms and colours merely decorative? Are they just pictorial images and nothing more?

A.N.: I can't explain the contents of my work in words. My memory travels far into the labyrinths of my past which brings to my mind the cow-dung plastered earthen floor, the door adorned with sandalwood paste, the palm leaves with inscriptions and the primordial memory of the lotus that sways in the presence of the supreme power, the sun, the spring of life and shakti or nature, the feminine, dynamic and vibrant concept of power and the masculine power which is static and immovable. Time impregnated with the memory of timeless life and death and finally the eternal power that triumphs over time and death—Art—timeless, eternal, antidestiny.

AKKITHAM NARAYANAN

1939	*Born in Kerala.*
1961	*Diploma in painting, Government School of Arts and Crafts, Madras; National exhibition of the Lalit Kala Akademi, New Delhi.*
1962–64	*Government of India Scholarship for painting.*
1965	*One man show Max Müller Bhavan, Goethe Institute, Madras.*
1966	*One man show Triveni Gallery, New Delhi.*
1967–70	*French Government scholarship, studied monumental art under Jean Bertholle; studied engraving under Lucien Couteau; International Festival of painting, Cagnes-sur-Mer, France (1970 and 72).*
1971	*Award at 4ᵗʰ International Festival of painting, Cagnes-sur-Mer, France.*
1972	*Award at the All India Print exhibition, New Delhi.*
1973	*One man show at Steintor Verlag Gallery, Germany, International Print exhibition, Manila, Philippines, Noverbre a 'Vitry, Vitry-sur-seine, France.*
1974	*One man show, Heinemann Gallery, Bonn, Germany.*
1975	*IIIrd Triennale—India, New Delhi.*
1976	*One man show Le Haut Pavé Gallery, Paris.*
1977	*IIIrd Graphic Biennale, Vienna, Austria; Salon de Mai, Paris.*
1978	*Retrospective at the Haut Pavé Gallery, Paris; one man show at Miyawaki Gallery, Kyoto, Japan; one man show at Seibu Gallery, Kyoto, Japan.*
1988	*One man show, Pundole Gallery, Bombay.*
1990	*One man show, Chitrakoot Gallery, Calcutta and Sarala Art Centre, Madras.*
1991	*One man show, M & R, Kolbein, Garbsen, Germany.*
1995	*One man show, Chateau de Talcy, France.*

M.V. Devan, the architect and artist who is featured in this book, interviewed Akkitham Narayanan in 1999.

PARAMASIVAM

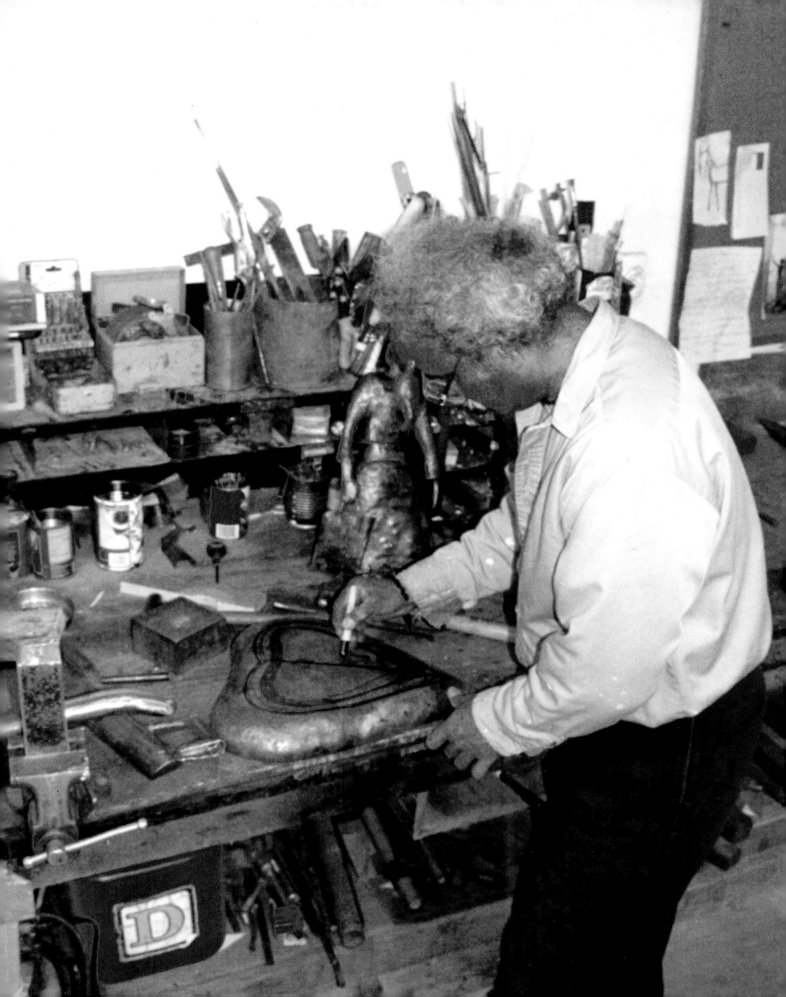

S. Paramasivam

Cathy Spagnoli: How has your work evolved in recent years? What are some of the new directions?

S. Paramasivam: My work has not changed greatly since my *Kite* and *Shadows* series. These were movable wall sculptures that signalled quite a departure from older works of stationary forms. My free-standing 'tree groupings' are also different from earlier single sculptures. I have been doing various *Tree* series for a long time, and they are my favourite works. I like the forms, with big bottoms, shaky tops, and emptiness in between. One single piece does not seem comfortable, so I have to make several of those pieces and place them close to each other. It is much the same as looking at one single tree and a group of trees in the natural environment.

This series has also changed over time: in the recent ones, I used some moveable parts. The magic of movement then made me consider mobiles, and I balanced four flat pieces together, through trial and error. During that process of experimentation, I knew I wasn't getting just what I wanted, but I got something! Then, still searching, I ended up placing a moving bird on a narrow base, which made me feel better for some time. I am quite confused about these mobiles now. I think there may be something else I want, but I'm not sure. So perhaps future works will explore this path.

C.S.: What personal challenges have you faced as an artist?

Pillars ▷
(Beaten and riveted copper)
1999

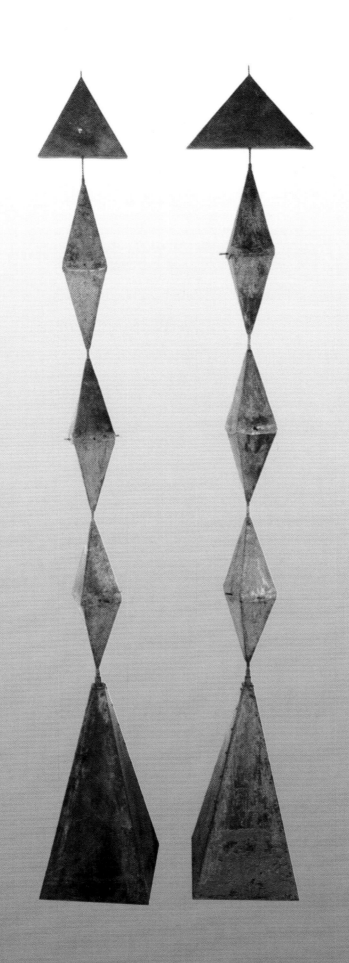

Red Leaves ▷
(Beaten and riveted copper)
2000

S.P.: Looking back at my childhood and family background, then art school, I think I have always put my faith in somebody else, and never had enough confidence that I could do things on my own. After going to the US, although I kept my art going, old habits stayed with me and grew stronger. My wife, Cathy, spent a great amount of time and energy to change deeply embedded old roots into newer seeds so that some personal changes could be seen. I started to take things easier and went along with events as they came. There is that saying about teaching new tricks to an old dog. If I can't teach myself to change, that would be a weakness, but I think I am learning now.

I came from a modest background and grew up in a quiet city with few cultural opportunities. So I didn't have certain advantages of wealth or family connections. I struggled in college but free hostel was a blessing and, luckily, I was active and handy, even making crayons to pay the canteen bills. Art sales were also harder at first, but living at Cholamandal was helpful since many people came there. So we didn't have to go push ourselves elsewhere. And, when foreigners visited, I learned to speak better English, which helped me to meet more people and thus gain confidence.

C.S.: Do you face many technical difficulties as you work?

S.P.: So far I have not. I have worked largely with copper and bronze sheets, using riveted nuts and bolts to put sculptures together. The sculptures might look involved, but they are not too difficult technically. I colour my copper and it can sometimes be a challenge to get the right shade, effect, and coverage. I have done bronze castings, big and small, in a very well equipped, non-profit studio. With all their electronic gadgets, the huge kilns there make things easier.

C.S.: You have travelled widely in Asia; how has that influenced you?

S.P.: I have been to Japan a few times and understood something about the people and their culture. I was in Korea, Thailand, and Singapore more briefly, but received

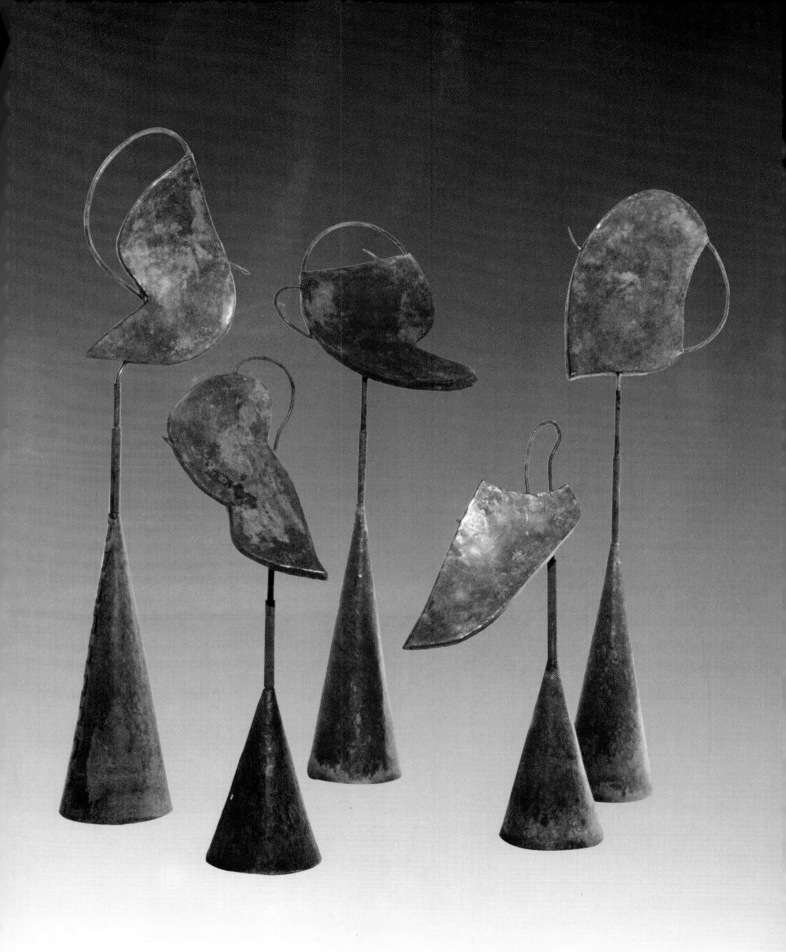

Tree ▷
(Beaten and riveted copper)
2001

many impressions. Japan and Korea have many temples and sculptures; in fact Kyoto, in Japan, seems to have more temples than houses. Both countries have made their buildings often in wood, which decays fast, while Indian buildings were made of stone, which is more permanent. But I was impressed by the care given to temples and monuments in Japan and the efforts to preserve them.

Both Korea and Japan have been highly influenced by Western cultures yet they try to maintain their own traditions. I think this is very important. Traditional arts, like pottery and papermaking, have a strong presence in both cultures and are exhibited in the galleries, along with contemporary works. These various traditions are kept well and alive, with very high standards and quality.

C.S.: Who has been your influence over the years?

S.P.: Well, this is one of those questions which are almost impossible to answer. Just as people always like to say 'about 3,000 people were present', yet one can never tell the exact number. But I will try to answer the question by naming some of the many who have helped and influenced me.

I will always remember my father. He struggled to feed his family and lived gently, with a simple faith. Even though he didn't have the money to keep me going in Madras, he always tried to help. In secondary school, I was influenced by our talented arts master, Kandaswamy. Soon after Mr C. Dakshinamoorthy gave me his time, along with information and encouragement about the School of Art, so he deserves much gratitude. Later in that school, our instructor Santhanaraj, the painter, inspired me greatly.

Of course, Mr K.C.S. Paniker was instrumental in envisioning and creating Cholamandal Artists' Village, and I am most grateful for that. Then, as a Cholamandal artist moving into metal sculpture, I was influenced by the sculptors, Nandagopal and Janakiram. Later, in the US, I found the work of Alexander Calder and David Smith inspirational. For both my personal and professional

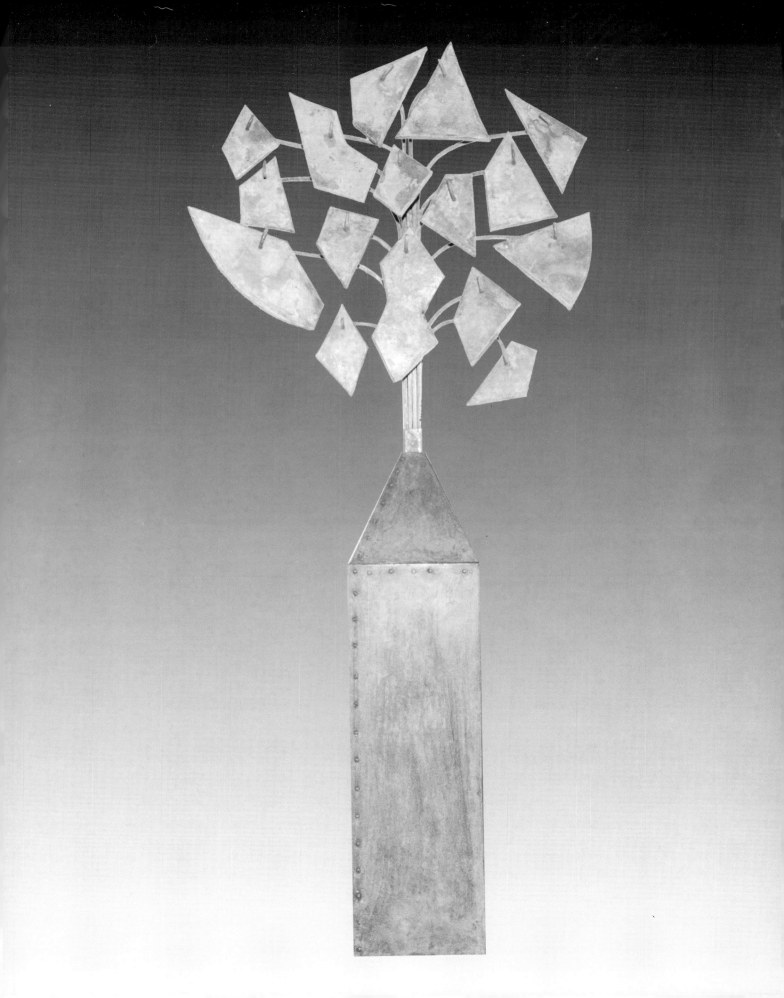

Cactus ▷
(Beaten and riveted copper)
2001

life, a warm couple, Gene and Harriet Spagnoli, have helped me very much over the years. And, I shouldn't forget one thing: Cathy was about to leave India from Delhi, but at the last minute, she decided to return to Madras and thus became part of my life. So a big thanks to her. Our story makes one believe in karma.

C.S.: How is the role of art different in the US and in India?

S.P.: The US produces enormous amounts of material wealth. But the arts are not neglected either: states spend huge sums to build and renovate art museums, art is designed right into new building budgets, and school boards usually provide art supplies and teachers. I have been in several schools in the US—every one of them looks like an art museum.

Modern art shows are much appreciated. In downtown Seattle, there are many galleries specializing not only in painting and sculpture, but in photography, glass and other media. Exhibitions are usually for one-month periods (unlike the shorter periods favoured in India) and all new shows open on the first Thursday of the month. These openings draw huge crowds, and the Seattle Art Museum stays open that night, free to all. Some brave artists even display their works on the sidewalks, and in nice weather, music and street theatre add to the fun.

I am not trying to compare and say that there is no art in India. There is, in each and every village. But the arts, including modern art, are a part of American society in such a way that universities give the same importance to visual art degrees as to those in engineering. Everybody can have an opportunity to learn and create art.

C.S.: Are the materials of art similar in the two countries?

S.P.: The wealth and range of materials make a big difference. Americans waste more, while Indians are very resourceful. Several years back, I had an opportunity to show my work at Bumbershoot Arts Festival, the biggest art event in northwestern US. Several artists there created a typing pool with typewriters under

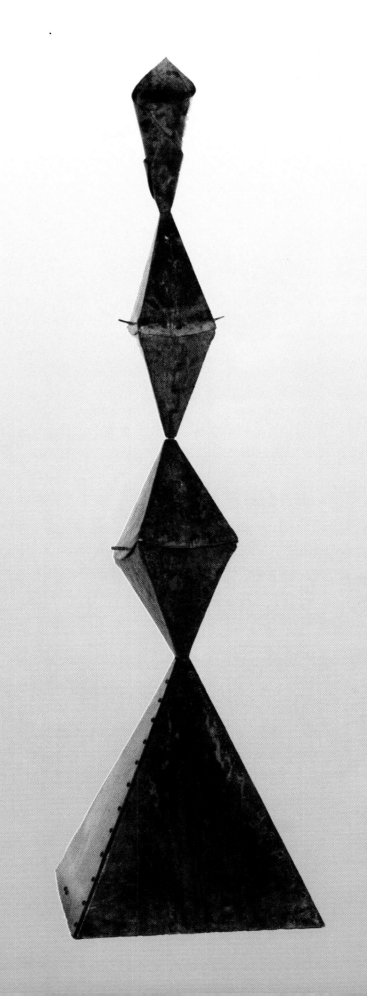

Bird ▷
(Cast bronze and copper)
1985

water, above water, floating on the wall, on the grass, on the steps—more than a hundred of them. One can wonder how much time it took to collect all those typewriters, probably not too long. And I'm sure most of them worked well. At the end of the show, all were piled up and thrown away. That is how one cares about materials in the US.

But there is one gallery I'd like to mention, where resources, including human energy, are used wisely. The gallery Art Not Terminal was started about twelve years ago by a group of artists who worked at various jobs for their bread and butter. They all wanted to show their art when they pleased, without going through a selection process. Staffed and beautifully maintained entirely by volunteers, the space is provided by the city for a nominal rent and located in a nice part of downtown Seattle. Although the artists earn their living as house painters, carpenters, electricians, or office workers, their faith in the arts is unquestionable. Most of them show regularly along with newcomers, paying a small fee and never dreaming about sales. It is an inspiring space.

C.S.: How do the lives of artists differ in your two worlds?

S.P.: At Cholamandal, since the seventies, according to young artists I've talked to, things have changed little as far as survival is concerned. One still waits for the sale to come, even though serious buyers always look for an established name. Art materials in India are very expensive compared to the income. Any sale that comes through for young artists seems only to pay their food bills. In India there is a limit to what one can do and buy on such a tight budget. If a young artist at the beginning of his career could afford to buy a decent car for just under 4,000 rupees, I'm sure he would do any job that came along.

In the US, at the turn of the century, the automobile industry giant, Henry Ford, thought that 'the guys who made the cars ought to be able to afford one themselves so that they could go for a spin'. His ideals influenced many and gave Americans

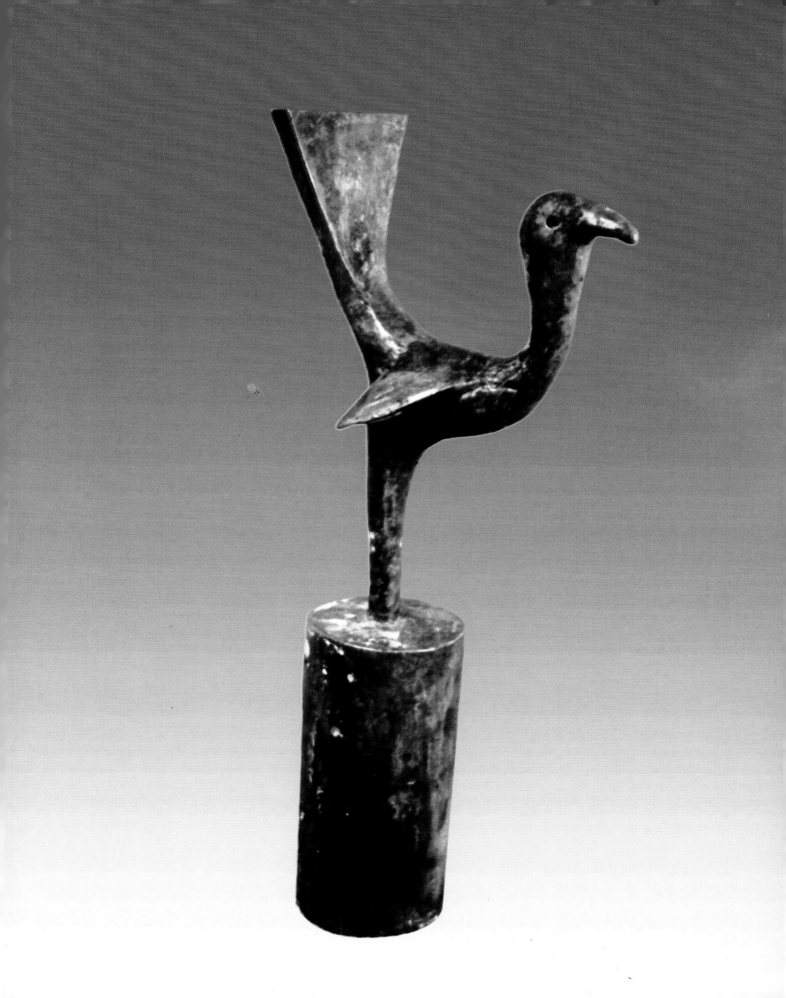

a new definition for the word basic. In the US, even a cup of coffee is cheap, compared to any salary. I can buy chunks of casting bronze for only a little more per pound than coffee, while a tube of oil colour costs less than an hour of a carpenter's pay. There are various tools artists can buy without spending a fortune; one can even cut mounts, and frame one's own artwork. Art stores offer free or low-cost workshops on a regular basis, teaching everything from canvas priming to portrait painting.

However, since there are large numbers of American artists, most find it hard to make a living from their art and so look for part-time work. The greatest American sculptor, Alexander Calder, trained as an engineer and worked first in a field unrelated to his art. My friend, Mike Devoe, who gets commissions for public art and has fine arts degrees from prestigious colleges, supplements his income with carpentry work. And I, too, have done other work at times in the US: giving workshops in schools, catering, and building our island house.

C.S.: What about the next generation growing up at Cholamandal—will it keep the spirit of Cholamandal alive?

S.P.: There are more opportunities now. There are a number of young adults over the age of twenty who are members' children living in or near Cholamandal. Several of them are into art or related activities. There are also younger children, still growing up in Cholamandal—I'm sure some of them may become artists. I don't know much about the offspring of members who live far from the village. However, there are a number of young artists from abroad who, although non-members, are all active residents of Cholamandal. Cholamandal encourages them by displaying their work and providing some housing or studio space. Thus they may also be part of Cholamandal's future.

S. PARAMASIVAM

1942 *Born in Gudiyattam, Tamil Nadu.*

1966 *Becomes a life member of Cholamandal Artists' Village.*

1967 *Diploma in Fine Arts, Government School of Arts and Crafts, Madras.*

1968 *Prize at the All India exhibition of Art, Kerala.*

1977 *Settles in Seattle, USA.*

1981 *Prize for Sculpture, Mercer Island.*

1982 *Prize for Sculpture, Ocean Shores; Pelican Bay Gallery, solo show, Seattle.*

1983 *One man show, Greenwood Gallery, downtown Seattle.*

1988 *Bumbershoot show, WA, Seattle Urban League, WA; International Art show, NY; Mercer Island Visual Arts League, WA; National Art exhibition, New Delhi; Tibals of Water Street, Pt, Townsend, WA.*

1989 *Honourable Mention, Mercer Island.*

1990 *Show in Osaka, Japan; 'Metalist Conflux' Pratt Gallery group show, WA; Pacific Northwest Art Show; Bellevue Art Museum, WA; International Art Show, Whatcom Country Museum, WA.*

1991 *Show at Chola Gallery, Madras; Madras State Lalit Kala Akademi Annual show; 'Madras Metaphor' exhibition organized by Ebrahim Alkazi at Art Heritage Gallery, New Delhi.*

1993 *Featured in the book* The Madras Metaphor *by Oxford University Press.*

1998 *Featured in the book* An Algebra of Figuration *by Oxford University Press.*

2002 *'Sculptural Configuration—Prospective/Retrospective', exhibition at Chola Sheraton, Chennai and featured in the catalogue released by OUP at the event.*

Cathy Spagnoli is an American storyteller who has travelled widely in several countries, especially in the US, Canada, Japan, Korea, Thailand, Singapore and India, researching and telling stories. She lives in Seattle, USA, with her sculptor husband S. Paramasivam. This interview took place in 2002.

PETER

M.J. Peter

M.J. Peter was born to liberal-minded parents in an orthodox Christian community in Kerala in 1930. When he received the SSLC certificate after his ten formal years of school study, he was already bubbling with an artistic fervour waiting to be channelized.

Finding no real support or guidance for such an ambition, Peter himself embarked on a work-cum-study programme in his home town. He grabbed the first opportunity that came his way when renowned photographer and Malayalam filmmaker Parameswaran Nair offered to teach him photography. Temporarily abandoning the idea of becoming a painter, Peter set about establishing a photo studio to support himself financially. It was while working at the studio that he came in contact with the artist Vasudevan Namboodiri, who was working in those days as an illustrator for the *Mathrubhumi Weekly*. Peter started sketching and painting under Namboodiri's guidance once a week for a couple of months. Realizing the inadequacy of such a mode of instruction, Namboodiri advised Peter to join the School of Arts in Madras in 1964.

Peter had heard that K.C.S. Paniker was the Principal of the School of Art in Madras then, and was further motivated to seek admission there in 1964. The first year was one of financial hardship, but from the second year he received a scholarship awarded by the University of Madras.

Still Life ▷
(Pastel on paper)
1967

Hailing from the state of Kerala, which had elected the first communist government in India in 1950, Peter was already familiar with and an ardent admirer of leftist political ideology. His contemporaries in the School of Arts remember him as an active participant during the charged debating sessions at the college cafeteria. With his training in photography, he was also a much sought-after photographer for documenting the artists' works on the campus.

The School of Art had a vibrant atmosphere. The same sense of enthusiasm pervaded the premises of the Lalit Kala Akademi on Subbiah Naidu Street in Vepery, one of the quainter areas of the city at that time. It was a meeting ground for young artists to try out and learn new skills. Peter lived in a rented room very close to the Akademi and had fellow artists like Balan Nambiar and A.C.K. Raja for company. It was in such an invigorating environment, when the idea of Cholamandal was born, that Peter volunteered to be one of its founding members.

After completing his course, Peter went back to Kerala and took up a job as an art teacher at the Udyogamandal School run by the FACT industry in the township of Alwaye. He stayed in that job until he retired. Cholamandal always beckoned him and he would visit the place whenever he could, endorsing the many plans and programmes of the community's Association. But now, age and indifferent health keep him in his hometown in Kerala, although the spirit in him keeps his artistic search alive.

K.N. Damodaran

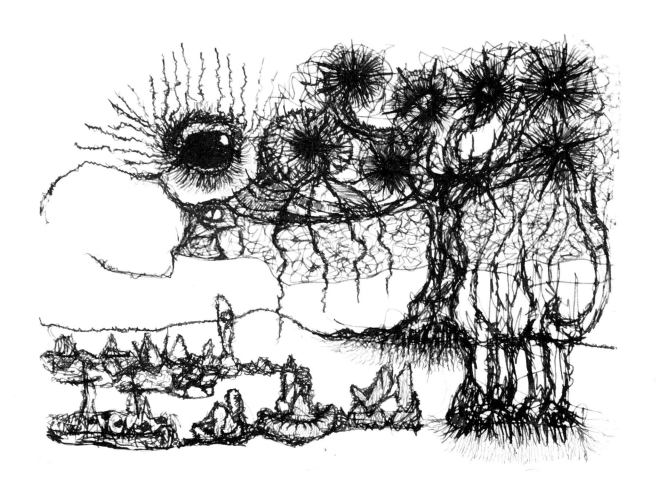

△ *Landscape*
(Ink on paper)
1968

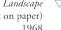

Landscape
(Ink on paper)
1968

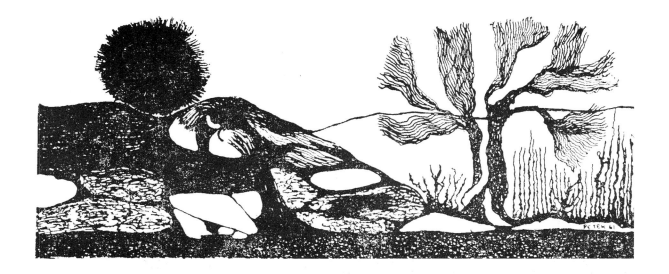

M.J. PETER

1930 *Born in Kerala.*

1947 *Passes the SSLC exam; learns photography from Parameshwaran Nair, the photographer and Malayalam film producer; establishes his own photo studio.*

1963 *Apprentices under painter Vasudevan Namboodiri and learns the fundamentals of art.*

1964 *Hears about K.C.S. Paniker and the Madras Movement in Art and joins the School of Arts and Crafts, Madras; awarded a scholarship by the University of Kerala.*

1966 *becomes a member of Cholamandal Artists' Village and buys a plot of land.*

1969–90 *Teaches at the Udyogamandal School run by the FACT industry in the township of Alwaye.*

1990 *Settles in Trichur, Kerala.*

K.N. Damodaran graduated in painting from the Government School of Arts and Crafts, Madras, and became an instructor in the College of Fine Art, Trivandrum. He later became a lecturer at the Institute of Fine Arts, Trichur, Kerala. The article was written in 2001.

RAMANUJAM

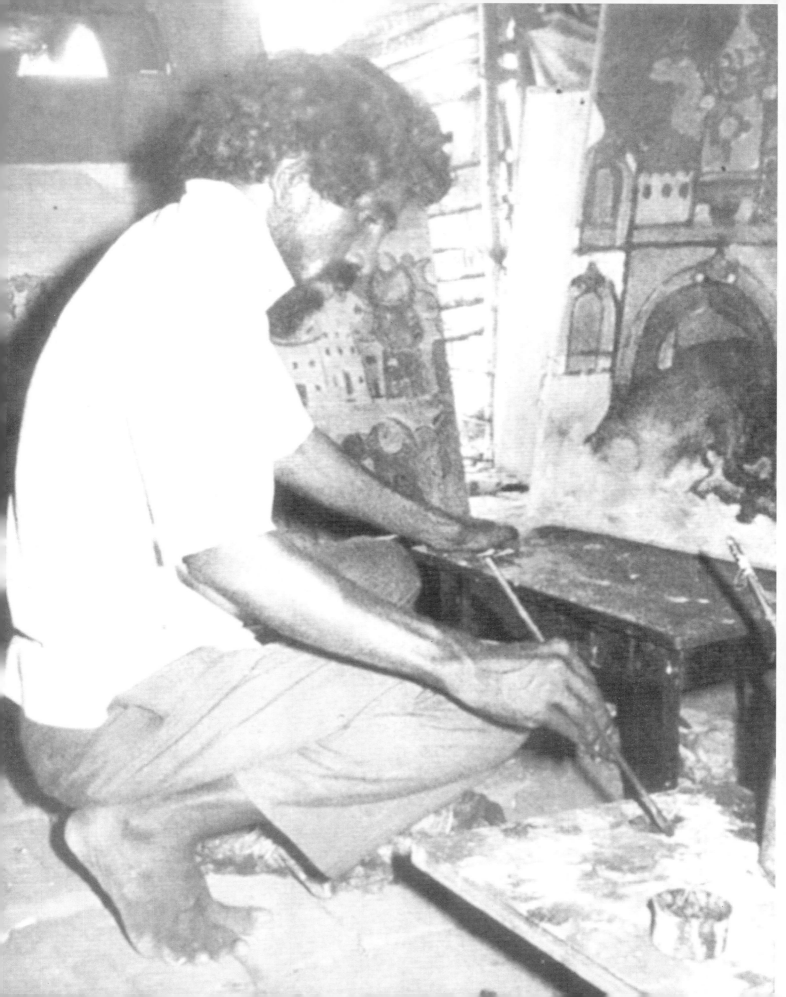

K. Ramanujam

K. Ramanujam died on 4 June, 1973 at the age of thirty-three, after taking his own life. He was cremated at the Triplicane burning *ghat* the next day.

Two of his canvases still lie incomplete. In one, he had sketched a fantastic elephant raising its trunk in salutation. The last picture he completed was a drawing, clouded ominously with soft black formations, peopled with strange creatures, and himself moving strangely in it with the body of a dog.

Ramanujam was born a retarded child into a fairly orthodox Iyengar family in Triplicane, Madras. His speech was never distinct and in comprehension unusually tender, vivid, but tearfully at odds with that of those around him. He could not cope with school, and had to give up after middle school. Adolescence and manhood took hold of him, and he turned into a puzzle. Of slight build, shoulders drooping, he slouched along absorbed all the while in the fantastic working of his own mind. Because he had shown an interest in drawing, his parents brought him to the School of Arts and Crafts at Madras, and K.C.S. Paniker, who was principal at that time, took him as a student.

He quickly absorbed the craft of drawing and painting and began to churn out pictures, one after the other, in an almost continuous stream: each picture a meticulous record of the 'dream' that gently carried him along. They were filled with strange presences, in the form of penguin-like birds, fat snakes, the horned head of a bull, and every now and then a clock showing time. He knew what these meant because he drew them with an absolutely certain line, coloured them, as in

Untitled ▷
(Oil on canvas)
1968

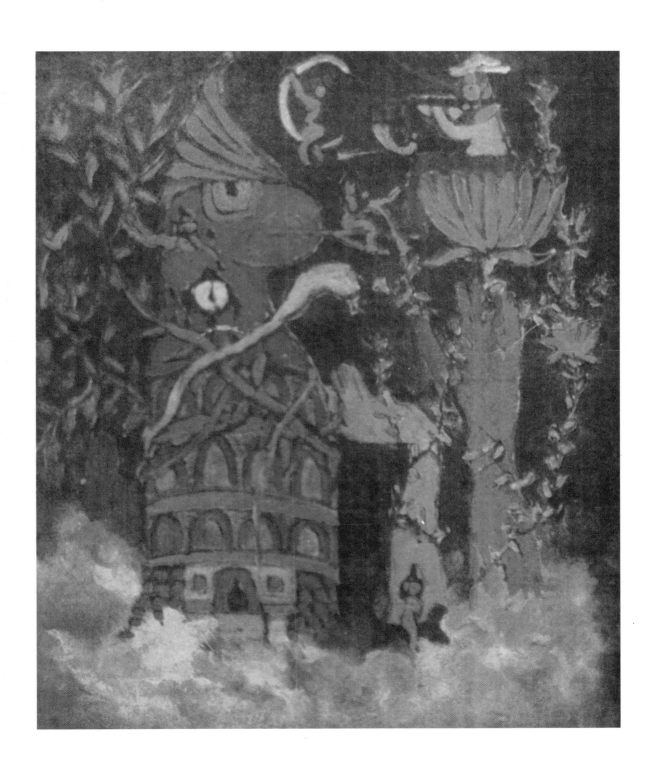

his early oil paintings, with bold fresh colour. In his execution, right down to the minutest detail, there never was any doubt or indecision. Such assurance could sometimes overpower, as his last black and white drawings show.

At art school, relieved of his domestic circumstances, Ramanujam made efforts, quaintly, to find himself among other people. He changed his manner of dress—from *dhoti* to pyjamas—tasted meat, and could be found sometimes in the adjacent compound of St Andrews Church, all alone, teaching himself to smoke.

He began to appear in his pictures—making peace between warring penguins, passing through clouds on some winged creature, resting in the palm of a huge anonymous hand. Always smartly turned out, with a cigarette stuck in his mouth. In a series of remarkable wash drawings at this time, Ramanujam spoke of the utmost tenderness, the wholly unguarded love of a child, in fear and fantasy. He confided in K.C.S. Paniker, who tended him and stayed close to him: 'The army of muses came in search of me and from this shadow of the tree of shell I looked on them in sadness,' 'I rested in the palm of a hand and the creepers gave me shelter,' and 'Their memories heaped on me tier on tier, yet sweet the beloved burden.'

These ideas Ramanujam expressed in his Tamil to Paniker, who translated them to make titles for his pictures.

He would very often not go home from art school. He would be found sleeping on the pavement, on several occasions without having had anything to eat. He would at times sell his pictures to a fellow student for five rupees or so; the fellow student would paint it over with plastic emulsion to do his own painting.

But Ramanujam's work was getting to be known. Visitors to the arts school were surprised by his pictures. George Butcher, critic, Arts Council of Great Britain, was struck by Ramanujam's work, and picked up his paintings immediately to be shown at the Commonwealth Arts Festival. While yet a student, Ramanujam was awarded a national scholarship by the Ministry of Education. He began to sell and earn.

▽ *Resting in the Beast's Mouth*
(Oil on canvas)
1968

Coll.: Bhaskar and Sumitra Menon,
Beverly Hills, California.

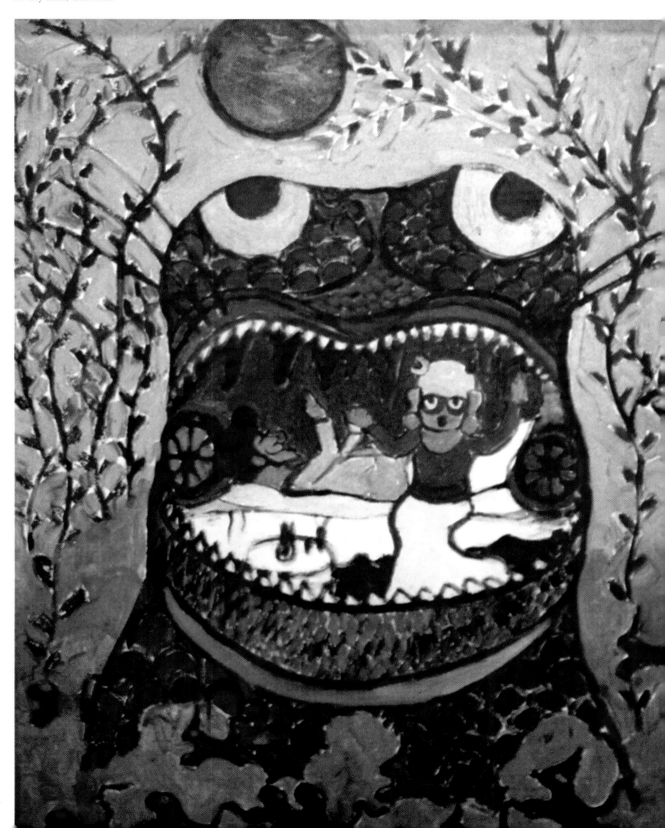

Tribute in the press ▷
on Ramanujam's demise
1973

In 1964, he finished his course. He rejoined his fellow artists at the artists' village in Cholamandal, and carried on painting. His pictures were shown at a national exhibition in Delhi, and international exhibitions in Copenhagen, Oslo, Vienna, and Eastern European countries. His pictures were acquired by the State Lalit Kala Akademi and by a very large number of collectors, both in India and abroad. He received commissions. One of them, almost a wall-sized mural, the largest he ever did, can be seen at the Connemara Hotel in Madras. He was hailed in other centres of art, like Baroda and Delhi.

But much of all this he could not make out. His pictures kept speaking of the fearful loneliness.

Ramanujam could hardly be influenced. But for a regard he expressed, now and then for Chagall, it was as if other painters did not exist. He read almost anything he could get at in Tamil, and drew from such sources as mythology, *Chandamama* stories, palmistry, Tamil films and things that he would pick up, like shells, or the maze of veins of a dead leaf, to cast his 'dreams'.

These he used during the last two years, to realize dreams of the most uncommon splendour; the palace deep under the sea lit entirely by rays of the jewels worn in the hair of the queens, luxuriant foliage hanging from the walls of a palace that stood up on long white pillars that grew wings and swayed slightly.

In these pictures, there began to appear a force that was threatening to take a hold of him. This was the power of his own craft, his own ability as a painter. His skill turned increasingly ruthless. It became harrowing and he was estranged.

Ramanujam sought to feel life. He spoke about finding a bride. He wished there would be someone who would help him. He wanted to paint differently. He wanted to change completely.

The last drawing that he did was a struggle. It had come on suddenly, hopelessly, and he did not last.

Josef James

8 THE INDIAN EXPRESS Saturday JUNE 9 1973

SATURDAY PAGE

ART

Not to be able to do more than one thing well can sometimes be an advantage in creative work. It can invest it with an edge, intensity and dimension. A painter with this awesomely constricted mental spectrum tends to be a lonely soul, for the world has a trick of being brusque and impatient with him, driving him deep into his own inner self seeking refuge. Ramanujam was cruelly handicapped in many ways. It astounds one to think how he bore his cross for 33 years. Like Maugham's Strickland, he clutched his solitary gift of painting like a drowning man a straw. His work already seems to assume a new dimension after his death, for it is pointed in message and guileless.

k ramanujam

in fear and fantasy

K. RAMANUJAM, painter, aged 33 died on Monday, June 4. He took ill suddenly in the early hours, he was rushed to the hospital but in a few hours, he was no more. He was cremated at the Triplicane burning ghat the next day in the afternoon.

He had not completed two canvases he was working on; in one of them he had sketched a fantastic elephant that raised its trunk in salutation. The last picture he completed was a drawing, cluttered enormously with soft black formations, peopled with strange creatures and himself moving strangely in it with the body of a dog.

Ramanujam was born, a retarded child into a family embodying fierce spirit in Triplicane Madras. His speech was never distinct ... he could pronounce phrases he ... which only fully at odds ... around him. He ... to school, and ... himself after ... from a girl ... and to ...

... along absorbed all the while in the fantastic working of his own mind. Because he had shown an interest in drawing, his parents brought him to the School of Arts and Crafts at Egmore and K. C. S. Panicker, who was the principal at that time, took him as a student.

He quickly absorbed the craft of drawing and painting, and began to put out pictures, one after the other, in almost a continuous stream each picture meticulous record of the "dreams" that gently carried him along. They were filled with strange creatures, in the form of elephants, ... the sexes, horrible heads of a bull and every animal that a child, seeing them, fear. What these meant because he drew them with an absolutely certain line, coloured them, as in his early oil paintings, with a bold fresh colour. In his execution, right down to the minutest detail, there never was any doubt or hesitation. Such insistence could sometimes overpower, as the last stretch of his black and white drawings show.

At the Arts School, relieved of his domestic circumstances, Ramanujam made efforts, quixotic, to find himself among other people. He changed his manner of close-crown shirt to polished, tailored trousers and could be found sometimes in the adjacent compound of St. Andrews Church, all alone, teaching himself to smoke.

He began to appear in his pictures—making peace between mankind, peaceably, passing through clouds on some winged creature, resting in the palm of a huge mysterious hand. Always heavily framed too, with a cigarette stuck in his mouth. In a series of paintings each drawing at this time, Ramanujam spoke of the utmost tenderness, the wholly unguarded love of a child, in fear and fantasy. He confided in K.C.S. Panicker, who beckoned him and stayed close to him.

"The story of snakes came in search of me and from the shadow of the tree of shelf I looked on them for comfort. I rested in the palm of a hand ... the overseas gate the snakes ... their monsters creped on me and ...

tier on tier, yet sweet the beloved burden.

These ideas Ramanujam expressed in his Tamil to Panicker, who translated them to make titles for his pictures.

He would very often not go home those days from the Arts School. He would be found sleeping on the pavement, on several occasions without having had anything to eat. He would at times sell his pictures to a fellow student for five rupees or so; the fellow student would paint it over with plastic emulsion to do his own painting.

But Ramanujam's work was getting to be known. Visitors to the Arts School would be taken aback by his pictures. George Butcher, the critic of the Arts Council of Great Britain, when he visited the Arts School, was struck by Ramanujam's work, and picked them up immediately to be shown at the Commonwealth Arts Festival. While yet a student, Ramanujam was awarded national scholarship by the Ministry of Education. He began to sell and earn.

In 1964, he was finished with the Arts School. But he rejoined his fellow artists at the artists Village in Cholamandal, and carried on painting. His pictures were shown at the National Exhibition in Delhi, and international exhibitions in Copenhagen, Oslo, Vienna and Eastern European countries. His pictures were acquired by the State Lalit Kala Akademi and are in a very large number of collections, both in India and abroad. He received commissions. One of them, almost a wall-sized mural, the largest he ever did, can be seen at the Connemara Hotel in Madras. He was hailed in other centres of art, like Baroda and Delhi.

But much of all this he could not make out, his pictures kept on telling of the fearful loneliness.

Ramanujam could hardly be influenced. But for a regard he expressed now and then for Chagall, it was as if the other painters were not there. He read almost anything he could get at in Tamil, and drew from such sources as mythology, "Chandamama" stories, palmistry, the sets of Tamil films and things that he would pick up, like shells, the shapes of teeth of a dead leaf, to feed his "dreams".

These he used during the last two years, to realise "dreams" of the most uncommon, splendour the palate deep under the sea is entirely by the rays of the seven worn in the hair of the queens who lived there, luminant palace hanging from the walls of the palace that stood on its long white pillars that grew wings and slightly swayed, and others.

In these pictures that Ramanujam began to do, there began to appear a force that was threatening to take hold of him. This was the power of his own craft, his own ability as a painter. His craft turned increasingly ruthless. It became harrowing and he was estranged.

Ramanujam sought then to find his life. He spoke off and on about finding a bride. He wished here would be someone who would help him in his pursuit of carried differently. He wanted to change completely.

The last drawing that he did was a struggle. It had come on suddenly, hopelessly, and he did not last.

By Our Art Reviewer

Serpent ▽
(Drawing on paper)
1968

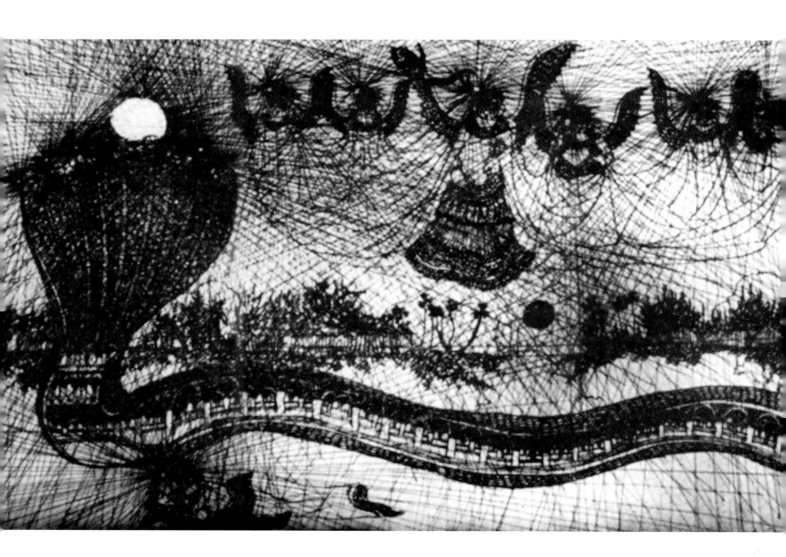

K. RAMANUJAM

1941 *Born in Madras.*

1962–64 *National Scholar.*

1965 *Participated in the Commonwealth Arts Festival in London; National exhibitions of Art of the Lalit Kala Akademi and in the group shows in Bombay, Madras and New Delhi; collections in the National Gallery of Modern Art, New Delhi, State Lalit Kala Akademi, Madras, and Gallery Chemould, Bombay; executed three mural drawings for the Hotel Connemara, Madras, commissioned by the architect Geoffrey Bawa.*

1973 *Passes away in Madras.*

The article on K. Ramanujam was written by Josef James, the editor of this book. It was published in the *Indian Express*, Madras, as a tribute to the artist when he took his life on 4 June, 1973.

REDDEPPA NAIDU

M. Reddeppa Naidu

Modern Indian art in its postcolonial phase had to battle with tensions of tradition vs modernity, Indian vs Western, progressive vs conservative, globalism vs localism. In India, after the nationalist discourse, the projection and preservation of an indigenous cultural heritage had become the dominant centrality within the context of a Third World paradigm and multiculturalism. Postcolonial identity as a process of self-reflection became a persistent questioning of the frame and space of this representation.

Indigenism as an ideological concept was an imperative move for postcolonial people to reclaim their dignity and liberty. Indigenism as an attitude change was thus most predominant in the region south of the Vindhyas. In Madras, K.C.S. Paniker, principal of the Madras School of Arts and Crafts, a visionary, theoretician and a dynamic leader in the initiation of the Madras Art Movement, was largely disillusioned by the influx of modern styles, ideas, and their pastiche. He seriously turned inwards for a dialogue with traditon. In constructive debates and arguments with his colleagues and students, he exercised his persuasive pedagogy to reclaim and reinvent their indigenous sources and create art that would be 'Indian in spirit and world-wide contemporary'.

Amidst such upheavals, one artist who made a notable contribution to the 'indigenist' discourse within the Madras Art Movement was Reddeppa Naidu. A traditionalist with a modern sensibility, his art was born out of a restlessness that

Deity ▷
(Oil on masonite board)
1971

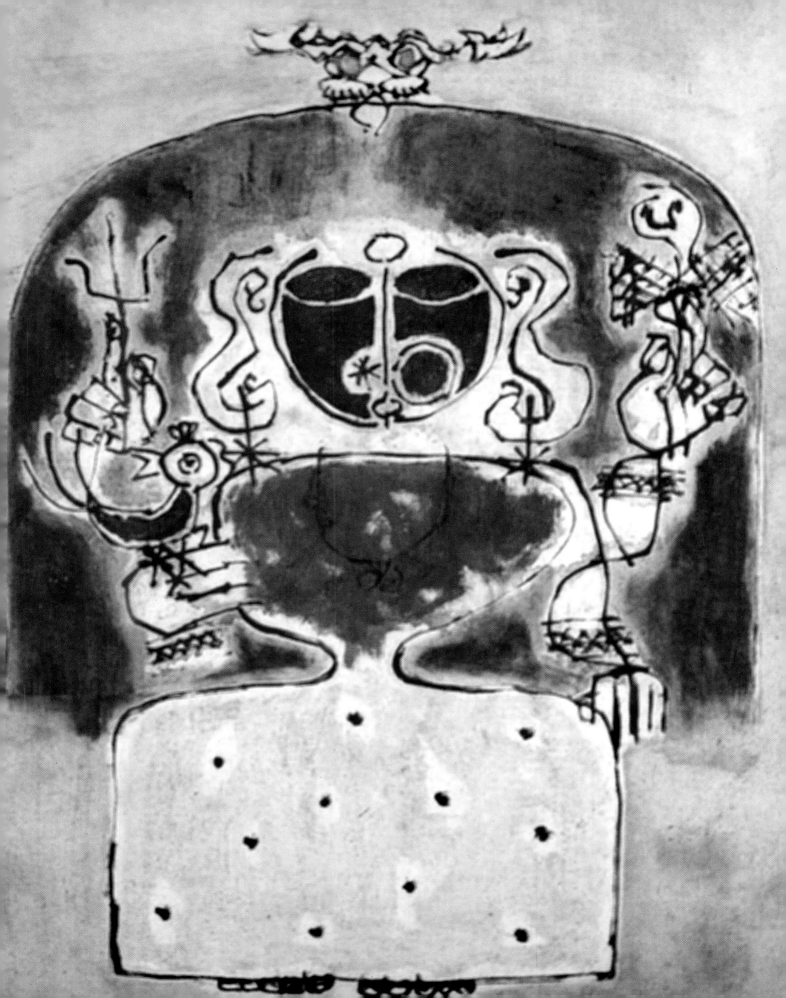

Godavari ▷
(Oil on masonite board)
1972

based its inquiry on tradition and its innovative adaptation and reinterpretation within the modern paradigm. This duality of tradition and modernity was crucial for him since his roots were within a culture that had one of the longest civilizations. In this respect his sensibility, personal vision, and individual imagery distinguished his art within the nation's mainstream. His place within the Madras Art Movement is influential to the same degree as Paniker's was with his contribution of the *Words and Symbols* series.

Reddeppa's early education was in the village of Kapulapalem in Andhra Pradesh and later at Vinjaram, renown for its Telegu literati. This exposure at an impressionable age opened up for him vistas for comprehending the spirit behind the traditional arts and crafts. These formative experiences proved crucial for Reddeppa's artistic journey as he had to log these memories to bring them in the service of rethinking and reinventing mythologies and iconic forms for defining the question of 'identity' and 'authenticity' of modern art within mainstream internationalism.

A notable feature of the art institution where Reddeppa studied from 1955–1960 was that it provided an ambience for free experimentation. The students were allowed a free ride with their creative predilection. There was no rigid curriculum to be doggedly pursued, allowing both the teachers and students an autonomy, which proved beneficial as it did with Reddeppa Naidu.

Consequent to this freedom, Reddeppa Naidu delighted in rendering the genre of routine activities observed at local markets, by the sea-side, the activities of street urchins, cockfights, or jostling women at the water tap. He rendered these scenes impressionistically, capturing spontaneously the spirit of the moment with broad strokes in palette knife. These titillating genres offered space for creative experimentation, bringing him to the notice of Paniker who, enthused by the dynamic vision of young Reddeppa, made him a member of the Progressive Painters' Association in 1956.

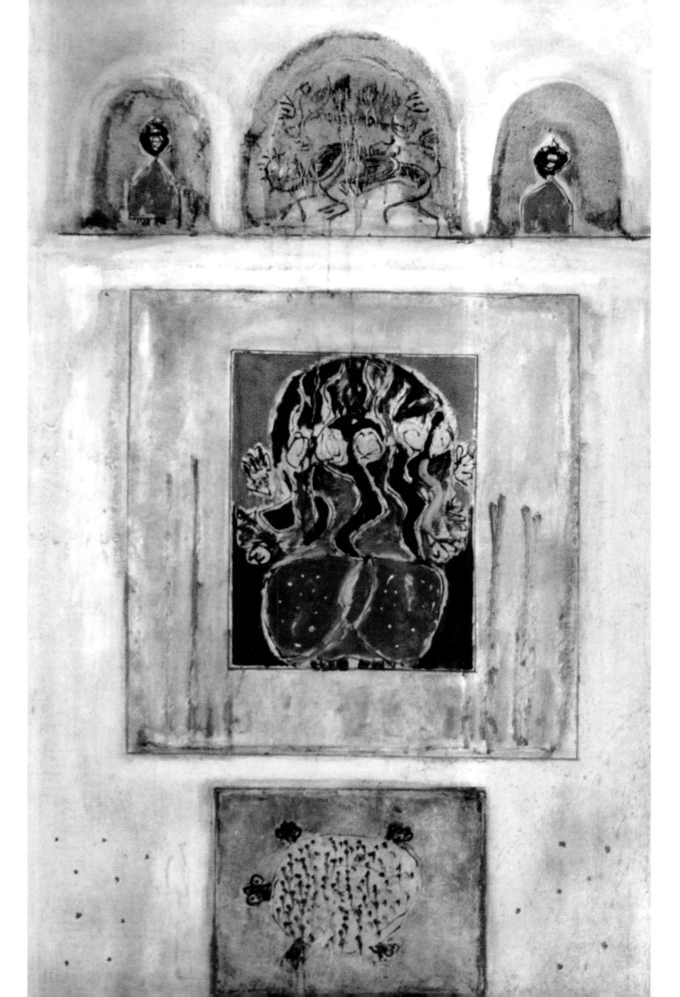

The Spire ▷
(Oil on board)
1963

The early sixties was a period of intense search not only for Naidu but also for Paniker. Paniker primarily aimed at exploring new possibilities for the visibility of southern artists on the national scene, defining the regional modern within the national milieu, and to counter American hegemony in the body of abstraction as practiced by New York artists. It was during this phase that Reddeppa also came under the spell of cubism. The shifting geometric planes and the conceptual viewpoint attracted Naidu since it negates the tyranny of optical truth leading to an emphasis on design and patterning. Reddeppa's choice of architectural themes, particularly of churches, went parallel with cubism and he painted the St Thomas Cathedral and the St George's Cathedral, the two landmarks in Madras. In both these works he laid emphasis on the soaring tower. The other architectural elements were rendered distinctly with a few sketchy brush-strokes loaded with grey colour.

In 1962, he was invited to become a founder member of the Group 1890 (the number of the house where the meeting was held), which emerged at Bhavnagar under the militant leadership of J. Swaminathan. Its significance was that it was not formed on any regional or other considerations but on the basis of an ideological affinity. The Group 1890 was a search towards an answer for the problematic Indian identity within the larger consciousness of internationalism. It was not a stylistic movement and its intent was critical introspection to break the hegemony of the Paris School. Swaminathan invited Reddeppa Naidu to be a member and a representative from the south. The decision to invite artists from other centres stemmed from strategic concerns. Swaminathan's invitation to Reddeppa Naidu was based on his admiration for his works and a resonance of his ideas. Reddeppa was influenced by the ideology of the Group 1890 and a poet friend facilitated his restless search at this juncture by gesturing towards the ubiquitous presence of Balaji at Tirupathi as a visual mine for a modern interpretation of iconic and mythic subjects.

Reddeppa Naidu, through his close scrutiny of Indian canonical and traditional

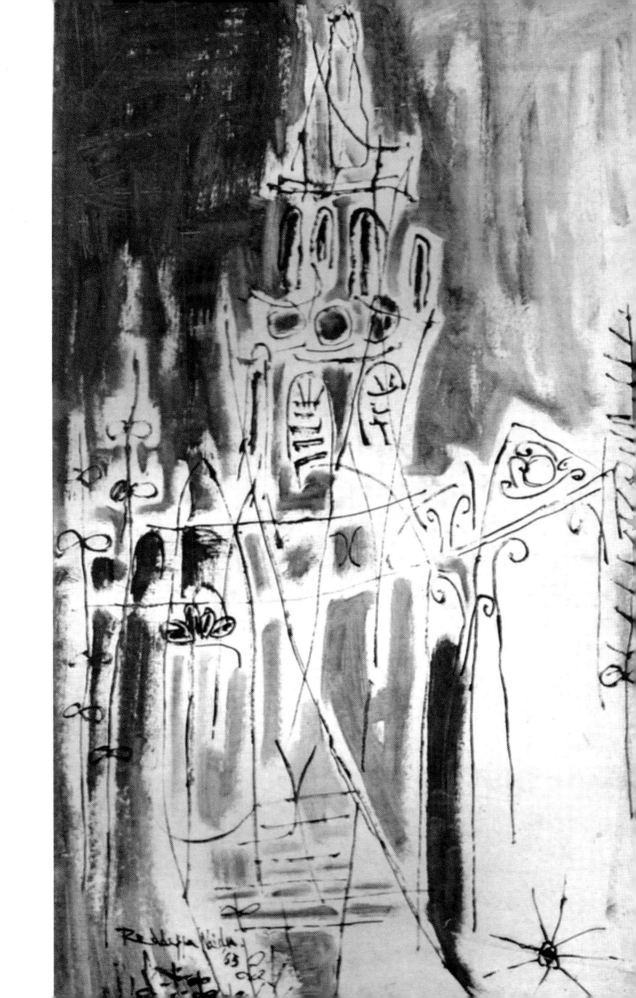

folk art forms, realized the versatility of line and made it a dominant tool for the mediation of his creative expressions. The discourse on line was a major agenda within the locus of the Madras School of Arts and Crafts with Paniker, Munuswamy, Santhanaraj, and Dhanapal. The nervous, flighty, lyrical, energetic, and constructive line was melded with diaphanous colours to create an aura of sheer poetic lyricism.

Reddeppa's initiation towards the study of iconic forms as desacralized images was instrumental in charting an innovative trajectory for his art. For him the external shape of the iconic deities was a dead crust, since he was primarily seeking to go beyond to represent the spirit of humanity ensconced with these forms. Says Reddeppa, 'I decided to go deep into the subject and after reading the Indian epics and Puranas to which these religious forms are related, I made up my mind to paint more of these while freeing them from all their earlier context and achieving a purely aesthetic expression. This was a journey that introduced me to a new kind of imagery…, that lay in the iconography of our region in terms of beauty and lyricism.' This explains the broad generalization of his forms that were bereft of details with broken lines and shapes that gestalt.

Thus his *Deity* series (Devi and Ganesha) of the sixties was an attempt to move away from the problem of 'representation' to 'essentializing' the iconic forms that would not indicate any sanctimonious value. Over the years, Reddeppa had internalized the human form, engendering the possibility now of intuiting the image as an abstraction. He therefore dematerialized it but maintained a semblance of identity. Durga as a deity was not the traditional image but projected as a personalized conceptual imagery. Since Reddeppa Naidu's cultural politics operated on the terrain of tradition, in his iconography he pushed the concepts to pure aesthetic expressions. Evidently textures of tradition change with history, productively contextualizing his modern sensibility within Indian iconographic and narrative sites. Reddeppa personalized his imagery with an innovative visual

▽ *Sakuntala*
 (Ink drawing on paper)
 1997

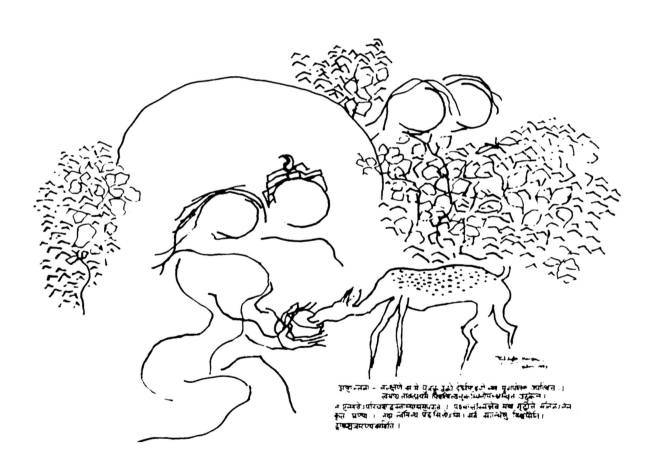

vocabulary through the constructive integration of iconic and narrative elements, together with folk art essentials evidenced in village deities and other ubiquitous symbols as snakes, parrots, and triangles.

The *Deity* series was followed by the *Musician* series (mid-sixties) in which Reddeppa pointedly explored the spirit of music as personified by musicians in their wholehearted absorption with their art. Reddeppa considered music to be one dimension of human creativity enabling the versatile mind to initiate a journey from within for deep introspection. In this series, Reddeppa explores the manifest abstract qualities of sound through his personalized broad generalization of form, in which faces are traced without specific features, and the form and stance eloquently convey the spirit of the whole. Says Reddeppa, 'I don't want to fix limitations on their expressiveness. They must challenge the viewer to complete the picture with his own imagination.'

The visualization and rendering of select passages from the Mahabharata and Ramayana epics was a trope, a turning away from the iconic or other regional art forms towards a tradition in narration. In these large canvases he attempted to conflate the cultural values in the epics with experiences of his modernity. Undoubtedly these epics have been read and meditated upon through centuries, but its visualization in contemporary vocabulary marks it as novel, innovative, and different.

On the instruction of the patron Deendayal, Reddeppa Naidu illustrated the eighteen *parvas* from the Mahabharata (1972–74) and fifteen episodes from the Ramayana (1974–86). These *parvas* had a special significance for Reddeppa as they concerned human frailties and efforts were required to transcend them in the realization of truth.

Reddeppa, in attempting to bring forth the concepts to the canvas, meditated ascetically for hours. His wife recalls the moments of anguish and despair when

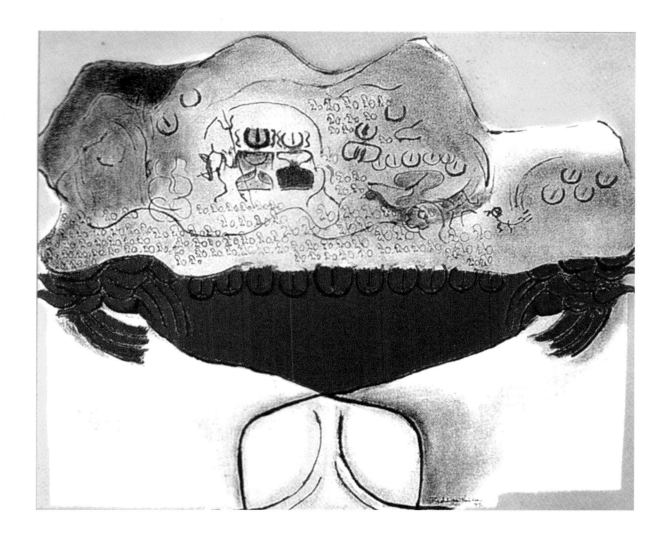

△ *Ramayana*
(Oil on canvas)
1978

he went through the agonies of conceptualizing and finally delivering on canvas the various imageries from the depth of his consciousness. She says, 'He lived in the painting. He would never give up unless he felt satisfied by the joy of its materialization. He was like a mendicant deeply absorbed, grew a beard and was blissfully unaware of his surroundings. It is easy to do one Rama and one Krishna, but to visualize them in thirty-four canvases was a Herculean task.' This clearly reflects the modernity of the artist in his anxiety to have his concepts creatively realized and living on the irreducible dimension of the canvas, significantly also as designs and patterns.

In the mid-nineties, Reddeppa Naidu who had responded innovatively to the mythic tales and legends, moved towards the picturization of the female character. His point of reference was the monumental work of Sanskritic literary genius Kalidasa's *Abhignanasakuntalam*. This series of fifteen canvases and four line drawings (1994–95) were not an ode to a woman's love. It projected her core of emotional inner strengh, her tenacity, resilience, patience, and unending endurance towards her loved ones. This series was the product, consequent to his illness, when his devoted wife and daughters unflinchingly took care of him and revived his frail health. Says Reddeppa, '*Sakuntalam* as a story exists in the *Adiparva* (Mahabharata). Sakuntalam lives in one form or the other in every home of this country. Hence these paintings are a tribute to the women of India.' Reddeppa, by creating the female-centred canvases was not playing upon the theory of 'patriarchal' dominance, nor was he valorizing the woman in her all-encompassing role. He pays an overarching tribute to her selflessness in every exigency.

In addition to his signature line and lyrical colours, Reddeppa in his epics and *Abhignanasakuntalam* series has inscribed verses in the Sanskrit and Devnagiri scripts. This calligraphic juxtapostion with imagery enhances the stylistic character of the painting.

Ashrafi S. Bhagat

M. REDDEPPA NAIDU

1932	*Born in Andhra Pradesh; formal education at Kakinada, Andhra Pradesh.*
1960	*Diploma in painting from the Government School of Arts and Crafts, Madras.*
1960	*Government of India Cultural Scholarship.*
1962	*National Award of the Lalit Kala Akademi, New Delhi.*
1963	*Joins the Weavers Service Centre, Government of India, and retires as the Deputy Director in 1990; awarded the gold medal of Andhra Pradesh, State Lalit Kala Akademi.*
1965	*IVth Paris Biennale.*
1967	*Gold Medal of the Hyderabad Art Society.*
1969	*Xth São Paolo Biennale, Brazil.*
1971	*XIth São Paolo Biennale, Brazil.*
1978	*IVth Triennale—India, New Delhi.*
1982	*Group show sponsored by Air-India at Alliance Française, Madras.*
1983	*Group show sponsored by Mahindra & Mahindra at Jehangir Art Gallery, Bombay.*
1988	*Elected fellow of the Tamil Nadu Lalit Kala Akademi. Visited Moscow and Leningrad and the Hermitage Museum.*
1989	*The Nehru Centenary exhibition on Nature and Environment organized by the Lalit Kala Akademi, New Delhi.*
1991	*VIIth Triennale—India, New Delhi.*
1997	*The Poetic Line—An exhibition of the* Sakuntala *series of paintings; conferred the Hony. Doctorate of Letters, Sree Venkateswara University, for his services to art and culture; curated the exhibition of artists below the age of fifty in connection with fifty years of independence for the Lalit Kala Akademi, New Delhi.*
1999	*Passes away at Cholamandal.*

Ashrafi Bhagat is the Head of the Department of Fine Arts, Stella Maris College, Chennai. She is an art critic for *The Hindu* and has contributed articles to various prestigious art journals and magazines. She is the author of *Retrospective / Prospective—Sculptural Configurations,* a brochure brought out by OUP, Chennai. This article on Reddeppa Naidu was written in 2001.

RICHARD JESUDAS

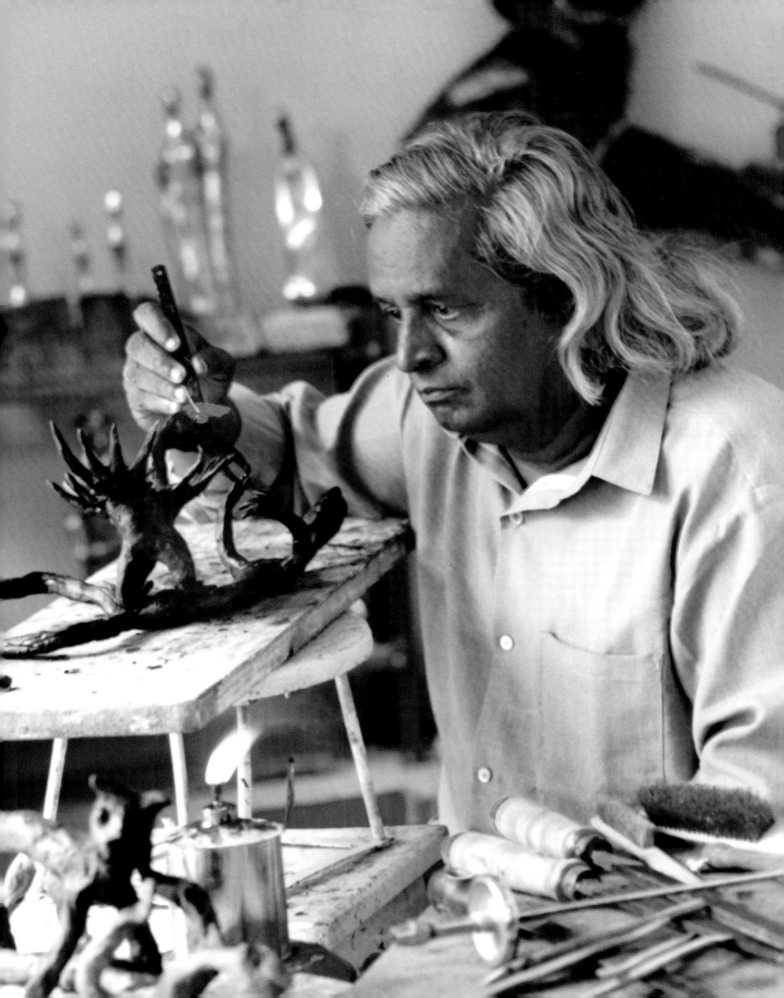

Richard Jesudas

Lakshmi Venkatraman: You seem to have spent a major part of your life at the Government School of Arts and Crafts in Madras, first as a student and then as a member of the faculty. When did you join and could you tell us about that initial phase?

Richard Jesudas: I joined the Government School of Arts and Crafts in 1956 when D.P. Roy Chowdhury was the principal, and took up a course in sheet metal. The process of embossing wherein the metal sheet is pushed from behind to create the intended sculptural forms seemed fascinating. At that time in my life, being able to watch D.P. Roy Chowdhury at work was itself a great opportunity. He would involve anyone standing around him by asking for suggestions on certain postures, and positions. This kind of interaction kindled my interest in sculpture. Also, the students of metal work were asked to make armatures with metal wires for the sculpture department. This was another motivating factor in joining the sculpture department after my initiation into sheet metal work.

L.V.: Could you tell us about some events or experiences in the school that you think further inspired you in pursuing your chosen career?

R.J.: When D.P. Roy Chowdhury retired in 1957, K.C.S. Paniker, who was already on the teaching faculty, became the principal. He succeeded in upgrading the school into a college. Then Paniker also got an All India tour grant sanctioned so

Prayer ▷
(Bronze)
1996

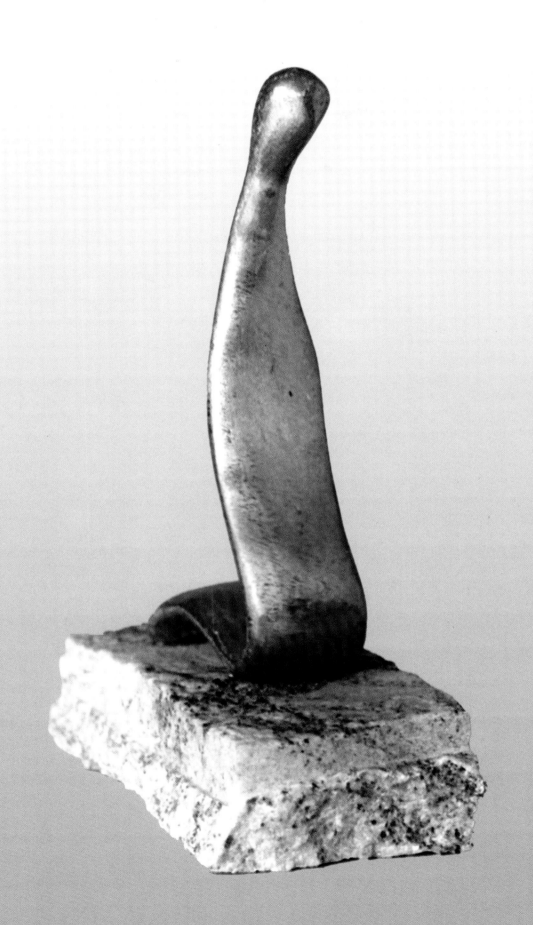

that the art students could visit the major centres of art in India and broaden their understanding of India's cultural and art heritage. It was a great educational experience. During Paniker's time, seven of the students obtained national scholarships. P.V. Janakiram, the well-known sculptor, was my contemporary. It was in such a stimulating atmosphere that my interest in sculpture got nurtured.

L.V.: What kind of sculptures did you do at the beginning of your career?

R.J.: Influenced by D.P. Roy Chowdhury, I started with realistic human forms and portraits. But later Paniker encouraged us to look at more contemporary works and evolve our individual style.

L.V.: Did you ever make sculptures in the traditional south Indian style?

R.J.: We did learn the rules laid down for traditional sculpture. To ignore it would have meant severing that vital connection to our roots that has sustained us in our search. We adapted some of the styles and techniques in our contemporary idiom. Most sculptors still follow the ancient technique of lost-wax process in bronze casting.

L.V.: How did your craft background help you in sculpture?

R.J.: During my days as a student, the atmosphere at the college was liberal in a certain sense. There was a tacit understanding that art cannot be taught, but a lot can be done to open eyes and minds to meaningful form. The students had the freedom to move from one section to another observing and learning from the teachers and students at work. This kind of interaction aroused one's curiosity and I learnt many things. For instance, I learnt to use enamel on sculptures, weld wires and rods to sculptures made of metal sheets which were embossed, giving it a somewhat rounded effect, while these sculptures were mostly frontal. This kind of experimentation goes on and even now I am trying out a different technique of shaping. From a sheet metal I peel out a strip and by turning or twisting it in

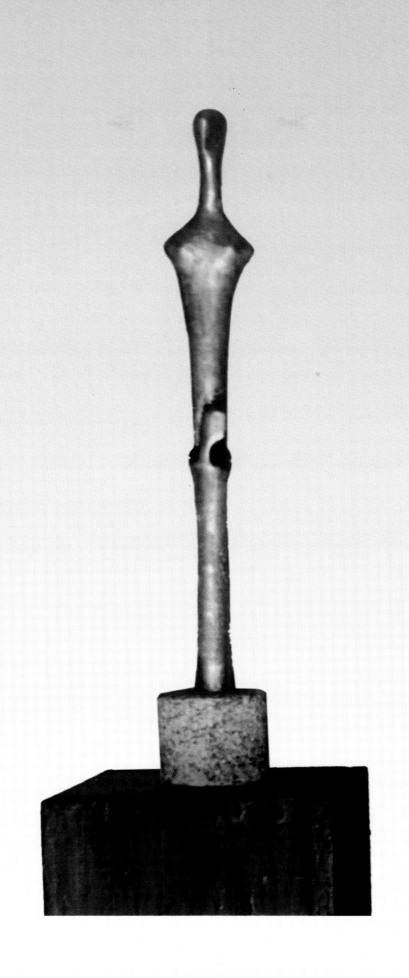

Family ▷
(Bronze)
2000

different directions, I obtain certain shapes. The reflecting light falling on the shapes gives a beautiful three-dimensional effect. Recently I used zinc and created two works of embossed sculpture.

L.V.: Did you seek employment after completing your course in art college?

R.J.: Yes, I needed employment. There was a ceramic research centre under the Industries and Commerce department in our college. When I began looking for a job, Paniker and Dhanapal advised me to join the research centre as a decorator.

In 1964, however, the sheet metal department needed a demonstrator and I fulfilled the requirements. It was an innovative period. Vidyasankar Sthapathi, Janakiram and a few other sculptors joined the metal work section as students. I enjoyed helping and guiding students and it was a mutually enriching experience. We tried out oxidizing and silver-plating metal and the 'crackling' effect in ceramics in the ceramic section of the sculpture department.

I was constantly in the midst of artists in an institution where teaching prepared a readiness to learn and grow. I had many interests at that time and worked with many materials. In the ceramic section I used to play around making small figures with clay and fire them in a country kiln. Before I retired, I also got to work in the print-making section.

In 1963, Paniker encouraged the young students to organize an exhibition of their works. There was a design section in which some interesting experimentation in batik painting was going on. I also began to do batik. Paniker helped us get the necessary equipment and gave us the space to start printing batiks on a comparatively large scale. Inspired by the response, he founded the Artists' Handicrafts Association. The exhibition of batik works was a great success.

L.V.: You said you like guiding students. Do you still have students coming to you after retiring from the college?

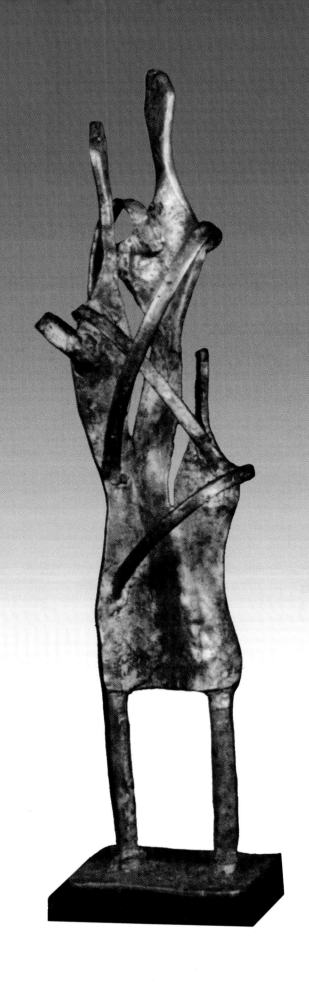

Affection ▷
(Bronze)
1995

R.J.: After I retired in 1997, I still have students from the sculpture and textile department coming to my house in Cholamandal often trying out new things. I too learn new techniques. The learning process goes on.

L.V.: Could you reflect on the days before you joined the college as a student? What motivated you to join the college?

R.J.: My parents had very modest means and my father died when I was nine months old. My mother taught in a school and supported me. My grandfather was a gifted craftsman employed in Madras and was a source of inspiration for me during my high school days. But joining the College of Art was not viewed favourably by most of our kin. They expected me to take up some profession that would fetch a steady income. I felt quite vexed and left home. Surviving on a meager meal a day, I had eighteen months to complete the course I had joined at the School of Art. Paniker got to know about my predicament and soon empathized with me. He helped me tide over the situation by getting me to execute small commissioned works.

L.V.: Are you currently working on any specific project?

R.J.: I have built my house in Cholamandal and live with my wife and son. I realize that art for me continues to be a way of life here as well. Look at my son who is also a graduate of the same college and is a growing, evolving artist in his own right, I see life's path stretching far with many possibilities. As for myself, I never think of sculpture or painting in terms of exhibitions. One must sculpt or paint for oneself and that is what this community provides the space for.

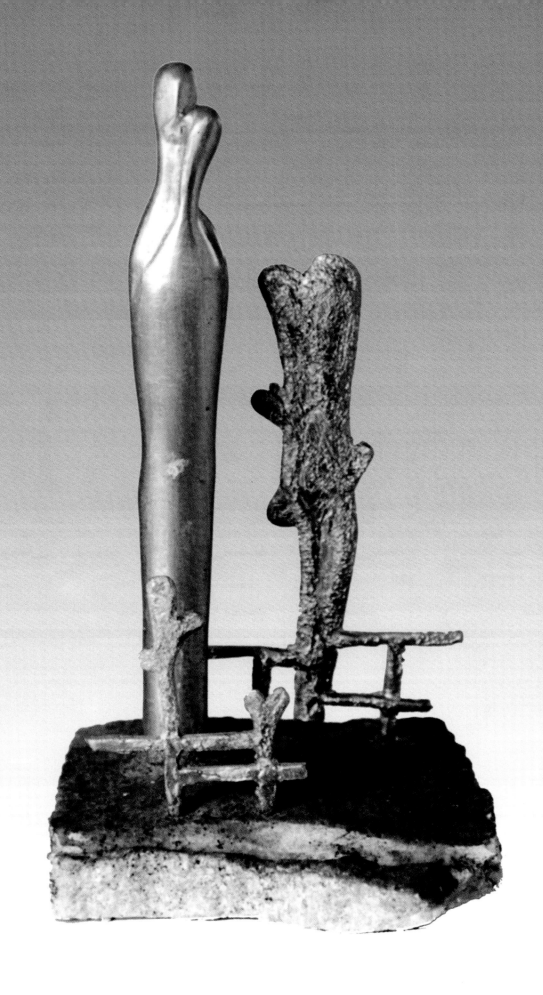

◁ *Untitled*
(Ink and wash on paper)
2000

RICHARD JESUDAS

1939	*Born 31ˢᵗ December at Thiruvallur, Madras.*
1962	*Diploma in Fine Arts, Modelling and Sheet Metal.*
1967	*State Lalit Kala Academy Award.*
1970	*Group exhibition, Artists' Handicrafts Association, Madras.*
1989–93	*Group exhibition, Tamil Nadu Arts and Crafts Improvement Association, Madras (and also in 2000).*
1992	*College of Arts and Crafts Alumni Association exhibition, Madras.*
1999	*Took part in Small Format Art exhibition held at Cholamandal Artists' Village, Chennai; Cholamandal Artists' Group Show at Spencers Company Ltd., Chennai; Cholamandal Artists' Group Show at Souvenir Art Gallery, Pondicherry.*
2000	*State Lalit Kala Academy Award–2000; 'Chinga Melam—2000' at Kerala Kala Peedam Art Gallery, Cochin; 'Small Format Bronze exhibition', Cholamandal Artists' Village Art Gallery, Chennai; 'Exhibition of Paintings and Sculpture', Chola Sheraton Hotel Art Gallery, Chennai; 'Gems 2000', a rare art auction in aid of General Education on Multiple Sclerosis at Park Sheraton, Chennai.*
2001	*'Mere' (an exhibition to raise funds for the earthquake in Gujarat), Park Sheraton Hotel Art Gallery, Chennai.*
2002	*'Vasanthakalam', art exhibition at Amethyst, Chennai.*

Lakshmi Venkatraman graduated from the Fine Arts department of the Stella Maris College, Chennai, in 1965. She has been an art critic for *The Hindu* since 1988. She is the recipient of the Art Critic Award of the Lalit Kala Akademi, New Delhi, 1995. This interview with Richard Jesudas was conducted in 2002.

SELVARAJ

A. Selvaraj

The sages of the world united and went to Brahma, the creator. 'We have food, clothing and shelter, but we need something more than that. The four Vedas are available only to a certain class. What about the men in the fields, homes, and forests?' Brahma thought for a while and *Panchama Veda* was created. The fifth Veda made humankind a creator. To food, clothing, and shelter was added an urge to create from nature. Humankind was given the power of creation inspired by nature to abstract ideas in the different media. Thus, say the Shastras, art was born.

The art form of dance captured that pure joy of movement. The beauty in motion in the rhythms of nature and the walks of animals, the flight of birds, the movements of the sea and river, the sway of the tree, were all abstracted in the human body in dance.

Looking back at his formative years as a student, Selvaraj says, 'Dance happened to me even as a student, in the locally famous high school in Gudiyattam, a suburb of Madras that has cradled and nurtured the talents of about fifteen contemporary artists such as Santhanaraj, Dakshinamoorthy, Paramasivam, and others.' Selvaraj would always be a part of any cultural event. He took part in dances and drama and even got a few prizes. 'My parents were farmers, but were very interested in education,' says Selvaraj, 'They had land in Gudiyattam. Young boys like me

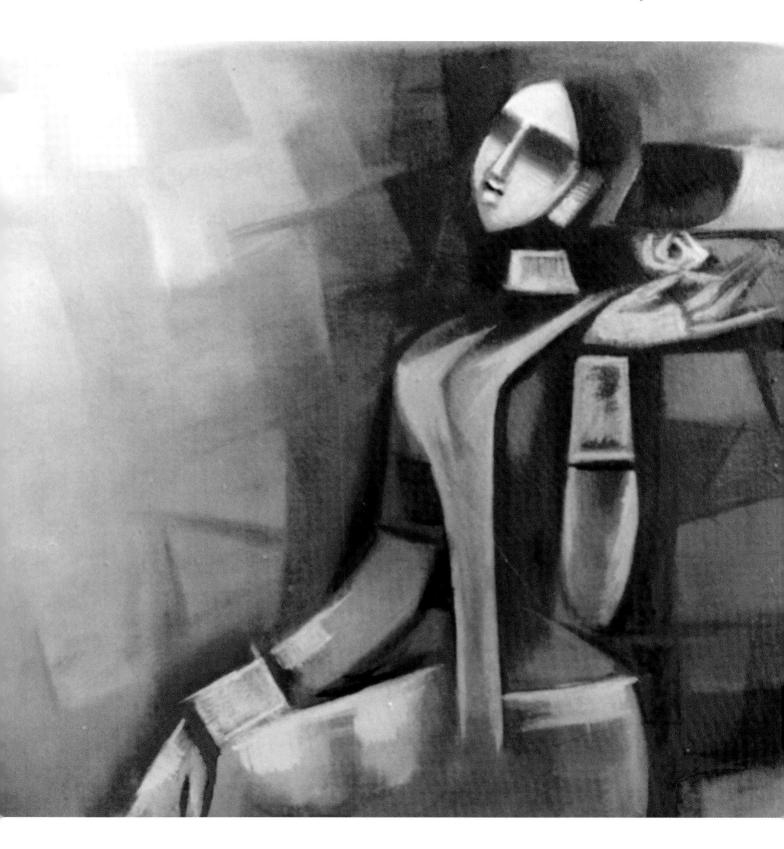

Flute Player ▷
(Oil on canvas)
2003

would gather in the field after dinner waiting impatiently for Mr Om Ezhilan, who encouraged us to compose dances and dramas. He taught us dance, and the students would sometimes spend the night in the field. My parents had given space for helping students and Mr Ezhilan almost ran what could be called a 'non-formal educational centre'. Ezhilan later joined a prominent teachers' training college in Madras and finally ended up as a lawyer in that city.

When Selvaraj joined the School of Arts and Crafts in Madras at the age of seventeen, as an adolescent he was struggling to understand and reflect on his own internal sense of chaos and order. He had come to Madras looking for guidance. Back in Gudiyattam, he had already rocked the boat and his needs challenged the status quo.

As a school student, Selvaraj did not even inform his family that he was taking drawing and painting lessons. Gudiyattam high school was the only school that offered these subjects to students. 'No one at home knew I had joined this section in school and they believed that I was being groomed to become an engineer.' But he had a precedence at home. An elder brother had been the first person from the village to have joined the School of Arts and Crafts. He retired as an auditor after inspiring many young boys from Gudiyattam to become artists. Kandaswamy, the drawing teacher at the school, was another unforgettable man who kindled his interest in art and even helped him forgo his Hindi and Science classes to attend drawing classes. He also later encouraged Selvaraj to join the School of Arts and Crafts. For Selvaraj, these men were unsung saviours of his formative years in a society that had yet to accommodate modern art and dance as an alternate choice to affirm an individual's freedom.

K.C.S. Paniker was the principal of the Government School of Arts and Crafts in Madras when Selvaraj joined. Murugesan, Anthony Das, and Santhanaraj all taught in the Fine Arts section and kept encouraging the figurative style. 'Watching the teachers who worked in front of us never dictating to us the manner in which we

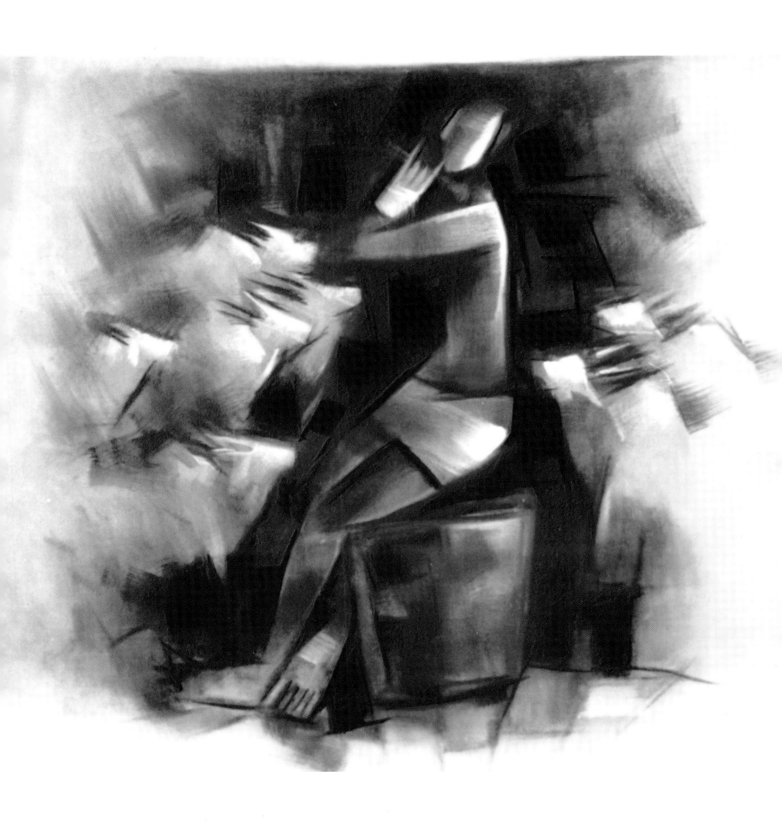

She ▷
(Oil on canvas)
2003

should paint, but just letting us observe and encouraging us whenever they sensed that need, helped me create my own style. There is a timelessness in the figurative style and an understanding of human anatomy becomes essential as also giving expression to the lines. Creating beauty was my aim,' says Selvaraj. Even as a student in the second year of college, Selvaraj participated in national-level exhibitions and took part in group shows and one man shows.

Coming to Madras opened up another possibility for him. While many of his peers and role models were all going into abstraction, he remained faithful to figurative painting and sculpture. While classical dance seemed too structured for modern artists, Selvaraj actually started learning it from a well-known dance teacher and this influenced his painting. It gave an emotional and expressive directness so characteristic of his work.

Selvaraj could sense the enormous explosion of energy that came out of the modern art movement in Madras. So when Paniker retired there was a whole group of young artists with him that fuelled the fire of creativity, and Cholamandal was born.

'When Cholamandal was founded in 1966, I became a member but did not come away to live here immediately, although I bought a piece of land,' Selvaraj says. He had already taken up a job with the government as an artist. He made posters for the Health Department, organized exhibitions, and also made models for the Tamil Nadu stalls, some of which attracted attention in Delhi. 'This led me on to something new. Making models for the government with thermocole and other materials kindled an interest in sculpture. I learnt the traditional "lost wax" method.' Andal is a favourite theme. The beauty of the human figure with its emphasis on femininity and the consequent fullness that seems to come from within the rounded forms, heighten the sense of physical presence. Again, the dancer and modern artist in him find fusion when he stands back admiring one of the sculptures, 'Don't you think this looks like our master's pose?' referring to the fact that we

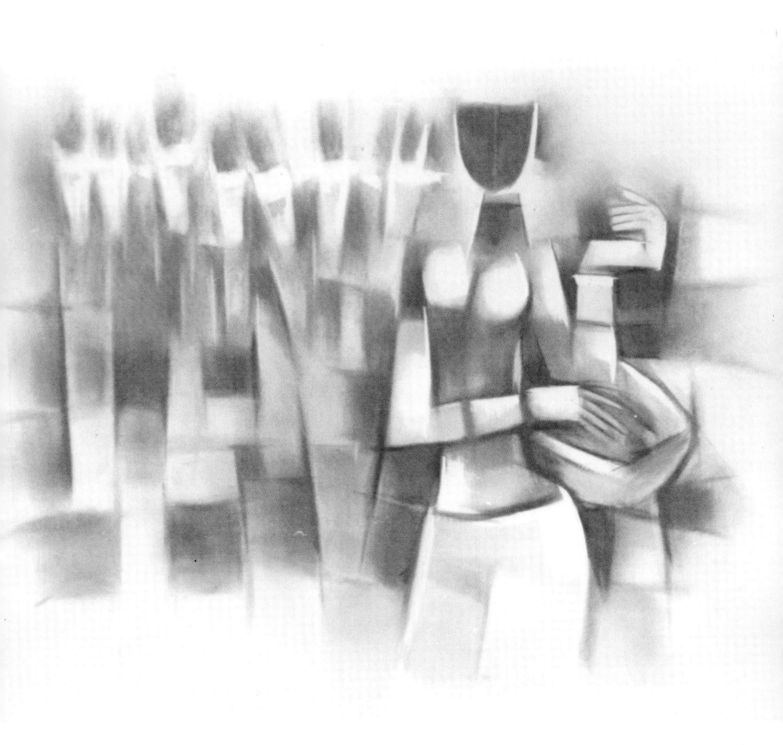

both share a dance teacher, Mr Dhananjayan. I agree as I look at the work that seems to have absorbed the rhythmic freedom that makes the dancer's body reflect the pure joy of movement.

Throughout his career with the government, he remained loyal to Cholamandal and sent his works for exhibitions in the artists' village. He quietly nurtured the dream of settling down in the community of artists with his family, but until then he had to work and save enough for his dream house.

'The dance experience slowly affected my style both in painting and sculpture. They acquired a fluidity, and in the paintings I am now able to get a flow of light and dark. My style remains clearly figurative and I feel inspired by musicians, dancers, village women, and deities,' says Selvaraj, reflecting on his journey from Gudiyattam to Cholamandal.

One discerns in Selvaraj's work an attempt to re-establish a relationship between the past and the present, to mix the modernist and traditional modes to create something contemporary.

Sitting in the studio in the house that Selvaraj was at last able to build in Cholamandal, he looks back and reflects,
 A painter does not become a painter by merely attending classes in an art institution. He has to have that inner vision, that turmoil to urge him on. My teachers at the School of Art did not teach us to paint in the conventional sense, but they showed us how they worked and encouraged us to find our own way. There was a sense of community there and today living in Cholamandal, I experience that feeling again in a different way. From my Gudiyattam days when I groped in the dark, to a return to meaning, to define what is distinctly mine, I have come to realize that nobody has accomplished anything alone. I am happy to be in the midst of those for whom art is at the core of their existence.

<div align="right">V.R. Devika</div>

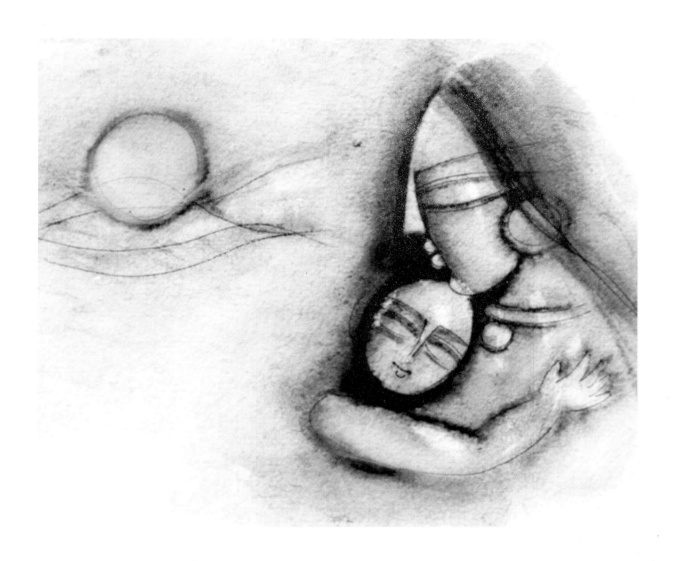

△ *The Moon*
(Ink and wash on paper)
2001

The Bird ▽
(Acrylic on handmade paper)
2000

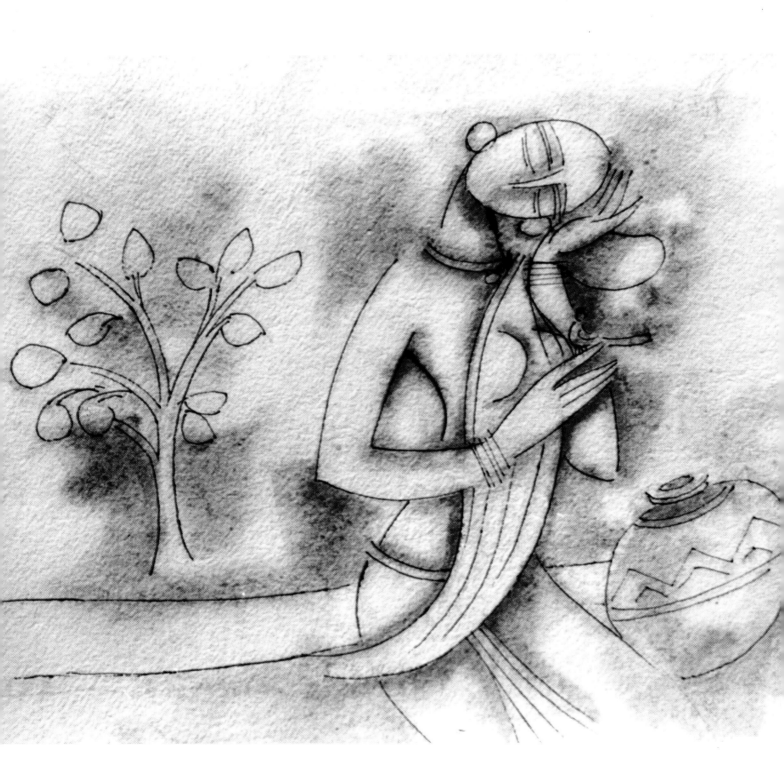

A. SELVARAJ

1943	*Born in Gudiyattam, Tamil Nadu.*
1960	*Diploma in Fine Arts, from Government School of Arts and Crafts, Madras.*
1966	*Becomes a life member of Cholamandal Artists' Village, Madras; exhibited, National Art exhibition at New Delhi (also in '85); three man show in Madras; award, Progressive Painters' Association, Madras; one man show in Madras.*
1970	*Workshop at Gandhigramam, Tamil Nadu.*
1973	*One man show in Bangalore (also in '78 and '80).*
1983	*Workshop at National Institute of Design Ahmedabad (Gujarat); State Lalit Kala Akademi annual show (also in '95, '96, '97, '99 and 2001).*
1986	*National workshop at Bandh Nagar, U.P.*
1988	*National workshop at Pune.*
1990–92	*Workshop at Ministry of Agriculture, Government of India, New Delhi.*
1995	*Workshop organized by Ovium Nunkalai Kuzhu, Madras at Ooty.*
1996–97	*Exhibited Ovium Nunkalai Kuzhu, Madras.*
1999	*Small format exhibition, Cholamandal; International Agro fest camp at Chennai.*
2000	*Cholamandal Annual show (also in 2002 and 2003).*
2001	*One man show at Cholamandal, Chennai.*

V.R. Devika has been a school teacher known for her experiments in art links to education. She trained in Bharatanatyam and has researched folk art. She has developed the education and culture programmes for the Madras Craft Foundation and is a consultant for its project, Dakshinachitra. She also coordinates events of the Prakriti Foundation and is the founder of the Aseema Trust.

SENATHIPATHI

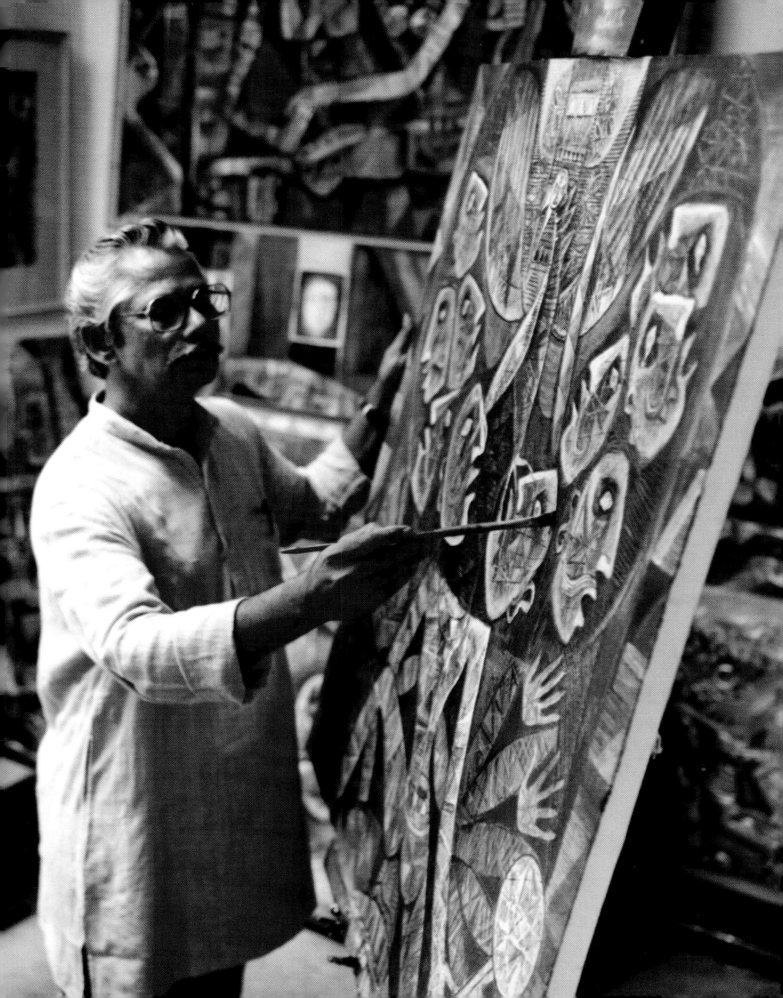

M. Senathipathi

Deepa Chandrasekaran: What are the events and who are the people who played a major role in your being an artist today?

M. Senathipathi: My forefathers were landlords, they were tied to the land and had no leanings towards art. There was one uncle who was quite artistic. In those days the walls were plastered so finely that you could see your face in them. My uncle used to paint 2×2 ft and 3×2 ft pictures of gods and goddesses on the walls of our ancestral home. I used to watch my uncle paint when I was around four or five years old. I think it was then that I felt the first stirring of my artistic impulses. When I was around seven or eight I began to paint on the walls myself. I would gather some friends and we would build temples and deities.

In my early years I had no formal schooling. We had what was called the *thinnai pallikudam* or literally the doorstep school. The villagers would find a learned person, gather children of various ages and try to teach them some alphabets and numbers. We were obviously not learning much this way, so my family shifted to the Maduranthagam Taluka to give us a more formal education. Here my love for art was reinforced. My art teacher was impressed with my paintings. He suggested that I join the School of Arts and Crafts in Madras. That was the first time that I ever heard of it. By that time my father had lost all his property to the Zamindars. After a short while he passed away. The rest of the family moved to Madras.

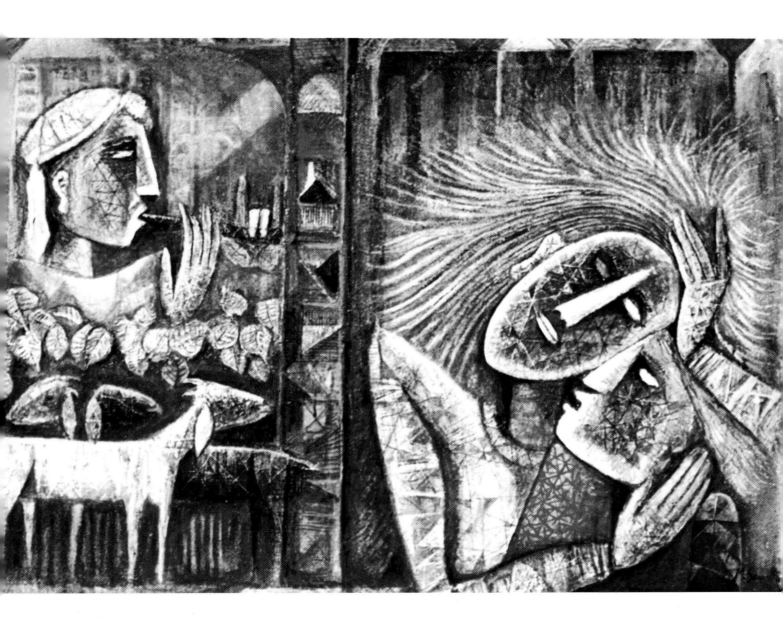

△ *Tribal Village*
(Acrylic on canvas)
1999

Draupadi ▷
(Acrylic on canvas)
1996

D.C.: If you had not lost your land, do you think you would have become a landlord instead of an artist?

M.S.: I was very young when we lost our land, so I have never really thought about it. Look at the irony of life, my father had only two daughters from his first marriage. He married my mother in order to have male heirs to look after the property. After my brothers and I were born, we lost our property.

Nevertheless, I do not think I would have ever been anything but an artist. By the end of my school days, I was sure that I wanted to be a painter. We moved to Madras and I joined the School of Arts and Crafts.

D.C.: Can you trace your development as an artist during your college days?

M.S.: In those days landscapes were the norm. For the first two years, I largely did landscapes and was influenced by Van Gogh's works. It was also a time of pure experimentation trying to find my niche.

In my third and fourth years, I was greatly influenced by Santhana Raj, my instructor. His approach to colour, lines, and his drawings as a whole appealed to me. A young plant needs a tree or a post to support itself before it can grow strong roots and flourish on its own. Similarly, I needed Santhana Raj to help me find my feet. I started working along those lines. My initial works had traces of his style, especially my pen-and-ink renderings. Later, as I became more confident, I developed a style of my own.

D.C.: You have travelled in Europe and Britain. Did these visits influence your work?

M.S.: I travelled much later in my career as an artist. It was in 1988. I do consider it an educational experience, but it was more of a voyage into my past. It was wonderful to see all the great masters' original works. In Holland, I went to the Van Gogh Museum. As I said, I was inspired a lot by Van Gogh when I was doing

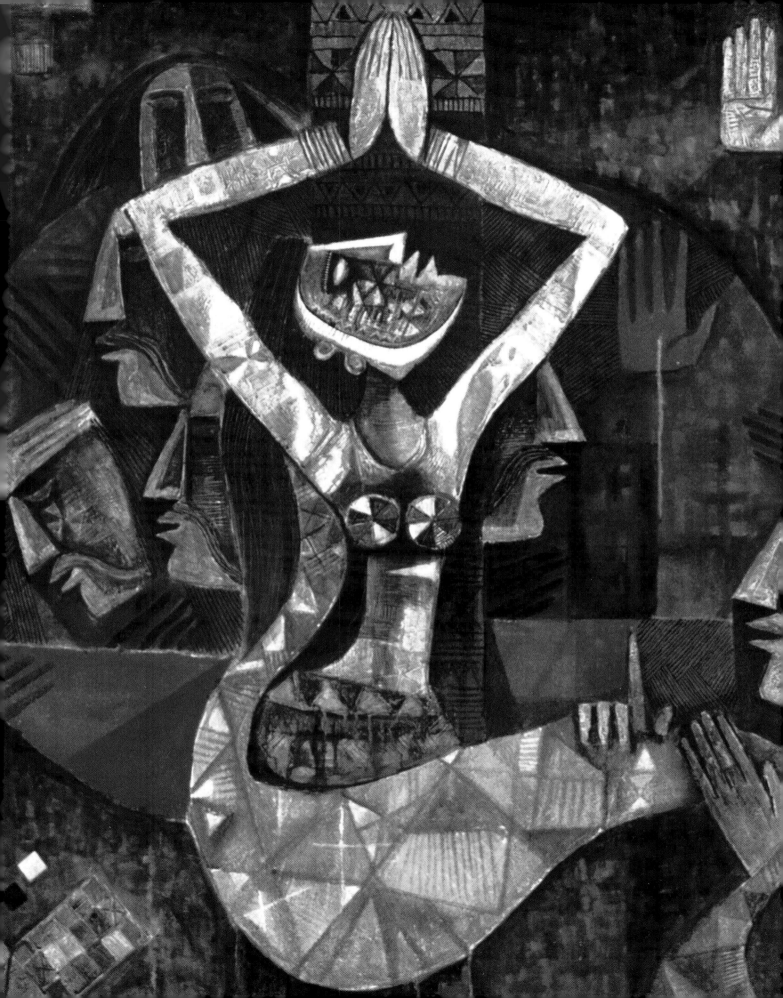

landscapes. For me it was a thrilling experience to see his entire work showcased there. I also saw several other museums and galleries, notably the Henry Moore Foundation and the Picasso Museum. I look back at it as an opportunity to broaden my vision. I also exhibited my paintings in Europe.

D.C.: Do you remember the first painting that you sold?

M.S.: Yes, it has a special place in my heart. In my final year of school in 1965, I had my first show with two friends. It was very rare in those days when paintings were seldom bought. At an exhibition, one or two would be sold and usually the buyer would be the person who inaugurates the show! At a time like that, we sold nineteen works to a gallery owner.

D.C.: After the golden era of the Art School came to an end, did you have any trouble finding your footing as an artist?

M.S.: Oh, yes. As soon as I finished my course, my family expected me to take up a job. For one year, I worked as an art teacher at a school and there were a lot of family problems. I was frustrated and depressed. There was no time for creativity. It is difficult for an artist to work outside and be creative. I just could not do any creative work, I felt totally tied down.

Around that time, I got married. I went to invite K.C.S. Paniker for my wedding. He asked me to join as a member of Cholamandal and stop working outside. There was opposition from all sides, both family and friends. Even classmates from the School of Arts and Crafts warned me about its *ashram*-like environment.

True, it was a struggle here in the early days. There was no electricity or bus service. We needed money to take care of our basic needs and to create. Paintings would not sell, but I had to paint to be happy. It was Paniker's idea that we do some craftwork like terracotta, metal work, and batik, to support ourselves. We would sell the craftwork and use the money for food, colour, and canvas.

▽ *Mother and Child*
 (Mixed media on handmade paper)
 2002

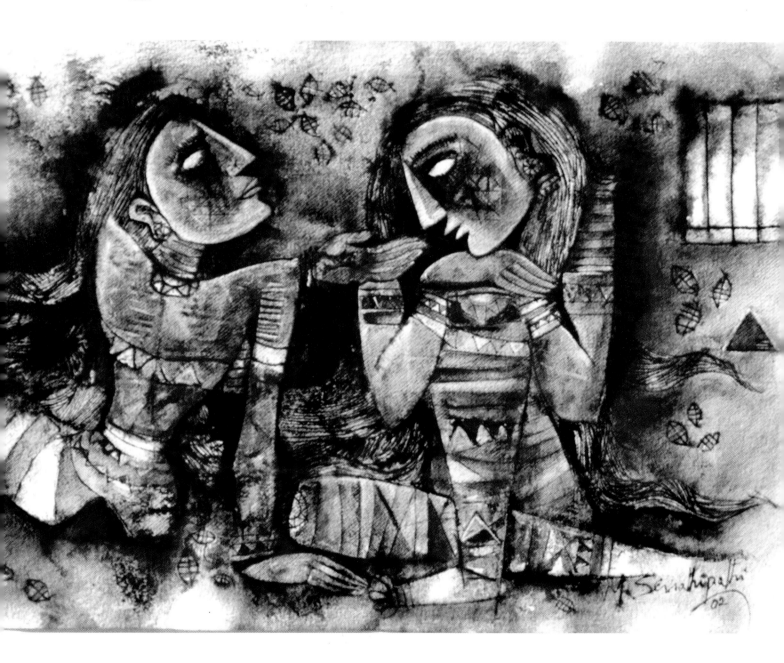

Mother and Daughter ▷
(Mixed media on handmade paper)
2002

I remember, once we did not have money to buy zinc, copper, and other metal sheets. We collected old vessels, cut them and used those for metal sculptures and relief work.

D.C.: Were you disheartened by these struggles?

M.S.: No, Cholamandal freed me from working under anybody. The presence of other artists helped, there was a healthy environment of competition. Here I had time to paint and develop my own style. I broke away from impasto and started experimenting with black and white paintings. They were critically acclaimed and well received by the public. I then began experimenting with ink, acrylic, and mixed media.

D.C.: Your work has a touch of cubism. Is it a deliberate use of that style?

M.S.: It is definitely not a conscious effort. I feel it best expresses my feelings and ideas. I however do not believe in painting abstract forms. For me, it has to be figurative. I do not believe in playing with my knowledge of colours, there has to be a theme in all my work.

D.C.: Why do you have this fascination for mythological themes?

M.S.: The fascination for mythological figures dates back to the days when my uncle used to paint the figures of gods and godesses on the walls. It remains with me till today. Also, neatly arranged pictures in the *pooja* room of my parents' home and the Hindu mythological stories heard during my childhood have been a strong influence. I am a religious person and it finds reflection in my work. I do use mythology in my paintings and metal relief works, but present them in my own way. I paint what appeals or affects me the most at any point in time.

An artist cannot be removed from society, if so, his work becomes hollow. I was working with mythological themes, but I became disturbed by the violence,

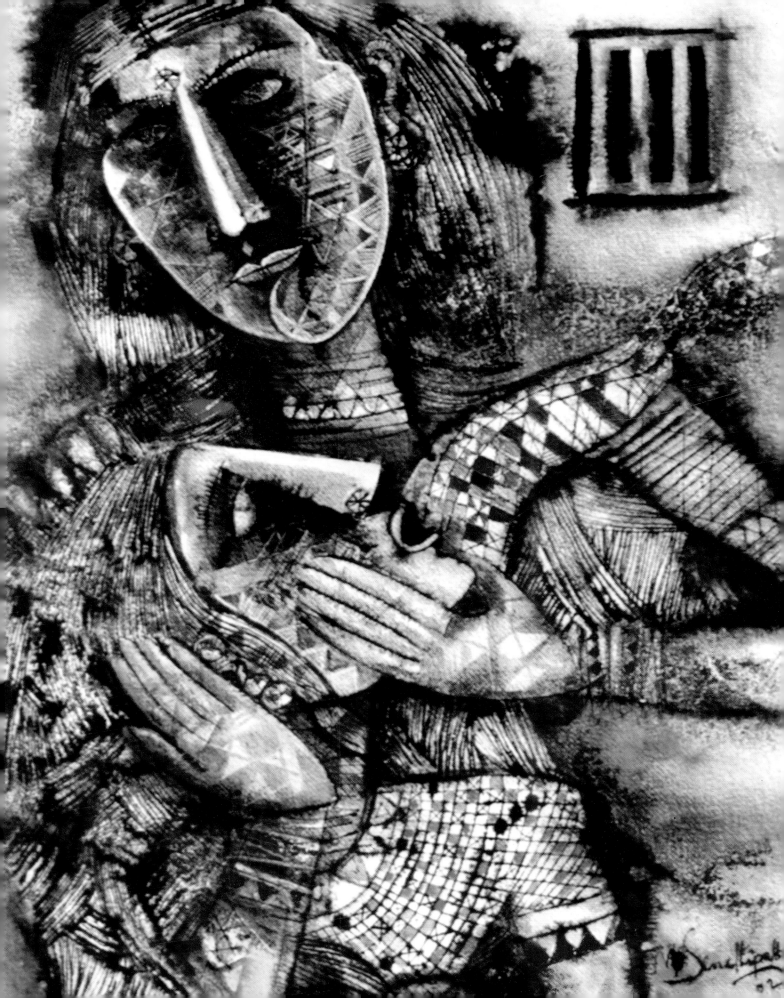

confusion, and insecurity surrounding me. There was an overwhelming feeling that nothing is safe or secure. My feelings quite naturally found their way into my paintings, I painted a series on the theme of insecurity. During the seventies too there was a lot of political tension. In those days, my black and white drawings would depict the fear, insecurity, and confusion prevalent during that time.

D.C.: Have you ever felt like experimenting with other art forms, like sculpture and terracotta?

M.S.: I have done all of those in my early days in Cholamandal to supplement my income. But I can express myself best through painting. I want to concentrate and expand my ideas through my chosen media—canvas and paint. Dabbling in too many things would cause a break in concentration. At the same time I devote a majority of my time to painting, just to keep the cycle of creativity going; I set aside two months to work on metal relief.

D.C.: Have you ever been tempted to paint for commercial purposes?

M.S.: If that were the case, I would not have so many of my works left with me. Buyers may prefer abstract forms today and realistic figures tomorrow. I do not bother too much about the trends, and remain faithful to my style. If you are not true to your central character and imitate others' styles, your work loses its essence. If people say your work resembles someone else's then you have lost your individuality. Today, I have an identity of my own.

Nowadays, individuals and corporate houses like to acquire paintings as status symbols. There is a growing awareness among the public. Still, it is very important to showcase your work. Visibility is important for an artist. It is meaningless to keep your work hidden in your studio just because there are people who do not understand your work. There will be criticism as much as there will be praise. This gives you scope for growth. For example, if water in a well is not used, it will stagnate and dry out. You have to draw water to keep the well fresh and to irrigate

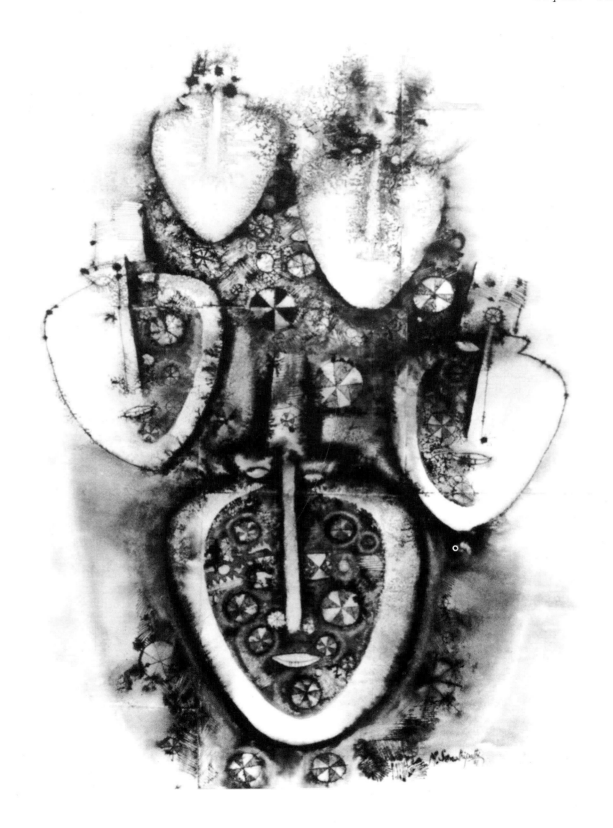

the ground around it. Similarly, visibility helps the artist grow and also educates the public.

D.C.: With young artists coming in from all over the country, not to mention the world, do you think the essential character of Cholamandal has changed?

M.S.: The artists today come from all over India because of the name that Cholamandal has. They also have the confidence that they can showcase their work here. In Cholamandal, the basic idea of helping young artists remains the same. The association helps these young artists by giving them a place to stay and by including them in the exhibitions here.

The young artists observe and learn from us. The artists from outside bring with them their varied styles, so just as they take, they also contribute. In that sense, the tradition continues. As for what Cholamandal would become in say twenty years from now, I really have no idea. We have not planned for generations. The young people will take it from here.

M. SENATHIPATHI

1939	*Born in Madras, Tamil Nadu.*
1965	*Diploma in Drawing and Painting, Government School of Arts and Crafts, Madras.*
1976	*All India Art exhibition arranged by Indian Pugwash Society on the occasion of 25th International conference on Science and world Affairs, Taj Coromandel, Madras; National exhibition of Art, Lalit Kala Akademi, New Delhi (also in '96).*
1979	*Exhibition of painting and sculpture of Contemporary India, Kala Yatra, Taj Coromandel, Madras—Taj Art Gallery, Bombay—Taj Mahal Hotel, New Delhi—British Prints décor service, Calcutta.*
1981	*Exhibition of paintings and sculptures of Contemporary India, Kala Yatra at Wimsa Loke Art Gallery, Kuala Lumpur; Tamil Nadu Lalit Kala Akademi Award, Madras.*
1982	*The Asia and Pacific Museum, Poland.*
1984–86	*Senior Fellowship, Department of Culture, Government of India, New Delhi.*
1985	*Cholamandal Artists' exhibition at Morocco by Indian Council for Cultural Relations.*
1986	*President, Artists' Handicrafts Association, Cholamandal Artists' Village, Madras (continues till date); VI Triennale India, Lalit Kala Akademi, New Delhi.*
1987–88	*Member of the Jury, Lalit Kala Akademi, Madras.*
1988	*Travelled to London (British Council Visitorship/Grant), France, Holland, Belgium, West Germany.*
1989	*Gate Foundation, Den Haag Museum, Holland.*
1990	*Gate Foundation, Amsterdam, Holland.*
1996	*Quay side gallery, Cambridgeshire, England.*
2002	*Raffles Hotel Arcade, artfolio space, Raffles Singapore; nine solo exhibitions and participated in national and regional exhibitions.*

Deepa Chandrasekaran has a Bachelor's Degree in History from Stella Maris College, Chennai, and a Master's Degree from Central University, Hyderabad. She has worked as a freelance journalist and as an editor for the Times group. Currently, she is an entrepreneur in the BPO sector. The interview with M. Senathipathi took place in 2002.

SULTAN ALI

Sultan Ali

Born in Bombay in 1920 of Ismaili Khoja parents, originally from Gujarat, Sultan Ali found himself at Madras at the age of fifteen, being groomed for the confectionery business which his father had embarked upon.

However, a few years later, an irrepressible passion for painting that would harbour no oppositon, impelled Sultan Ali to the door of the principal of the Madras School of Arts and Crafts, Debi Prosad Roy Chowdhury. Himself a man of an ardent and impetuous nature, D.P. Roy Chowdhury was pleased to discern in the young lad so firm a resolve to pursue a career in art.

Sultan Ali's passion had seemingly been aroused by a modest, self-effacing teacher of art at St Andrew's High School in Bombay, who had gifted the boy of fourteen with a box of Windsor & Newton watercolours and a set of sable brushes. This simple but touching gesture of recognition and encouragement had kindled a flame that was to sustain the artist through a career of some fifty years.

D.P. Roy Chowdhury was a reputed artist, with a wide range of talents in a variety of media. A brilliant organizer and an inspiring teacher, his was a charismatic personality that encouraged a student to pursue his own particular bent, provided it was sustained by sheer hard work, a sense of social consciousness, and a spirit of idealism. Himself a prolific sculptor in the romantic tradition of Rodin and Bourdelle, D.P. Roy Chowdhury strove to imbue the course at the School with an

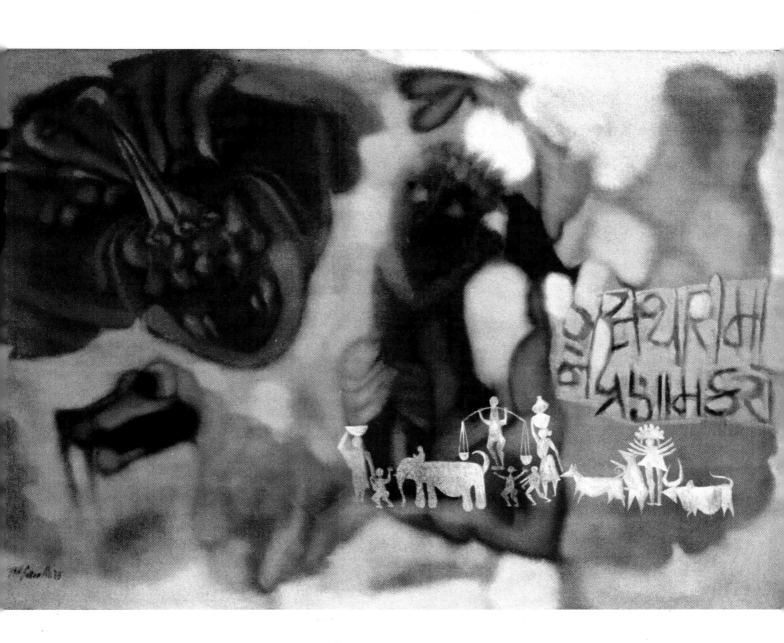

△ *Bhayanaka*
(Oil on canvas)
1985

emphasis on craftsmanship and technique, which some students found reassuring and providing the essential groundwork, while others, rather oppressive.

The early forties were among the most vital years of the freedom struggle under the leadership of Mahatma Gandhi, and the nationalistic fervour had aroused a newly awakened interest in indigenous styles of painting and craft traditions which, in any case, Roy Chowdhury had initially brought with him from Bengal.

However much he chafed against it, Sultan Ali had to acknowledge that the thorough training in anatomy, life drawing, perspective, composition, and the handling of the media of pencil, crayon, watercolours, tempera, and oils; the study of styles ranging from the classical Greek to the classical Indian; from fresco to miniature painting; from the conventionalized Indian to the naturalistic Western, along with an exposure to craftsmanship in woodcarving and metalware, was to provide him with that technical facility and assurance that distinguishes his work.

Besides, Sultan Ali was fortunate to be part of a coterie of artists of the calibre of K.C.S. Paniker, Sushil Mukherjee, Prodosh Das Gupta and Paritosh Sen, all of whom had gravitated to Madras to benefit from the teachings and example of that brilliant teacher. Such an environment was conducive to the growth of a fresh and receptive talent such as Sultan Ali's.

After completing the course, faced with the task of teaching art to children of the Rishi Valley School in Andhra Pradesh, Sultan Ali found himself confronted with the challenge of a vast, uncharted territory which demanded an approach for which his arduous, textbook training had ill prepared him. If anything, it was to prove the most serious obstacle in a situation where technical skill was no match for the spontaneous verve, the startling innocence and freshness of vision of the child. The four years between 1951 and 1954 represented a process of opening up to an experience as different as dancing under a gushing mountain stream is to sinking slowly into the depths of a stagnant village pool.

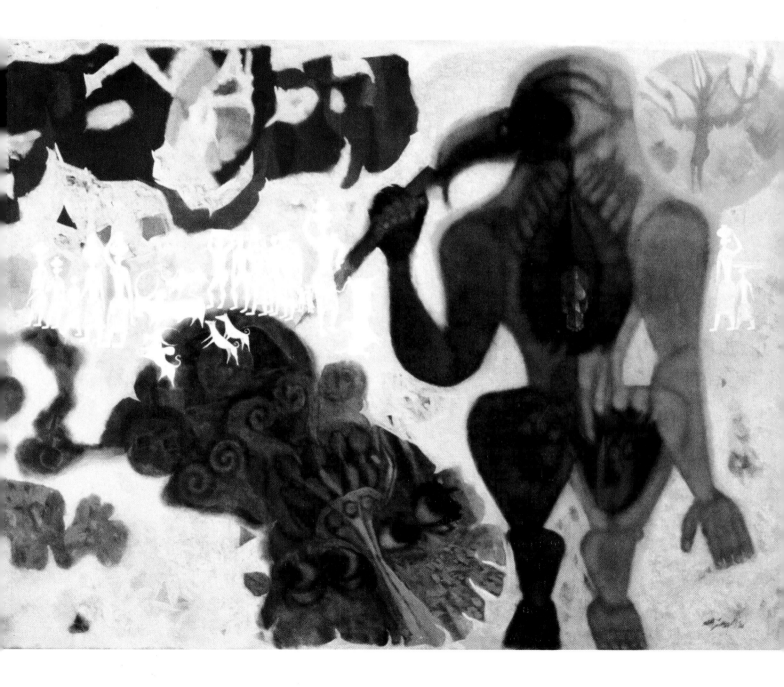

▽ *Neelapaksha Asghar*
 (Oil on canvas)
 1986

Sultan Ali's years since 1954 as Exhibition Officer in the Lalit Kala Akademi in New Delhi may well have been occasioned by his desire to be at the very hub of the nation's art activity: the National Exhibitions of Art which assembled each year works in all media from all corners of the subcontinent; the international Triennales which revealed to Indian artists the new forms of creative expression in other parts of the world; the proximity of the Sahitya Akademi and the Sangeet Natak Akademi also provided cultural and intellectual stimulus. Besides, the discerning yet supportive art reviews of such writers as Charles Fabri and Richard Bartholomew ensured perceptive critical responses from which the artist could learn a great deal. Altogether, the atmosphere in the capital was both invigorating and challenging.

Yet, there lurked in Sultan Ali that restless and unavowedly romantic streak which made it impossible for him to resist the haunting, siren call of the world of the tribals that the anthropologist Verrier Elwin had so evocatively portrayed in his various books on the Maria Gonds, the Baigas, and the Murias of central India, and the tribals of the North-East Frontier Agency. With the same wild enthusiasm that had drawn him to the Madras School as an adolescent, Sultan Ali now flung himself into the physical and imaginative world of the tribals.

Elwin's *Tribal Art of the Eastern Region* revealed to Sultan Ali an art that, in his own words, was 'chaste, pure, naïve and spontaneous, besides being powerful and vibrant in form', and inspired him to build his own visual vocabulary on these qualities. It changed his outlook and served him to 'create art which had affinity with my environment and tradition and yet led me to that modernity which may be termed "Indian Modernity", quite capable and competent as Western modern art was… it liberated me considerably from the influence of the West, and moulded my thinking on an altogether different plane'.

Sultan Ali's detailed recounting of this experience is worth recalling in that it

▽ *Nageen*
(Watercolour on paper)
1981

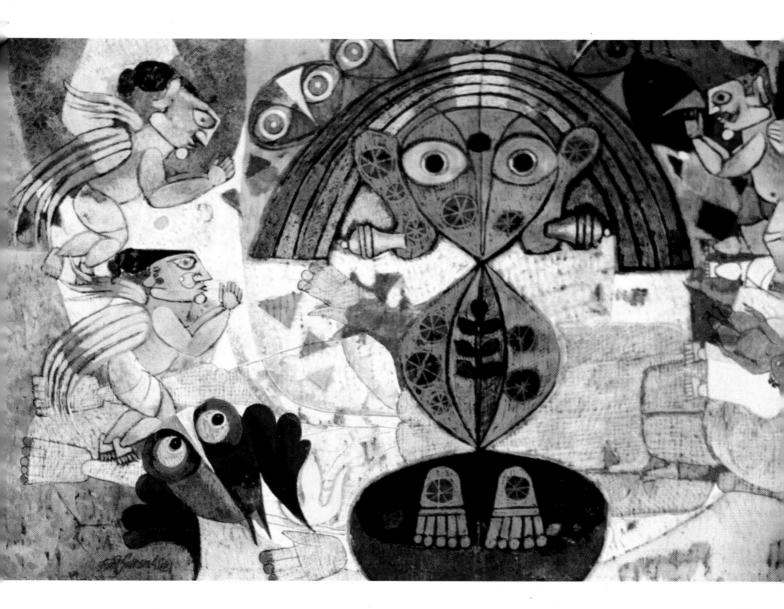

provides significant clues to his further development as an artist:

On actually visiting Bastar and its vicinity, I could hardly believe the experience I encountered. In spite of the ruggedness, there was a peculiar refinement. Casualness prevailed, yet there was discipline and method. Tribals, young and old, were busy, and one hardly ever witnessed any slothfulness. They appeared clean, and what struck me most was their ethical philosophy, sense of duty, moral principle, skillful endeavour and ardent commitment to their community.

I felt that a sophisticated society like ours, of which I was an offspring, was self-contradictory and chaotic, huddled in urban confines.... I was entranced to see the art of the tribals everywhere: on the walls of their dwellings, inside and out, exquisitely decorated with simple pigments; doors embellished with intricate designs, with inlaid beads and trinkets. Wood carvings and other images scattered about for rituals; articles of daily use artistically designed with intricate patterns.... One felt that art had a purpose, aim and function here; it was closely knit into their life and tradition. For us, a work of art had hardly any purpose; it was a mere decorative object to flaunt our ego and our wealth. How trivial, by comparison was our outlook on life. We have been looking down on tribals as primitive, wild and backward. What a paradox! They are the ones who live close to nature, enjoying its bounty and beauty, allowing it to penetrate into their lives. No wonder their art had so much spontaneity, purity and bhakti, which drew it towards it....

Visiting different centres besides Bastar, like Korapur, Jagdalpur, Narayanpur, Bhandara, Raipur, Mankala, Chinwada and other small villages in Orissa and Madhya Pradesh, I felt I was viewing open-air museums, where the art and culture of the tribals were spread out like an open book....

The more I travelled in the tribal belt areas, the more convinced I was of the originality and vibrancy of their art and life. But I also felt a little perturbed, as I had absorbed so much of their tradition and culture that the problem was how to assimilate it and build up a vast visual vocabulary that would project my personality.

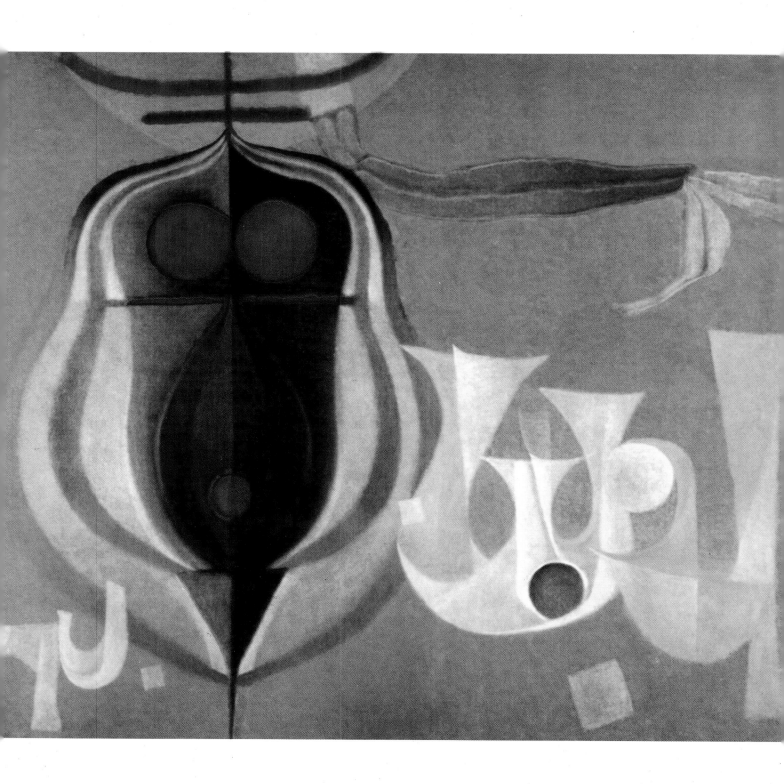

Pancha Pushpa
(Oil on canvas)
1977

In 1969 Sultan Ali resigned from his post at the Lalit Kala Akademi and joined his old friend K.C.S. Paniker at the Cholamandal Artists' Village near Madras. For the next twenty-one years, he was to develop a pictorial language that was markedly influenced by his direct experience of tribal life and culture. Creatures and forces of nature assume anthropomorphic forms, symbols of powers, both earthly and magical: the black serpent; the earth mother; the sun king; the fierce bull; Garuda rescuing the earth spirit from the attack of the evil snake; symbols of fire and water; terrestrial shackles and aspiration.

Good and evil, life and death, joy and pain; knowledge and ignorance, each the obverse of the other, are manifestations of an unending and timeless cosmic cycle. The stark, taut, graphic power of tribal art, a universe oscillating from the lyrical and ecstatic to the grotesque and brutally destructive; the potent physical reality, and at the same time the elusive mystery of the invisible, intangible forces at work beneath the surface. The dual world of matter and spirit, the apparent and the hidden; the seething, pulsating fullness of life and at the same time the sense of the illusoriness of human action. Deeds crackle into vacant gestures; scorpions, vestiges of human feelings, raise their poison tails; anger and pride congeal into bull-like shapes; mantras, chants, incantations, invocations, all strive to exorcize the evil out of life; scripted forms, dying echoes of ancient wisdom, stutter into a mere formal device—the entire jungle world, its reality and its myriad myths had been poured into the crucible of Sultan Ali's imagination to re-emerge as forms, harsh and brutal in their impact. Through the chaos and torment of the process of distillation, the artist sought *ananda*. Did he achieve it? No one can say. Sultan Ali's works can be seen as sustained efforts to come to terms with that unnerving reality.

<div align="right">Ebrahim Alkazi</div>

SULTAN ALI

1920	Born on 12 September, in Bombay.
1939–45	Diploma in painting from the Government School of Arts and Crafts, Madras.
1947–48	Senior Instructor, Painting Department, Government School of Arts and Crafts , Madras.
1954–69	Exhibition Officer, Lalit Kala Akademi, New Delhi.
1956	Contemporary Indian Art exhibition to Romania, Hungary, Bulgaria, Czechoslovakia and USSR by the Government of India.
1963	President of India's Silver plaque at AIFACS exhibition, New Delhi.
1966	IIIrd Venice Biennale, Italy; National Award of Lalit Kala Akademi, New Delhi; 9th International exhibition of drawings and engravings, Lugano, Switzerland.
1967	IXth Biennale of São Paolo, Brazil.
1968	Indian Contemporary Art exhibition, Brussels, Amsterdam, Copenhagen, Vienna and Oslo.
1971	IInd Triennale—India, New Delhi.
1973	25 years of Indian Art, Lalit Kala Akademi, New Delhi.
1978	National Award of the Lalit Kala Akademi, New Delhi.
1979	Asian Artists' exhibition—Part I, Fukuoka Art Museum, Japan.
1981	Neue Kunst aus Indien, Iwalewa Haus, Bayreuth, West Germany.
1984	New-Tantra exhibition compiled by NGMA, New Delhi to West Germany.
1985	Exhibition of paintings by Cholamandal Artists to Morocco, Algiers and Egypt by Indian Council for Cultural Relations, New Delhi.
1986	Conferred Fellowship of the Tamil Nadu State Lalit Kala Akademi.
1988	Government of India's Senior Fellowship.
1998	Passes away at Calcutta.

Ebrahim Alkazi needs no introduction to theatre enthusiasts. A towering figure in the world of Indian theatre, he served for many years as Director of the National School of Drama, New Delhi. However, the art world knows him more as the dynamic figure behind the successful running of Art Heritage Gallery, New Delhi. The article on Sultan Ali was written in 1994.

VASUDEV

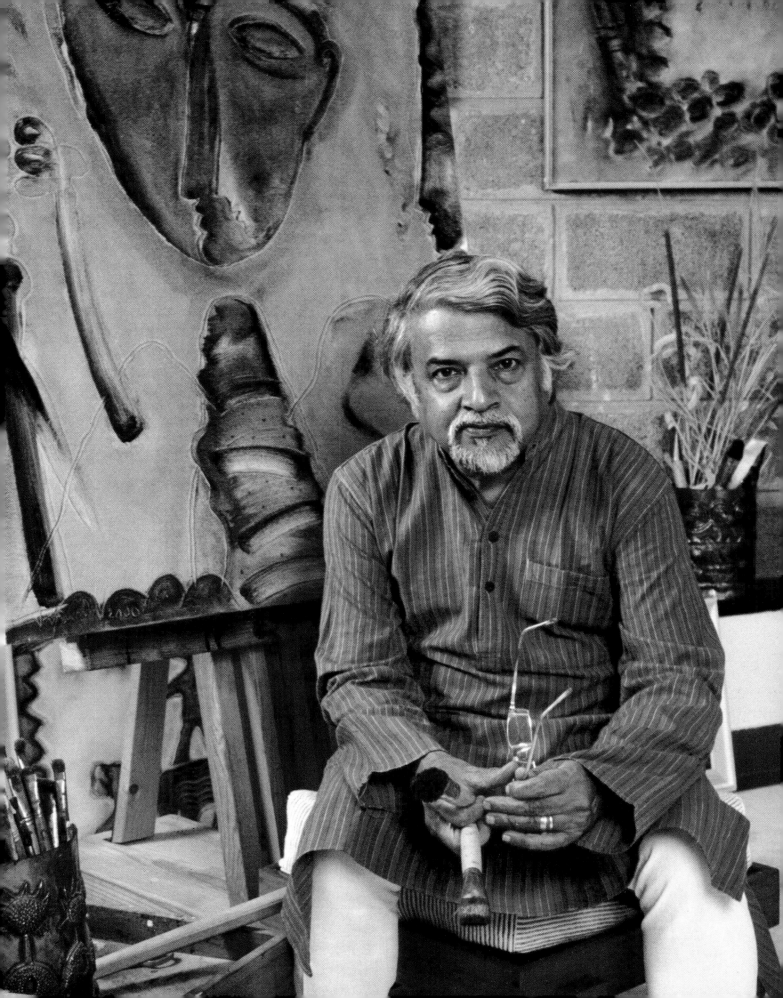

S.G. Vasudev

The world as a stage—Shakespeare was not the only one to offer us this view. It is reflected in early Indian literature as well as with Lope de Vega, Calderon, in the religious dramas of the Jesuits and, of course, in J.V. Goethe's *Faust*. The 'Life and Death of a Rich Man', depicted in the dramatic poem 'Everyman', shows this *theatrum mundi* as both allegory and effigy. In the fine arts of Europe, it can be traced from Piero della Francesca onwards, to contemporary painting. This theme has been playing a decisive role in Vasudev's later work.

His early oeuvre of the sixties and seventies was filled with signs and symbols, as his teacher, K.C.S. Paniker used them at the Government School of Arts and Crafts in Madras. *Kalpanika*, imagination—these were some of the titles of paintings from this early period. But soon he discovered the Tree of Life, *Vriksha*, as an archetypal motive which still fascinates him. Creation and growth, the eternal cycle of life, is represented by the symbol of the tree: leaves fall to the ground and, from the ground, and frequently also from the centre of a human body, the tree rises again, spreading its crown, sending its leaves back to the ground. This simile is part of Indian philosophy as much as it is of Western thought. Vasudev varies the Tree of Life again and again, takes it as a sign of the cosmos: man, beast, and plant unite in a constant stream of life: *panta rhei*—everything is in motion. Next to it, the unification of man and woman, the progenitive act, is constantly present as a theme, it being just another form of the infinite transmission of vitality. This theme is depicted in the paintings called *Maithuna*, Act of Love. The tight embraces symbolize a vivid existence.

Vriksha ▷
(Oil on canvas)
1982

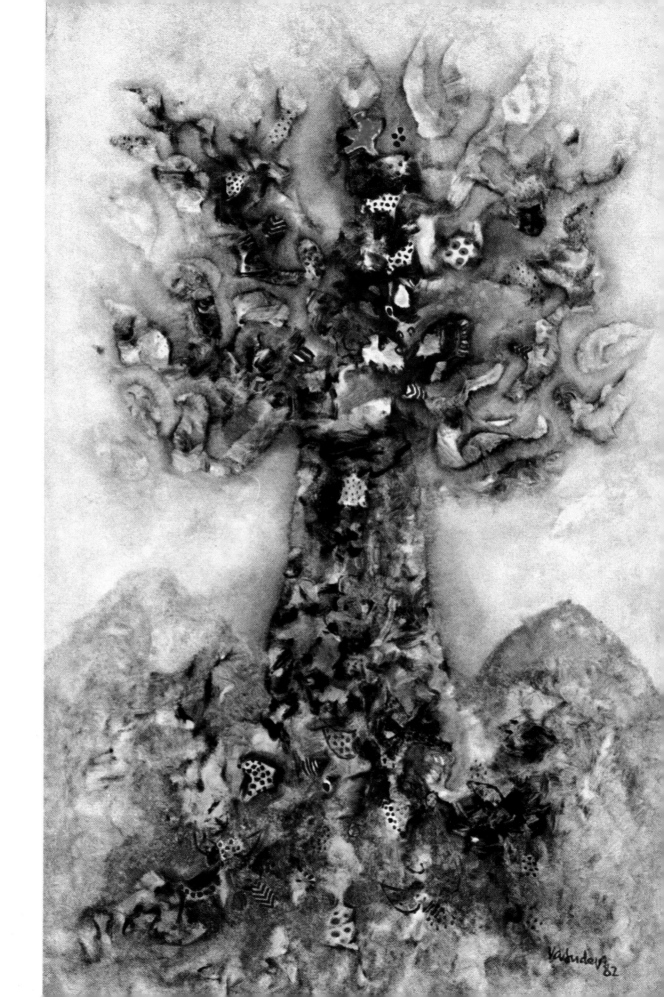

Man and Tree ▷
(Oil on canvas)
1989

Vasudev's oeuvre spans four decades. During this period he has also turned to many other subjects. There is the series, *He and She*, which refers to the *Maithuna* paintings, though not showing the archetypal unification of man and woman but, rather, the confrontation, the discussion, the dissent. Many of these pictures cast a merciless light on the apartness, rather than the togetherness, of man and woman.

The dichotomy in Vasudev's oeuvre can also be traced in another series. During a period of utter distress in the eighties, when personal tragedy dominated his life, portraits emerge which he calls *Manscape*. Human faces are presented, churned and crossed with curly lines, almost agonizing crevices in the colour, the landscapes of an agitated soul. In contrast to them he then presents a series of *Earthscapes*. The human face vanishes almost completely; a glance of the rough bark of the earth is suggested.

The trace of human presence is almost completely lost in these paintings of the late eighties and early nineties. *Vriksha*, the Tree of Life, now pierces the painting, though often with no branches or boughs at all, a silent trunk without any signs of life. Yet, step by step, at the fringes, return traces of an animated world: animals, oscillating streaks of colour, dots, lines which mingle under the predominantly dark colours.

The paintings of the eighties grew more and more abstract. They had almost lost a positive attitude and vision of life. In the nineties, however, a new vitality intrudes. The main theme now is the *Theatre of Life*. Man, banished almost entirely from the *Earthscapes*, returns into the artist's world.

And how! We are looking at theatre stages where dramatic scenes are presented: man and woman, man and animal are approaching each other, are connecting, are eyed by many onlookers, gapers, who perch at the edge of the stage and follow what's going on, sometimes almost with lust. The frame of the stage doubles the framing. The spectator experiences a double refraction. Frequently the two frames

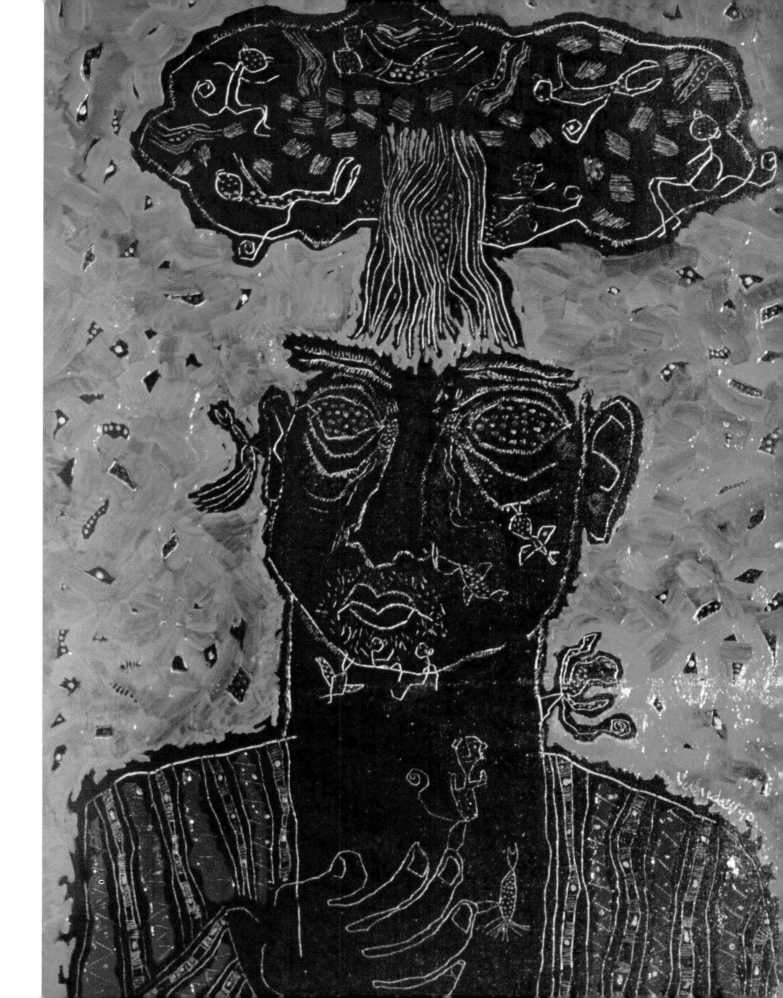

are intricately positioned against each other, as they are with the German painters, Sigmar Polke or Gerhard Richter. The paintings are also reminiscent of the daring horizontal shiftings of Anselm Kiefer.

Here we discover new philosophical and creative thoughts, an intercultural approach, which shines up at the same time in the Eastern and Western world. The spectator becomes an observer, placed outside the action, almost like an unmoved witness of actual events in this world, shown on television—or computer—screens. Such screens are suggested in some of the smaller paintings by Vasudev, where the action is offered to us by means of a radiating disk emerging from the centre, framed by ornaments of plants and wooden particles.

Theatrum mundi? Perhaps we should instead use another conception of the Baroque: *Spectaculum mundi*. For this term describes even more the voyeuristic approach which is inherent to our times. Jean Cocteau and Igor Stravinsky employed it in the introduction to their grand dramatic poem, *Oedipus Rex*. The narrator of this semi-opera starts by exclaiming *'Spectateurs!'* And spectators we all have become, today more than ever.

It is striking that the paintings of the past six years highlight this looking-on, this viewing. We find, for example, a couple at the shoreline, stretched out on a blanket, surrounded by billowing palm trees and, at the upper rim of the painting, caressed by waves. We see them in a bird's-eye view. We may look through two, even three, frames at a performance, which refers to the caricature stage presentations of Honoré Daumier, the nineteenth-century French artist. And we may again see faces, portraits, as in close-ups, occupying almost all of the setting. However, they are rather unmoved, taciturn, expressionless, withdrawn from any emotional allocation.

Some of these faces remind us of early Egyptian sphinxes or of Indian temple dancers at Khajuraho, Belur and Halebid. Also the timeless Buddhist cave-paintings in Ajanta come to mind.

△ *Theatre of Life*
(Oil on canvas)
2000

Theatre of life ▷
(Oil on canvas)
1998

Today we are very remote from the incidents that we witness, filtered by the media. Andy Warhol once put it very clearly: how can anything really touch us when we see it reproduced hundreds of thousands of times, in newspapers and on screens, in pictures and elsewhere? Reproduction alienates us from the real event. As a spectator, one adopts a neutral position. This is very visible in the paintings of the *Theatre of Life* series. We do not discern precisely what is happening, the acting figures are very remote, their motions cannot be exactly identified. The spectators, perched on the edge of the painting, are at times just stencilled faces. Witnessing is the artist's subject, rather than participating.

Human activities are reduced and sometimes concentrated to simple descriptions. Hands are thrown up, feet run into nothingness, man and beast seem to hover on a figure—against a formless background. However, the combination of excellent skill in using colour and form ensure that these paintings become incomparable icons of a contemporary interpretation of our world. As in the seventies and early eighties, Vasudev again employs a positive attitude, and very strong and light colours. His famous blues, comparable only to the intensity of stained-glass windows in French cathedrals, return. Yellow, red, and very intense rust brown, too, come back to his palette. He still frequently uses his special technique of scratching lines into the colour. But now Vasudev also uses broad strokes of the brush, the structure of which becomes a defining element in the painting. The surface becomes more animated, dissolved and thus livelier.

'All the world's a stage, and all the men and women merely players.' Shakespeare goes on to say: 'They have their exits and their entrances.' But they are always related to each other. The spectator remains outside, the actors, as remote as they may be, should be conceived in relation to each other. This is, perhaps, the secret of Vasudev's art: to see, to look, yet to be part of it. The world is in flux, man is an acting as well as a looking person, himself seeing but also being seen, part of the *panta rhei*. The complexity of Vasudev's approach to the world is the complexity of our times and its manifold appearances.

Ernst W. Koelnsperger

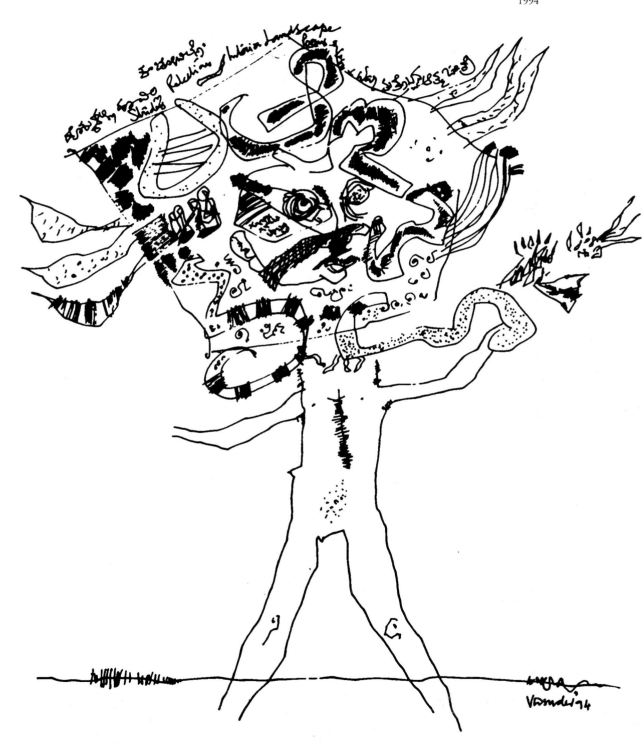

Untitled ▽
(Line drawing in paper)
1994

S.G. VASUDEV

1941	*Born in Mysore, Karnataka.*
1966	*Diploma in Fine Arts, Government School of Arts and Crafts, Madras.*
1967	*One man show, British Council, Madras and Jehangir Art Gallery, Bombay; National Award, Lalit Kala Akademi, New Delhi.*
1969	*Art direction for award-winning film* Samskara; *one man show Shridharani Gallery, New Delhi.*
1971	*Art direction for award-winning film* Vamsavriksha.
1972	*International exhibition of drawings, Yugoslavia. (Also in '74, '76, '86 and '88.)*
1977	*One man show, The City Hall, Ottawa, Canada; travelled in USA as State Department invitee (also in 1983, '90 and 2002).*
1980	*French Government invitee, also travelled in Germany.*
1983	*One man show, the European Patent House, Munich, Germany.*
1985	*ICCR delegate to China.*
1986	*Paris Biennale, Cuban Biennale.*
1991	*One man show, Crimson Art Resource and Max Müller Bhawan, Bangalore.*
1996	The New South *group show, London, U.K.*
1997	*One man show, the British Council and Apparao Galleries, Chennai.*
1999	*One man show, Admit One Gallery, New York, USA; Vadehra Art Gallery, New Delhi; Sakshi Gallery, Bangalore and Mumbai.*
2002	*One man show, Gallerie Müller and Plate, Munich, Germany; The Nehru Centre, London.*
2003	*Retrospective of Copper Reliefs at Gallery Sumukha, Banagalore and Jehangir Art Gallery, Mumbai.*

Ernst W. Koelnsperger is an Indologist and art collector who lives in Germany. He works for 'Studiosus Reisen', München and writes and lectures on philosophy and culture. This article was written in 2002.

VENKATAPATHY

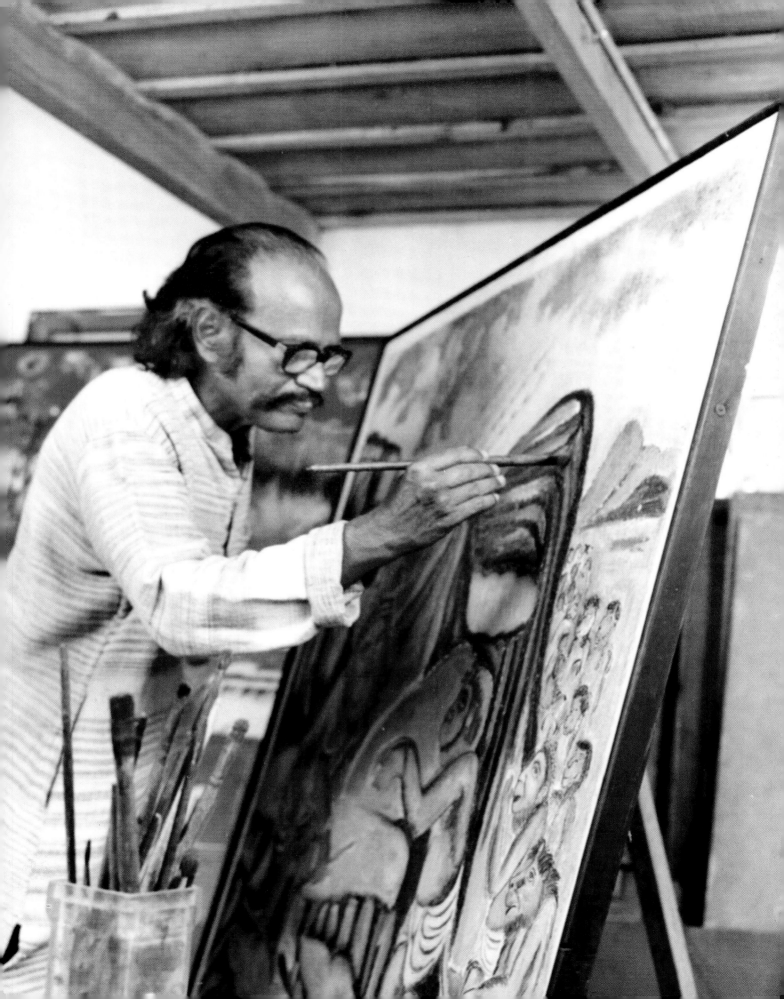

D. Venkatapathy

D. Venkatapathy has been drawing and painting for over three decades and his sources and subjects range from the mythological to the mundane, from the earthy and the exotic to the common and the trivial. Though a prolific artist in various media, the line seems to be an uncompromising factor with him and appears to dictate his technique. He has no doubt indulged in watercolours and acrylics, but his style has remained faithful to the line through which he has created his personal and uninhibited imagery.

At the Government School of Arts and Crafts, Madras, he was extremely fortunate to have K.C.S. Paniker as his principal, and was guided by a brilliant group of teachers including A.P. Santhanaraj, who taught him the naturalness or readiness of expression—an absence of strain in painting and drawing. Venkatapathy's persistence was even more stringent: a persistent scrutiny and a persistence of vision. For him the entire world was an open-air theatre where passion flared in the verdant natural greenery, flowers trembled in the crevices of hills and empty horizons turned each day into a brush with the eternal.

More myth than history lay buried in his subconscious and he turned to the Puranas and Indian mythology to create lasting images of gods and goddesses and his series of paintings on the Ramayana were like a wide canvas that embraced the art scene with a full panoramic sweep. The *Ramayana* series was done both in pen-and-ink and acrylic and as much as the compositions were rhythmic, the symbolism of the great epic was enshrined and preserved.

Under the Tiger ▷
(Acrylic on canvas)
2000

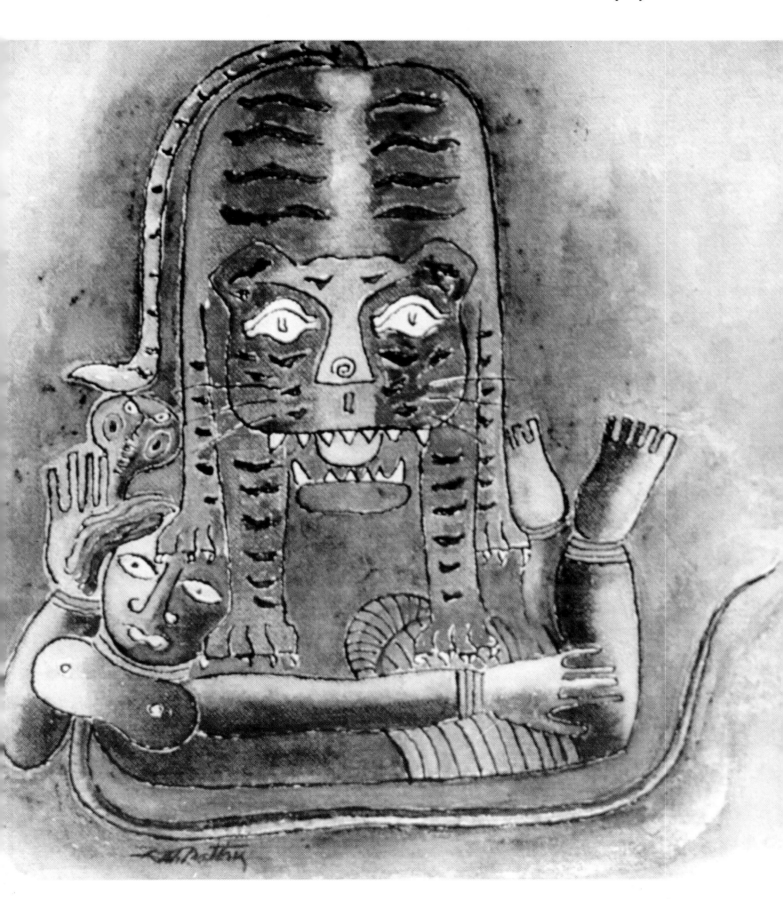

The late Sultan Ali, commenting on Venkatapathy's work, said: 'His faith in tradition is passionate and that perhaps holds him back from venturing into modernity. His creativity is fuelled by his telling vocabulary which enables him to achieve poise and harmony. It is his mastery over line that facilitates the exceptional flow of his curves and contours. His technique is steady and sustained, which helps him build varied textures over the entire surface of his compositions.'

When Venkatapathy was an art student he did dense, packed drawings and it is important to understand that this graphic quality is a strong component of his painting. He is actually drawing while he is painting and even colour has a relatively small part to play in his work. In his case one has to forget the splendour of pure hues and the startlingly golden glimmerings. The invisible comes alive with tender lights, a spell is cast, and an intensely romantic view of life is powerfully embodied. Aloof from the art world, its publicity, its ideological battles, and its commercialism, Venkatapathy lives in a milieu that insulates him from the avant-garde diversion, and from the start, his tradition and path have already been clear.

He taught in a reputed institution for some time and then settled down to discovering himself through drawing and painting, and an extraordinary web of connections can be established among any group of Venkatapathy's pictures, no matter how randomly chosen, since each carries with it numerous aspects of the artist's life and thought. In the beginning it was just nature and landscapes, hills and earthscapes. Painting from nature fulfilled him, gave him a painting vocabulary and humbled him. His search for a sustaining content in art led him to two modes of painting—working outdoors from life and painting in the studio from imagination. He also took trips outside the city to paint landscapes and went in for scenes that stirred him.

His earthscapes were more in the nature of folk art in which he saw a continuity with the past. Each of the folk art of today, he realized, was inspired by the same motivations of earlier periods. He slowly began introducing primitive forms and

▽ *Sundarakaandam*
(Acrylic on canvas)
2002

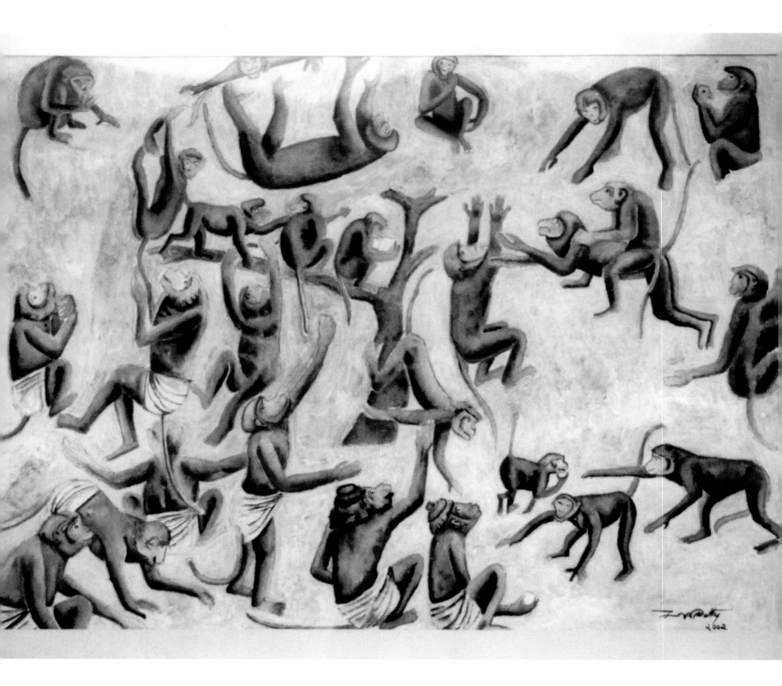

Sethupandham ▷
(Oil on canvas)
2000

elements in his compositions which led to a totem series and different kinds of masks done in tempera and watercolours. He appears to have been influenced by African and Mexican art in designing the masks. Some of them he did in oil pastels, giving them a live character as well as a ritualistic significance that is associated with masks in India.

From the eighties onward, he switched to black and white drawings on Biblican themes, the Puranas and the epics. Richly worked out gods and goddesses took shape under his delightful touch and the lines etched out by him stood as a strong-bodied commitment that whatever the medium, forms of beauty and satisfaction were well within his reach.

Venkatapathy, after many decades of work, confesses that his present phase of art is the most fulfilling for him 'because of my maturity and understanding of life'. Venkatapathy's world suggests our legendary, primal, and ancestral background, drawing freely on all the deposits of our image-bank and potential mythological and metaphorical resources. Thereby he could boldly assert that 'the mythological series like the *Ramayana* is my very best work'—the fluid lines are oddly impersonal, nearer to folk-tale than the distant past. For textbook modernists, this kind of work may be irredeemably marginal, questioning the entire concept of avant-garde mainstream, but Venkatapathy's emergence as one of the most sustained artists of his generation has been part of twentieth-century art history.

In being recognized as a 'typically Indian artist', Venkatapathy believes that the beauty of his work lies in the harmony that he creates in his compositions and that, in brief, is also his philosophy—that he would like to finish a work in the way he wants. He would liken this concept to a long episodic drama in which each section can be a fresh attempt to make a symbolic structure, commenting on and attempting to push it further. There is the suggestion of a pilgrimage—of that continuous narrative through landscape to mythology.

Anjali Sircar

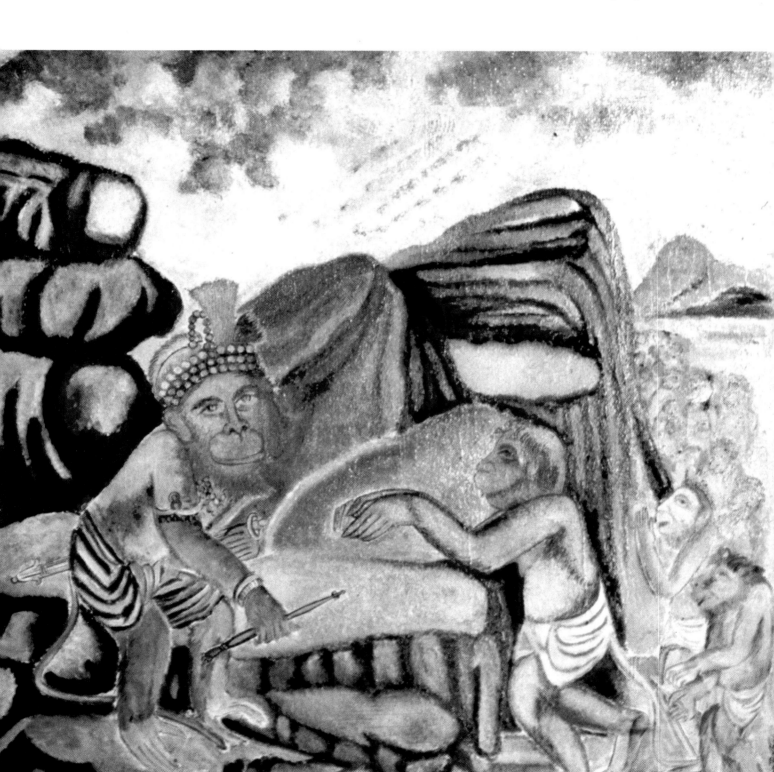

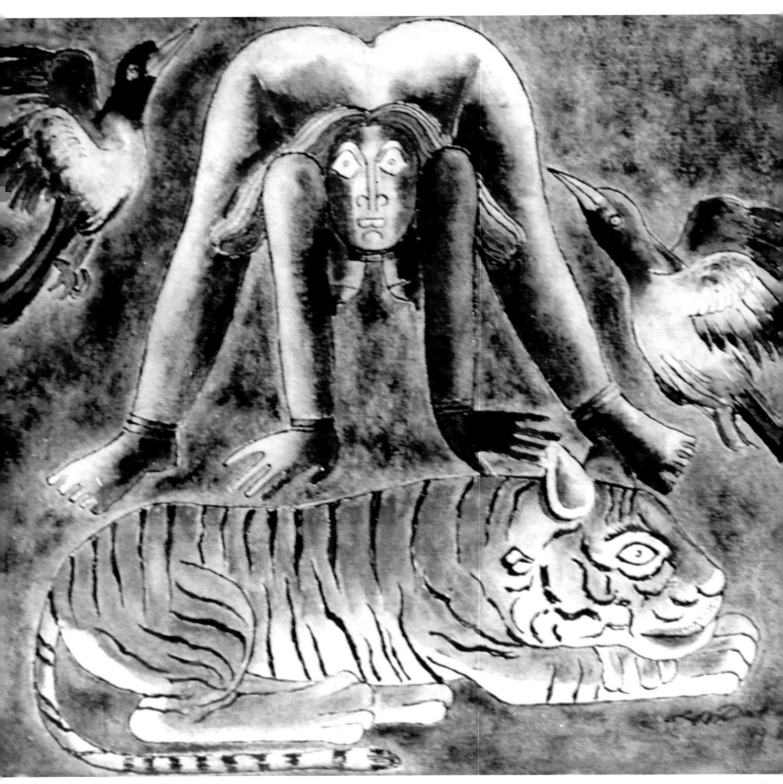

Woman and Beast △
(Acrylic on canvas)
2000

D. VENKATAPATHY

1935	*Born in Vellore, Tamil Nadu.*
1964	*Trained in fresco painting at Banasthali Vidyapith, Rajasthan; awarded Silver Medal by Academy of Fine Arts, Calcutta; exhibited at the Tamil Nadu State Lalit Kala Akademi (also in 1966, '67, '77, '79 and '92).*
1966	*Award of the Tamil Nadu State Akademi, Madras; Silver Medal of the South Indian Society of Painters, Madras; among the first batch of artists to move into Cholamandal.*
1967	*Diploma in painting, Government School of Arts and Crafts, Madras.*
1972	*Cholamandal Artists' Village exhibition sponsored by UNICEF, New Delhi.*
1978	*'40 artists of Madras' organized by British Council, Madras; Ooty painters' camp conducted by Tamil Nadu State Akademi.*
1981	*National exhibition of Art, New Delhi (also in '82, '86, '92',93, and '94).*
1982	*Robin Hood International, 27th Annual exhibition, Sydney and Australia; the Asia Pacific Museum, Poland.*
1985	*Award of the Tamil Nadu State Lalit Kala Akademi; Cholamandal Artists' Village exhibition organized by the Indian Council for Cultural Relations in Morocco.*
1986	*Bharat Bhavan Biennale, Bhopal.*
1987	*Painters' camp conducted by South Zone Cultural Centre, Madras.*
1991	*VIIth Triennale India, Lalit Kala Akademi, New Delhi.*
1992	*Award of the Karnataka Chitrakala Parishad, Bangalore.*
1996	*Received silver plaque on being honoured as a veteran artist of India by All India Fine Arts and Crafts Society; also participated in the show organized for the veteran artists.*
2003	*Nominated as an eminent artist member of the Lalit Kala Akademi, New Delhi.*

Anjali Sircar has been associated with the modern art movement in India for over three decades. She graduated from Madras University and studied journalism in Calcutta. She has received the Art Critic Award of the Lalit Kala Akademi, New Delhi, and her monograph on L. Munuswamy has been published by them. The article on Venkatapathy was written in 2003.

VISWANADHAN

V. Viswanadhan

Looking at a few decisive events in the life of a painter allows us to understand his creative evolution, explain the meaning of a life when it assumes the proportion of a remarkable epic, and follow the steps in the development of a work of art.

Kerala, a state in southern India with an ancient and rich tradition of poetry, theatre, and music for ritual dances, is a land of the setting sun and the birthplace of Viswanadhan.

After secondary school, Viswanadhan enrolled in the university to study economics and political science, but soon realized that this would not satisfy his innate aspirations. Attracted by literature and the theatre, he seriously considered studying Sanskrit. After a period of indecision, he entered the Government School of Arts and Crafts, Madras; painting seemed best suited to his temperament at that moment in his life. He now had an opportunity to discover first-hand the varied cultures and landscapes of India, an opportunity which he would not have again until 1976 when he began his first film and made a second initiatory trip through India. This journey triggered an obsession with the opposing but impossible duality of wishing to be elsewhere than where he was. This can best be expressed, on the one hand, by a withdrawal into the microcosm of his studio where he had created an introverted and solitary universe of individual research and, on the other hand, by the need for contact with this duality, which led him to the freedom generally associated with nomads.

Viswanadhan first visited France in 1968 at the invitation of the Biennale des Jeunes. What was to have been a short visit turned into a long stay. An important

Untitled ▷
(Casein on canvas)
1997

Red Painting ▷
(Oil on canvas)
1967

gallery saw his work and asked him to exhibit with them. Paris soon became his permanent home.

Viswanadhan believes that 'drawing the spirit from the matter' has been the basis of his work on paper, canvas, and metal plate. This allows us to understand his continuing research and sensual interest in material. Such experimentation reveals the potential of his work's support. The entire body is involved in working on a drawing or a painting as it moves back and forth through space to the paper or the canvas in order to become as completely familiar as possible with the surface being worked on.

A series of paintings on paper done between 1968 and 1977 used small formats because of the limited space in which he was then working. The technique used was one developed by the artist and it had a captivating effect. The outline was drawn by a metal stylo with thick stamping ink. Oil paint was applied with a brush and the work washed with the essence of turpentine. The transparent and thin paint revealed the geometric forms.

Viswanadhan used a number of techniques in those early years in Paris, indicating an interest in discovering innovative styles. Watercolours and oils, for example, were mixed and contrasted in a unique manner. The fragile transparency of one medium blends into the relatively opaque quality of the other. The resulting alchemy creates subtle shadings of light and shadow. A few paintings on paper have a margin running around the sheet like a frame, suggesting a separation between the inner and outer space of the work. In some works from the seventies, gold and silver watercolours create shimmering icons.

Viswanadhan did his first 'sewn' paintings in 1974; by 1983 they reappeared in a more developed style. He used a highly personal and somewhat strange technique to recompose the different pieces into one. Using strong hand-made paper, these works combine a technique used in handicrafts with a sophisticated sense of organization. This forthright, perhaps impertinent, method allowed the artist to create a single, coherent composition from autonomous and different parts. The use of such a technique in painting undoubtedly satisfies a compelling urge for

the immediate reconstitution of a fleeting intuition, unless it simply corresponds to a desire to unite or expand limited surfaces within a field reduced by visual images. The thread used in sewing expresses an intention to reassemble the different parts of the work, as if one were reconstructing the scattered pages of a novel. Neither a puzzle nor an inert object, but rather an articulated body within the rediscovered unity of a painting.

His later drawings (1995–97)—large, horizontal formats and smaller square drawings using India ink applied with a bamboo stylo—reveal a freedom and mastery of expression.

Highly evolved, they are done with ease. Their dynamic internal rhythm is created by oblique lines while the barest of geometrical forms unite them. Totally concentrated, Viswanadhan continues to work on these drawings from one day to the next until he completes a series. Such continuity allows the artist to express all imaginable variations until he reaches the end. With a light and rapid, firm or fleeting gesture, the vibration of the irregularly drawn line breathes inspiration onto the white paper.

Viswanadhan's life seemed to have been inscribed on the roster of painting which he created in the silence and loneliness of his studio. Exhibitions were his only moments of diversion breaking his self-imposed isolation. Everything in his life was built each day on alternating moments of joy and deception, satisfaction and doubt, elation and fear. Nothing in the rhythm of one day succeeding another could apparently be challenged.

But the fragile thread of destiny was suddenly broken in 1976 when the artist was involved in an automobile accident in Germany. His fate was suspended between life and death; the shock was to deeply affect his inner equilibrium.

When Viswanadhan awoke in a hospital, he heard someone asking: 'Where do you come from?', 'Who are you?' The questions reverberated into a disturbing personal echo and he felt what Rabindranath Tagore expressed: *'Je ne puis trouver la quiétude, je suis étranger à mon propre cœur.'* (I cannot find any quiet; I am a

△ *Untitled*
(Mixed media on canvas)
1970

Untitled ▷
(Mixed media on canvas)
1972

stranger to my own heart.)

His recovery was accompanied by a profound change in his awareness of time and space and led him to question his identity, his relation to the world and others, as well as the meaning and importance of painting in his life.

He sought a new orientation, a new road in order to find an answer to his anguish, and found it in the form of films as the best medium for his investigation of the exterior world.

Films would be the adequate means of expression capable of rebuilding the lost links in the memory of origins.

Viswanadhan's arrival in Paris marked the beginning of his adventure in painting. His first exhibitions were decisive in the development of his painted work, the various stages of which have been marked by abrupt changes. These changes coincided with successive exhibitions and have allowed us to follow these modifications in his pictorial journey. Shortly after he settled in France, he was offered an artist's studio in 1971. The space allowed him to experiment with large canvases. His entire body through its movement transmitted a dynamic rhythm to the canvas stretched out on the floor. This preparation of the surface to be painted recalls the mandala technique, consisting of drawing concentric circles evoking the concept of the cosmos. Early in life, Viswanadhan was introduced to Tantric ritual by his father. The total view of the drawing on the ground seen from above is his only reminiscence of this experience; his concern is exclusively pictorial.

The early Paris paintings (1969–71) done on large canvases using a mixed technique offer a luxurious variety of colours covering the canvas with exuberant forms in a kind of 'all over'. Vital energy is profusely expressed. His texture consists of a thick coat of vividly coloured pigments which produce effects of density through a succession of overlapping layers.

The 1972–75 paintings were done with acrylic; the composition is clear. Geometric forms outline the work's structure in square formats. The transparency allows the

white background to show through. In a 1975 painting, the weft can be seen almost totally devoid of colour. This extreme in going practically to the limit of experimentation is frequent and reveals new solutions.

1976 marks a turning point in Viswanadhan's work. The *Sand* panel creates a pre- and post-accident boundary. The changes lead to new paths. The cinema introduces new forms of expression. The start up of work on films brought a new light into his perception of painting.

The *Prismatic Paintings* (1976–85) are done on square canvases. Geometric forms—mazes, triangles, circles—bring a monumental order to each work. Few colours are used—bright yellow, ochre, and brown. This limited palette indicates a desire for sobriety as well as extreme concision. The simplicity obtained with acrylic exposes the background of the canvas to view.

The *White Paintings* (1981–84), almost monochromatic, were done between the films *Sand* and *Water* and illuminated by a few touches of orange, yellow, or red. Light plays on the casein as if reflected through the eye of a prism.

The Malayalam word *sukla* defines white as the revelation of truth; it implies the insertion of reality into vision. A painting assumes shape from white, the basis of its final harmony. Casein, a phosphoprotein of milk, is used as binder of colour pigments. Because of its smooth, fluid consistency, casein allows for the expression of transparency and opacity, light and shadow, the essential basis of any image produced by colour.

Paintings in which orange-red-green dominate were done in 1989, a year in which *Fire* was filmed. Important changes appeared in the combination of colours painted in overlapping layers; rectangular forms created by colour uniformly applied give the painting its movement and contrast. A frontal interpretation of the work is asserted during this period and imposes a direct confrontation to the eye in front of the striking presence of the work.

In his latest paintings (1995–97), the artist uses a palette of red and green. A new construction consisting of coloured tensions induces a sharp visual shock, a meeting

△ *Untitled*
(Etching)
2000

of interacting harmonies and flaming colours. The background of the painting is suddenly revealed between the intervals of coloured space by vivid whites and yellows like points of light coming from the depths.

Viswanadhan's work is built on the alternation of opposites. The paintings sometimes evoke by their refinement and elegance the overlapping transparent veils worn by women during the Mughal reign and at other times, brilliant festive banners by their strong, bright colours.

Analysing a work of art places the artist in front of the alternative designated in Buddhist philosophy by the terms *stravara* and *jangama*. One implies a conventional and academic position, a closed and obstructed field of thought; the other places behaviour in an open and creative set of dynamics, in a perspective of development and liberty.

The act of painting leads the artist toward an interior process of self-knowledge. The use of cinema, moreover, leads to an understanding of the exterior world and others. It relays multiple visions authorized by the 'cosmological eye'—to use an expression from Henry Miller—attentive to communicating the cycle of life and death.

This commitment corresponds to *purna*, the totality of existence expressed through the body and spirit, the global dimension with which we and the universe are merged.

Studying the journey accomplished so far allows us to consider the place of the artist in the landscape of art at present. The history of twentieth-century art overflows with a long prolific series of abstract movements and forms.

For Viswanadhan, any classification or reference would not define him; he cannot be reduced to any movement or any family of inspiration. The artist feeds on the sources of two cultures: Western and Indian. His work, marked by this intense confrontation, has entered time wreathed in its own light. It can hope to leave the imprint of his presence just as the wind leaves a trace after its passage.

Alberte Grynpas Nguyen

V. VISWANADHAN

1940	*Born in Kerala.*
1966	*Diploma in Fine Arts, Government School of Arts and Crafts , Madras; among the first batch of artists to move into Cholamandal.*
1967	*Paris Biennale, France.*
1968	*Lives and works in Paris since 1968; National award of the Lalit Kala Akademi, New Delhi.*
1969	*One man show Galerie, Ved Aaven, Aarhus, Denmark.*
1970	*One man show, Galérie de France, Paris.*
1978	*One man show Galerie Stig Carlsson, Hogonas, Sweden.*
1981	*International Biennale of Engraving, Moderna Galeria, Ljublijana, Yugoslavia.*
1985	*One man show at Centre Georges Pompidou, Paris, France.*
1986	*Festival du Cinéma du Réel, Centre Georges Pompidou, Paris (Grand Prix du Cinéma du Réel); Festival dei Popoli, Florence, Italy. (1ˢᵗ prize for the best documentary of the year).*
1987	*Film* Ganga *shown at the 'Week of Directors' Movies', Malaga, Spain; Berlin Film Festival; Viennale 1987, Vienna, Austria; Jerusalem Film Festival, Israel.*
1988	*Film* Agni *shown at Festival du Cinéma du Réel, Centre Georges Pompidou, Paris, France.*
1992	*Film shown at Hirschorn Museum and Sculpture Garden, Washington DC, USA.*
1994	*Film* Air/Vayu, *La Semaine de la Critique, International Film Festival, Locarno, Switzerland.*
1997	*One man show at Vadehra Art Gallery, New Delhi. '50 years of Independence', Lalit Kala Akademi, New Delhi.*
1998	*Geometry and Symbols: retrospective exhibition at NGMA, New Delhi; Indian Contemporary Art, NGMA, New Delhi.*
2001	*Retrospective at NGMA, New Delhi.*

The art critic Alberte Grynpas Nguyen wrote the article on Viswanadhan in 1998 in French. The text was translated from French by Leonard Radlo.

PANIKER

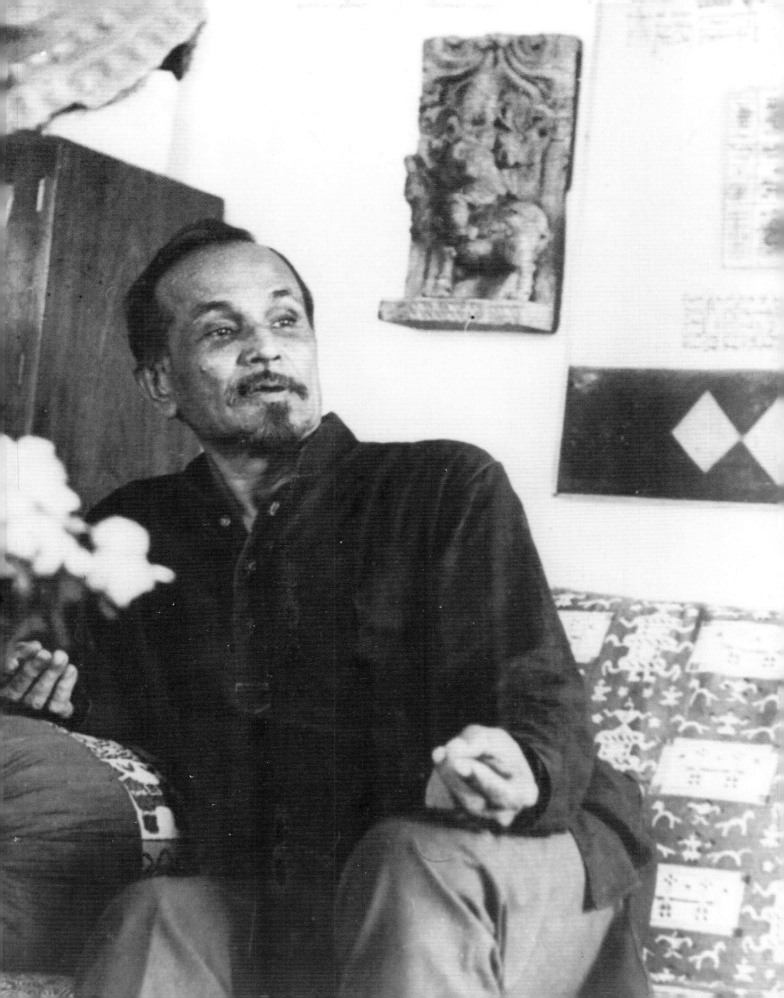

K.C.S. Paniker

Paniker's work in his later years has taken on a grim aspect. The unexpected note of assertiveness and the technical audacity that characterized the earlier phases of his work, he now conserves and applies in what appears to be a very serious argument. His ways with form and arrangement have always been unusual. But what had been even more remarkable was the clear sense of inward necessity which had driven him on each occasion to express himself in such unusual ways. Such a sense of dire necessity and the open agitation in a painter are clear enough indications of the hold of a subject which is of a radical and uncompromising nature. In his current work, Paniker seems to find his ground to face it squarely. He tests and theorizes, looking for a technique with which he can confirm the extraordinary subject of his work.

Painters who get to such a state turn severe almost characteristically. They shed colour, eschew tone and try to perform with line, which is the most primitive and the most restricted means at his disposal. What is proved in such austerity is presumably proved indeed. Tone and colour can thereafter arrive to give it body and fulfillment. The linear emphasis will be almost everything in such a work and it will be of a very intense and searching nature.

The line is almost everything in Paniker's later work, and it is of an intense and searching nature. The fact that this has been so for him for well over ten years

Words and Symbols ▷
(Oil on canvas)
1964

would have one suspect that what is being searched for in these pictures is something that is not easily found. For the moment it is unknown, but tantalizingly close to him and it must, he appears to insist, become identified with some theory that can provide for him a solution to the issue between drawing and the picture. The issue is fundamental and one that has been raised several times before, but Paniker dares it again in-depth and in the midst of a serious controversy.

The notion of a three-dimensional linear space that the Renaissance painters advanced and which they applied in the rule of perspective, and the pure theory of it which the cubists abstracted later on are to date the only technically sound solutions to the issue between drawing and picture. Those who repudiate these solutions cannot therefore make a case for their drawing and even for picture making except a personal and emotional one. Paniker was one who would not submit his subject to received theory in its applied or pure form, and this stance left him with no case at all to draw or to make pictures. Rather than relent as many others did who were left desolate like him, Paniker broke off and set out arguing his own case.

He made his departure in the landscape, the genre he used extensively for developing his arguments. Rather than solidify the free space with the straight line structure of perspective or with regular blocks of colour, he made it into a fluid thing held up with a distribution of highly accented, broken, and curling lines. The irregular edges of colour that one gets as a bonus when working in watercolour, a medium in which Paniker excelled, might have suggested to him this very unconventional possibility of asbstraction. The same kind of line, he proved, worked well in his figure drawing to yield an unstructured, fluid formation in place of solid anatomy. The highly 'nervous' line and the running colour appeared to be a strategem with which he could create some very fresh and fluid experiences. It thrilled many, quite a few took to it and got off in the sixties in an important

Christab and Lazarus ▷
(Watercolour on paper)
1950

movement in the contemporary art of the country. However, the case that Paniker was making with such a line, as in his *Garden* series of pictures for all its assertiveness and lure proved an unsubstantial one. It conspicuously lacked the mechanism to strike and to convict.

No one saw this more clearly than Paniker himself. In the mid-sixties when this appears to have happened, he turned around and returned to his drawing in great anxiety and started his research with it. He had found that a landscape or a figure or a group can be drawn without using or even implying at any stage the straight line structure. Could he then draw with the broken, accented line not those things that are known and can become images, such as the landscape, figure or group, but such things that are abstract of which we can have no sensual evidence whatever? Could he say, in other words, that what could be drawn in his particular manner is some real thing? Such questions touch certain depths, but the uncompromising nature of his subject and its imminence in his work caused these to be asked.

Paniker proceeded to test his drawing by denying it the convenience of the image. If one is to rely on images, as one conventionally does, for making the lines of ones drawing cohere, drawing becomes something to which an otherwise known thing can be reduced to. Paniker in his *Words and Symbols* pictures, reversed this role and attempted with his drawing to bring into being unknown bodies and substances. In *Fruit Vendor* where he tried it for the first time, he could sense such presences in the slight manifestations of colour here and there in the picture. In his subsequent work, one observes him move on, relieving his drawing of the burden of every known image, leaving the little twitches of his line free to come together in intelligible formations of their own. They made little texts, so to say, and with them he literally spelled into being hugely uncertain bodies of unknown substances. And these stood apart like sense from a text of script.

That made an entirely new paradigm in art. This series of pictures makes it

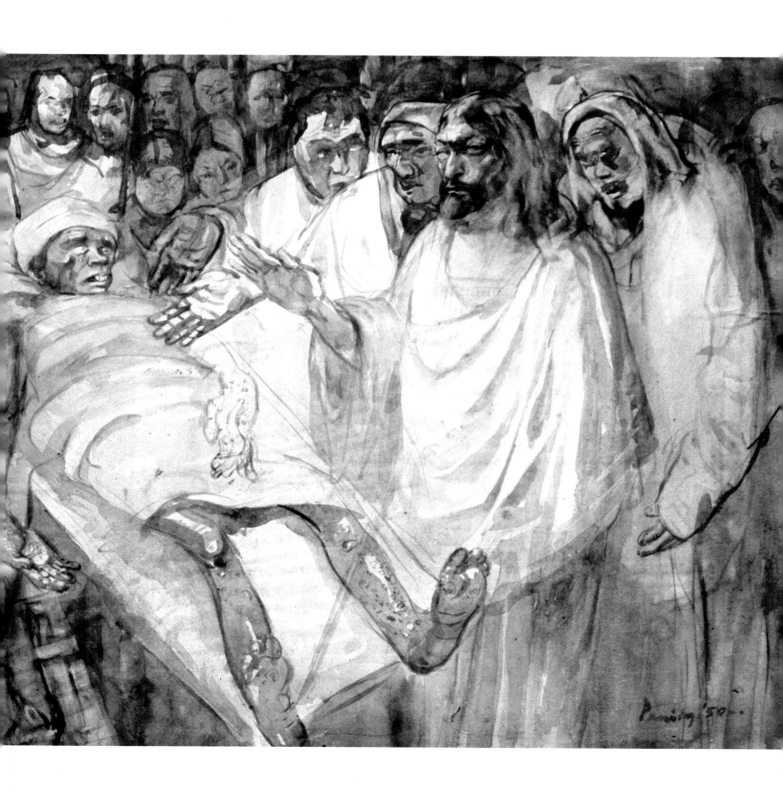

Lumbini Gardens ▷
(Oil on canvas)
1956

reasonable to believe that there exists a drawing which can do away with the image completely and yet have an enormous capacity for detail. If that is a possibility, Paniker goes on to argue, it would be possible to form with that kind of drawing, bodies that can have no delineation, no mass and no temporal being; and that is, to introduce a whole class of beings one has no familiarity with or previous knowledge of art.

To go on from that state of his achievement, Paniker will have to break free from the analogy with the script on which his drawing at the moment is heavily dependant. Because of this dependence, he is forced to make his drawing cohere in just those ways in which a script can cohere. If this can be done away with, he might move on to picture bodies of greater rarity and subtlety.

The extraordinary relationship between drawing and body that Paniker establishes is, of course, purely pictorial. It isn't, in other words, a relationship which one knows already to exist in the nature of things. And no artist can carry or take matters beyond that. It must now occur to fellow-seekers with him in other disciplines to find the paradigm advanced in these pictures and to venture with it a new theory of reality. With that development, the unknown subject that vexes this painter so deeply would have arrived and the case on its behalf made out at last.

Josef James

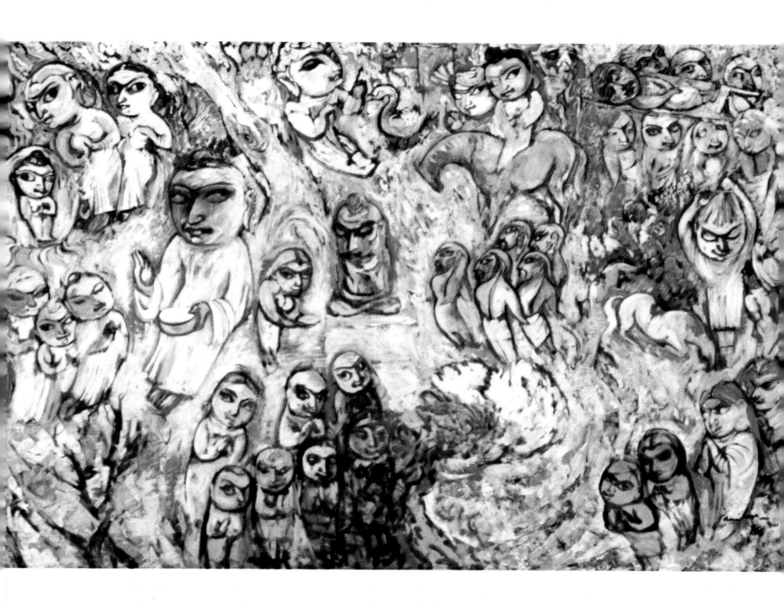

Chitram Ezhuthu

by K.C.S. Paniker

What more suitable medium can one invent for making pictures than the written word?

Every letter in the written word has a highly evolved form, a form attained through usage and guided by man's racial or national sense of seeing and shaping, the line following the laws of continuity and free manual rhythm of action. Man has been writing for centuries; he has continually sought to make his writing beautiful and yet, in practice, he is most un-selfconscious, with the result that each man's writing announces his own true character and personality. What more suitable medium can one invent for making pictures than the written word? The Chinese and the Japanese have demonstrated it to the satisfaction of the world. In India, the Tantric tradition enjoins the use of the written word, symbols, figures and that most marvellous of all inventions, the tabular column for picture making. Colour is used to put the message across effectively. The Kalamkari painters of India, especially those of Andhra and the other southern states, paint their cotton temple hangings depicting the heroes of the epics; the legend is always interspersed with the figures, written with great calligraphic freedom. The drawings and symbols used also share this calligraphic quality.

Perhaps these thoughts occur to me because of a growing appreciation of the great traditions of man in the field of art. There are people who believe that the tendency today is to escape from the weight of traditions and to move towards a sort of internationalism in the visual arts of painting and sculpture. English critic Herbert Read states: 'The internationalism of modern art makes it difficult for the critic

Fruit Seller ▷
(Oil on canvas)
1963

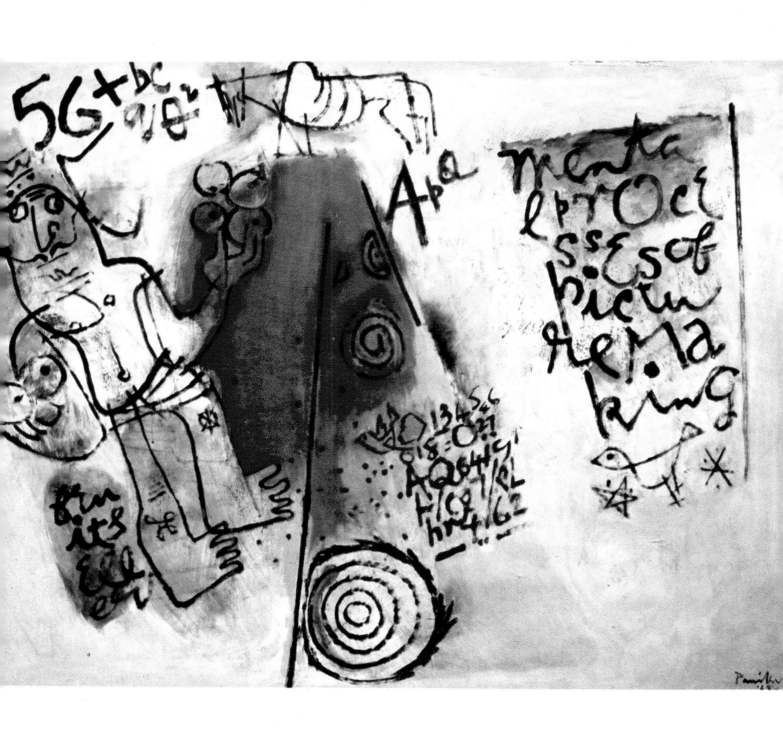

Ancestral Assertion ▷
(Oil on canvas)
1965

to claim a distinctive type of art for his own country. There is no British art since 1945—there is an art, more vigorous than any art Britain has known since the death of Turner (1855), which has made a distinctive contribution to a world-wide movement of the arts.' This statement tends to imply that the present-day art of Britain has very little to do with the British character as the world knows it. How an art can be international without national characteristics is beyond one's comprehension. The redeeming feature in Sir Herbert's disturbing statement is his use of the term 'distinctive contribution'. This, I presume, again brings one back to the concept of racial and national character in the artist, as a feature of perennial interest. Again, one cannot help feeling that it is premature to say anything positive about the acceptance of 'modern art' by all peoples of the world to such an extent as to reject the great traditions of mankind wholly and entirely as Sir Herbert's statement might appear to imply. We have yet to wait another few decades to see exactly how the resurgent Asians and Africans react to Europe or America's new art of the early twentieth century. In Asia and Africa, one finds the West's approach to utilitarian architecture and industrial design. The art of modern Europe and America still remains incommunicable to the vast millions of the rest of the world. A few of the initiated have learnt to accommodate the alien point of view, more often without any genuine understanding of their own deep-rooted traditions from which wars and invasions have partially torn them apart.

Talking of the problems of the Oriental artist today, Ludwig Goldscheider says:

An Indian artist, on the other hand, cannot merely study the Ajanta and the Tanjore wall paintings and imitate them on a smaller scale—this would not make him a modern master: he has to go through the school of world art. But to become a genuine artist he is not allowed to forget or suppress his racial and national way of seeing and shaping—he has to be an Indian artist or nothing at all. In the end, his painting will be as different from all European art as the thinking of India—Upanishads and the Buddha—is different from European thought. (No true message without that difference.)

If this thought is accepted then it would mean that according to Sir Herbert, Britain and the rest of Europe are tending towards the acceptance of a common

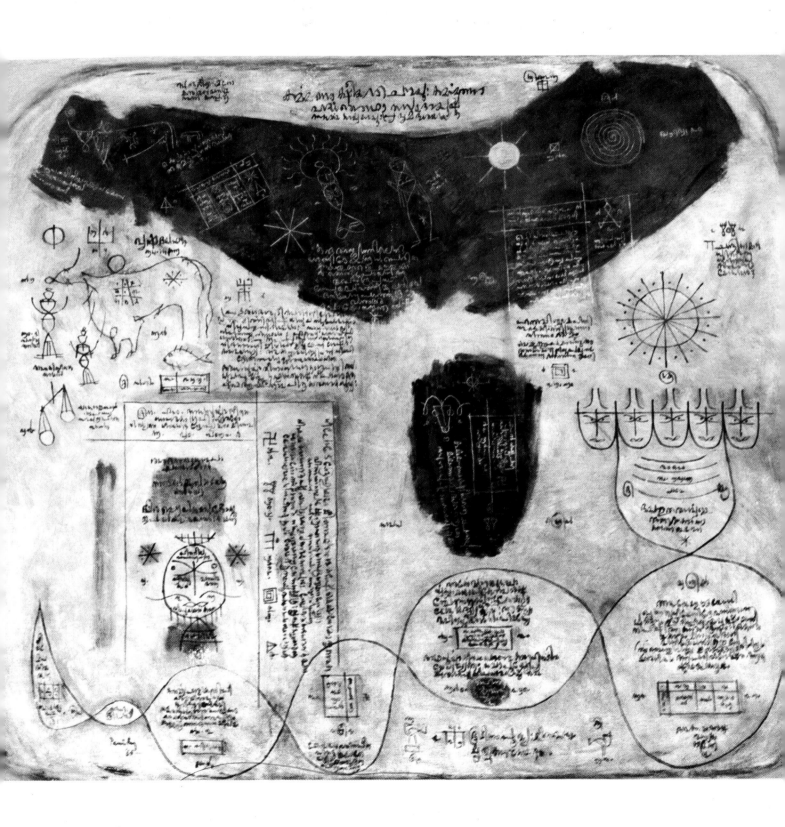

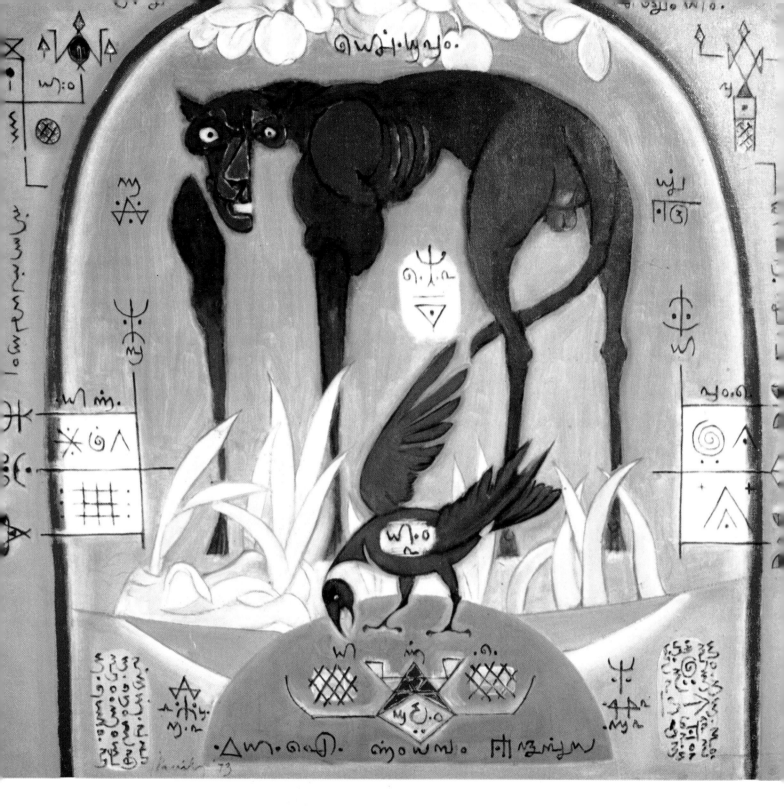

Dog △
(Oil on canvas)
1973

Figure and Symbols ▷
(Oil on canvas)
1976

art form surrendering all national and racial characteristics which hitherto were interesting aspects of the arts of the various peoples of Europe.

Let us now listen to T.S. Eliot. In his essay 'Tradition and the Individual Talent', he states that the 'the most individual or original parts of a poet's work may be those in which the dead poets, his ancestors, assert their immortality most vigorously'. A historical sense which is indispensable, gives the poet, says Eliot, a perception not only of the pastness of the past, but of its presence. It makes him not only traditional but 'most acutely conscious of his place in time, of his own contemporaneity'. These thoughts make one wonder if we in India can, with our present brand of internationalism, ever hope to paint or sculpt with true significance so long as we deny our ancestors—so long as they do not assert their immortality through us.

Paniker

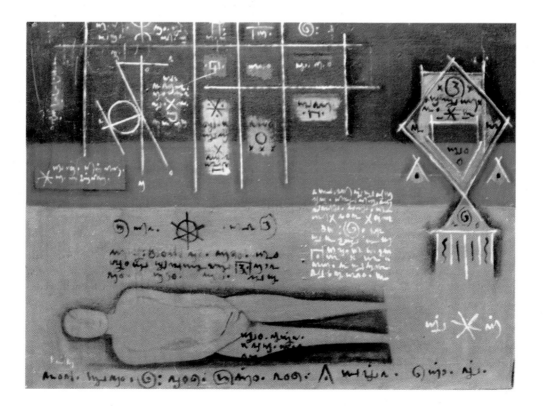

K.C.S. PANIKER

1911	*Born on 31st May, in Coimbatore, Tamil Nadu, India.*
1917–30	*Formal education in Kerala State and Tamil Nadu.*
1936–40	*Art education at the Government School of Arts and Crafts, Madras.*
1944	*Establishment of the Progressive Painters' Association, Madras.*
1954	*One of the Nine Eminent Artists and Member of Executive Board of the Lalit Kala Akademi, New Delhi; travels in Europe; one man exhibitions of paintings at the India House, London, and Paris.*
1957	*Appointed Principal, Government School of Arts and Crafts, Madras.*
1959	*Extensive travel in USSR and talks on Indian art in Moscow, Leningrad, and Kiev.*
1961	*VIth Bienal de São Paulo.*
1962	*Participation in the Indian Art exhibition in Mexico; upgrading of the Government School of Arts and Crafts, Madras to a Government College of Arts and Crafts.*
1963	*Member, Indian Delegation, World Art Congress, New York; travel to USA and discussions with American artists as a guest of the State Department, USA.*
1964–67	*Tokyo Biennale, Festival Hall exhibition, London and the Venice Biennale; National Award for painting; retirement in 1967 from the principalship of the Government College of Arts and Crafts, Madras; the establishment of Cholamandal Artists' Village, Madras, in 1966.*
1977	*Passes away in Madras.*

The article on K.C.S. Paniker was written in 1972 by Josef James, the editor of this book.

The article 'Chitram Ezhuthu' was written by K.C.S. Paniker in 1968 on the significance of the written word and the manner in which it is incorporated in his series of paintings *Words and Symbols*. The *Fruit Seller*, painted in 1963, was the first in this series wherein he achieved a 'breakthrough'.

INDIA

Delhi

Kolkata

Mumbai

Chennai
Cholamandal Artists' Village

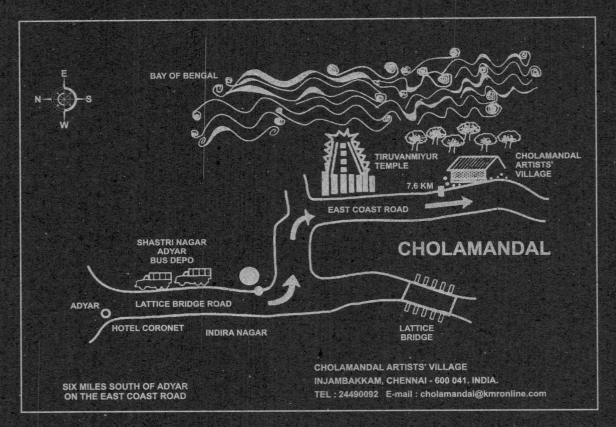

BAY OF BENGAL

E
N — S
W

TIRUVANMIYUR
TEMPLE

CHOLAMANDAL
ARTISTS'
VILLAGE

7.6 KM

EAST COAST ROAD

CHOLAMANDAL

SHASTRI NAGAR
ADYAR
BUS DEPO

ADYAR

LATTICE BRIDGE ROAD

HOTEL CORONET INDIRA NAGAR

LATTICE
BRIDGE

CHOLAMANDAL ARTISTS' VILLAGE
INJAMBAKKAM, CHENNAI - 600 041. INDIA.
TEL : 24490092 E-mail : cholamandal@kmronline.com

SIX MILES SOUTH OF ADYAR
ON THE EAST COAST ROAD